COLONIAL DESIRE

Despite its overt intentions, argues Robert Young, today's cultural theory repeats and renews many of the key concepts and terms, such as hybridity, through which culture and race have been defined in the past. Young traces the links between the paradigms of today's theory and writings on culture, civilization and racial difference in the nineteenth century. Culture is shown to have worked through an uneasy syncretism, carrying within it an inner dissonance that marks a resistance to Western culture within Western culture itself. Young asserts that 'Englishness' has been less fixed and stable than uncertain, fissured with difference and a desire for otherness.

At the same time, racialized thinking has never been marginal to English culture. Even 'scientific' theories of race were always also theories of cultural difference. Race and culture developed together from the very first. And at the heart of Victorian racial theory, Young discovers colonial desire: an obsession with sexuality, fertility and hybridity: a furtive fascination with miscegenation and inter-racial transgression.

Robert J. C. Young is a Fellow of Wadham College, Oxford, and University Lecturer in English at Oxford University. He is the author of *White Mythologies: Writing, History and the West* (Routledge 1990).

D0188124

COLONIAL DESIRE

Hybridity in Theory, Culture and Race

Robert J. C. Young

London and New York

First published 1995
by Routledge
11 New Fetter Lane, London EC4P 4EE

Simultaneously published in the USA and Canada
by Routledge
29 West 35th Street, New York, NY 10001

Typeset in Palatino by Solidus (Bristol) Limited

Printed and bound in Great Britain by
TJ Press (Padstow) Ltd, Padstow, Cornwall

British Library Cataloguing in Publication Data
A catalogue record for this book is available from the British Library

Library of Congress Cataloging in Publication Data
A catalogue record for this book has been requested

ISBN 0–415–05373–0 (hbk)
ISBN 0–415–05374–9 (pbk)

For Maryam

CONTENTS

PLATES

TABLES

PREFACE: *SOUTH PACIFIC*

Coconut palms, banyan trees, golden beaches, rolling surf. A famous musical, set during the Second World War, in the exotic South Seas, with lush songs to match: 'Some Enchanted Evening', 'I'm Gonna Wash That Man Right Outa My Hair', 'Honey Bun', 'Younger than Spring-time'.... A typical, untroubled Orientalist fantasy. I had seen the film as a child but not understood that its plot turned around the question of children.

The film shows us two romances that go wrong. Ensign Nellie Forbush, the nurse from Little Rock, is wooed by the romantic Frenchman, Emile de Becque. No sooner does Nellie finally declare herself to Emile than she notices a line of Polynesian children nearby. She thinks he is joking when he says that they are his. When she realizes that he is not, she jumps into her jeep and goes back to base.

Handsome Lt Joseph Cable from Philadelphia takes the boat to the 'off-limits' romantic island Bali Ha'i and immediately falls in love with Liat, a beautiful young Polynesian girl. Embracing her passionately, he leaves reluctantly and keeps returning. One day they talk happily about marriage. Until her mother, 'Bloody Mary', mentions their having children. Cable breaks away, and runs back to his boat. Exotic romance is one thing. But its dusky human consequences are another.

The rest of the film tells of how both Americans learn to overcome their immediate racist reactions of desire and aversion, of simultaneous attraction and repulsion, and come to understand that such racism is not instinctive, but learnt. Cable sings: 'You've got to be taught/Before it's too late./Before you are six, or seven, or eight./To hate all the people your relatives hate'. Too late for what? For the advent of desire.

This is a book that traces the emergence of desire in history, its genealogy and its disavowal in the history of racialized thought. The impresario that stages this patriarchal drama is called 'culture', itself the production of an emergent capitalist European society; the con-flictual structures generated by its imbalances of power are con-sistently articulated through points of tension and forms of difference

that are then superimposed upon each other: class, gender and race are circulated promiscuously and crossed with each other, transformed into mutually defining metaphors that mutate within intricate webs of surreptitious cultural values that are then internalized by those whom they define. Culture has always carried these antagonistic forms of inner dissonance within it: even 'Englishness' has always been riven by its own alterity. And so too racial theory, which ostensibly seeks to keep races forever apart, transmutes into expressions of the clandestine, furtive forms of what can be called 'colonial desire': a covert but insistent obsession with transgressive, inter-racial sex, hybridity and miscegenation – the story, in fact, of *South Pacific*.

ACKNOWLEDGEMENTS

I would like to thank the librarians of the Balfour Library at the Pitt Rivers Museum, Oxford, the Bodleian Library, the British Library, the Radcliffe Science Library and Rhodes House Library, for their assistance in tracing the often curious books around which this book is written. Clare Brown gave me the benefit of her comprehensive knowledge of the photographic archives at Rhodes House. I want too to express my gratitude to those who have discussed many of the ideas developed in this book with me and often indicated new, fruitful directions for me to pursue: Philip Barker, Gillian Beer, Gargi Bhattacharyya, Simon Brooks, Theo D'haen, John Gurney, Catherine Hall, Stephen Howe, Lauren Kassell, John Knight, Kenneth Mills, Tom Paulin, Anita Roy, Mineke Schipper, Gayatri Chakravorty Spivak, Lynnette Turner and Megan Vaughan. I would also like to take this opportunity of thanking the following for their comradeship and support, both in the past at Southampton and still in the present: Isobel Armstrong, who made it all possible, Derek Attridge, Joe Bristow, Tony Crowley, Maud Ellmann, Ken Hirschkop, Kadie Kanneh, Jo McDonagh, Laura Marcus, Bill Marshall, Peter Middleton, Jonathan Sawday, Lindsay Smith and Clair Wills. Matthew Meadows has interrogated and augmented my cultural preoccupations over many years with characteristic energy and warmth. Homi Bhabha has taken a close interest in this project and as always has offered valuable criticisms and advice; I am indebted to him for his challenging, friendly companionship. Lastly, my very special thanks to Badral Young.

Grateful acknowledgement is given to the Bodleian Library to reproduce illustrations from the following: Robert Knox, *The Races of Men* (1850), 1902.e.48, pp. 40, 52; John Beddoe, *The Races of Britain*, (1885), 1902.d.86, facing p. 252; Bryan Edwards, *The History, Civil and Commercial, of the British Colonies in the West Indies* (1793), PP.61.C.TH, engraving entitled 'The Sable Venus'; Arthur W. Read, Photographic Album, MS.Afr.1493, Folio 2 verso, top, 'Picnic (?)'.

1

HYBRIDITY AND DIASPORA

Walk through the majestic iron gates with which Greenwich Park faces the river Thames, and make your way up the steep grassy hill which overlooks the Isle of Dogs, and the level, desolate flats of East London. Follow the snaking, restless river westwards towards Rotherhithe, where the Mayflower pub irreverently marks the spot from which the puritanical Pilgrim Fathers emigrated to America in 1620. Keep climbing upwards, taking care not to stumble against the roots of any trees. As you reach the top, you find yourself standing before a large eighteenth-century building with elegant Georgian windows overlooking the river. You are facing the Old Royal Observatory, Greenwich. Walk round its walls until you come to a brass strip set in the pavement. The smooth, gold band in the ground marks the Prime Meridian, or Longitude Zero. At the top of this small hill, you have found yourself at the zero point of the world, at the centre of time itself. Paradoxically, for Greenwich to be the centre of the world in time it must be inscribed with the alterity of place. Stand to the left-hand side of the brass strip and you are in the Western hemisphere. But move a yard to your right, and you enter the East: whoever you are, you have been translated from a European into an Oriental. Put one foot back to the left of the brass strip and you become undecidably mixed with otherness: an Occidental and an Oriental at once. It was with a supremely knowing gesture towards the future that in 1884, the division of the newly homogenized temporal world into East and West was placed not in Jerusalem or Constantinople but in a South London suburb. In that gesture, it was acknowledged that the totality, the sameness of the West will always be riven by difference. With each passing decade London has been ever more successful in living up to its officially proclaimed heterogeneous identity, so that now, turning back towards the river and looking down at the park laid out below you, at the Londoners stretched out on the grass or wandering to and fro according to trajectories unknown to anyone except themselves, just walking home or coming and going from one country to the next,

you could scarcely imagine a more varied mingling of peoples, whose ancestors hark back to the Caribbean and Africa, India, Pakistan, Bangladesh, China, Tibet, Afghanistan, Somalia, the Balkans, mixed and merged with others whose predecessors turned up in the British Isles as Angles, Celts, Danes, Dutch, Irish, Jews, Normans, Norsemen, Saxons, Vikings.... The cleavage of East and West in that bronze strip on the hill has gradually been subsumed into a city that, with the potent attraction of economic power exerting the magnetic field of force of the North over the South, has drawn the far-off peripheries into the centre. And with that historic movement of intussusception, the Prime Meridian, the Longitude Zero, the centre of the world, has become inalienably mixed, suffused with the pulse of difference.

The Secret Agent, Conrad's tale of an attempt to blow up the Greenwich Observatory, to destroy the imperial metropolitan centre at its heart, also charts a story of a complex cultural interaction taking place in the everyday life of the city. It shows that the London of 1894 was already defined by incongruous combinations of relationships, mentalities, genders, classes, nationalities and ethnicities. For Conrad, the anarchic ambiguities of the narrative become identified with a rivenness within English culture itself. Today the Englishness of the past is often represented in terms of fixity, of certainty, centredness, homogeneity, as something unproblematically identical with itself. But if this was ever so, which is seriously to be doubted, it is noticeable that in the literary sphere such forms of Englishness are always represented as other, as something which other people possess, often as an image of consummate masculinity – so, for example, in Jean Rhys's novels, it is the distant, unresponsive men whom the heroines look to lean on that are always presented as possessing these untroubled characteristics.[1] If we consider the English novel, we find that what is portrayed as characterizing English experience is rather often the opposite, a sense of fluidity and a painful sense of, or need for, otherness. Perhaps the fixity of identity for which Englishness developed such a reputation arose because it was in fact continually being contested, and was rather designed to mask its uncertainty, its sense of being estranged from itself, sick with desire for the other.

It is striking that many novelists not only of today but also of the past write almost obsessively about the uncertain crossing and invasion of identities: whether of class and gender – the Brontës, Hardy or Lawrence – or culture and race – the Brontës again (the irresistible, transgressive Heathcliff is of mixed race), Haggard, Conrad (not only *The Secret Agent,* but also of course in *Heart of Darkness,* the imbrication of the two cultures within each other, the fascination with the 'magnificent' African woman, and among many other novels, his first,

2

Almayer's Folly, the story of an inter-racial marriage), James, Forster, Cary, Lawrence, Joyce, Greene, Rhys.[2] So much so, indeed, that we could go so far as to claim it as *the* dominant motif of much English fiction. Many novels of the past have also projected such uncertainty and difference outwards, and are concerned with meeting and incorporating the culture of the other, whether of class, ethnicity or sexuality; they often fantasize crossing into it, though rarely so completely as when Dr Jekyll transforms himself into Mr Hyde.[3] This transmigration is the form taken by colonial desire, whose attractions and fantasies were no doubt complicit with colonialism itself. The many colonial novels in English betray themselves as driven by desire for the cultural other, for forsaking their own culture: the novels and travel-writings of Burton, Haggard, Stevenson, Kipling, Allen or Buchan are all concerned with forms of cross-cultural contact, interaction, an active desire, frequently sexual, for the other, or with the state of being what Hanif Kureishi calls 'an inbetween', or Kipling 'the monstrous hybridism of East and West.'[4] This dialogism was emphasized in the colonial arena, but it can also can be shown to be specific to English cultural identity in general. We shall see that even what is often considered a founding text of English culture, Matthew Arnold's *Culture and Anarchy* (1869), is predicated on the fact that English culture is lacking, lacks something, and acts out an inner dissonance that constitutes its secret, riven self. For the past few centuries Englishness has often been constructed as a heterogeneous, conflictual composite of contrary elements, an identity which is not identical with itself. The whole problem – but has it been a problem? – for Englishness is that it has never been successfully characterized by an essential, core identity from which the other is excluded. It has always, like the Prime Meridian, been divided within itself, and it is this that has enabled it to be variously and counteractively constructed.

Englishness is itself also uncertainly British, a cunning word of apparent political correctness invoked in order to mask the metonymic extension of English dominance over the other kingdoms with which England has constructed illicit acts of union, countries that now survive in the international arena only in the realm of football and rugby. The dutiful use of the term 'British' rather than 'English', as Gargi Bhattacharyya observes, misses the point that in terms of power relations there is no difference between them: 'British' is the name imposed by the English on the non-English.[5] (Even so, others remain excluded: the United Kingdom is in fact the 'United Kingdom of Great Britain and Northern Ireland', with Northern Ireland left hanging on, hanging off dangling, as if it is ready to move away and re-embrace the rest of Eire.[6]) In the nineteenth century, the very notion of a fixed English identity was doubtless a product of, and reaction to, the rapid

change and transformation of both metropolitan and colonial societies which meant that, as with nationalism, such identities needed to be constructed to counter schisms, friction and dissent. Today's self-proclaimed mobile and multiple identities may be a marker not of contemporary social fluidity and dispossession but of a new stability, self-assurance and quietism. Fixity of identity is only sought in situations of instability and disruption, of conflict and change. Despite these differences, the fundamental model has not altered: fixity implies disparateness; multiplicity must be set against at least a notional singularity to have any meaning. In each case identity is self-consciously articulated through setting one term against the other; what has happened is that the hierarchy has now been reversed. Or has it?

The need for organic metaphors of identity or society implies a counter-sense of fragmentation and dispersion. There is a story behind the way in which the organic paradigm so beloved of the nineteenth century quickly developed alongside one of hybridity, grafting, of forcing incompatible entities to grow together (or not): to that extent, we still operate within its legacy of violence and corruption. The characteristic cultural movement produced by capitalist development in the nineteenth century was one of simultaneous processes of unification and differentiation. The globalization of the imperial capitalist powers, of a single integrated economic and colonial system, the imposition of a unitary time on the world, was achieved at the price of the dislocation of its peoples and cultures. This latter characteristic became visible to Europeans in two ways: in the disruption of domestic culture, and in the increasing anxiety about racial difference and the racial amalgamation that was apparent as an effect of colonialism and enforced migration. Both these consequences for class and race were regarded as negative, and a good deal of energy was expended on formulating ways in which to counter those elements that were clearly undermining the cultural stability of a more traditional, apparently organic, now irretrievably lost, society. Yet by the 1850s there were already those such as Herbert Spencer who were asserting that 'progress consists in a change from the homogeneous to the heterogeneous'.[7]

Today's comparative certainty has arisen because heterogeneity, cultural interchange and diversity have now become the self-conscious identity of modern society. It is striking, however, given the long history of cultural interaction, how few models have been developed to analyse it. In the nineteenth century, models such as diffusionism and evolutionism conceptualized such encounters as a process of the deculturation of the less powerful society and its transformation towards the norms of the West. Today the dominant models often stress separateness, passing by altogether the process of acculturation

4

whereby groups are modified through intercultural exchange and socialization with other groups. Since Sartre, Fanon and Memmi, postcolonial criticism has constructed two antithetical groups, the colonizer and colonized, self and Other, with the second only knowable through a necessarily false representation, a Manichean division that threatens to reproduce the static, essentialist categories it seeks to undo.[8] In the same way, the doctrine of multiculturalism encourages different groups to reify their individual and different identities at their most different, thus, according to Floya Anthias and Nira Yuval-Davis, encouraging extremist groups, who become 'representative' because they have the most clearly discernibly different identity.[9] It is only recently that cultural critics have begun to develop accounts of the commerce between cultures that map and shadow the complexities of its generative and destructive processes.[10]

Historically, however, comparatively little attention has been given to the mechanics of the intricate processes of cultural contact, intrusion, fusion and disjunction. In archaeology, for example, the models have been ones of diffusion, assimilation or isolation, not of interaction or counteraction. Significant historical work has been done on the exchange of commodities, of diseases, of healing systems and of religions.[11] Otherwise, the most productive paradigms have been taken from language. Pidgin and creolized languages constitute powerful models because they preserve the real historical forms of cultural contact.[12] The structure of pidgin – crudely, the vocabulary of one language superimposed on the grammar of another – suggests a different model from that of a straightforward power relation of dominance of colonizer over colonized. Today this structural device is often repeated in novels in English so that the vernacular idiom tacitly decomposes the authority of the metropolitan form. If language preserves one major product of contact, a second, less usual model, which will be retrieved and developed in the course of this book, is equally literal and more physical: sex. In the British Empire, Hyam observes in a curiously unguarded metaphor, 'sexuality was the spearhead of racial contact'.[13] The historical links between language and sex were, however, fundamental. Both produced what were regarded as 'hybrid' forms (creole, pidgin and miscegenated children), which were seen to embody threatening forms of perversion and degeneration and became the basis for endless metaphoric extension in the racial discourse of social commentary. So, for example, in 'The Nigger Question' (1849), Thomas Carlyle speaks of how the anti-slavery lobby and liberal Social Science,

> led by any sacred cause of Black Emancipation, or the like, to fall in love and make a wedding of it, – will give birth to progenies and

prodigies; dark extensive moon-calves, unnameable abortions, wide-coiled monstrosities, such as the world has not seen hitherto![14]

Both these models of cultural interaction, language and sex, merge in their product which is characterized with the same term: hybridity. The word 'hybrid' has developed from biological and botanical origins: in Latin it meant the offspring of a tame sow and a wild boar, and hence, as the OED puts it, 'of human parents of different races, half-breed'. The OED continues: 'A few examples of this word occur early in the seventeenth century; but it was scarcely in use until the nineteenth'. 'Hybrid' is the nineteenth century's word. But it has become our own again. In the nineteenth century it was used to refer to a physiological phenomenon; in the twentieth century it has been reactivated to describe a cultural one. While cultural factors determined its physio-logical status, the use of hybridity today prompts questions about the ways in which contemporary thinking has broken absolutely with the racialized formulations of the past.

A hybrid is defined by Webster in 1828 as 'a mongrel or mule; an animal or plant, produced from the mixture of two species'. Its first recorded use in the nineteenth century to denote the crossing of people of difference races is given in the OED as 1861. Although this is certainly too late (it was used by Josiah Nott in 1843), this date is certainly significant.[15] Prichard had already used the term 'hybrid' in the context of the question of human fertility as early as 1813.[16] However, since the whole point of his argument was to deny that humans were different species, he never directly used the term 'hybrid' to describe humans, speaking instead of 'mixed' or 'intermediate' races. Its appearance between 1843 and 1861, therefore, marks the rise of the belief that there could be such a thing as a human hybrid. The word's first philological use, to denote 'a composite word formed of elements belonging to different languages', dates from 1862. An OED entry from 1890 makes the link between the linguistic and racial explicit: 'The Aryan languages present such indications of hybridity as would correspond with ... racial intermixture'.[17]

HYBRIDITY AND FERTILITY

In the nineteenth century, as in the late twentieth, hybridity was a key issue for cultural debate. The reasons differ, but are not altogether dissimilar. The question had first been broached in the eighteenth century when the different varieties of human beings had been classed as part of the animal kingdom according to the hierarchical scale of the Great Chain of Being. Predictably the African was placed at the bottom of the human family, next to the ape, and there was some discussion as

to whether the African should be categorized as belonging to the species of the ape or of the human. The dominant view at that time was that the idea of humans being of different species, and therefore of different origins, conflicted with the Biblical account; moreover, the pressure of the Anti-Slavery campaign meant that the emphasis was very much on all humans belonging to a single family. But there were some dissenters. Edward Long, a Jamaican slave-owner, argued in his influential *History of Jamaica* of 1774, that 'for my own part, I think there are extremely potent reasons for believing that the White and the Negro are two distinct species'.[18] In British scientific circles, the idea was first formally proposed by the Manchester surgeon Charles White in his *Account of the Regular Gradation of Man* (1799). With White we can see Long's expedient prejudices move into the realm of scientific theory. Yet, as the liberal German anthropologist Theodor Waitz observed in 1859, scientific discussions of such issues always contained their own hidden ideological agenda. Waitz, who was increasingly isolated in his own belief in the unity of the human species, spelt out the political and cultural implications of the scientific theory of specific difference among mankind:

> If there be various species of mankind, there must be a natural aristocracy among them, a dominant white species as opposed to the lower races who by their origin are destined to serve the nobility of mankind, and may be tamed, trained, and used like domestic animals, or may, according to circumstances, be fattened or used for physiological or other experiments without any compunction. To endeavour to lead them to a higher morality and intellectual development would be as foolish as to expect that lime trees would, by cultivation, bear peaches, or the monkey would learn to speak by training. Wherever the lower races prove useless for the service of the white man, they must be abandoned to their savage state, it being their fate and natural destination. All wars of extermination, whenever the lower species are in the way of the white man, are not only excusable, but fully justifiable.[19]

Much of anthropology hung, therefore, on this single issue; as Henry Holland noted in 1850, 'the question as to the unity and single origin of the human race, governs the whole subject'.[20] From the 1840s onwards, the question of species, and therefore of hybridity, was always placed at the centre of discussions and was consistently and comprehensively treated. The generally accepted test for distinct species, formulated by the Comte de Buffon in France and John Hunter in Britain, was that the product of sexual intercourse between them was infertile. Robert Knox, the Edinburgh anatomist and racial theorist, summed it up thus:

Naturalists have generally admitted that animals of the same species are fertile, reproducing their kind for ever; whilst on the contrary, if an animal be the product of two distinct species, the hybrid, more or less, was sure to perish or to become extinct ... the products of such a mixture are not fertile.[21]

A hybrid is a cross between two species, such as the mule and the hinny, which are female–male and male–female crosses between horse and ass. The point generally made is that both the mule and the hinny are infertile, which results in the species remaining distinct, held separate by an apparent natural check. As a result of this definition, the argument that the different races of men were different species hinged on the question of whether the product of a union between different races was fertile or not. Given the large mixed-race population of the West Indies, few initially doubted the fertility of such offspring. This did not defeat either White or Long, however. White argued that infertility was not a sufficient criterion of specific difference. Long took the opposite tack and invoked his local knowledge to argue that though unions between white and black evidently produced fertile offspring, such fertility declined through the generations. Long thus conflated the cultural term 'mulatto' with the biological characteristics of the mule:

> Some few of them [Mulattos] have intermarried here with those of their own complexion; but such matches have generally been defective and barren. They seem in this respect to be actually of the mule-kind, and not so capable of producing from one another as from a commerce with a distinct White or Black.[22]

This phenomenon of diminishing fertility, Long claimed, provided proof that white and black were of different species. Although few seem to have taken much notice of his argument at the time, it was resurrected by another group of slave-owners seventy years later, and its influence was to linger into the twentieth century. So in the chapter on 'Nation and Race' in *Mein Kampf*, Hitler argues that Nature's rule consists of 'the inner segregation of the species of all living beings on this earth', and that where this natural apartheid is infringed, Nature resists 'with all possible means ... and her most visible protest consists either in refusing further capacity for propagation to bastards or in limiting the fertility of later offspring'.[23]

The question of humans being one species or many, and the attendant importance of hybridity, though often mentioned in passing, was for many years generally regarded as more or less settled in favour of a consensus that they were one. The Enlightenment humanitarian ideals of universality, sameness and equality reigned supreme. William Lawrence's brief discussion of the matter in his *Lectures on Physiology*,

Zoology, and the Natural History of Man of 1819 would be typical of the received attitudes of the period, and a particularly significant example, given Lawrence's modern zoological treatment of humans.[24] Serious argument promulgating difference and inequality only surfaced seriously with the debates about race that grew up before the American Civil War, where the two main contesting positions were named 'monogenesis' (one species) and 'polygenesis' (many species). Although polygenism clearly went against the Biblical account of the descent of all mankind from Adam and Eve, various ingenious ways were found around this problem for those who did not want to contradict the Bible. It was the increasing vigour with which the racial doctrine of polygenesis was asserted that led to the preoccupation with hybridity in the mid-nineteenth century. This was because the claim that humans were one or several species (and thus equal or unequal, same or different) stood or fell over the question of hybridity, that is, intra-racial fertility – a question which could never in fact be satisfactorily settled according to the terms in which the debate was conducted. It has continued into the twentieth century: the question of 'Human Hybrids' was still an issue for discussion in the *Eugenics Review* in the 1930s; in 1931 E. B. Reuter devoted a chapter of *Race Mixture* to 'The Hybrid as a Social Type'; and the topic persisted in works about race as late as 1974.[25] It has often been suggested that there are intrinsic links between racism and sexuality.[26] What has not been emphasized is that the debates about theories of race in the nineteenth century, by settling on the possibility or impossibility of hybridity, focussed explicitly on the issue of sexuality and the issue of sexual unions between whites and blacks. Theories of race were thus also covert theories of desire.

Until the word 'miscegenation' was invented in 1864, the word that was conventionally used for the fertile fusion and merging of races was 'amalgamation'. A writer on colonization in Australia and New Zealand, for example, comments in 1838 that:

> It may be deemed a cold and mercenary calculation; but we must say, that instead of attempting an amalgamation of the two races, – Europeans and Zealanders, – as is recommended by some persons, the wiser course would be, to let the native race gradually retire before the settlers, and ultimately become extinct.[27]

The use of the term 'hybridity' to describe the offspring of humans of different races implied, by contrast, that the different races were different species: if the hybrid issue was successful through several generations, then it was taken to prove that humans were all one species, with the different races merely sub-groups or varieties – which meant that technically it was no longer hybridity at all. So Huxley, in

1863, identifying race with variety, cautioned the 'working men' to whom he was lecturing that

> there is a great difference between 'mongrels,' which are crosses between distinct races, and 'hybrids,' which are crosses between distinct species. The mongrels are, so far as we know, fertile with one another. But between species, in many cases, you cannot succeed in obtaining even the first cross; at any rate it is quite certain that the hybrids are often absolutely infertile one with another.[28]

Huxley thus distinguishes between technical terms that define the difference between monogenists and polygenists; in practice, however, as Huxley's urging of distinction itself suggests (rather like the contemporary insistence in Lacanian psychoanalysis that we must *never* confuse the phallus with the penis) the irresolvable nature of the dispute meant that the terms 'hybridity' and 'mongrelity' tended to be used interchangeably, particularly by those who wanted to confuse the distinction in any case.[29]

Today, therefore, in reinvoking this concept, we are utilizing the vocabulary of the Victorian extreme right as much as the notion of an organic process of the grafting of diversity into singularity. In Britain in the 1840s, liberals such as the great ethnologist J. C. Prichard rejected the applicability of the concept of hybridity to man, suggesting that the perceived difference of race merely indicated variety within a single species. In his *Natural History of Man* (1843) Prichard devotes two special sections to this question, entitled 'Of the Determination of Species – Phenomena of Hybridity', and 'Of Mixed Races of Men – History of Several Mixed Human Races', and states that:

> I believe it may be asserted without the least chance of contradiction, that mankind, of all races and varieties, are equally capable of propagating their offspring by intermarriages, and that such connexions are equally prolific whether contracted between individuals of the same or of the most dissimilar varieties. If there is any difference it is probably in favour of the latter.
>
> If we enquire into the facts which relate to the intermixture of Negroes and Europeans, it will be impossible to doubt the tendency of the so-termed Mulattoes to increase. The Men of Colour, or the mixed race between the Creoles and Negroes are, in many of the West Indian islands, a rapidly increasing people, and it would be very probable that they will eventually become the permanent masters of those islands, were it not for the great numerical superiority of the genuine Negroes. In many parts of America they are very numerous.

Prichard goes on to give examples of amalgamation, that is, of 'intermixed tribes descended from different races of men' which, he argues, show that 'an entirely new and intermediate stock has been produced and multiplied'.[30]

Prichard's confidence that his argument was irrefutable was, however, misplaced. From the 1840s, the new racial theories based in comparative anatomy and craniometry in the United States, Britain and France endorsed the polygenetic alternative, and discussions of the question of hybridity became a standard discursive feature of any book on natural history or race, and one of the most persuasive means through which any writer on racial theory established himself as being, in Foucault's phrase, 'in the true'.[31] Waitz noted in his *Introduction to Anthropology* (the first substantive textbook of the new science) that 'there certainly prevails in modern times an inclination to assume a plurality of species, where formerly races only were distinguished; and in proportion as this has been done, fecundity alone as a decisive mark of unity of species has lost its weight'.[32] By 1859, therefore, the assumption of specific difference between humans had itself become an argument against the criterion of fertility as a definition of species. By that date, discussions of the question had become a good deal more subtle than the simple issue of whether the progeny of a hybrid was fertile or not. In particular, it became more accepted by both sides that there were degrees of hybridity, between 'proximate' and 'distinct' species. This, however, could be appropriated for either side. In the first place, it allowed the argument that hybridity could no longer be taken as an irrefutable test for species. On the other hand, as Darwin was to point out, the crucial question was also how species was itself defined.[33] In Darwin's version, in *The Origin of Species* (1859), degrees of hybridity meant that species could no longer be regarded as absolutely distinct. Central to Darwin's thesis, and crucial for his argument that species are not fixed but develop according to the rules of natural selection, was his argument that 'there is no essential distinction between species and varieties'.[34]

For this to work, Darwin had to argue that varieties could, in certain circumstances, develop into different species; to prove this, he focussed on the difficulties that naturalists had in distinguishing them. Darwin devotes a whole chapter in *The Origin of Species* to 'Hybridism', where he argues that though the general rule of infertility may apply, it is never an absolute rule. With regard to animals, although there was comparatively little properly scientific research to draw on, Darwin cites a number of cases, such as cross-bred geese, where the offspring are 'highly fertile'; he also cites the 'doctrine, which originated with Pallas, that most of our domestic animals have descended from two or more aboriginal species, since commingled by intercrossing' (271),

concluding with an observation of little comfort to the polygenists: 'It can ... be clearly shown that mere external dissimilarity between two species does not determine their greater or lesser degree of sterility when crossed' (282–3). Given the paucity of scientific evidence, Darwin for the most part focusses on the researches of botanists, and goes into great detail citing cases where crossings of varieties are infertile, and crossings of species are fertile. He concludes that:

> First crosses between forms sufficiently distinct to be ranked as species, and their hybrids, are very generally, but not universally sterile. The sterility is all of degrees, and is often so slight that the two most careful experimentalists who have ever lived, have come to diametrically opposite conclusions in ranking forms by this test. The sterility is innately variable in individuals of the same species, and is eminently susceptible of favourable and unfavourable conditions. The degree of sterility does not strictly follow systematic affinity, but is governed by several curious and complex laws.
>
> (288)

Darwin argues that the question of sterility has little to do with absolute distinctions between species and varieties: the facts, rather, 'clearly indicate that the sterility both of first crosses and of hybrids is simply incidental or dependent on unknown differences, chiefly in the reproductive systems, of the species which are crossed' (276). Similarly,

> First crosses between forms known to be varieties, or sufficiently alike to be considered as varieties, and their mongrel offspring, are very generally, but not quite universally, fertile.
>
> (289)

So the facts that 'for all practical purposes it is most difficult to say where perfect fertility ends and sterility begins', and that neither the incidence of fertility nor that of infertility is universal, Darwin suggests, support his general view that there is no fundamental distinction between species and variety.[35] However, although he used discussions of hybridity to bolster his argument about the evolution of species, Darwin had nothing decisive to say about hybridity as such. As Stepan suggests, without an understanding of genetics, 'the role of hybridization in evolution was too difficult a problem for Darwin to solve'.[36]

In his chapter 'On the Races of Man' in *The Descent of Man* (1871), Darwin returns to the topic but this time with direct reference to human beings and the question of race: he begins by adducing all the evidence in favour of the classification of man as comprising different species. Citing Knox, Nott and Gliddon, Agassiz and others, his main

12

source for analysis of the infertility of hybrids is Paul Broca's influential *On the Phenomena of Hybridity in the Genus Homo*, a work first published in article form in 1858–9. The French anthropologist makes an argument about the variations of hybridity very similar to Darwin's own in *Origin of Species*. Darwin points out how, once this argument, together with the larger overall argument about the principle of evolution, is accepted, the monogenesis–polygenesis controversy is no longer viable, for whether different ethnic human groups were classified as species or varieties, there was in any case no essential difference between them:

> when the principle of evolution is generally accepted, as it surely will be before long, the dispute between the monogenists and the polygenists will die a silent and unobserved death.[37]

So it did, but not before the end of the century.[38] As so often with racial issues, instead of being abandoned altogether, the scientific arguments in support of racial prejudice moved elsewhere, to the theory of 'types', to questions of psychological, intellectual and 'moral' differences, to the terrifying ideas of social Darwinism and eugenics, and the adaptation of evolutionary theory to ideas of racial supremacy and the extinction of races, all of which are already anticipated in the section in *The Descent of Man* entitled 'On the Extinction of the Races of Man': 'Extinction follows chiefly from the competition of tribe with tribe, and race with race.... When civilised nations come into contact with barbarians the struggle is short'.[39]

The effect of Darwin's work with respect to race was by no means as decisive as in other areas of natural science.[40] Darwinism displaced some racial ideologies, but replaced them with others.[41] Initially, in fact, his arguments were often considered to favour a version of the polygenist argument (for there was no intrinsic reason in his schema to suggest why all human beings should necessarily have evolved from a single origin), enabling a new form of scientific polygenism that clashed with an anti-Darwinian, Biblical, monogenetic degenerationism.[42] Although in the longer term Darwin changed the nature of discussions of race by moving the question away from that of single or many species as he had suggested, this issue had already been sidestepped in his own day by a shift towards the concept of 'type' and the typical. Already used by Cuvier, Edwards and Chambers earlier in the century, type came into widespread use in the 1850s because it neatly brought together the implications of both species and race while dispensing with the theoretical and terminological difficulties of both.[43] Despite Darwin's emphasis on change, the invocation of human 'types' rather than species could avoid the thorny question of single or multiple origins and allow the notion of permanent differences, 'fixed

13

and congenital', to be re-established on the basis of a common-sense appeal to history, according to the sort of argument proposed by Knox, or, as here, by one of his American admirers, Henry Hotze:

> It is enough that, so far as the records of human existence can be traced, the distinctions of race were what we find them now; and that, therefore, we are justified in regarding them as being permanent in the only sense in which any earthly phenomenon can be called permanent. With the 'origin of species' we are not called upon to concern ourselves; the fact of specific difference suffices us. So long as the world of which we know has existed, the Negro has been a Negro, the Asiatic an Asiatic, the Caucasian a Caucasian; and we must conclude, therefore, that these distinctions will continue as long as the races continue to exist.[44]

This assertion was backed up by an appeal to historical and monumental records. Knox claims that 'the idea of supporting ethnological propositions by the testimony of ancient monuments, originated, I think, with myself: in proof I may refer to M. Edwards' letter to Thierry the historian'.[45] W. F. Edwards, an English West Indian comparative anatomist and anthropologist resident in Paris, does indeed bear out Knox's claim, and we shall see that the work to which he refers was to be a significant one for the cultural theory of Matthew Arnold. But notwithstanding claims to priority, it was undoubtedly Nott and Gliddon who developed the significance of Egyptian cultural artifacts as key evidence for the proofs of racial theory. This method of analysis eventually lost scientific credibility as the vast time-scale of Darwin's evolutionary theory became accepted. Nevertheless, the analysis of culture as symptomatic of the racial group that produced it continued unimpeded.

The doctrine of the permanence of type may have side-stepped the problem of species, but it still had to confront the question of hybridity. How could the permanence of racial types be reconciled with Prichard's arguments for the unlimited fertility of inter-racial unions, and the formation of new intermediate stocks? Broca's recent book (on which, as we have seen, Darwin also relied) had made a case for more limited forms of fertility, which allowed Knox to propose a more subtle argument than one that simply disputed *in toto* Prichard's claims for intra-racial fertility. In the second edition of his influential work *The Races of Men* (first published 1850, extended in 1862), Knox devoted a whole supplementary chapter to 'An Inquiry into the Laws of Human Hybridité' in which he addresses the question.[46] By way of reply to Prichard's assertion that the offspring of mixed unions are prolific, Knox makes a series of arguments in order to refute him: first of all, dismissing Darwin's arguments in *The Origins of Species* ('it is not

science') in favour of his notion of permanent 'types', and invoking the authority of Buffon, Cuvier and Voltaire, he claims that 'from the earliest historic times, mankind were already divided into a certain number of races, perfectly distinct'. Second, he invokes the authority of Pouchet who had argued that questions of 'the power of reproduction' should be put aside: 'we must attend solely to the union of different human races with regard to vitality of produce'.[47] In other words, he moves the question away from the ability to reproduce *per se* to the vigour of reproduction through several generations. Knox disputes the examples supposed to prove that hybrid races exist by arguing point blank that none can be found in the world. The reason for this, he suggests, is that they are never in fact self-supporting, that is, 'requiring the infusion of no fresh blood from the parent race or species'. Clearly, it was hard for any one to prove in any given situation such as the West Indies that hybrid peoples only ever mated with other hybrids through several generations. As a corollary of this argument, Knox invokes Edwards's idea of reversion, to claim that the products of inter-racial unions are either infertile, or if fertile, after a few generations will revert 'to one or other of the species from which they sprang'.[48] This thesis was to prove an extremely influential one, and became the dominant view throughout the rest of the century and beyond. Whereas the claim for the absolute infertility of mixed unions became harder to sustain the more that mixed-race populations developed, it was impossible to prove or disprove the reversion theory except by a controlled experiment that would analyse the results of human couplings over four or five generations, that is, over at least a hundred and fifty years. Finally, like Gobineau in 1853, or Nott in 1854, who cites 'the existence of certain "*affinities* and *repulsions*" among various races of men', in arguing for the permanence of types, Knox also places considerable emphasis on the way in which the males and females of each species are clearly attracted to each other and mate freely, whereas between different species there appears to be a natural mutual repugnance to pairing that keeps them apart.[49] Attraction and repugnance between the races became a key issue in the debate about racial difference; it was clearly linked to sexuality, a factor that was not lost upon Darwin.

Summarizing his arguments so far – 'that the statement as to the fruitfulness of the human hybrid rested on no sure data; that history disproved the assertion by showing that the human hybrid in time became extinct' – Knox then recalled another that was already becoming equally influential:

further, that the hybrid was a degradation of humanity and was rejected by nature. In support of this latter view, I instanced

Mexico, Peru, and the Central States of America, foretelling
results which none attempt now to deny.

(497)

The example of Central and South America, invoked by Prichard to
prove the fertility of inter-racial unions, is here taken to prove that the
different peoples of the world can indeed be transplanted, but that, as
Knox declares, history shows that they 'like all exotics, have degen-
erated' – through the effects of either climate or mixed unions, or both.
The claim of degeneration was thus the final, and undoubtedly the
most powerful, retort to any apparent demonstration of the fertility of
mixed unions. Its triumph is marked by the fact that in 1855 the fourth
edition of Prichard's *Natural History of Man* was corrected with an
'Introductory Note' on race by Edwin Norris and made consonant with
Knox and Edwards' laws of 'decomposition' and of diminished fertility
between dissimilar races.[50] As the century progressed, the alleged
degeneration of those of mixed race came increasingly both to feed off
and to supplement hybridity as the focus of racial and cultural
attention and anxiety. At the same time, however, as being instanced
as degenerate, and, literally, degraded (that is, lowered by racial
mixture from pure whiteness, the highest grade), those of mixed race
were often invoked as the most beautiful human beings of all.[51]

One particular problem remained, however, namely, that though, for
Knox, Europeans and Africans, say, were clearly of different races,
even different species, the question became more difficult with respect
to Europeans themselves. Did not Europe itself provide examples of
hybrid races? Here Knox admits a possible modification to his model,
as a result of Broca's argument that there were degrees of difference in
hybridity:

> as in many species of animals experiment has proved that the
> hybrid of remote species is unfruitful, whilst the offspring of
> naturally affiliated may prove fruitful and self-supporting to all
> time, so it may be with the races of men: the hybrid of a Papuan
> Negro or Bosjiemen with a European race may be unfruitful; the
> hybrid of a Teuton or Celt with a Scandinavian or Italian, a Sclave
> or Goth, may lead to the establishment of a self-supporting hybrid
> race permanent and enduring.

(499)

Broca himself went so far as to classify differing degrees of fertility as
agenesic, dysgenesic, paragenesic and eugenesic.[52] This fundamental
difference between 'proximate' and 'distant' races was to find wide-
spread acceptance, and was even partly accepted by Nott in *Types of
Mankind*. Knox denies even this possibility: taking France and Britain

as his models, he claims, improbably, that 'modern Gaul, after having been overthrown by several races, has in the course of centuries depurated itself from all exotic elements' (499). For Britain, on the other hand, made up of a mixture of Belgian, Kymraig, Teutons, Danes and Normans, a similar process of purification cannot be asserted. Knox argues, however, that this does not mean that the British have become a hybrid race, for these races 'gave rise to no new or hybrid race, but the mixed population amongst whom all these elements and several others ... are distinctly recognisable' (500–1). Though the races may now be intermingled, they remain distinct, and it is still possible to distinguish between them. The races do not fuse but live on separately, in a kind of natural apartheid – an idea that in fact first occurred to Knox whilst serving in the army in South Africa. He developed the thesis formally in the 1820s in collaboration with his friend Edwards. The two men meant it very literally, encouraging the doctor and amateur ethnologist John Beddoe to go around Britain studying the varieties of the physiognomies of the inhabitants.[53] In the 1860s, as we shall see, it was this idea of a living racial mixture that remains distinct that was developed by Matthew Arnold into a theory of English culture as multicultural.

Whether merged or fused, the English did not transform themselves so easily into the imagined community of a homogeneous national identity. In fact, it became increasingly common in the later nineteenth century for the English to invoke Defoe's account of 'that Het'rogeneous Thing, An Englishman', and to define themselves as a hybrid or 'Mongrel half-bred Race', often, after the unification of Germany in 1871, in a spirit of oppositional rivalry to the Germans, who regarded themselves as pure Teutons. So Carl Vogt, the German anatomist, was to claim in 1863 that unlike the pure German Saxon 'the Anglo-Saxon race is itself a mongrel race, produced by Celts, Saxons, Normans and Danes, a raceless chaos without any fixed type'.[54] Having initially, at the beginning of the century, somewhat implausibly claimed themselves as Germans, the English responded to ever-increasing Prussian rivalry by flaunting their hybridity as an English virtue. In 1861, John Crawfurd observed that 'At best we [English] are but hybrids, yet, probably, not the worse for that'.[55] *The London Review* in the same year was more enthusiastic: 'We Englishmen may be proud of the results to which a mongrel breed and a hybrid race have led us'.[56] A few years later, Herbert Spencer, repeating the distinction between distant and proximate races, held up Britain, 'peopled by different divisions of the Aryan race', as an example of a society that had progressed through racial amalgamation.[57] As late as 1919, the anthropologist Sir Arthur Keith remarked on how 'it is often said, that we British are a mixed and mongrel collection of types and breeds'.[58] Today, as the rival notion of

17

the imperial 'bulldog breed' ebbs away, commentators are again invoking hybridity to characterize contemporary culture.

If hybridity has become the issue once more, we may note that it has been, and can be, invoked to imply contrafusion and disjunction (or even separate development) as well as fusion and assimilation. In these discussions of hybridity from the past, there are a range of possible positions that are taken up:

1 the straightforward polygenist *species* argument: the denial that different peoples can mix at all; any product of a union between them is infertile, or infertile after a generation or two; so that even where people intermingle physically, they retain their own differences (though those differences, when combined, may make up the totality of the nation) (Long, Nott in his early article, 'The Mulatto', Hitler);

2 the *amalgamation* thesis: the claim that all humans can interbreed prolifically and in an unlimited way; sometimes accompanied by the 'melting-pot' notion that the mixing of people produces a new mixed race, with merged but distinct new physical and moral characteristics (Prichard, Gobineau's 'quaternary' types);

3 the *decomposition* thesis: an admission that some 'amalgamation' between people may take place, but that any mixed breeds either die out quickly or revert to one or other of the permanent parent 'types' (first advanced by Edwards, endorsed by Thierry, Arnold, and subsequently adopted by Nott and Gliddon, but combined with 4);

4 the argument that hybridity varies between 'proximate' and 'distant' species: unions between allied races are fertile, those between distant either are infertile or tend to degeneration (Nott and Gliddon, Broca, Darwin, Spencer, Galton). This became the dominant view from the 1850s to the 1930s;[59]

5 the negative version of the amalgamation thesis, namely the idea that miscegenation produces a mongrel group that makes up a 'raceless chaos', merely a corruption of the originals, degenerate and degraded, threatening to subvert the vigour and virtue of the pure races with which they come into contact (Gobineau, Agassiz, Vogt).

We have seen how Vogt suggests this apparently sinister last possibility, which also shows how assimilation of Darwin proved no barrier to the principles of polygenesis: Vogt, like Darwin, relies on Broca's account of hybridity, and argues that 'the mongrel races gradually attain by inbreeding that constancy of characters which distinguishes the original race, so that from this commixture new species may arise'; he also suggests that 'heterogeneous races have by intermixture given rise to raceless masses, peoples which present no fixed character'.[60]

Paradoxically, these 'raceless masses' which attain no new species through hybridization threaten to erase the discriminations of difference: the naming of human mixture as 'degeneracy' both asserts the norm and subverts it, undoing its terms of distinction, and opening up the prospect of the evanescence of 'race' as such. Here, therefore, at the heart of racial theory, in its most sinister, offensive move, hybridity also maps out its most anxious, vulnerable site: a fulcrum at its edge and centre where its dialectics of injustice, hatred and oppression can find themselves effaced and expunged.

In each case, as here in Vogt, these rarified possibilities of intermixture are developed into social theory. So Spencer's sociology was formulated around the assumption that 'hybrid societies are imperfectly organizable – cannot grow into forms completely stable; while societies that have been evolved from mixtures of nearly-allied varieties of man, can assume stable structures, and have an advantageous modifiability'.[61] Such social theories did not just use notions of hybridity in a merely metaphorical way: as here, they were elaborated around the different effects of the conjunction of disparate bodies, derived from received knowledge about the literal issue of sexual interaction between the races. In the different theoretical positions woven out of this intercourse, the races and their intermixture circulate around an ambivalent axis of desire and aversion: a structure of attraction, where people and cultures intermix and merge, transforming themselves as a result, and a structure of repulsion, where the different elements remain distinct and are set against each other dialogically. The idea of race here shows itself to be profoundly dialectical: it only works when defined against potential intermixture, which also threatens to undo its calculations altogether. This antagonistic structure acts out the tensions of a conflictual culture which defines itself through racial ideologies. At the same time, the focus on hybridity also inscribes gender and the sexual division of labour within the mode of colonial reproduction. Gayatri Chakravorty Spivak comments that 'The possession of a tangible place of production in the womb situates the woman as an agent in any theory of production'.[62] In introducing a problematic of sexuality at the core of race and culture, hybridity suggests the necessity of revising normative estimates of the position of woman in nineteenth-century socio-cultural theory. Such a figure, however, remains that of the 'historically muted subject of the subaltern woman', who only becomes a productive agent through an act of colonial violation.[63]

BAKHTIN: LINGUISTIC HYBRIDITY

These gendered, dissonant dialectics recur in a later development of the linguistic model of hybridity in the work of Bakhtin. Bakhtin uses 'hybridity' in its philological sense in order to describe something particular in his own theory. It is a commonplace of Romantic thinking that, as Humboldt puts it, 'each language embodies a view of the world peculiarly its own' – an idea that was developed by Voloshinov into the 'struggle for the sign'.[64] For Bakhtin, however, hybridity delineates the way in which language, even within a single sentence, can be double-voiced.

> What is a hybridization? It is a mixture of two social languages within the limits of a single utterance, an encounter, within the arena of an utterance, between two different linguistic conscious-nesses, separated from one another by an epoch, by social differentiation or by some other factor.[65]

> (358)

Hybridity describes the condition of language's fundamental ability to be simultaneously the same but different. This insight, often identified with Romantic irony, is central to the contemporary work of Derrida and de Man, who point to it as a general characteristic of language, an undecidable oscillation in which it becomes impossible to tell which is the primary meaning. Bakhtin's irony, however, is more dramatic: he uses hybridization to describe the ability of one voice to ironize and unmask the other within the same utterance. He describes this phenomenon as an 'intentional hybrid', because, following Husserl, it will always involve 'directedness', encompassing the intended orienta-tion of the word in any speech-act towards an addressee. For Bakhtin, hybridity describes the process of the authorial unmasking of another's speech, through a language that is 'double-accented' and 'double-styled'. He defines it as follows:

> What we are calling a hybrid construction is an utterance that belongs, by its grammatical [syntactic] and compositional mark-ers, to a single speaker, but that actually contains mixed within it two utterances, two speech manners, two styles, two 'lan-guages', two semantic and axiological belief systems. We repeat, there is no formal – compositional and syntactic – boundary between these utterances, styles, languages, belief systems; the division of voices and languages takes place within the limits of a single syntactic whole, often within the limits of a single sentence. It frequently happens that even one and the same word will belong simultaneously to two languages, two belief systems that intersect in a hybrid construction – and consequently, the

20

word has two contradictory meanings, two accents.

(304–5)

Within a single 'pidgin' utterance, the voice divides into two voices, two languages. This double-voiced, hybridized discourse serves a purpose, whereby each voice can unmask the other.

Hybridity is thus itself a hybrid concept. Bakhtin makes a further, central distinction between such intentional hybridity and what he calls unconscious 'organic hybridity':

Unintentional, unconscious hybridization is one of the most important modes in the historical life and evolution of all languages. We may even say that language and languages change historically primarily by hybridization, by means of a mixing of various 'languages' co-existing within the boundaries of a single dialect, a single national language, a single branch, a single group of different branches, in the historical as well as paleontological past of languages.

(358–9)

In organic hybridization, there will be mixing and fusion, 'but in such situations the mixture remains mute and opaque, never making use of conscious contrasts and oppositions' (360). At the same time, Bakhtin is ready to concede its culturally productive effect:

It must be pointed out ... that while it is true the mixture of linguistic world views in organic hybrids remains mute and opaque, such unconscious hybrids have been at the same time profoundly productive historically: they are pregnant with potential for new world views, with new 'internal forms' for perceiving the world in words.

(360)

For this kind of unconscious hybridity, whose pregnancy gives birth to new forms of amalgamation rather than contestation, we might employ Brathwaite's term, 'creolization', or the French *métissage*, the imperceptible process whereby two or more cultures merge into a new mode.[66] Bakhtin, however, is more concerned with a hybridity that has been politicized and made contestatory: hybridity as division and separation. As with carnival and heteroglossia, it is the organizing intention of the artist that dialogizes hybridity: 'Intentional semantic hybrids are inevitably internally dialogic (as distinct from organic hybrids). Two points of view are not mixed, but set against each other dialogically' (360). In organic hybridity, the mixture merges and is fused into a new language, world view or object; but intentional

21

hybridity sets different points of view against each other in a conflictual structure, which retains 'a certain elemental, organic energy and openendedness' (361). Bakhtin concludes:

> Summing up the characteristics of a novelistic hybrid, we can say: as distinct from the opaque mixing of languages in living utterances that are spoken in a historically evolving language (in essence, any *living* utterance in a *living* language is to one or another extent a hybrid), the novelistic hybrid is *an artistically organized system for bringing different languages in contact with one another*, a system having as its goal the illumination of one language by means of another, the carving-out of a living image of another language.
>
> (361)

Bakhtin's doubled form of hybridity therefore offers a particularly significant dialectical model for cultural interaction: an organic hybridity, which will tend towards fusion, in conflict with intentional hybridity, which enables a contestatory activity, a politicized setting of cultural differences against each other dialogically. Hybridity therefore, as in the racial model, involves an antithetical movement of coalescence and antagonism, with the unconscious set against the intentional, the organic against the divisive, the generative against the undermining. Hybridity is itself an example of hybridity, of a doubleness that both brings together, fuses, but also maintains separation. For Bakhtin himself, the crucial effect of hybridization comes with the latter, political category, the moment where, within a single discourse, one voice is able to unmask the other. This is the point where authoritative discourse is undone. Authoritative discourse Bakhtin argues must be singular, it 'is by its very nature incapable of being double-voiced; it cannot enter into hybrid constructions' (344) – or if it does, its single-voiced authority will immediately be undermined.

THE CULTURAL POLITICS OF HYBRIDITY

For Bakhtin the undoing of authority in language through hybridization always involves its concrete social dimension. In an astute move, Homi K. Bhabha has shifted this subversion of authority through hybridization to the dialogical situation of colonialism, where it describes a process that 'reveals the ambivalence at the source of traditional discourses on authority'. For Bhabha, hybridity becomes the moment in which the discourse of colonial authority loses its univocal grip on meaning and finds itself open to the trace of the language of the other, enabling the critic to trace complex movements of disarming alterity in the colonial text.[67] Bhabha defines hybridity as 'a problem-

atic of colonial representation ... that reverses the effects of the colonialist disavowal, so that other "denied" knowledges enter upon the dominant discourse and estrange the basis of its authority' (156). The hybridity of colonial discourse thus reverses the structures of domination in the colonial situation. It describes a process in which the single voice of colonial authority undermines the operation of colonial power by inscribing and disclosing the trace of the other so that it reveals itself as double-voiced: 'The effect of colonial power is seen to be the *production* of hybridization rather than the noisy command of colonialist authority or the silent repression of native traditions'. The voice of colonial authority thus hears itself speaking differently, interrogated and strategically reversed: 'If the effect of colonial power is seen to be the production of hybridization ... [it] enables a form of subversion ... that turns the discursive conditions of dominance into the grounds of intervention' (154). Bakhtin's intentional hybrid has been transformed by Bhabha into an active moment of challenge and resistance against a dominant cultural power. Bhabha then translates this moment into a 'hybrid displacing space' which develops in the interaction between the indigenous and colonial culture which has the effect, he suggests, of depriving 'the imposed imperialist culture, not only of the authority that it has for so long imposed politically, often through violence, but even of its own claims to authenticity'.[68] In more recent work, Bhabha has extended his notion of hybridity to include forms of counter-authority, a 'Third Space' which intervenes to effect:

> the 'hybrid' moment of political change. Here the transforma-
> tional value of change lies in the re-articulation, or translation, of
> elements that are *neither the One* (unitary working class) *nor the
> Other* (the politics of gender) *but something else besides* which
> contests the terms and territories of both.[69]

At this point, hybridity begins to become the form of cultural difference itself, the jarrings of a differentiated culture whose 'hybrid counter-energies', in Said's phrase, challenge the centred, dominant cultural norms with their unsettling perplexities generated out of their 'disjunctive, liminal space'.[70] Hybridity here becomes a third term which can never in fact *be* third because, as a monstrous inversion, a miscreated perversion of its progenitors, it exhausts the differences between them.

Today the notion is often proposed of a new cultural hybridity in Britain, a transmutation of British culture into a compounded, compo-site mode. The condition of that transformation is held out to be the preservation of a degree of cultural and ethnic difference. While hybridity denotes a fusion, it also describes a dialectical articulation, as

23

in Rushdie's 'mongrelization'. This doubled hybridity has been distinguished as a model that can be used to account for the form of syncretism that characterizes all postcolonial literatures and cultures.[71] At the same time, in its more radical guise of disarticulating authority, hybridity has also increasingly come to stand for the interrogative languages of minority cultures. In *The Signifying Monkey*, Henry Louis Gates Jr has developed a theory of the ironizing double-voiced 'trickster' discourse of the Black literary tradition in which one point of view is self-consciously layered palimpsestically on – and against – another: the signifying monkey exploits what Voloshinov called the 'inner dialectical quality of the sign' to produce a hybridized, critical speech.[72] In the British context, Stuart Hall has written persuasively of the interrogative effects of hybridization on contemporary culture. In his influential account of 'New Ethnicities', Hall suggests that a shift is taking place in black cultural politics: the first moment was that in which

> the term 'Black' was coined as a way of referencing the common experience and marginalization in Britain and came to provide the organizing category of a new politics of resistance, amongst groups and communities with, in fact, very different histories, traditions, and ethnic identities.[73]

This was the moment of homogenization, of constructing a counter-hegemony, an organic hybridization which could contest dominant representations of Blacks in white cultural and aesthetic practices. Hall suggests that this form of contestation has now moved to include simultaneously a second, a new politics of representation which comprises

> an awareness of the black experience as a *diaspora* experience, and the consequences which this carries for the process of unsettling, recombination, hybridization and 'cut and mix' – in short, the process of cultural *diaspora-ization* ... which it implies.[74]

Black cultural politics, though always contestatory, thus involves in Bakhtin's terms both organic and intentional hybridization, processes of merging and of dialogization of ethnic and cultural differences set critically against each other. These processes, Hall suggests, do not make up a narrative, first one and then the other: 'rather, they are two phases of the same movement, which constantly overlap and interweave'. They operate dialogically together, in a double-voiced, hybridized form of cultural politics. Similarly, Kobena Mercer has pointed to the emergence of a 'dialogic tendency' in black film practice:

> Across a whole range of cultural forms there is a 'syncretic'

24

dynamic which critically *appropriates* elements from the master-codes of the dominant culture and 'creolises' them, disarticulating given signs and re-articulating their symbolic meaning otherwise. The subversive force of this hybridizing tendency is most apparent at the level of language itself where creoles, patois and Black English decentre, destabilise and carnivalise the linguistic domination of 'English'.... Creolising practices of counter-appropriation exemplify the critical process of dialogism.[75]

Though here the inflection is more partial and more locally conceived, hybridity once again works simultaneously in two ways: 'organically', hegemonizing, creating new spaces, structures, scenes, and 'intentionally', diasporizing, intervening as a form of subversion, translation, transformation. This doubleness is important both politically and theoretically: without the emphasis on the active, disjunctive moments or movements of homogenization and diasporization, it can easily be objected that hybridization assumes, as was often the case with the nineteenth-century theorists of race, the prior existence of pure, fixed and separate antecedents. But its dialectical structure shows that such hybridity is still repeating its own cultural origins, that it has not slipped out of the mantle of the past, even if, in its appropriation by black cultural theorists, hybridity has been deployed against the very culture that invented it in order to justify its divisive practices of slavery and colonial oppression. From that historical perspective, we may say that the identification here of hybridity with carnivalization and creolization as a means towards a critical contestation of a dominant culture suggests that the threat of degeneration and decay incipient upon a 'raceless chaos' has been not yet been fully redeployed and reinflected. Hybridization as creolization involves fusion, the creation of a new form, which can then be set against the old form, of which it is partly made up. Hybridization as 'raceless chaos' by contrast, produces no stable new form but rather something closer to Bhabha's restless, uneasy, interstitial hybridity: a radical heterogeneity, discontinuity, the permanent revolution of forms.

Whichever model of hybridity may be employed, however, hybridity as a cultural description will always carry with it an implicit politics of heterosexuality, which may be a further reason for contesting its contemporary pre-eminence. The reason for this sexual identification is obvious: anxiety about hybridity reflected the desire to keep races separate, which meant that attention was immediately focussed on the mixed race offspring that resulted from inter-racial sexual intercourse, the proliferating, embodied, living legacies that abrupt, casual, often coerced, unions had left behind. In this situation, same-sex sex, though clearly locked into an identical same-but-

25

different dialectic of racialized sexuality, posed no threat because it produced no children; its advantage was that it remained silent, covert and unmarked.[76] On the face of it, therefore, hybridity must always be a resolutely heterosexual category. In fact, in historical terms, concern about racial amalgamation tended if anything to encourage same-sex sex (playing the imperial game was, after all, already an implicitly homo-erotic practice).[77] Moreover, at one point, hybridity and homosexuality did coincide to become identified with each other, namely as forms of degeneration.[78] The norm/deviation model of race as of sexuality meant that 'perversions' such as homosexuality became associated with the degenerate products of miscegenation: Dorian Gray's depraved excursion to the erotic demi-monde of London inevitably involves an ambiguous encounter with a 'half-caste'. The identification of racial with sexual degeneracy was clearly always overdetermined in those whose subversive bronzed bodies bore witness to a transgressive act of perverse desire.

HYBRIDITY: FROM RACIAL THEORY TO CULTURAL CRITICISM

At its simplest, hybridity, however, implies a disruption and forcing together of any unlike living things, grafting a vine or a rose on to a different root stock, making difference into sameness. Hybridity is a making one of two distinct things, so that it becomes impossible for the eye to detect the hybridity of a geranium or a rose. Nevertheless, the rose exists, like the vine, only in so far as it is grafted onto the different stock. Neglect to prune either, and the plant eventually reverts to its original state. In the nineteenth century, we have seen that a common analogous argument was made that the descendants of mixed-race unions would eventually relapse to one of the original races, thus characterizing miscegenation as temporary in its effects as well as unnatural in its very nature. Hybridization can also consist of the forcing of a single entity into two or more parts, a severing of a single object into two, turning sameness into difference, as in today's hybrid shares on the stock market, although they, in the last analysis, are merely parts of a whole that will have to be re-invoked at the wind-up date. Hybridity thus makes difference into sameness, and sameness into difference, but in a way that makes the same no longer the same, the different no longer simply different. In that sense, it operates according to the form of logic that Derrida isolates in the term 'brisure', a breaking and a joining at the same time, in the same place: difference and sameness in an apparently impossible simultaneity. Hybridity thus consists of a bizarre binate operation, in which each impulse is qualified against the other, forcing momentary forms of dislocation

and displacement into complex economies of agonistic reticulation. This double logic, which goes against the convention of rational either/ or choices, but which is repeated in science in the split between the incompatible coexisting logics of classical and quantum physics, could be said to be as characteristic of the twentieth century as oppositional dialectical thinking was of the nineteenth.

Hybridity thus operates within the same conflictual structures as contemporary theory. Both repeat and reproduce the sites of their own cultural production whose discordant logic manifests itself in structural repetitions, as structural repetition. We shall not here be examining in any further detail the complex procedures of contemporary accounts of cultural hybridity; rather, we will be examining its historical genealogy, tracing the strange and disquieting ramifications of its complex, forgotten past. There is an historical stemma between the cultural concepts of our own day and those of the past from which we tend to assume that we have distanced ourselves. We restate and rehearse them covertly in the language and concepts that we use: every time a commentator uses the epithet 'full-blooded', for example, he or she repeats the distinction between those of pure and mixed race. Hybridity in particular shows the connections between the racial categories of the past and contemporary cultural discourse: it may be used in different ways, given different inflections and apparently discrete references, but it always reiterates and reinforces the dynamics of the same conflictual economy whose tensions and divisions it re-enacts in its own antithetical structure. There is no single, or correct, concept of hybridity: it changes as it repeats, but it also repeats as it changes. It shows that we are still locked into parts of the ideological network of a culture that we think and presume that we have surpassed. The question is whether the old essentializing categories of cultural identity, or of race, were really so essentialized, or have been retrospectively constructed as more fixed than they were. When we look at the texts of racial theory, we find that they are in fact contradictory, disruptive and already deconstructed. Hybridity here is a key term in that wherever it emerges it suggests the impossibility of essentialism. If so, then in deconstructing such essentialist notions of race today we may rather be repeating the past than distancing ourselves from it or providing a critique of it. Commentators talk of 'pseudo-scientific' racial theory in the nineteenth century, as if the term 'pseudo' is enough to dismiss it with ease: but what that term in fact implies is that racial theory was never simply scientific or biologistic, just as its categories were never wholly essentializing. Today it is common to claim that in such matters we have moved from biologism and scientism to the safety of culturalism, that we have created distance and surety by the very act of the critique of essentialism and

the demonstration of its impossibility: but that shift has not been so absolute, for the racial was always cultural, the essential never unequivocal. How does that affect our own contemporary revisions of that imagined past? The interval that we assert between ourselves and the past may be much less than we assume. We may be more bound up with its categories than we like to think. Culture and race developed together, imbricated within each other: their discontinuous forms of repetition suggest, as Foucault puts it, 'how we have been trapped in our own history'.[79] The nightmare of the ideologies and categories of racism continue to repeat upon the living.

2

CULTURE AND THE
HISTORY OF DIFFERENCE

I hope and believe that, with very rare exceptions, all ... recognize
that we are now fighting for the freedom which for ages past has
been the peculiar appanage of the Anglo-Saxon race, and without
which that spurious imitation of true civilization, termed German
Kultur, would afford the keynote to the further progress of the
world, and thus pronounce an irrevocable divorce between wis-
dom and morality on the one hand and learning on the other.

Lord Cromer, 1916[1]

As Roman imperialism laid the foundations of modern civilisation,
and led the wild barbarians of these islands along the path of
progress, so in Africa today we are repaying the debt, and bringing
to the dark places of the earth, the abode of barbarism and cruelty,
the torch of culture and progress, while ministering to the material
needs of our own civilisation.... We hold these countries because it
is the genius of our race to colonise, to trade, and to govern.

Lord Lugard, 1922[2]

Has culture always been a way of giving meaning and value to
sameness and difference? If culture has conventionally been opposed
to nature, it has always also laid a conceptual claim to the natural and
the organic. Moreover, it is striking that, like Coleridge's unifying
imagination, culture must paradoxically always take part in an anti-
thetical pair or itself be divided into two:

culture versus *nature*;
culture versus *civilization*;
culture versus *anarchy*;
high culture versus *low culture* (in rough historical sequence: folk/
working-class/mass/popular culture).

And more recently:

technocracy versus the *counter-culture*;
culture versus *sub-culture*;
culture as *high culture* versus *anthropological culture*, culture as
material production and symbolic systems.

29

What is noticeable here is the historical movement whereby the externality of the category against which culture is defined is gradually turned inwards and becomes part of culture itself. External or internal, this division into same and other is less a site of contradiction and conflict than culture's founding possibility: like gender, class and race, its willing accomplices, culture's categories are never essentialist, even when they aspire to be so. This is because culture is always a dialectical process, inscribing and expelling its own alterity. The genealogy of the concept of 'culture' shows that it does not so much progress as constantly reform itself around conflictual divisions, participating in, and always a part of, a complex, hybridized economy that is never at ease with itself, but rather involves, in Jonathan Dollimore's words, 'a mercurial process of displacement and condensation, so fluid yet always with effects of a brutally material, actually violent kind'.[3] It is in this sense that we can understand Adorno's famous remarks to Benjamin about the relation of high art to popular culture: Adorno argued that they coexist in a dialectic in which each has equal value, even if they are in all other respects unequal:

> Both bear the stigmata of capitalism, both contain elements of change.... Both are torn halves of an integral freedom, to which however they do not add up. It would be romantic to sacrifice one to the other.[4]

Adorno suggests that Benjamin himself, in his essay 'The Work of Art in the Age of Mechanical Reproduction', is guilty of this romantic sacrifice in his account of the loss of the aura of high art and the inauguration of the democratizing tendency of modern mechanical art such as cinema. Adorno contends that art, and more generally culture, does not exist in a particular tendency, or in a totality, but in a dialectical structure that can only be unresolvable. He argues that 'culture' involves an essentially antagonistic concept, and to hold on to this truth the critic must sustain its untotalizable dialectic. This breach is the result of the division of labour instituted by capitalism, which means that it not only produces culture itself in its remorselessly dialectical forms, but also enables a critical position to be taken up with regard to that culture. The alienation produced by the division of labour thus both creates culture and allows a critical perspective on it.

CULTURE AND CIVILIZATION

According to Williams in *Keywords* (1973), the word 'culture' is one of the two or three most complicated words in the English language.[5] 'Culture' comes from the Latin *cultura* and *colere*, which had a range of meanings: inhabit, cultivate, attend, protect, honour with worship.

These meanings then separated out: with Christianity, the 'honour with worship' meaning of *cultura* became the Latin *cultus*, from which we derive our word 'cult' – and from which the French derive their word *couture*. More significantly, the 'inhabit' meaning became the Latin *colonus*, farmer, from which we derive the word 'colony' – so, we could say, colonization rests at the heart of culture, or culture always involves a form of colonization, even in relation to its conventional meaning as the tilling of the soil. The culture of land has always been, in fact, the primary form of colonization; the focus on soil emphasizes the physicality of the territory that is coveted, occupied, cultivated, turned into plantations and made unsuitable for indigenous nomadic tribes.

In English 'culture' in its early use was a noun of process, almost, we might say anachronistically, of organic process: the ploughing of the earth, the cultivation of crops and animals: 'agri-culture'. From the sixteenth century this sense of culture as cultivation, the tending of natural growth, extended to the process of human development: the cultivation of the mind. In the eighteenth century it came to represent also the intellectual side of civilization, the intelligible as against the material. With this it gradually included a more abstract, general social process, and, in 'cultivated', took on a class-fix: as J. S. Mill put it succinctly, 'cultivation, to be carried beyond a certain point, requires leisure'.[6] The OED cites 1764 as the date that 'cultured' was first used in the sense of 'refined'.

The social reference of cultivation was allied to the earlier distinction between the civil and the savage: to be civilized meant to be a citizen of the city (preferably walled), as opposed to the savage (wild man) outside or the more distant barbarian roaming in the lands beyond. It thus operated within the terms of the later ideological polarity of the country and the city, for the inhabitants of the city contrasted themselves to the savages outside by appropriating, metaphorically, an agricultural identity.[7] The city people became the cultivated ones, and the hunters defined by their lack of culture – agricultural, civil and intellectual. This refined culture of the city was first named as 'civilization' in English by the Scot James Boswell who in 1772 recorded a dispute with Johnson:

> On Monday, March 23, I found him busy, preparing a fourth edition of his folio Dictionary.... He would not admit *civilization* but only *civility*. With great deference to him, I thought *civilization*, from *to civilize*, better in the sense opposed to *barbarity*, than *civility*.[8]

'Better in the sense opposed to barbarity': Boswell here also illuminates Benjamin: although it is more often invoked generally in relation to

31

oppression, the latter's famous comment that there is 'no document of civilization that is not at the same time a document of barbarism' refers not only to the barbaric acts of history done in the name of civilization, but also to the necessary interdependence and entanglement between civilization and barbarism in the mutually defining opposition that is supposed to set them apart.[9]

It was above all in France that civility had evolved into the idea of 'civilization' in its dominant Enlightenment sense of the achieved but still progressive secular development of modern society. Civilization was fundamentally a comparative concept that took on its meaning as the end-point in an historical view of the advancement of humanity. Civilization expressed not only the culmination of this long historical process, an 'achieved condition of refinement and order', but also the process itself.[10] This reformulation of history into a series of stages meant that those earlier periods that civilization was deemed to have surpassed had to be quickly constructed: the prehistory of savagery and barbarianism, the Ancient World, Medieval and Renaissance Europe, were all now part of a narrative that led towards the civilization of the present. We find 'civilization' being used in this teleological sense by Turgot, and perhaps most famously by Condorcet, whose *Outline of the Intellectual Progress of Mankind* (1795), which traces ten incremental historical stages that form man's progress to civilization, is, according to Williams, 'regarded as the Enlightenment's culminating attempt to interpret sociocultural evolution in terms of increments in the rational content of thoughts, customs, and institutions'. This progressivist position quickly became part of a general European interpretation of the history of the world which is now often criticized for its euro-centrism. The account of the history of humanity did at least, however, assume universal values and equal rights for all. Though unilinear and hierarchical, such a view generally considered any hierarchy as a temporary one, merely a difference of stage at the present which could be transformed through education, not a constitutive basis of differ-ence for all time. In this context, it is worth noting that at the same time that 'civilization' was being formulated as an account of the refining process undergone by society as a whole, 'culture' was used in a progressive sense with reference to the individual or group, as a particular form or type of intellectual development, namely the improvement of the mind by education and training. There was thus an intrinsic enabling relation between culture and education. The concept of culture was developed as part of the Enlightenment stress on education as enculturation: this radical egalitarian position, whose origins can be traced back to Locke and which became the basis of much nineteenth-century Liberal thought, underlies the Enlighten-ment claim of the fundamental equality of all men and women.

According to this idea, if equality does not actually exist in the present, the possibility of enculturation means that every one is at least potentially equal to everyone else.

An English literary example of this view can be found in Henry James Pye's poem *The Progress of Refinement* (1783), which traces the history of 'man' in a typical fashion from a state of nature, through barbarism, to the 'first seats of the arts', Arabia, Asia (credited with first giving Refinement birth) and Egypt, and from thence to Greece. Pye then traces the history of Europe through the Classical and Medieval periods, the Renaissance, the Reformation, up to 'the present state of Refinement' in Europe and the world. Within this single schema of unmitigated improvement, the European colonization of the world is regarded as inestimably beneficial:

> Dire were the scene! – but Europe's gentler kind,
> Tempting the billowy deep and fickle wind,
> With venturous prows each distant seat explore,
> And boldly tread the inhospitable shore;
> Tame the wild waste, correct the unwholesome air,
> And fix of polish'd life the empire there.[11]

The gleaming empire that is being established here is not that of commerce or nation, but rather of the 'polish'd life', the larger cosmopolitan cause of civilization itself. Pye continues:

> May Europe's race the generous toil pursue,
> And Truth's broad mirror spread to every view;
> Awake to Reason's voice the savage mind,
> Check Error's force, and civilize mankind....
> No more with arms the trembling tribes destroy,
> But soft Persuasion's gentler powers employ,
> Till, from her throne barbarian Rudeness hurl'd,
> Refinement spread her Empire o'er the world.
> (II, 771–4, 779–82)

Pye clearly recognizes in these final lines some contradiction in the equation between colonization through military force and the refinement of the world, but the poem is remarkable for its general confidence of purpose, and for the way in which it affirms that Europe's role will be to 'Awake to Reason's voice the savage mind': mankind will be civilized through a simple process of education, with no sense of the savages being intrinsically inaccessible to reason. In this genteel prospect for world civilization, it is noticeable that a little earlier, Pye uses the word 'culture' in a way that embraces both its agricultural and its more modern social reference, significantly invoked specifically to describe what the African lacks:

The sable African no culture boasts,
Fierce as his sun, and ruthless as his coasts;
And where the immeasurable forests spread
Beyond the extent of Ocean's Western bed,
Unsocial, uninform'd, the tawney race
Range the drear wild, and urge the incessant chace.[12]

When Refinement reaches its benign vision of World Empire, we are only at the end of Book Two. The final Book, which amounts to a social anthropological analysis of contemporary British culture, begins to worry in typical Protestant earnestness about the 'effects of commerce when carried to excess' and the 'danger when money becomes [the] sole distinction': in other words, effeminate luxury.[13] The poem therefore concludes with an admonition that warns of the dangers of over-refinement:

Urged to excess her heighten'd powers destroy
The expanded bud, and blast each promised joy.
(III, 591–2)

The anxieties expressed in this portrait of a sick rose reveal a gap opening up between material civilization and spiritual or moral values that anticipates the Romantic reaction of a few years later (refinement itself would be sublated into the consumptive refinements of the Romantic artist, before being transmuted into the more general cultural fantasy of degeneration).[14] Pye himself was rewarded for the civility of his account of universal refinement by being made poet laureate in 1790.

In Britain, French progressive ideas of civilization had most impact in the city most closely affiliated to Parisian intellectual life: Edinburgh. The intellectual dominance of political economy meant that there the stages of civilization were conceived in categories of economic development: hunting, pasturage, agriculture and commerce.[15] This is the schema adopted in Adam Smith's *Wealth of Nations* (1776), or, to take a less well known literary example, in Richard Payne Knight's poem *The Progress of Civil Society* of 1796. Knight's poem traces a history of society according to its economic stages before devoting a fifth book to the influence of 'climate and soil' (though their power is limited; the polygenist Knight informs us that society has developed in the North and South through 'two distinct races of men; the one the farthest removed from, and the other nearest approximating, the Negro').[16] Although the earliest stages of civilization were associated in the eighteenth century with primitive peoples of various degrees of development, it was not until the nineteenth century that this economic four-stages model was modified to a three-stages model which

34

defined human history according to the cultural-racial categories of savagery, barbarism and civilization. The OED cites Matthew Arnold as the first person to distinguish between savages and barbarians in English (1835), but it was J. S. Mill's essay 'Civilization' of the following year which formalized the trio not as general categories but as a hierarchy of the historical stages of man, bringing geography and history together in a generalized scheme of European superiority that identified civilization with race.[17] The apogee of this conflation came in Prichard's theory of racial difference, in which he posited that the first people had been black and identified the cause of subsequent whiteness as civilization itself. White skin therefore became both a marker of civilization and a product of it.[18] This shift of defining categories from economic to racial-cultural, typical of its age, only highlights the way in which both the four-stages model of the eighteenth century, and the three-stages model of the nineteenth century, define civilization through difference, against a hierarchy that invokes the state of other, historical or non-European, societies. However much they may have been denigrated by being placed lower in the scale, these other societies were by the same token nevertheless essential to the European sense of self and concept of civilization. Mill's essay is symptomatic here: 'The word Civilization', he announces,

> is a word of double meaning. It sometimes stands for *human improvement* in general, and sometimes for *certain kinds* of improvement in particular.
>
> We are accustomed to call a country more civilized if we think it more improved; more eminent in the best characteristics of Man and Society; farther advanced in the road to perfection; happier, nobler, wiser. This is one sense of the word civilization. But in another sense it stands for that kind of improvement only, which distinguishes a wealthy and powerful nation from savages or barbarians.[19]

Here Mill attempts to hold together 'civilization' in its eighteenth-century sense of 'perfectibility' with its more modern sense of being defined by what it is not; he ends his definition by concluding that 'whatever be the characteristics of what we call savage life, the contrary of these, or the qualities which society puts on as it throws off these, constitute civilization'. This is then followed by contrasts between the salient features of savage and civilized life (savages, for example, apparently do not 'find much pleasure in each other's society', whereas the civilized middle classes do). The extent to which savagery had to be created in the nineteenth century as an antithesis to the values of European civilization becomes clearer and clearer. Even the Great Exhibition of 1851, which was created in order to advertise industrial

and technological achievements, included a small number of ethno-
logical exhibits, thus making, as Stocking remarks 'ritual affirmations
of European industrial progress, in the context of contemporary
savagery'.[20] At the same time, the civilizing mission to those very
savages was itself devised in order to resolve the conflicts within
civilization. Lenin cites Cecil Rhodes in 1895:

> I was in the East End of London [working-class quarter] yesterday
> and attended a meeting of the unemployed. I listened to the wild
> speeches, which were just a cry for 'bread', 'bread!' and on my way
> home I pondered over the scene and I became more than ever
> convinced of the importance of imperialism.... My cherished idea
> is a solution for the social problem, i.e., in order to save the
> 40,000,000 inhabitants of the United Kingdom from a bloody civil
> war, we colonial statesmen must acquire new lands to settle the
> surplus population, to provide new markets for the goods pro-
> duced in the factories and mines. The Empire, as I have always
> said, is a bread and butter question. If you want to avoid civil war,
> you must become imperialists.[21]

HERDER AND NATIVE CULTURE

In retrospect, Mill's word of double meaning can be seen as holding
together within itself the dialectic of 'civilization' and 'culture' and all
that the conflict between them implied. If the two words had devel-
oped alongside each other in the late eighteenth century, in the early
nineteenth century the Germans were to pull them apart. This was at
least partly in reaction to the French (and the French invasion of
German territories), and goes hand in hand with the development of
notions of German ethnicity. We could characterize this separation
between civilization and culture as an epistemic shift if it were not for
the fact that it was in many ways already implicit in Enlightenment
thinking. The differences between Diderot and Rousseau emphasize
the fact that the Enlightenment itself was by no means a unitary
phenomenon. While on the one hand civilization, especially in France,
marks the triumph of modernity, in which the modern world was for
the first time confident enough to set itself up as equal to or better than
antiquity, at the same time European explorations of other worlds had
demonstrated the potential relativity of European culture and values,
and opened up the possibility of a critical relation to its prevailing
ideology.[22] The Enlightenment enthusiasm for other cultures, mostly
imperial ones, such as India, China, Persia or ancient Egypt and Rome,
provided a means of achieving a cultural distance from which a writer
such as Montesquieu, or Swift, could construct an ideological critique

of contemporary Europe. Romantic writers after Rousseau turned to primitive or popular culture for the ground of their ideological interrogation of European civilization, and this represents the first signs of a turning inward of European culture, of the exploitation of an inner division in which it began to be set against itself. In the eighteenth century in Germany the word *Kultur* had been considered as a synonym for 'civilization', particularly in the sense established by Enlightenment historians in their universal histories which described the secular process of human development. It can still be found much later being used in this way in Freud's *Civilization and Its Discontents* (*Das Unbehagen in der Kultur*, 1930) – except that the very antithesis of Freud's title suggests the eruption of a concomitant antithetical view of civilization. This is the mark of the decisive change initiated, according to Williams and almost every other intellectual historian, by Herder: a Romantic reaction against the grand claims for civilization, in which the word 'culture' was used as an alternative word to express other kinds of human development, other criteria for human well-being and, crucially, in the plural, 'the specific and variable cultures of different nations and periods'.[23] It seems clear that what Herder was doing was articulating the reaction against secular human progress that was emerging at a key stage in the contradictory development of European capitalism. The tension that materialized between civilization and culture rehearsed the oneiric operation through which what we now call 'culture' defines and demarcates itself: culture has always been conflictual, antagonistic, exactly in fact what one would expect of the product of capitalism. The desire for differentiation in race theory was a product of the same historical scene of writing: racism's coercive site of production coincided with that of culture and class.

In his *Outlines of a Philosophy of the History of Man* (1784–91), Herder provided a genetic, universal history of culture (variously translated into English in 1800 as 'cultivation' and 'civilization') which traces the cultural origins of man back to the very beginnings of recorded history and emphasizes the extent to which different cultures have contributed knowledge and technology that have been subsequently utilized by later ones. In this shift of the stages of human history towards technological development, Herder clearly establishes an anthropological perspective which leads him to qualify European claims to superiority:

Vain therefore is the boast of so many Europeans, when they set themselves above the people of all the other quarters of the Globe, in what they call arts, sciences, and cultivation, and ... deem all the inventions of Europe their own, for no other reason, but because they were born amid the confluence of these inventions and traditions.[24]

Herder's attack on ethnocentrism, in fact, aligns him squarely with Enlightenment rather than Romantic thinkers: as Todorov observes, citing Fontenelle, Helvétius, La Bruyère, Montaigne and Rousseau, 'the critique of ethnocentrism was ... widespread in the eighteenth century'.[25] Even though he does not always succeed, Herder also makes a conspicuous attempt not to present his history of man from a eurocentric racialized perspective; in his anthropology, all the different cultures of the world are seen as participating in and contributing to its development within the general relation of what he calls 'the childhood, infancy, manhood, and old age of our species' (v). He dismisses the growing tendency in continental science to emphasize racial differences, regarding variations in complexion as merely the effect of climate, and all human beings as part of one huge family. In a perfect example of the teleological logic of organic form, this humanity is itself the beginning and end of human nature:

> Mankind, destined to humanity, were to be from their origin a brotherly race, of one blood, and formed by one guiding tradition; and thus the whole arose, as each individual family now rises, branches from one stem, plants from one primitive nursery.[26]

Within this universal sameness, Herder argues that the principal law of history is one of difference and diversity. This would be another example of his affiliation to the Enlightenment tradition were it not that he adds a highly significant new twist: Herder claims that individuals, and the character of nations, develop not only in relation to the local climate (a common Enlightenment assertion) but also in intimate connection to the land and the specific popular traditions that develop out of it. This becomes the overriding argument of the *Outline*:

> What is the principal law, that we have observed in all the occurrences of history? In my opinion it is this: *that every where on our Earth whatever could be has been, according to the situation of the place, the circumstances and occasions of the times, and the nature or generated character of the people.*

<div align="right">(348, italics in original)</div>

Herder's emphasis on locality sounds innocent enough, and in his time was doubtless affiliated to the liberal doctrine of environmentalism; but the heavy emphasis on an intrinsic link between particular people and specific places was later developed into polygenist theories of 'acclimatization' and 'non-acclimatization', such as those of the Swiss-American biologist Agassiz, who argued that distinct human types (in effect, species) developed in different regions of the world, and degenerated when taken from them.[27] According to Herder, in consonance with this insistence on the determining role of place and

situation, all cultural achievements were also strictly local: 'If a man were to compose a book of the arts of various nations, he would find them scattered over the whole Earth, and each flourishing in its proper place' (204).

This attachment to native place not only leads Herder to make his central argument of identifying culture in all its senses as the basis of the nation, but also unexpectedly forms the foundation of many of his apparently liberal opinions: his hostility to slavery is based not on the immorality of slavery *per se*, but on the iniquity of tearing peoples away from their native land; in the same way, his attacks on colonialism do not censure it on the basis of unjustified oppression and exploitation of other peoples but rather because he considers that it will decimate the colonizing nation: for Herder territorial expansion will inevitably destroy the fundamental unifying principle that 'every nation is one people, having its own national form, as well as its own language' (166). The nation, therefore, above all else, makes up the constitutive unit of human society, and this cultural unit defines the political unit, the *Volk*-state:

> The most natural state ... is *one* nation, with one national character ... a nation is as much a natural plant as a family, only with more branches. Nothing therefore appears so directly opposite to the end of government as the unnatural enlargement of states, the wild mixture of various races and nations under one sceptre. A human sceptre is far too weak and slender for such incongruous parts to be engrafted upon it: glued together indeed they may be into a fragile machine, termed a machine of state, but destitute of internal vivification and sympathy of parts. Kingdoms of this kind ... appear in history like that type of monarchies in the vision of the prophet, where the lion's head, the dragon's tail, the eagle's wings, and the paws of a bear, combined in one unpatriotic figure of a state.
>
> (249–50)

Such hybridized, forced unions between nations, Herder argues, are bound to disintegrate, while colonists themselves will degenerate in unnatural climates, just as, according to Herder, Africans have degenerated from the original Adamic European form. The importance of climatic environment, as in the later 'ethno-climatology' of Knox and Hunt, stems from its role in creating local cultures, which necessarily then have the virtues of homogeneity, uniformity and sameness. With this emphasis on the relation of culture to indigenous, localized peoples, within a general argument espousing human diversity, Herder sets up much of the basis of many conservative, racialist doctrines of the nineteenth century, which were often equally anti-colonial, as

39

we shall see in the case of Gobineau and Knox.[28] Moreover, although for Herder humans are all one species, his stress on individual ethnicities and their relation to locality almost seems to invite adaptation to the polygenist idea that they are several. At the same time, Herder's integrative stress on culture as the totality of a nation, rather than as intellectual or material progress *per se*, paradoxically opened up a potential division between culture and civilization within the nation.[29]

Herder's trenchant criticisms of colonialism and slavery can therefore hardly be described, as they are by Williams, as an opposition to civilization as such. In the same way, although he is commonly credited with questioning the assumption of the universal histories that civilization was a linear process leading up to its apex in eighteenth-century European civilization, Herder's relativism certainly does not prevent him from judging between peoples in terms of their 'degree of civilization' (480), from seeing human progress as solely the result of the operation of human reason, from regarding the historical development of mankind in terms of a succession of creative civilizations leading up to the German; according to Herder, the German nations in particular have proved 'the solid bulwark, that has protected the remains of civilization from the storms of time, developed the public spirit of Europe, and slowly and silently operated on all the regions of the Earth'.[30] At times he is also happy to make the usual sort of eurocentric aesthetic and cultural evaluative comparisons between different nations and civilizations. But his project, the tracing of a history of culture since the earliest moments of humankind, also works from the idea that cultures develop from each other incrementally, and can therefore be conceived of as plural. Herder thus in certain respects displays a remarkable cultural relativism, very different from the idea of a world divided between 'civilization' and 'barbarism'. Moreover, Herder is notable for the impartiality with which he attempts to discuss other cultures, commenting, for example:

> It is but just, when we proceed to the country of the blacks, that we lay aside our proud prejudices, and consider the organization of this quarter of the globe with as much impartiality as if there were no other.[31]

It is in such an anthropological spirit of objectivity that Herder advocates the use of the word 'culture' in the plural (thus anticipating its more relativistic anthropological sense) to denote the diversity of cultures both between and within nations. However, as Olender remarks, 'Herder forgot his concern with impartiality in working out the mechanism of his philosophy of history'.[32] Though differentiated from all others, each culture was still judged according to its degree in

40

an hierarchical scale of civilization. Moreover, while Herder opposes the totality of culture to the machine-like nature of civilization, at the same time he introduces a scission within the notion of culture itself. For Herder culture was always hybrid, even if he also identified a particular culture with the distinctive character of a nation.

Herder's argument thus works by a central paradox, which we will see repeated in Gobineau: while on the one hand colonization and racial mixture are regarded by Herder as introducing a fatal heterogeneity, on the other hand the very progress of mankind comes as the result of diffusionism, or cultural mixing and communication, whereby cultural achievements of one society are grafted onto another. So, for example, with the end of the Roman Empire, Herder comments: 'Every where new nations were grafted on the old stock; what buds, what fruits did they produce for mankind?' (525). No nation of Europe, he argues, has raised itself to 'a polished state' by pulling itself up by its own cultural bootstraps: Europe has taken most of its culture (writing, mathematics, religion etc.) from the Romans, the Greeks, the Arabs and the Jews. While he ascribes the basis of physical and cultural differences between nations to the effect of climate, the overall cultural change and development that his history chronicles results from physical interaction and cultural transmission.

Thus a conflictual tension exists at the heart of Herder's argument: on the one hand, cultures develop organically into nations by virtue of their homogeneity, attachment to the soil, their traditions and single language, but on the other hand, the 'golden chain of improvement that surroundest the earth' tells a different story, namely that the progress of culture works by a regenerative development between cultures, in which one nation educates another through mixing and migration:

> The education of our species is in a double sense genetic and organic: genetic, inasmuch as it is communicated; organic, as what it communicates is received and applied. Whether we name this second genesis of man *cultivation* from the culture of the ground, or *enlightening* from the action of light, is of little import; the chain of light and cultivation reaches to the end of the earth.
>
> (227–8)

Herder thus denies that the metaphoric basis of the distinction between civilization and culture has any significance at the level of concept. This is doubtless because for him culture grows indigenously, but is also transmitted between civilizations. He thus implicitly sets up an opposition between an emphasis on climate, natural place and education, and migration, intermixture and the grafting of one culture on to another. Colonization and racial mixture can introduce a fatal heterogeneity, but cultural development operates through an organic

41

grafting, diffusion and absorption between cultures. Herder thus utilizes the diffusionist and isolationist models simultaneously – the two models that were to become the two dominant oppositional theories of cultural development in nineteenth- and twentieth-century archaeology and anthropology.

Herder therefore speaks with a forked tongue: offering on the one hand rootedness, the organic unity of a people and their local, traditional culture, but also on the other hand the cultural education of the human race whereby the achievements of one culture are grafted on to another, sometimes occurring via revolution, or change of state (for example, the end of the Roman empire) or through migration, which Herder acknowledges as an historical tendency. In this way he resolves the central anthropological question of how the unity of the human race squares with its inherent diversity. However, it was only too easy subsequently to break his paradoxical thesis into two, so as to emphasize only singularity or diversity. The ambivalence in Herder's work explains how he manages to appear both liberal and proto-fascist at once, an ambivalence that was not necessarily carried through to his reception and influence. Those who read him emphasized the ideas of locality, nation and homogeneity of race and culture. They also took from him anti-Enlightenment ideas of relativism, of difference and of the superiority of German culture.

Herder's relativism was itself a sign of the Romantic questioning of the dominant Enlightenment ethos of civilization, progress, perfectibility – and equality.[33] The effects of industrialization in particular gave weight to an alternative view that saw contemporary civilization as fallen and diseased, and looked for a return to a more natural, healthy way of life. Culture came to represent this antithesis to civilized values. Emphasis was placed on national, traditional cultures, natural language rather than artificial rhetoric, and popular culture rather than the high culture of civilization.[34] This Romantic passion for ethnicity, associated with the purity of a people, language and folk-art still in intimate relation with the soil from which they sprang, was also closely related to the development of racial ideologies and the idea of the permanent difference of national-racial types. The identification of culture with natural values meant that it formed the basis for the attack on what was seen as the mechanical, over-industrialized, over-rationalized, materialistic character of nineteenth-century civilization. In that sense we find a Romantic precedent for Derrida's critique of Lévi-Strauss, namely that 'culture' was not opposed to 'nature', but was rather the term that came in between the nature/civilization opposition, being used to distinguish between 'human' and 'material' development.[35]

Herder certainly introduced the notion of culture as 'a particular way of life, whether of a people, a period or a group', though by the end of

the century this was often identified, as *Kultur*, with German culture as such. The missing link in Williams's argument, however, is that the idea of culture as the specific form of particular societies initially developed from Herder into a right-wing anthropology focussed on ideas of race and nation. It was only at the end of the century, when civilization itself had become so identified with colonialism and the project of imperialism, and could no longer even be used in its relativistic comparative sense, that liberal anthropology sought to discriminate between culture and civilization, and to use the former to describe the 'savage' and 'barbarian' cultures that civilization had come to destroy. To be able to do that, however, 'culture' itself had to be appropriated not only from its German nationalist context, but also from that of the most racist school of nineteenth-century anthropology.

If 'culture' articulated the divisions within the concept of 'civilization', therefore, Herder's work shows how, from the very first, it was never a straightforward antithetical category. In the nineteenth century, its complexity only increased as it became inscribed with the estranged antagonisms and contradictions that emerged out of Victorian society. Foremost amongst these was race.

'CULTURE, OR CIVILIZATION'

J. S. Mill was clearly following a more liberal interpretation of Herder when, in a well known statement in the essay on Coleridge, he identified 'the philosophy of human culture' with the history and 'the character of the national education' that makes a nation:

> The culture of the human being had been carried to no ordinary height, and human nature had exhibited many of its noblest manifestations, not in Christian countries only, but in the ancient world, in Athens, Sparta, Rome; nay, even barbarians, as the Germans, or still more unmitigated savages, the wild Indians, or again the Chinese, the Egyptians, the Arabs, all had their own education, their own culture; a culture which, whatever might be its tendency upon the whole, had been successful in some respect or other. Every form of polity, every condition of society, whatever else it had done, had formed its type of national character.[36]

In nineteenth-century Britain 'culture', as here in Mill, was typically used to refer to the characteristics and products of human society from the most primitive to the most civilized: if civilization was both the process and the result of the history of such societies, each one had achieved its own cultural level within that framework. Culture was

43

thus extended from the learning process of the individual to that of particular societies, to combine the social with the educational: 'all had their own education, their own culture'. The specific, particular culture of an individual society was here clearly set by Mill within a larger notion of culture as the product of humanity at large: 'the culture of the human being'. The dominance of this meaning of the word 'culture' is corroborated by the common use at that time of the phrase 'intellectual culture'; it is only through such a qualifier that culture's reference is moved towards that proposed by Matthew Arnold in *Culture and Anarchy* (1869). In that text Arnold contrasts, in typical German Romantic fashion, material civilization with intellectual culture, and invokes the latter with reference to certain specific characteristics of intellectual refinement previously associated with civilization: education, improvement, progress and perfection.[37] Williams remarks that in 1852 Newman complained that there was no word available in English for something that apparently corresponded to Arnold's 'culture': it was only, Williams suggests, *Culture and Anarchy* itself that at last gave 'the tradition a single watchword and a name'.[38] But the idea that Arnold was giving a name to a tradition is misleading because it implies that it was at that time the dominant one. What Arnold was doing, rather, was reinvoking and allying himself to a much older tradition, namely the Renaissance humanist device of using civility as a means of separating the gentleman scholar from both the aristocracy and the people. This move in effect constituted an attempt to re-appropriate civilization and culture from the wider scope of their Enlightenment humanitarian reference: in this way Arnold laid the basis for the subsequent development of cultural elitism later in the century.

According to Williams, 'culture' in its anthropological sense (in his definition, 'the specific and variable cultures of different nations and periods, and also the specific and variable cultures of social and economic groups within a nation') was 'decisively introduced into English' by E. B. Tylor's *Primitive Culture* (1871): if so, the slowness with which it caught on is indicated by the fact that this anthropological meaning does not appear in the original edition of the OED.[39] This can be partially explained by the fact that anthropological literature is not well represented in the OED. But the real reason is that there were already two anthropological uses current in the nineteenth century: the first was that used by Mill, referring to the particular degree of civilization achieved by individual societies within a general notion of the culture of humanity and the 'grand march of intellect', in Keats's phrase. The second was a notion of culture that comes closer to Tylor's definition, but was used by anthropologists who can fairly be described as reactionaries who sought to promulgate the inequality of races.

44

This story has customarily been one that anthropology itself has tried to occlude, suggesting instead that it was founded on a modern relativistic view of other societies very different from the Enlightenment progressive model of the advancement of human society. As Lévi-Strauss tells the official story:

> From its beginning in the early nineteenth century until the first half of the twentieth, anthropological thinking focussed largely on trying to find a way of reconciling the assumed unity of its subject matter with its diverse, and often incomparable, particular manifestations. For this purpose, the concept of civilization – connoting a set of general, universal, and transmissible abilities – had to give way to the concept of culture in its new meaning: it now signified particular life styles that are not transmissible, that can be grasped only as concrete products – skills, customs, folkways, institutions, beliefs – rather than as virtual capacities.[40]

Lévi-Strauss's description of the move from a concept of civilization to a concept of culture 'in its new meaning' passes over what the concept of culture was in its old meaning. This was often indistinguishable from race: as George Stocking observes, 'carrying much of the meaning that "culture" does today, "race" was a kind of summation of historically accumulated moral differences sustained and slowly modified from generation to generation'.[41]

TYLOR AND 'PRIMITIVE CULTURE'

Some years ago Stocking challenged the assumption, which derives from Kroeber and Kluckhohn, and which is reaffirmed by Williams, that since the nineteenth century there have been two concepts of culture, broadly speaking a 'high' culture associated with Arnold, which assumes itself ethnocentrically to be perfection, and an anthropological, relativistic concept of culture (associated with Tylor) as the 'complex whole' of any individual society's material and ideational system.[42] Stocking even suggests that 'in certain ways Arnold was closer to Tylor than to the modern anthropological meaning' (73). He begins with the definition that opens Tylor's *Primitive Culture*, and, according to Williams and others, introduced the modern concept of culture:

> Culture or Civilization, taken in its widest ethnographic sense, is that complex whole which includes knowledge, belief, art, morals, law, custom, and any other capabilities and habits acquired by man as a member of society.[43]

Stocking points to two difficulties here: first, that Tylor defines culture

as synonymous with civilization (although it is true that in the title of his book he chooses the former over the latter), and second, that this apparently synchronic definition of culture is nowhere evident in the rest of the book. In fact Tylor was not unusual in using the terms culture and civilization interchangeably: the term culture was employed by anthropologists of all persuasions to denote degrees of civilization for many years before 1871. This typical equation of civilization and culture is reinforced by the fact that, despite the modern-sounding initial definition, the rest of Tylor's opening chapter operates wholly within a linear, hierarchical, progressivist notion of civilization (or culture), similar to Herder's and the Enlightenment historians', encompassing the whole history of humanity, regarded as different only in degrees and stages. This perspective is most clearly indicated, according to Stocking, by Tylor's use of the comparative method and by the fact that, contrary to modern practice, he only uses the term 'culture' in the singular (80–1). So, after the sentence just cited, Tylor continues:

> The condition of culture among the various societies of mankind, in so far as it is capable of being investigated on general principles, is a subject for the study of laws of human thought and action. On the one hand the uniformity which so largely pervades civilization may be ascribed, in great measure, to the uniform action of uniform causes; while on the other hand its various grades may be regarded as stages of development or evolution, each the outcome of previous history, and about to do its proper part in shaping the history of the future. To the investigation of these two great principles in several departments of ethnography, with especial consideration of the civilization of the lower tribes as related to the civilization of the higher nations, the present volumes are devoted.

Nowadays we customarily criticize this view of the whole of humanity being estimated, and evaluated, according to a single hierarchy of development leading towards the achievement of high European civilization. What Stocking argues, however, is that Tylor was in fact taking the liberal position.

The background to this discussion involves ideas in Victorian anthropology to which we shall return in subsequent chapters; for now it is enough to say that two sets of antithetical positions are at stake: the 'progressivist' Enlightenment view that man had gradually evolved from a savage state into a civilized one (and would continue doing so until he reached perfection) versus the 'degenerationist' view, derived from the Bible, that man had been originally created as white and civilized, with the true religion revealed to him, but had in certain

circumstances since degenerated into savagery. In addition to pointing to the frequent occurrence of historical ruins all over the world that suggested that civilizations, like that of Ancient Rome, tended to degenerate, the degenerationists also could draw on the argument that since, according to the Bible, man had only existed for 6,000 years, there could not possibly have been enough time for him to advance from a state of savagery to one of civilization – given that the remains of Egyptian and other societies, which were clearly civilized, stretched back for most of that 6,000 years. The second antithesis related to the origin of man: the Bible affirmed that all human beings were one, and were derived from the original pair in the Garden of Eden. This 'monogenist' argument was increasingly countered by the 'polygenist' view that the diversity of human beings was such that it could only be accounted for by treating the different races of mankind as different species. The latter position was obviously amenable to the additional implication that if different races were different species, which were not physically the same, then so they might be unequal in other ways: in intellectual and social capacities, for example. In general, it would be fair to say that most progressivists were also monogenists, since polygenism in discarding any notion of the unity of mankind would no longer fit into a general narrative of human progress. But there was no logical reason why monogenists could not also be degenerationists, and many were, since both positions seemed to have the benefit of Biblical sanction.[44] Polygenists, on the other hand, though instinctively degen-erationists, could also be partial progressivists, to the extent that they could claim that while primitive races had remained static since their creation, civilized ones had progressed.[45] Historical change could be accounted for by the argument that many of these would, however, have subsequently degenerated. The result of these debates was to place great emphasis on geological time, which was used as a way of showing the possibility of evolutionary change, so as to dispute both the Biblical account of the origin of man, or the doctrines of the permanence of racial types.[46]

By the 1850s the Enlightenment ethos of the universal sameness and equality of humanity was being increasingly ridiculed as the evident diversity of human societies became ever more apparent. Polygenism had come to be widely regarded as the modern scientific view opposed to the traditional Biblical orthodoxy. In this situation, the only way to maintain the unity of humankind, and therefore egalitarian principles, was, as Stocking observes, to treat 'human differences as correlates of evolutionary stages' (70). Humans were one not because they were all the same, but because their differences represented different stages in the same overall process. Thus though the progressivist notion may seem elitist now, at that time it was opposed to the idea that humanity

was different, not comparable, and unequal. In this context, it was important, therefore, not to talk about cultures, or civilizations in the plural, for that would set them apart and allow the commentator to judge the people who created them as unequal – and fundamentally different. Paradoxically, it was therefore only the racist degeneration-ists who from the 1850s talked about civilizations in the plural.

Tylor, like the great ethnologist J. C. Prichard before him, was trying to uphold the unity and equality of the human race. Prichard held to it through his diffusionism, while Tylor's reaction was to identify culture with civilization and resist their division, and to assume a progressive evolution of humanity at both a material and a spiritual or moral level within a eurocentric hierarchy of values. Tylor emphasized this general evolutionary scheme because he wished to oppose the widespread doctrine of degeneration that held that the 'primitive' stages were relapses rather than an early stage of development. At the same time, in an atmosphere in which it was being suggested that different races were in fact different species, only an accommodation of all the races within the same scheme could attest to their common origin and their common, equal humanity. The paradox was that analysing cultures as independent progressive units in order to refute the degenerationists played straight into the hands of the polygenists.[47] The evolutionary method emerged, significantly, in the 1860s, at the very time when polygenism was becoming the dominant scientific view. The preva-lence of polygenism meant that the modern style of anthropological analysis of different cultures in their own particular, discrete terms could not be contemplated – for this was exactly the position of the polygenists, who preached a difference not of degree, but of kind.

The Swiss-American polygenist Henry Hotze, for example, in his 1856 Analytic Introduction to Gobineau's *Essay on the Inequality of Human Races*, shows clearly how 'culture' was used in a linear scale of value but set absolutely against any unifying dynamic scheme of a single line of human development. He writes:

> The highest degree of culture known to Hindoo or Chinese civilization, approaches not the possessor one step nearer to the ideas and views of the European. The Chinese civilization is as perfect, in its own way, as ours, nay more so. It is not a mere child, or even an adult not yet arrived at maturity; it is rather a decrepit old man. It too has its degrees; it too has had its periods of infancy, of adult age, of maturity.... And yet, because Chinese civilization has a different tendency from ours, we call it a semi-civilization. At what time of the world's history have we – the *civilized* nations – passed through this stage of semi-civilization?[48]

The use of the word 'civilization' in the plural as 'civilizations' did not

become common until the 1860s. The idea that there could be other civilizations could be thought to mark the appearance of a more relativistic view of human history. However, as we have suggested, in this context, it did not herald the modern liberal form of cultural relativism, but that of the polygenists who were concerned to emphasize absolute forms of racial and cultural difference. Culture was invented for difference: the first use of the word in its anthropological sense (by Trollope in 1862), significantly enough was to describe the 'different culture' of the North and South in the American Civil War.[49]

Stocking argues that Tylor's book was in certain respects a direct challenge to Arnold's *Culture and Anarchy*. In so far as he shared a normative notion of a hierarchy of values, Arnold was in fact quite close to Tylor in his notion of culture; by the same token both men 'saw culture as a conscious striving toward progress or perfection' (84). On the other hand, Tylor explicitly takes issue, from his opening sentence, with Arnold's distinction between civilization and culture, between material and spiritual states, which seemed to ally him to the degenerationists, such as the polygenist Anglican theologian Archbishop Whately (who taught Arnold as a boy how to carve Australian boomerangs).[50] To this extent, Stocking argues that the very title of Tylor's 1871 volume, *Primitive Culture*, was meant as a specific rebuke from a progressivist who wished to put culture and civilization back together again, arguing that culture can exist among all men, however crude or primitive its level, and that the development of man's spiritual or cultural life advanced according to the same laws of progress as his material life. Differences are those of development rather than origin: 'civilization actually existing among mankind in different grades', as Tylor puts it.[51] Though this undoubtedly represents Tylor's general position, the direct challenge to *Culture and Anarchy* seems more questionable. Stocking admits that Arnold's stress on the potential of education and the ideal of perfection seemed to distance him from the degenerationists; moreover, it is misleading to assume that the conjunction of primitivism and culture was in itself a radical step. The anthropologist James Hunt, for example, polygenist and racialist, in his translation of Carl Vogt's *Lectures on Man* (1864) lists 'Civilisation of Primitive Peoples' in the headnote list of topics to Lecture X; but in the lecture itself, the subject is introduced with the sentence: 'As regards the primitive culture of man, it was manifestly confined within narrow limits'.[52]

What this suggests is that the 'modern' anthropological notion of cultures without the inevitable implication of racial difference could only emerge with the eventual decline of polygenist thinking at the end of the nineteenth century: only then could a culture be seen as discrete, different and determining, without carrying the implication

that the people who created it were permanently inferior. Enthusiasm for degenerative polygenism began to degenerate itself not so much with Darwin's *Origin of Species* (1859), for some found the theory of natural selection perfectly adaptable to a theory of the diversity of human origins, but rather with the abandonment of the 6,000-year limit for the age of man after the discovery of human remains with the bones of extinct animals in Brixham Cave in 1858, and the rise of social evolutionism.[53] Even so, the doctrine of polygenism survived for many years after that.[54] It was only when social evolutionism had become the dominant view that its characterization of primitive people as backward, rather than as an irredeemably different species altogether, could itself be challenged in the name of an even more liberal view of cultures as indigenous, distinct entities. Today's politics of cultural difference must also presuppose sameness and equality.

CULTURE AND MODERNISM

One mustn't overrate the culture of what used to be called 'top people' before the wars. They had charming manners, but they were as ignorant as swans.

Lord Clark, *Civilisation* (1969)[55]

The idea of 'cultures', with 'culture' itself being used as a relatively neutral word that described holistically the way of life of non-European societies, was introduced by Boas only in the twentieth century.[56] The fact that Boas was able to do this marks the moment when the doctrine of polygenism had finally declined out of view, lifting the racist penumbra that had overshadowed any consideration of cultures as distinct. The advent of social evolutionism meant in effect that a revised version of the eighteenth-century progressive scheme was retrieved: the apparent psychic unity of mankind meant that diversity could be safely acknowledged. At the same time the reworking of the implications surrounding the anthropological notion of culture occurred when the term 'civilization' no longer referred to the achievements of human progress in general but rather comprised the ideological project of imperialism: it was only at this point that liberal anthropology redefined 'culture' in such a way as to distinguish it from 'civilization'. Nevertheless, although it no longer finds a place within a general theory of racial difference and inequality, the twentieth-century anthropological notion of culture as determining still operates a notion of difference that works within an implicit hierarchy, overarched by the divide between the West and the non-West. The study of a culture in itself without such evaluation only works by excluding consideration of the wider context in which it operates; but

the language and discourse in which the investigation is written, the place where the field-notes are published, give the game away. This fabrication of the modern anthropological meaning of culture was inextricably linked with the cultural re-evaluation of primitivism associated with early Modernism. Indeed the idea of the culture of a society as an artifact worth studying in itself reflects early twentieth-century modernist aesthetic practices. If the racism involved in the idea of discrete cultures was no longer apparent, this is not to say that it had disappeared altogether. Here Modernism itself gives the clue: sympathetic to primitive cultures, its racism was converted into anti-Semitism, and to its own doctrine of high cultural elitism.[57] In other words, at this point the hierarchy of higher and lower cultures within the scale of civilization around the world was transferred to European culture itself (with high culture paradoxically allying itself to non-European primitivism). As the currency of the term 'civilization' dropped away, so 'culture' itself split apart and reworked the divisions internally in its renewed emphasis on high and low. Just as Tylor did not introduce the modern anthropological use of 'culture' into English in 1871, so it is doubtful whether Arnold's *Culture and Anarchy* can be held responsible for the notion of culture as high Culture, beyond perhaps, setting up its structural possibility. Arnold's definition of 'culture', after all, was so general and vague that blame for culture in its narrow, elitist sense can hardly be laid at his door. The constriction of culture's meaning towards the association with high art, specifically identified with the upper classes, was no doubt anticipated in his later definition in *Literature and Dogma*: 'Culture is, *To know the best that has been thought and said in the world'.*[58] But Arnold's influence contributed rather to the extent to which culture was made material in the nineteenth century, and was institutionalized through government activities such as the creation of a national primary school system. It is significant that compulsory national education was introduced in Britain in the late nineteenth century, for its rationale shared much of the spirit of colonialism.[59] The inferior races, at home and abroad, had to be civilized and acculturated into the ideological dynamics of the nation. This process involved the founding of many other cultural institutions, particularly public museums (from the 1850s onwards), as well as the privately funded creation of universities, public schools and Working Men's Institutes. Institutionalization was, perhaps, the most specific, and influential, message carried by *Culture and Anarchy*: however vaguely culture may have been defined as an achievement for the individual, Arnold leaves his reader in no doubt about how it is manifested materially: institutions – Oxford University, the Established Church of England, the State. What is observable, one might add, is the extent to which the dissension marked within the history of the

notion of culture continues to operate not only within its conceptual structure but also within the institutions designed to embody it.[60]

But the elitism of culture only really developed with the advent of aestheticism at the end of the nineteenth century, and the continuation of the reaction against the egalitarianism of mass or popular culture in the 'art for art's sake' movement of the early twentieth century – Modernism.[61] Even Williams admits that the hostility towards 'culture' (which he dates from Arnold) nevertheless gathered force in the late nineteenth and early twentieth centuries 'in association with a comparable hostility to aesthete and aesthetic'.[62] T. S. Eliot put the issues squarely when laying down the conditions that, according to him, culture requires:

> If they conflict with any passionate faith of the reader – if, for instance, he finds it shocking that culture and egalitarianism should conflict, if it seems monstrous to him that anyone should have 'advantages of birth' – I do not ask him to change his faith, I merely ask him to stop paying lip-service to culture.[63]

T. S. Eliot, the high Modernist poet from the American South with an interest in anthropology, exemplifies the milieu in which the modern anthropological notion of culture was born: class and race conflict. It was the elitist ideology of late nineteenth-century social Darwinism that assimilated the hierarchy of high and low cultures between the races to a hierarchy of culture between the classes;[64] at the same time, the 'primitive' animal vitality and emotionalism of the lower races was reassigned its Romantic role as an object of value to be retrieved for the benefit of the regeneration of a tired, degenerate, vulgarized, mechanical European civilization – a move that describes almost completely the content of *The Waste Land* (1922). The implication of this is that the modern anthropological sense of culture was created alongside, and indeed was developed as a part of, high culture. Both were concocted by a Western culture no longer able to contain its own inner dissensions by projecting them outwards into a racialized hierarchy of other cultures.

Freud fastened on these paradoxes of culture's conceptual economy when he argued that civilization was achieved through a cultural repression which itself then produced cultural discontent. By contrast, Marcuse's revisionary claim that this dialectic of civilization could be resolved into a non-repressive culture betrays the same longing for an unfallen world of an organic, instinctual culture that can be found in the nineteenth-century idolization of the Greeks, the Lawrentian espousal of sex or the romanticization in the West today of Third and Fourth World ethnicity.[65] In both cases, 'culture' can be seen to have taken on the antithesis developed by the German romantics between

civilization and culture, between the higher learning that is the mark of civilization, and the natural folk-culture, or way of life, that characterizes the modern anthropological sense of culture, between the 'higher' and the 'lower' races, and between the 'higher' and the 'lower' classes. What emerges from this history is the startling fact that the notion of culture developed so that it was both synonymous with the mainstream of Western civilization and antithetical to it. It was both civilization and the critique of civilization, and this characteristic form of self-alienation has marked culture from the very start.

In *Keywords*, Williams concludes his account of culture by specifying three broad active categories of usage for the term. Although we have disagreed with his history of how these different meanings developed, his summary of the differences between them still stands:

1 a general process of intellectual, spiritual and aesthetic development (from the eighteenth century);
2 a particular way of life, whether of a people, a period or a group;
3 the works and practices of intellectual and especially artistic activity (late nineteenth, early twentieth century).

Williams comments that in English senses 1 and 3 are often close and merge with one another, but remain generally separate from sense 2. The gist of our argument is that 2 yokes culture to the history of racialized thought, and that it is inextricably linked to 1 and 3. This second suggestion is partially implied in Williams's remark that:

Faced by this complex and still active history of the word, it is easy to react by selecting one 'true' or 'proper' or 'scientific' sense and dismissing other senses as loose or confused.... But ... it is the range and overlap of meanings that is significant.[66]

We can say, then, that culture, despite its high propriety in various social circles, is as a word strictly improper, divided against itself. Its own genesis and semantic operation also bears, in Adorno's phrase, the stigmata of capitalism, and repeats and acts out the conflictual structure of the class system that produced it.

Thus, as we have observed, culture must apparently always operate antithetically. Culture never stands alone but always participates in a conflictual economy acting out the tension between sameness and difference, comparison and differentiation, unity and diversity, cohesion and dispersion, containment and subversion. Culture is never liable to fall into fixity, stasis or organic totalization: the constant construction and reconstruction of cultures and cultural differences is fuelled by an unending internal dissension in the imbalances of the capitalist economies that produce them. Culture has inscribed within itself the complex and often contradictory differences through which

53

European society has defined itself. Culture has always marked cultural difference by producing the other; it has always been comparative, and racism has always been an integral part of it: the two are inextricably clustered together, feeding off and generating each other. Race has always been culturally constructed. Culture has always been racially constructed.

If the very object of anthropology could be said to be cultural difference, this clearly makes it a particularly significant discipline in our contemporary culture of difference: but what this passes over is the way in which it has participated in the history of difference, which continues to repeat on us today. A connection can be made here to that more general term that encompasses the project of the Enlightenment ideals of history, universality and reason: Modernity. Post-Modernity is increasingly seen not so much as a simple historical development that seeks to replace Modernity as the subversion of Modernity by itself: according to Zygmunt Bauman, by the very drive of the principles of Modernity to their self-dissolving limits.[67] The relation of 'civilization' to 'culture' suggests rather that post-Modernity marks the articulation and maturation of an inner dissonance that had quickly developed within the Enlightenment project – something that has previously gone by different names such as Romanticism. Here culture names the dynamic motor that drives the productive, critical dissension of Modernity and post-Modernity. To put it more generally, we could say that for two hundred years culture has carried within it an antagonism between culture as a universal and as cultural difference, forming a resistance to Western culture within Western culture itself. The history of racism has followed an identical trajectory. In Adorno's terms, culture and civilization are the torn halves of a society that never adds up.

3

THE COMPLICITY OF CULTURE
Arnold's ethnographic politics

According to Raymond Williams, the hostility often expressed towards the word 'culture' dates from the controversy generated by Arnold's *Culture and Anarchy* (1869), a work which to that extent may be said to have generated the very philistinism it wished to vanquish.[1] It would be difficult to underestimate the importance and influence of this book as a central, indeed foundational, account of culture for the humanities in Britain and the United States. Arnold's culture is often assumed to involve the propagation of high culture in the service of an organicist nationalism. In fact, it is a good deal more complicated than that, and comes much closer to certain aspects of contemporary cultural politics than one might expect. Arnold remains very much within the parameters of Enlightenment assumptions about the progress of civilization towards perfection. At the same time, however, his account bears a close relation to Herder's description of culture as something antithetical to the main material tenets of civilization's advance.[2] So Arnold rejects any assimilation of human perfection to a mechanical materialism. Culture, he argues, is not even a matter of *belles lettres* or aesthetics, for it involves a higher, inward spiritual principle. He opposes this to the self-interested material goals of industrial life, often simply designated as in Carlyle as 'machinery'. But Arnold by no means proposes an ivory-towered retreat from industrialization. For, like cultural theorists of our own day, Arnold is very much concerned to emphasize culture's social function and its role in promoting social change. As Williams demonstrates in *Culture and Society*, the first cultural critics were Romantic writers such as Burke and Coleridge. Arnold, like so many others in the literary tradition since, shared their desire to move from literature and aesthetics *per se* to something beyond them, to a larger function in that world that is represented in literary texts. We could characterize this as a repeated Quixotic tendency to mistake the representation for the thing itself, or otherwise as the desire to colonize, inhabit, cultivate, not just literature as such but also the object of literature, the outside

55

world, and thus to incorporate it within the institution of culture.

On the other hand, it is certainly true that Arnold's account differs substantially from the political and class polarities implied in today's cultural politics: popular or working-class culture finds no place in Arnold's scheme. He announces quite bluntly, indeed, that the working class has no culture, and implies frequently that culture's function is, as it were, to cook the 'raw and uncultivated' populace. This metaphor forms part of Arnold's identification of the working class with savages (equally lacking in culture), for a commonly perceived characteristic of savagery in this period was the eating of uncooked food.[3] Threatened as he felt Britain was with anarchy, riots at home (1867 was the last year of Transportation to Australia, so dissidents could no longer just be sent packing), colonial rebellions abroad, the Fenian campaigns of the mid-1860s and the 1867 Reform Bill, Arnold took what was already the well trodden path of Coleridge, Mill and Newman, in prescribing education as enculturation as a prophylactic for revolution. But the culture specified in *Culture and Anarchy* goes much further than even Mill's programme for 'making the masses themselves wiser and better', and is assigned much wider effects than ever before: for it has the supreme function of harmonizing British society, the ability to counter the disintegrating tendency of its class war and move it towards a new totality, the nation state.[4] It does this by being set above any particular interest, by producing a centre of order. 'We have got a *practical* benefit out of culture' [my emphasis], Arnold announces: 'We have got a much wanted principle, a principle of authority, to counteract the tendency to anarchy which seems to be threatening us' (82). How does culture achieve this? The answer, for Arnold, as for Burke and Coleridge before him, lay in institutions: literary academies, the universities (for him, always, Oxford; the use-oriented Cornell, on the other hand, is scathingly dismissed), schools, the established Church and the State. The function of the latter is to provide a framework for society, a higher controlling form that does not merely serve the interest of a particular class, but the greater interest of the nation as a whole. In this sense, each institution takes on a superordinate status comparable in the case of the State to a dynasty, or, in Arnold's terms, the nation. Williams astutely comments that: 'The State which for Burke was an actuality has become for Arnold an idea': the State takes over the presiding function which Newman had ascribed to the university.[5] But it was Arnold who first identified culture with the institution to this degree; if it was Burke who initiated the culture of national institutions, it was Arnold who inaugurated the institution of national culture.[6] This is never straightforward, even for Arnold: by setting up the institution in a structure of centre and periphery, a principle of order among disorder, he ensures that culture's institutional function works in a irrepressibly dialectical

way. Moreover, although culture serves as the basis of the nation, and therefore becomes associated with nationalism, its identification with Englishness is not at all obvious – for the whole argument of *Culture and Anarchy* is that culture in England is lacking. Culture is characteristically defined for Arnold in strictly exotic terms: his emphasis on European and Oriental culture makes a nonsense of any simple identification of Arnold's culture with Englishness. Saintsbury's attack on his patriotism is testimony to this aspect of his argument.

This characteristic also explains the curious paradox of why Arnold's culture has to be both a positive and a negative force at once. For Arnold the public functions for culture are all rigorously stabilizing, harmonizing and reducing all conflict or dissent. But at the same time, culture's role is also, paradoxically, to destabilize. For culture represents a critical stance that 'subverts' (Arnold's word) by encouraging detachment from received notions;[7] it encourages and enables a discriminating distance from stock habits and conservative assumptions – it is, we might say today, anti-reifying, indeed anti-ideological. Arnold describes it insistently as being a force with which to resist what he calls 'fetishism', a word that he uses in its strict anthropological sense of 'the worship of material substances' – I will come back to the significance of Arnold's use of this word in its anthropological sense a little later.[8] Culture questions the fetishizing interest of each class, which Arnold, wittily subverting the Enlightenment historical scheme, names the Barbarians, the Philistines and the Populace. The men of culture become '*aliens*' (Arnold's emphasis) from their own class: thus Arnold describes himself as a middle-class dissident, opposing Adam Smith's self-interest with the general interest, and the fetishization of 'free trade' with the notion of 'free play'.[9]

Perhaps nothing illustrates better the lack of historical awareness of our contemporary debates about literary theory than the fact that what is alleged to be one of the main culpable tenets of deconstruction, 'free play', is in fact a concept taken over into English from Schiller by Matthew Arnold. Derrida himself, of course, writing in French, never even uses the phrase: 'free play' was merely the English translation for the innocuous *jeu*, meaning game, or play. One can only wonder how many of those who attack Derrida's alleged irresponsibility and lack of moral commitment by citing this phrase would be just as happy if they had to cite Arnold's name instead. But even Arnold's notion of 'free play' does not involve rampant irresponsibility, even if it rejects, again in apparent anticipation of Derrida, 'canons of truth absolute and final' (151): rather, it involves the ability of culture to detach itself from self-serving interest or unquestioned, but strictly limited, ends. In that sense, 'free play' names the mechanism that enables the critic of society to achieve a position such as Edward Said advocates, between culture

and system.[10] Culture, by enlarging one's range, facilitates a point of exteriority to the totality, and it is through this device that it can work both as a lever for subversion and as an inclusive, containing force of harmonization. In this respect we can say that Arnold does not here propose the term 'culture' either in its aestheticized, civilized sense or in an anthropological one, for at this level, Arnold's culture becomes, like imagination, a category of consciousness, produced by the reading and knowledge associated with civilization. Arnold can even go so far as to say that 'culture is *reading*', although he quickly he adds that it is only reading with a purpose.[11] Its attraction, therefore, is that it gives the man of culture (and it is always a man) a special place – a mental place outside society – from which he can subvert anything in contemporary culture in the name of a higher or larger vision, exercising a double function of subversion and totalization through an oppositional stance – a position that doubtless accounts for its great attractiveness to intellectuals ever since. However, as we shall see, despite these claims for detachment, Arnold's theory of culture is in fact fully immersed within the ideology of his time.

Arnold thus performs a manœuvre that decisively transforms the marginal position of the alienated intellectual into the very centre of society. In a curious anticipation of today's cultural dynamics, the nation's peripheral Other, its minority culture, becomes its centre. But the category of 'minority' is double-edged: its older sense, as here, of an elite highlights the fact that minorities include the ruling as well as the excluded classes. Arnold achieves this by making the point of exteriority the centre of authority that enables a harmonious totality, a move that turns the whole power relation back to front or inside out, so that culture becomes the metropolitan centre to the excessive provinciality of individual class concerns. The implications of this move of marginalization are nowhere better illustrated than by the way in which the middle classes (and politicized working class) are named 'philistines', a term derived from the epithet 'philister' given by students in Germany to those townspeople who worked outside the university.[12] The term involves a further reversal: originally, of course, 'philistine' was the name for the non-Jews: in *Culture and Anarchy*, as we shall see, the Jews are identified as Hebraic, which is itself characterized as philistine. So the Jews become non-Jews, while (cultured) Englishmen take over the role of the chosen people. The world, according to Arnold, is divided into town and gown, the philistines and (by implication) the aesthetes, the ugly and the beautiful, the non-elect and the elect, so that it is the university, the guardian of culture, that is both outside and above society but simultaneously its centre. This cerebral place of detachment, the university, has since become the norm for the place of the cultural critic.

If culture's function is ultimately to produce stabilization, it achieves

this dialectically, through a form of destabilization. Only, according to Arnold, the contemplative, disinterested spontaneity of culture, the dissolving agencies of thought, can encourage a self-reflexivity that will allow members of all classes to look to a general interest beyond themselves. Culture allows each individual to achieve this return upon his own mind – although this very detachment will mean that he will not get involved in practical or political action.

Thus it is true that Arnold's state of free-play is opposed to 'the political'. Indeed, culture is described as being opposed to all religious or political interest or dissent, or, in a Burkean phrase, the abstract theories of Jacobinism. In fact, the only dissent allowed is that of Arnold himself, and the particular form of cultural dissent that Arnold proposes, that of the *déclassé* middle-class intellectual. This means therefore that it is hardly the case that *Culture and Anarchy* is not a political text. Indeed, it was originally explicitly entitled *Culture and Anarchy: An Essay in Political and Social Criticism* – though significantly, the subtitle was dropped in the edition of J. Dover Wilson which has been the general form through which the book has been known for the past sixty years. The limits to disinterested critical detachment are frequently evident in Arnold's authoritarian pronouncements, particularly over any instance of public disorder; even his powerful denunciation of the appalling conditions of poverty in the East End, rather than leading to any questioning of the economic system that enforces such social inequality, becomes instead the occasion for a typically middle-class Malthusian reproval of the irresponsible excessive procreativity of the poor. The political thrust of the book is already signalled by its main title which explicitly sets 'culture' not against barbarianism or savagery but against the political term 'anarchy', or lack of government.

Arnold's transformation of the Enlightenment's progressive historical schema into a political equivalent suggests the extent to which he utilizes the contemporary anthropological account of culture which had adapted historical difference into the differences between European and non-European societies. Here we see the function of Arnold's insistent description of the Liberals as worshipping 'fetishes' (at one point he uses the term seven times in the space of two pages);[13] if we recall that the rioting mob of the populace is described in terms of 'savagery' (it was by no means, in fact, unusual in this period to compare the working class to savages), we can see that Arnold has represented all classes in quasi-racial terms either as 'savages' or as 'barbarians'.[14] 'Civilization' has only the men of culture left. It is for this reason that Arnold can claim that culture seeks not 'to unite the classes' – as he has been symptomatically misquoted in the Newbolt Report and by many others ever since – but rather 'to do away with classes'

(70). The State becomes a work of art, the nation its culture.[15]

The title of the book suggests that Arnold's culture is to be a theory of government, or, as he would put it, the State, and so in many respects it is. And yet the title is, significantly, *Culture and Anarchy*, not *Culture or Anarchy* as one might have expected. In fact, the title is itself a hybrid, combining the Oxford lecture 'Culture and its Enemies' with the article that followed, 'Anarchy and Authority'. The fact that Arnold put the two together registers a recognition that, as we have seen, his culture is very much a dialectical concept that not only harmonizes but also itself exerts an anarchic function, necessary if it is to encourage a critical perspective on society. Arnold goes further to suggest that culture is itself fuelled by an inner dissonance, the product of conflict and of the 'ineffaceable difference' of what he describes as the two rival forces that 'divide the empire of the world between them'. These forces prove to be those of racial difference: 'Hebraism and Hellenism – between these two points of influence moves our world'.[16]

This racial division, according to Arnold, works dialectically within English culture. The latter has been formed, and is driven, by the polarities of the two races and their differing racial and cultural characteristics: he defines Hellenism as 'spontaneity of conscience', Hebraism as 'strictness of conscience' (132), but consistently widens the implications of both historically and aesthetically. As so often, racial difference soon gets defined through gender.[17] So Arnold characterizes Hebraism as a masculinized muscular doing, and Hellenism as a feminized flexible thinking. This ascription of gender difference at once has the effect of confirming and legitimizing the racial hierarchy as a form of analogous natural law, neatly transferring to race all the cultural values that patriarchy had already foisted upon gender. Sexual difference is thus allied to race as the basis of culture; Arnold's choice of Hellenism also invites the association of this difference with the sexual preferences of the Greeks, thus covertly marking the aesthetic realm of culture with the aura of homosexual love.[18] At the same time, the doubling of the two hierarchies has the effect of reaffirming the increasingly contested inequality of gender relations by assimilating them to the larger scheme of race, and what was known as 'the natural history of man'.[19]

So *Culture and Anarchy*, the highly influential, virtual founding document of English culture, locates that culture's energy and history as the product of racial difference. It thus neatly relocates and displaces the class conflict that is so clearly apparent in the turbulent social scenarios that it describes. The struggles between what for Arnold are in effect four classes (the aristocracy, the gentrified middle class, the radical dissenting middle class and the working class) are subsumed into the struggles of racial history. The cunning of this ruse becomes

evident here, as he turns the clashes of self-interest between the different classes into an intrinsic racial conflict, the struggles of his own day about specific political issues – reform, Irish self-rule, the position of women – into the eternal, irresolvable antimonies of race in history. Political dissent becomes explicable as the workings of a permanent racial difference.

The Malthusian 'cross and the check' (143) between these two antithetical, centripetal and centrifugal racial forces represent the currents that propel not only culture and history, but also each individual. Hebraism involves a strict contraction of consciousness, while Hellenism produces its expansive free play, thus reproducing in miniature the totalizing and detotalizing, expanding and contracting, subverting and containing, forces at work in society and history at large. The two instincts of the moral and the intellectual become an ambivalent Jekyll and Hyde play of instincts within each person in which the repression of desire by strict conscience, the moral check of Hebraism, is represented in almost Marcusian terms as encouraging excessive partiality and thus general confusion, death over life.

In the Britain of his own time, Arnold considers that the 'natural' course of things has been perverted by an excessive Hebraism. This is traced back to the British puritanism of the seventeenth century which succeeded the Hellenism of the Renaissance and has not relaxed its grip since. For Arnold it is this strictness of conscience that, paradoxically, has itself created contemporary disorder and disarray, a situation that can only be cured by a turn to Hellenism. Here Hellenism comes close to representing culture itself for Arnold, specifically as an internal condition of perfection, sweetness and light, while Hebraism, increasingly associated with the darkness of the Barbarians and the Philistines, becomes the principle of strictness so fanatical that it paradoxically leads to disorder through its own excess, now even threatening a 'great sexual insurrection of our Anglo-Teutonic race'.[20] The universities become institutional guardians against Hebraism, 'formed to defend and advance' the culture of Hellenism, and are thus identified culturally, sexually and racially.

Arnold's historicization of these forces of culture is important to recall in any account of his text. He states that although the two 'instincts' of Hebraism and Hellenism ultimately both lead towards the same harmonious order of sweetness and light, the course of history progresses through a dialectical principle of alternation, swinging from one to the other in 'epochs of expansion' and 'concentration': 'each of these two forces has its appointed hours of culmination and seasons of rule' (83, 139). He thus presents the dialectic between these forces as the motor of history, alternately pushing outwards in a movement of expansion and inwards in a movement of concentration, an inside/

outside structure repeated in the injunction that the appropriate response for each involves contemplation or action, or, we might say, mind and body. Arnold thus presents the dialectic between these forces as the motor of history, alternately pushing outwards in a movement of expansion and inwards in a movement of concentration. This means that the disinterested contemplation of culture is not a general prescription for all time but what Arnold deems to be required at the present moment. Given the alternation between these two principles, his theory of culture therefore does allow after all for the possibility of direct political involvement of the most active kind in a different situation. Any theory of culture that reverses Arnold's contemplative disinterestedness thus remains completely within the terms of the historical model of the conflict between Hellenism and Hebraism which he sets up. This curious life/death struggle has remained at the heart of cultural theory ever since.

ARNOLD AND RACIAL THEORY

But race is a very great reality.... Any analysis of a great creative period ... must have this chaotic spot in its centre: the incalculable fact of racial intermixture.

Wyndham Lewis[21]

So much for the bizarre textual economy of *Culture and Anarchy*. But what is this racial struggle all about, and where does it come from? The extent of the academic silence on the racial centre of *Culture and Anarchy* is quite remarkable. Apart from Faverty's very useful, though now dated, work, *Matthew Arnold the Ethnologist* (1951), only two recent critics have addressed the racial element in Arnold's work: Franklin Court has stressed the extent to which Arnold's educational theory was based on the German idea of *Alterumwissenschaft*, the activation of racial memory through a systematic knowledge of classical antiquity; Bryan Cheyette has provided an illuminating account of Arnold's construction of Hebraism, particularly in the context of his father's anti-Semitism, and has drawn attention to Arnold's comment that the chapters on 'Hellenism and Hebraism' are 'so true that they will form a kind of centre for English thought and speculation on the matters treated in them'.[22] But few critics have pondered the full significance of Arnold's use of a racial dialectic at the centre of *Culture and Anarchy*. Said cites Matthew Arnold as one of a list of writers who 'had definite views on race and imperialism, which are quite easily to be found at work in their writing'; but the full implications of Arnold's racialism in his theory of culture have nowhere been discussed in any detail.[23]

Arnold's relation to the racialist ethnology of his time was in fact first

denounced by Wyndham Lewis – on the grounds that Arnold supported the wrong race, and had characterized Shakespeare as a Celt rather than as a true English Saxon.[24] The question was confronted more seriously by Trilling, who argued that the science on which Arnold relies had now been superseded, that it had been very much the tenor of his day and that it was therefore something that Arnold himself could not be specifically blamed for. In evidence of this he cited a long list of contemporary writers who were racists to various degrees.[25] If he had added in the later version of these ideas, the anti-Semitism that developed from the 1880s onwards, he could doubtless also have included James, Eliot, Lawrence, Pound and Lewis. Today we would also instance Jung, Heidegger and de Man. Although Trilling is right that the issue of blame ceases to function in this context, it is surely not enough to dismiss the issue by pointing out that everyone else held the same opinions. In fact, many of Arnold's contemporaries, such as Prichard, Buckle, Huxley, Latham, Lubbock, Mill, Quatrefages, Tylor and Waitz, contested racialism – though it has to be conceded that there is not a single literary name to be found here. In any event, Trilling's apology for Arnold seems to have allowed the majority of critics to ignore the issue in his work ever since.

So, for example, the three modern editors of *Culture and Anarchy* say almost nothing about it, give no hint of Arnold's reading or the sources of his ideas, beyond referring to Ernest Renan and the Saxon/Celt distinction in 'On the Study of Celtic Literature' (1867). David DeLaura managed to write a whole book called *Hebrew and Hellene in Victorian England* without feeling any need to mention its basis in racial differentiation. But Arnold's use of the Hellenic/Hebraic distinction is not innocent. In the first place, by emphasizing the difference between the two, he reverses St Paul, who had pronounced that 'There is neither Jew nor Greek, there is neither bond nor free, there is neither male nor female: for ye are all one in Christ Jesus' (Galatians 3:12) (not until Joyce's 'jewgreek is greekjew: extremes meet' would the distinction be once again dissolved).[26] But above all, Arnold grounds and authenticates his Hellenism/Hebraism polarity through reference to the authority of contemporary racial science:

> Science has now made visible to everybody the great and pregnant elements of difference which lie in race, and in how signal a manner they make the genius of an Indo-European people vary from those of a Semitic people.
>
> (141)

The Aryan Indo-Europeans are thus contrasted to the Semites: in fact, the idea of history as a dialectic of the two master races was often voiced in academic circles of the mid-nineteenth century. This clash

between the Indo-European and Semitic language families formed the basis of the racial dialectic that dominated the thinking of the last third of the nineteenth century and the twentieth until 1945.

In this context, it is striking that Raymond Williams concludes his discussion of Arnold by suggesting that the problem with Arnold's theory of culture was that he had neither material ground nor spiritual truth to found it on.[27] This overlooks the key function of ethnology in Arnold's argument. At the same time, this also suggests why, despite his attack on fetishized stock notions, Arnold felt that he needed the grounding that 'the science of origins' could give him and was therefore content to take over the new ideas in ethnology so uncritically. Arnold here, as so often, is acting less as an original thinker than as a conduit for received opinion of the time. What he presents here is a version of the racialist culture of the nineteenth century: the difference is only that he defines it *as* culture. In fact, he was right – right in the sense that historically social ideas of race and culture developed simultaneously. As Bernal has argued in one of the most interesting parts of *Black Athena,* the curious and disturbing fact is that the rise of professional scholarship and the transmutation of knowledge into the different forms of academic disciplines, decisively established at the University of Göttingen (founded in 1734) and then in the new university of Berlin and elsewhere, was intimately bound up with the development of racial theory and the ordering of knowledge on a racial basis.[28] As Said observes, 'What gave writers like Renan and Arnold the right to generalities about race was the official character of their formed cultural literacy'.[29] The blunt fact that has even now not been faced is that modern racism was an academic creation. What we are dealing with here is the dominance of racial theory so widespread that it worked as an ideology, permeating both consciously and implicitly the fabric of almost all areas of thinking of its time. This racialization of knowledge demonstrates that the university's claim to project knowledge in itself outside political control or judgement cannot be trusted and, in the past at least, has not been as objective as it has claimed; the university's amnesia about its own relation to race is a sign of its fear of the loss of legitimation.

Racial theory was established on two initially independent bases, namely physiology and language. It was the German professor of natural history, J. F. Blumenbach, under whom Coleridge went to study at Göttingen from 1798 to 1799, who in the 1770s first classified the human races into twenty-eight varieties, as Linnaeus had classified other natural life forms. Blumenbach subscribed to the monogenetic rather than the polygenetic theory of human origins, that is, he followed the Biblical account of man being descended from a single source, Adam and Eve. The corollary of this was that he used the

eighteenth-century thesis of degeneration to explain the differences between the races. This meant that the pure origin of man was the white male – the universal measure since its institutionalization as the representative figure of humanity in the Renaissance – and that all other forms were a deterioration from this ideal, on account of either gender or geography, or both. The threat of racial degeneration was, of course, to linger on through the nineteenth century, decisively returning as the distinctive aura of the *fin de siècle*, and reaching its apex in Nazi race theory.[30] Blumenbach is credited with the invention of the term 'Caucasian' to describe the superior (as he believed) white race, amongst whom, however, he included Semites.[31] He thus anticipated the popular Romantic idea that the origins of mankind could be traced geographically to a pure source which seemingly moved ever eastwards – hence the term 'Caucasian', which by stopping at the mountains between the Black and Caucasian seas, was still considerably to the West of the ultimate origins that, according to Herder or Schlegel, lay in the mountains of the Himalayas. Nevertheless, in choosing the term 'Caucasian', Blumenbach was clearly participating in what was to become a fully-fledged theory of Aryanism, a term first used in this way in the 1790s, although its use did not become common in English until it was popularized by Disraeli in the middle of the nineteenth century.

This physiological classification of racial difference was transformed from the mere taxonomy of ethnography by the discoveries in contemporary historical linguistics (1780–1820s) of the Indo-European family of languages (sometimes at this time called the 'Indo-German') which linked European languages to Sanskrit and an ultimate proto-language originating in the Asia from which the Aryan Caucasians had supposedly come. Whereas formerly Hebrew had been assumed to be the most ancient tongue, this development put European languages for the first time in opposition to Semitic ones. The division of the world into the Aryan and Semitic races had already been anticipated by Schlegel, but its apparent confirmation by historical linguistics at the level of the so-called families of languages gave the idea a tremendous boost in prestige – comparable to the status of the science of linguistics in the era of structuralism. We may note here the insistently genetic emphasis on the metaphor of 'families' of languages, and the oft-charted language 'trees' which were to determine the whole basis of phylogenetic racial theories of conquest, absorption and decline – designed to deny the more obvious possibilities of mixture, fusion and creolization.

Early ethnographers had been eurocentric in their surveys of the world's different racial groups, but in general they had at least subscribed to the Christian monogenetic theory of human origins. The

combination of physical racial characteristics with language families allowed a system of classification and differentiation that was predominantly cultural. For J. C. Prichard, the greatest ethnologist of the early nineteenth century, whose over-riding aim was to defend the unity of the human species, it had been language that had been used as the basis for defining the differences between peoples according to a cultural, non-racialized system, difference of climate being the predominant explanation for difference of the colour of skin. For those like Prichard and his disciple R. G. Latham, the main ethnological activity was the tracing of the origins of races through genealogies derived from historical philology.[32] But in the mid-nineteenth century this view was increasingly challenged by those who promulgated what was described as the new scientific theory of race, which was developed in Dresden, Paris, Edinburgh, Philadelphia and Mobile, Alabama.

This new theory, championed in London by those such as James Hunt and Richard Burton who broke with Prichard's Ethnological Society and founded the rival Anthropological Society, highlighted essentializing physiological and anatomical dissimilarities as the main basis for analysing racial differences; comparative psychology then traced the mental differences between the races, often by combining craniological discussions of brain size with estimates of degrees of cultural advance. Its adherents at first had tried to distinguish it from the old method by characterizing the latter as 'ethnography' as opposed to the new 'ethnology' which, it was claimed, was far more comprehensive in scope. Thus Nott and Gliddon remark at the beginning of *Types of Mankind* (1854), the founding textbook of the new racialist American anthropology, that they understand ethnology:

> to include the whole mental and physical history of the various Types of Mankind, as well as their social relations and adaptations; and, under this comprehensive aspect, it therefore interests equally the philanthropist, the naturalist, and the statesman. Ethnology demands to know what was the primitive organic structure of each race? – what such race's moral and psychical character? … and what position in the social scale Providence has assigned to each type of man?[33]

The new ethnology, the science of races, was usually polygenist, and thus not only described physical and linguistic differences between different races, but investigated their intellectual and cultural differences so as to provide the political principles of social and national life. It was, in short, a practice of cultural politics. By the time of *Culture and Anarchy*, this modern, scientific view was fast becoming dominant. There is no evidence to suggest that Arnold himself was directly involved in the new racialism in Britain: unlike Swinburne, for

example, he never joined the Anthropological Society. But, as we shall see, he was implicated in it because he was heavily influenced by some of its main sources.

In the first place, the new scientific racial theory drew on an earlier tradition that Arnold knew well, in which race (closely allied to notions of lineage, stock and nation) had been invoked as a form of historical explanation. The method of tracing the genealogy of ethnological difference through the resources of historical philology was easily adaptable to a method of using racial differences for other forms of historical understanding. This was applied to the field of European history, most influentially in the first instance by Barthold Niebuhr, the German historian of Rome, who argued that the ethnic principle represented the motor force of historical change and development. Niebuhr's most devoted disciple in Britain was Thomas Arnold, Matthew Arnold's father, headmaster of Rugby School and Professor of History at Oxford. In his *Inaugural Lecture* at Oxford, delivered in 1841, he acknowledged English culture to be a synthesis of Roman, Greek and Hebrew culture, but claimed that its greatness derived from the fact that it was supplemented by a new element added, namely,

> the element of our English race. And that this element is an important one, cannot be doubted for an instant. Our English race is the German race.... Now the importance of this stock is plain from this, that its intermixture with Keltic and Roman races at the fall of the Western empire, has changed the whole face of Europe.... What was not [in the Ancient world] was simply the German race, and the peculiar qualities which characterize it. This one addition was of such power, that it changed the character of the whole mass.... But that element still preserves its force, and is felt for good or for evil in almost every country of the world. We will pause for a moment to observe over how large a portion of the earth this influence is now extended.... I say nothing of the prospects and influence of the German race in Africa and in India – it is enough to say that half of Europe, and all America and Australia, are German more or less completely, in race, in language, or in institutions, or in all.[34]

While this ominous account of the German race seems to anticipate twentieth-century ideologies, the noticeable difference here is the stress on the Germans fusing with other races to produce a new, more powerful mixture (this did not, however, prevent Thomas Arnold from inclining towards the doctrine of polygenesis with respect to the non-European races).[35] It was in fact this aspect of Arnold senior's argument to which Robert Knox, in *The Races of Men* (1850), took exception: he, like Arnold junior, was more interested in establishing antagonistic

racial differences within the mixture and objected to any suggestion that, as he put it, 'the Celtic and Saxon races were so united in Great Britain and Ireland that they now form but one *united race!*' He wrote: 'It was unquestionably a great error in Dr Arnold, to confound under the common name of Teutonic, races so diverse ... no minds are more distinct than the Saxon and the Celtic'.[36] Matthew Arnold reacted in strict Oedipal fashion against his father's celebration of the decisive influence of the Germanic race on world history, his 'Teutomania' as he called it, not by rejecting his racialism but by favouring the French and the Celts instead. To do this, he drew on the work of two very different ethnological authorities, Ernest Renan and W. F. Edwards.

ON THE STUDY OF CELTIC LITERATURE: RENAN

The great French Semitist and linguist Ernest Renan is generally agreed to have been the writer who most influenced Arnold in his thinking. His philological method meant that, in Nott and Gliddon's terms, he was an ethnographer. However, we can see in Renan's work that even with historical philology the definition of racial difference in terms of linguistic difference was increasingly used to emphasize an account of race characterized in terms of cultural value and a hierarchy based on the degree of civilization (Renan shared this equation of language with race with Max Müller).[37] It is in Renan's work that we find the immediate reference of Arnold's comment in *Culture and Anarchy*, cited above, that 'Science has now made visible to everybody the great and pregnant elements of difference which lie in race, and in how signal a manner they make the genius of an Indo-European people vary from those of a Semitic people'. The fundamentally racist basis of Renan's thinking has never been fully acknowledged by Arnold's critics. It was first emphasized in modern times by Aimé Césaire, who invokes Renan's *La Réforme intellectuelle et morale de la France* (1871) at the beginning of the *Discourse on Colonialism*. This was a book that had been reviewed sympathetically by Arnold. Although he specifies several points of disagreement with Renan, he does not quarrel with the sentiments of the following passage cited by Césaire:

> The regeneration of the inferior or degenerate races by the superior races is part of the providential order of things for humanity. With us, the common man is nearly always a déclassé nobleman, his heavy hand is better suited to handling the sword than the menial tool. Rather than work, he chooses to fight, that is, he returns to his first estate. *Regere imperio populos,* that is our vocation. Pour forth this all-consuming activity onto countries which, like China, are crying aloud for foreign conquest. Turn the

adventurers who disturb European society into a *ver sacrum*, a horde like those of the Franks, the Lombards, or the Normans, and every man will be in his right role. Nature has made a race of workers, the Chinese race, who have wonderful manual dexterity and almost no sense of honour; govern them with justice, levying from them, in return for the blessing of such a government, an ample allowance for the conquering race, and they will be satisfied; a race of tillers of the soil, the Negro; treat him with kindness and humanity, and all will be as it should; a race of masters and soldiers, the European race.[38]

A nation that fails to colonize, Renan warns, is irrevocably doomed to socialism, to a war between rich and poor. Although he condemns conquests of one European race by another, Renan suggests that there is nothing shocking about the annexation of the country of an inferior race by a superior race – such as the British occupation of India. Arnold does not demur from these sentiments. Tzvetan Todorov has recently demonstrated the full extent of Renan's racialism.[39] He describes the work of Renan, Taine and Gobineau, all of whom were read sympathetically and cited approvingly by Arnold, as the three 'most zealous propagators' of scientistic racialist doctrines in the nineteenth century.[40] Like his contemporaries Cuvier and Gobineau, Renan divided the peoples of the world into three races, the white, yellow and black, whom he considered different species; the yellow race was only partly capable of civilization, the black never at all. Given that his inegalitarian attitude to the 'inferior' races is every bit as extreme as Carlyle's towards 'Quashee', it comes as no surprise to learn that Renan was sympathetic to the work of Nott and Gliddon.[41] Although his praise of Gobineau's *Essay* was initially qualified, he was later to assert that 'the inferiority of certain races to others is proved'.[42] With respect to the 'superior' white Caucasian race, it was language, Renan believed, that demonstrated its history and origin, and this enabled him to subdivide it hierarchically into two further races according to the split between the 'two poles of the movement of humanity', the Aryan and Semitic language families.[43] Although Caucasians, the Semites were, in Renan's view, inferior. If Arnold took many of the predicates of his thinking from the Renan whom he admired so much, describing him in *Culture and Anarchy* as the 'friend of reason and the simple natural truth of things' (17), it is all the more remarkable that his own racialism remains so comparatively restricted. But among the ideas which he absorbed from Renan was that which suggested that like its vast array of languages, the Caucasian race was internally divided, fissured within and set against itself. This racial division was then extended to the individual Caucasian: Renan described himself, not altogether

THE COMPLICITY OF CULTURE

inaccurately, as a 'tissue of contradictions, one half of me engaged in devouring the other half, like the fabled beast of Ctesias who ate his own paw without knowing it'.[44] Unlike Hopkins, who sought to return to the original unity of European languages' Aryan origins by forcing the etymologies of words in his poetry through a violent Teutonic vigour, Arnold's move was to adapt this general thesis of contemporary estrangement and heterogeneity to a theory of Englishness as such.[45] At the same time, Arnold followed Renan in extending it to describe his own individual identity, exclaiming: 'Why, my very name [Matthew Arnold] expresses that peculiar Semitico-Saxon mixture which makes the typical Englishman'.[46]

It was in *On the Study of Celtic Literature* (1867) that Arnold first developed the idea that the English were made up of a dialectic of races, in this case of Celt and Saxon, representing the forces of light and of darkness, of spontaneity and domination, of culture and philistinism.[47] Arnold characteristically ignores domestic debates about the Irish in favour of Renan. Indeed initially, the reader might be forgiven for assuming the Arnold has merely produced an English version of Renan's celebrated essay, 'The Poetry of the Celtic Races' (1854), for Arnold follows the format of Renan's essay quite closely. Renan starts with a description of the Celtic landscape, 'full of a vague sadness', moving to an account of the Celtic people, 'a timid and reserved race, heavy in appearance but capable of profound feeling, and of an adorable delicacy in its religious instincts', and then follows with a detailed analysis of the glories of Celtic, particularly Welsh, literature.[48] Arnold takes over much of Renan's characterization of the racial 'physiognomy' of the Celts, particularly their great ability for sentiment: 'no race equals this for penetrative notes that go to the very heart' (2). In a famous remark, Renan develops this tacit sexuality explicitly: 'If it be permitted us to assign sex to nations as to individuals, we should have to say without hesitance that the Celtic race ... is an essentially feminine race' (8). While they are 'above all else a domestic race' (5), Celtic peoples are celebrated most for their 'imaginative power', but this is also their downfall: the Celtic race 'has worn itself out in taking dreams for realities, and in pursuing its splendid visions' (9). This combination of feminization and imaginative exhaustion makes it unsurprising when Renan allies these qualities to a lack of political effectivity.

Despite the similarities between the two essays, however, Renan produces different characterizations from Arnold in two ways. In the first place, he emphasizes the continued racial purity of the Celts, particularly savouring the Irish because they remain unmixed with foreign blood, none 'purer from all alien admixture' (4). Second, although he begins on an elegiac note for the 'ancient race', 'Alas! it too

is doomed to disappear, this emerald set in the Western seas', and concedes that Celtic culture is 'expiring on the horizon before the growing tumult of uniform civilization' (3), he sees the task of criticism of 'calling back those distant echoes' and concludes with a paean to the possibility that the Celts may experience a cultural and even political revival (59–60).

All the distinctive differences in Arnold's account augment the role of contemporary racial science. Sympathetic to Renan's more general assumption that 'inferior races' must disappear, indeed be exterminated, when confronted by superior peoples, Arnold begins by announcing that he is quite happy to see the extinction of all forms of Gaelic as living languages, characterizing Gaelic as 'the badge of the beaten race'.[49] Arnold, in his role of Inspector of Schools, was himself in fact instrumental in the enforcement of English rather than Welsh as the language of instruction in Wales.[50] But in *On the Study of Celtic Literature* he reveals that he does not seek to destroy it altogether: he wishes Celtic to become an object of academic study, the museum relic of an extinct culture. Celtic culture as such, according to Arnold, is, or should be, more or less extinct as an active, living force: the cosmopolitan Arnold is dismissive of the contemporary political claims for the Gaelic revival because of what he considers to be the natural course of national racial history: 'the fusion of all the inhabitants of these islands into one homogeneous, English-speaking whole, the breaking down of barriers between us, the swallowing up of separate provincial nationalities, is a consummation to which the natural course of things irresistibly tends' (296–7). As a result of desired political objectives and assumptions about the natural course of things, both apparent enemies of regionalism, Arnold insists that Celtic culture must be submerged in English culture rather than set against it. But the force of the essay is to suggest not a doctrine of assimilation but rather one of intermingling: Arnold is proposing fusion at the same time as he makes a claim for the permanence of the two racial types.

Despite its political evanescence, as 'an object of science', as a cultural form, Celtic can count for a good deal. 'Science', according to Arnold, 'exercises the reconciling, the uniting influence' (335): the crucial harmonizing power, which in *Culture and Anarchy* will be ascribed to culture itself, is here found in the racial-cultural kinships demonstrated by philology. The Celtic spirit can be released into English culture by turning it into an academic subject, so that it becomes part of English culture just as the Celt is, Arnold claims, part of the English race. Never was the colonial relation to other cultures in the nineteenth century more clearly stated: the force of 'modern civilization' destroys the last vestiges of a vanquished culture to turn it into an object of academic study, with its own university chair. The function of the chair is to

71

reactivate the traces of the colonized so as to transform the moribund culture of the colonizer, and even 'to send a message of peace to Ireland'. So, even in his own account, Arnold's appropriation of Celtic culture, despite his dismissal of the Gaelic revival, is political after all. It is a lasting irony that although he did succeed in exerting his influence so that a Chair of Celtic was established in Oxford, it lives on today not in the English Faculty but in that of Medieval and Modern European Languages. The Chair of Celtic has yet to bring about the effect which Arnold hoped for – the bringing of peace to Ireland.

ON THE STUDY OF CELTIC LITERATURE: EDWARDS

Fenian political antagonism is thus countered with racial integration and cultural assimilation. Arnold's ambivalent attitude towards Celtic culture was in many ways repressive. On the other hand, to his credit, in the 1860s anti-Irish prejudice was still rife in Britain, so to advocate the accommodation of Celtic culture in any form was also a radical move, particularly in the context of the Teutomaniacs. As Arnold himself notes, the earlier racial theory, espoused by his father, that the Celts were illegitimate intruders from a non-Caucasian race had by then been disproved by the demonstration that Gaelic was, after all, an Indo-European language.[51] But the racialized cultural assumptions about the Irish as simian or black lingered on. Kingsley's oft-cited description of the inhabitants of Sligo as 'dreadful' 'white chimpanzees', for example, dates from 1860; as late as 1885, Beddoe, in *The Races of Britain*, described the Irish as 'Africanoid'.[52] Knox, for his part, denied that Irish misery was due to English misrule, claiming instead that:

> the source of all evil lies in *the race*, the Celtic race of Ireland. Look at Wales, look at Caledonia; it is ever the same. The race must be forced from the soil; by fair means, if possible; still they must leave.[53]

Knox's illustrations of the Celt tell the real story (see Plate 1). Whereas the Irish Celts are portrayed as poor, over-fertile, their faces displaying negroid characteristics, there is no need to illustrate the Saxon type at all. Rather, Knox shows 'A Saxon House', adding 'standing always apart, if possible, from all others' (see Plate 2): his stately mansion thus manages to suggest the fundamental class basis of the racial distinction, at the same time as implying the instinctive racial purity of the bourgeois Saxon.

The idea that the English were really Saxon Teutons, and had already simply wiped out the Celts on English soil (here, at last, is the basis for

Plate 1 'A Celtic Group; such as may be seen at any time in Marylebone, London'. Robert Knox, *The Races of Men* (1850)

claims for Englishness as homogeneity) was still popular at this time. E. A. Freeman, for example, a prime proponent of the Germanic thesis, published his six-volume *History of the Norman Conquest of England* in the same year as *On the Study of Celtic Literature* in 1867. In the 1860s the counter-argument that it was the Celts who formed the true origin of the British was still unusual but was gathering strength; apart from Arnold's essay, its most notable manifestation at this time was Tennyson's *Idylls of the King* (1859–85) based on the Arthurian legends of Malory and the *Mabinogian*. In fact, however, it was to be politics rather than culture or racial science that ended the Teutonic argument: it collapsed with the unification of Germany in 1871.

Although Renan celebrated the Celtic survival in Ireland and France, he said little about Britain. Arnold therefore needed to look elsewhere.

Plate 2 'A Saxon House: standing always apart, if possible, from all others'.
Robert Knox, *The Races of Men* (1850)

The English-as-Teutons thesis meant that he had to find someone who could provide historical evidence of the survival of the Celts so that he could claim that they were already a living, material part of English cultural life. In a proto-run for the arguments of *Culture and Anarchy*, Arnold takes ethnology, which he calls 'the science of origins', very seriously. Instead of stressing the purity of the Celt from 'all admixture of alien blood' as Renan does, he emphasizes the survival of Celtic blood in that of the English. He contests the idea that the Celtic Britons 'should have been completely annihilated' and that the Saxons carried out the 'deliberate wholesale extermination of the Celtic race' (337). The 'main current of the blood', he concedes, may have become Germanic, but, he asks, 'can there have failed to subsist in Britain, as in Gaul, a Celtic current too?' (338). At this point, Arnold invokes the physiological data of W. F. Edwards's *Des caractères physiologiques des races humaines* (1829), which he had read in 1865.[54] Arnold pointedly remarks that the book 'attracted great attention on the Continent; it fills not much more than a hundred pages, and they are a hundred pages which well deserve reading and re-reading' (339). We have already encountered Edwards in an earlier chapter as the friend and colleague of

Robert Knox. His work is cited with approval by Gobineau; Nott and Gliddon invoke him at the beginning of their *Types of Mankind* (1854), as the prime authority and precedent for their theory of permanent racial and national types: 'the work of Edwards', they write, 'stands in many respects unrivalled. The high reputation of its author as a naturalist guarantees his scientific competency'.[55] Perhaps fortunately, Arnold was in fact not very up to date with his ethnology: inspired by Morton's *Crania Americana* (1839), J. B. Davis and J. Thurnam had more recently published their comprehensive *Crania Britannica. Delineations and Descriptions of the Skulls of the Aboriginal and Early Inhabitants of the British Isles* (1865, dedicated, with permission, to Queen Victoria), in which, despite Edwards's arguments, they had concluded that 'the series of Anglo-Saxon skulls, in their great resemblance to those modern Englishmen, vindicate the true derivation of the essential characteristics of our race from a Teutonic origin'.[56]

Edwards, like Knox, was one of those ethnologists interested in applying theories of race to a domestic European context: interest in European races, 'stocks', developed alongside more global analyses of racial difference. The question such theorists had to address was the problem of how to define European ethnicity. Europeans and Africans, for example, were to them clearly of different races, even of different species, which was supposedly proved by the fact that the hybrid product of unions between them, were, like the mule, infertile. But things became more difficult when one considered the Europeans themselves. Did not Europe itself provide examples of successful hybrid races? Edwards and Knox, however, argued that 'the mingled races of Europe are not hybrids', the ingenious arguments for which we have already encountered in Knox's essay 'An Enquiry into the Laws of Human Hybridité'.[57] Both men shared a method made up of a peculiar blend of scientific analysis and cultural inference, combining in effect the anatomical precision of Cuvier with the more cultural 'transcendental anatomy' of Geoffroy St-Hilaire. Edwards's contribution was to marry anatomy with history and national culture, Desmoulins with Thierry. His work was to exert a lasting influence on the development of the new scientific racism.[58] Born a white 'English' Jamaican, Edwards undertook his medical training in Paris, where he remained for the rest of his life, founding the Société d'Ethnologie in 1839; his *Recherches sur les langues Celtiques* was published posthumously in 1844. His brother, Henri Milne-Edwards, as Arnold mentions, was also an anatomist and zoologist who succeeded Geoffroy St-Hilaire in his chair of zoology. Edwards's *Des caractères physiologiques des races humaines, considérés dans leur rapports avec l'histoire* is addressed to Amédée Thierry, the French historian, who, in his *L'Histoire des Gaulois* (1828) first used the terms 'race' and 'class' as

analytic concepts for the understanding of history. Indeed, he was hailed by Marx as 'the father of the class struggle in French historical writing'.[59] This means, bizarrely, that Arnold's source was the very same dialectical historical model that was developed by Marx. Thierry's works analysed the way racial migrations and conflicts between the Celts (or Gauls) and Belgians in ancient French history had developed into a class struggle that resulted in the French Revolution. His brother extended this analysis to the effects of the Norman conquest on British history.[60] Edwards's contribution was to argue that the Thierrys' analysis could also be proved literally, physiologically: because of the permanence of racial types, the racial course of British and French history was still actually detectable in living national populations. Knox and Edwards both liked to analyse racial types as they walked about the streets of Paris or London. Lonsdale, Knox's first biographer, tells of how 'even when walking along the streets, thronged with men and women, he was always on the *qui vive* for Race features. He could see at a glance what ordinary men could hardly distinguish at their leisure'.[61] Knox's interest in British ethnicity was subsequently formalized by the Bristol doctor (trained in Edinburgh) John Beddoe, who went around the country in an attempt to chart the traces of the various races still mingling together, compiling an 'Index of Nigrescence' by recording racial characteristics on specially designed cards which he concealed in the palm of his hand. His research was to be published in *The Races of Britain* (1885), a book which traces with obsessive taxonomic fervour in more than a hundred pages of tables the ethnic origins, and alleged increasing 'nigrescence', of the inhab- itants of the British Isles (see Plate 3) and Europe (in 1904 Havelock Ellis extended his work by classifying the mental and emotional character-istics of each county in Britain).[62] Perhaps, one might speculate, it was this scientific emphasis on the vulnerable readability of the Englishman's physiognomy that led him to erect his defensive, inscrutable stiff upper lip.

Edwards's *Des caractères physiologiques des races humaines* was the book that initiated such projects of assimilating history to physiology and natural history. Edwards tells Thierry that the ancient races of whom he speaks can still be detected in present-day Europe not just through their languages but also through their physical, bodily – in other words, racial – forms. Arnold summarizes his project as follows:

Monsieur Thierry in his *Histoire des Gaulois* had divided the popula-tion of Gaul into certain groups, and the object of Monsieur Edwards was to try this division by physiology. Groups of men have, he says, their physical type which distinguishes them, as well as their language; the traces of this physical type endure as the

BOSTON. LINCOLN. LINCOLNSHIRE.

WEST-RIDING TYPES. NOTTINGHAMSHIRE.

JUTE? KENT. SUSSEX.

Plate 3 'English types'. John Beddoes, *The Races of Britain* (1885)

traces of language endure, and physiology is enabled to verify history by them. Accordingly, he determines the physical type of each of the two great Celtic families, the Gaels and the Cymris, who are said to have been distributed in a certain order through Gaul, and then he tracks these types in the population of France at the present day, and so verifies the alleged original order of distribution.

(339)

But what was the evidence for this permanence of 'physical types' that Arnold endorses so enthusiastically? Edwards tells of how he first conceived of this form of living history: on a visit to London, he was with his friends Knox and Thomas Hodgkin (who was later to become Professor of Pathological Anatomy at Guy's Hospital, as well as the founder of the Aborigines Protection Society, and author of a number of books on colonization).[63] Edwards mentioned to them Prichard's citation of a Greek author who had described the Egyptians as black, with frizzled hair. Knox, he reports, verified this statement not by recourse to a text but by taking him to see the tomb of an Egyptian king. There they saw illustrations which showed that the Egyptians of many thousand years before had portrayed the different races exactly the same as they could be found in the present. Some were clearly recognizable as Ethiopians. Others were as definitely Jews, who were, Edwards claims, identical to those he could see every day walking the streets of London.[64] Knox recounts the same incident twice in *The Races of Men*, and puts the inference bluntly:

> It was whilst examining the tomb, exhibited by Belzoni in London, 1822 or 1823, in so far as I can recollect, that I pointed out to my most esteemed friends, Messrs. Hodgkin and Edwards, the unalterable characters of races. Neither time nor climate seems to have any effect on a race.[65]

Knox claimed that he, not Nott and Gliddon, had been the first to make use of historical records in order to analyse the different racial types. Given the widespread influence of his ideas, it is a lasting irony that his 'historical records' were nothing more than modern copies of wall-illustrations displayed in Belzoni's spectacular mock-up of an Egyptian tomb at the Egyptian Hall, Piccadilly. Knox based his facts on what Belzoni himself, in the exhibition catalogue, described as merely conjectural racial identifications of his own.[66] This was the scientific evidence from which Knox and Edwards demonstrated the permanence of types, and refuted Prichard's claim that the varieties of racial difference could be ascribed to the influences of climate, heredity and civilization. Whereas Prichard's account posited the gradual evolution of human beings from the primitive to the civilized, Edwards's and

Knox's thesis was rather that, as far as could be judged from human history, they had always been the same as they were now, and had never changed.

But even if climate could be shown to have no effect on racial typology, what about 'the crossing of races'? In the endless invasions and conquests that made up European history, how could such types survive where there were no barriers, such as those of religion or caste, to maintain the distinctiveness of a race? Edwards proposes a model, or set of fundamental principles, for what happens when races mix with each other. In the first place, where there is a severe disproportion between two races in terms of numbers, he offers a theory of reversion: mixed breeds or races eventually revert to type when subsequent unions are with one of the original types. So traces of a single cross between black and white will generally disappear by the fourth or fifth generation. For analysis of the population of a nation, says Edwards, this is quite convenient, since small groups cannot alter the mass. The next situation to consider comes when the two different races are more equally balanced; assuming an unlikely scenario in which the different races always mate with each other, they would produce an intermediate type. But here Edwards invokes a certain experiment in which white and grey mice were crossed with each other: in each case, he reports, the product was a white or a grey mouse, together 'with the other characteristics of the pure race'.[67] On the basis of this experiment, Edwards advances the following theorem: that between distant races, the product of a union is a hybrid ('métis') whose progeny will, according to the thesis of hybridity, become increasingly infertile; but between proximate races, a union does not produce a mixture, but one or other of 'the pure, primitive types'. The two principles of racial mixture are therefore that sometimes nature mixes, sometimes separates the types. He concludes:

The human races which differ the most between themselves consistently produce hybrids. Thus the mulatto is always the result of a mixture of the black and white races. The other condition of the reproduction of the two primitive types, when the parents are of two proximate varieties, is less notorious, but no less true. The fact is common among the European nations. I have had frequent occasions to notice it. The phenomenon is not constant, but what of that? Crossing sometimes produces fusion, sometimes a separation of types; whence we arrive at this fundamental conclusion, that should people belonging to varieties of different, but proximate races, unite themselves with each other ... a portion of the new generations will preserve the primitive types.[68]

79

This thesis therefore allows Edwards to argue that while unions between whites and blacks produce mulatto children whose descendants, as was claimed, gradually die out, unions between closely related races, such as a Celt and a Saxon, produce a Celt or a Saxon. In this way, the white Europeans, like the Jews, have magically managed to preserve their ancient racial stock throughout history. By avoiding any possibility of a fusion resulting from physical contact, a major problem for race theory has thus been solved. It was this apparently bizarre thesis of the long-term results of sexual intercourse between different races that Josiah Nott was to reproduce approvingly; it formed the theoretical basis of Knox's, Beddoe's, even Davis and Thurnam's, ethnological writings and research.[69] In time, indeed, it became the standard account of the mechanisms of hybridity, and can be found repeated in every major work of anthropology, from Darwin to Tylor. It was also this description of the consequences of sexual intercourse between mice which provided the grounds for Arnold's claims for the survival of the Celts in Britain in *On the Study of Celtic Literature*.

Although the bulk of Edwards's book is concerned with continental Europe, he does briefly consider Great Britain, and, as Arnold notes, argues against the popular thesis that the Celts had been expelled or exterminated by the Saxons. It was clearly this that Arnold was most interested in, and he accordingly cites a long section of this part of Edwards's text in his essay. Although the Saxons occupied the territory, the Celts, Edwards claims, survived:

> For history, therefore, they were dead, above all for history as it was then written; but they had not perished; they still lived on, and undoubtedly in such numbers as the remains of a great nation, in spite of its disasters, might be expected to keep ... and so it turns out, that an Englishman who now thinks of himself sprung from the Saxons or the Normans, is often in reality a descendent of the Britons.[70]

Arnold determinedly allied his own critical activity to Edwards's physiological history which apparently proved that the English were not necessarily purely German. Whereas, he writes, the 'contact of the German of the Continent with the Celt was in prehistoric times, and the definite German type, as we know it, was fixed later, and from the time when it became fixed was not influenced by the Celtic type', in Britain 'there must yet ... be some Celtic vein or other running through us' (336). Arnold accordingly attempts to trace the historical racial and linguistic origins of the British – Saxon, Celt and Norman – to their cultural manifestations in particular definable characteristics of British literature:

80

It is not only by the tests of physiology and language that we can try this matter. As there are for physiology physical marks, such as the square head of the German, the round head of the Gael, the oval head of the Cymri, which determine the type of a people, so for criticism there are spiritual marks which determine the type, and make us speak of the Greek genius, the Teutonic genius, the Celtic genius, and so on. Here is another test at our service.

(340)

Literature and culture, as in Knox, thus becomes identified with racial history. Quickly discarding the Normans, and insisting on an identity between racial and political unity, Arnold detects in literature a dialectical antithesis between the spiritual Celt and the philistine Anglo-Saxon, curiously enough invoking a familiar economic model to do so: 'a vast obscure Cymric basis with a vast visible Teutonic superstructure' (334). In tracking the Celtic element in the English and their literature, Arnold is thus doing something very different from Renan's celebration of, and attempted retrieval of, the spirit of Celtic literature. He is also doing something very different from conventional literary criticism as we understand it today. Whereas Renan had described himself as tracing the physiognomy of the Celtic races, such physiognomy was invoked in its figurative sense ('the ideal, mental, moral, or political aspect of anything as an indication of its character', OED). Arnold, by contrast, specifically affiliates himself to Edwards's researches in physiology, which, he claims, have been able through scientific method to demonstrate the origins of English blood through the traces of 'physical type' and of language. Arnold's analysis of the racial components of English literature thus relies on an assumption of the permanent differences of racial type that can be detected by science.

On the Study of Celtic Literature begins with a description of a visit to the Welsh Eisteddfod at Llandudno in 1864, in which Arnold mentions that each year a Prize Essay is awarded. It was in fact judged by Lord Strangford, who provided the authoritative philological footnotes to *Celtic Literature*. The topic for this prize was 'The origin of the English nation, with reference more especially to the question "How far are they descended from the ancient Britons?"'. Many of the submitted essays on language and physical type were subsequently printed in the *Anthropological Review*. In the year of Arnold's visit no award was in fact made, and indeed it was not until 1868 that the Eisteddfod essay prize was awarded. The winning entry consisted of an essay that became the basis of none other than John Beddoe's 'classic work', *The Races of Britain*.[71] Arnold did not simply mingle with and draw upon these forms of contemporary knowledge – he went much further and

claimed a place alongside them for the literary critic who could also play his part as a scientist of racial origins, demonstrating the spiritual or cultural origins of the English through their expression in the national literature. Arnold's famous phrase, that the object of criticism is to see the object as in itself it really is, was thus not merely an expression of English empiricism, but an affirmation in the spirit of Renan of criticism's relation to the forms of scientific knowledge of the nineteenth century.

The Celtic origins of the English, Arnold argues, can be established on strictly scientific terms:

> The question is to be tried by external and by internal evidence; the language and the physical type of our race afford certain data for trying it, and other data are afforded by our literature, genius, and spiritual production generally. Data of this second kind belong to the province of the literary critic; data of the first kind to the province of the philologist and of the physiologist.
>
> (337)

Through this means, literary criticism is able to team up with the two other academic authorities that define race. Whereas other races are 'all of a piece', however, the English nature's particular quality is the result of its blood being 'mixed' and 'composite'. Its advanced state of composition requires some subtle and sophisticated testing for which literary criticism is best qualified. Arnold's ethnology is defined in a relation of internal to external evidence: the specific 'province' of the literary critic is that of the internal, 'so for criticism there are spiritual marks which determine the type'. Thus Arnold's *On the Study of Celtic Literature* takes the form of a 'literary, spiritual test' (340) that will demonstrate the 'type of our race', 'the characteristics which mark the English spirit, the English genius'.

CULTURE AND ANARCHY: CULTURE AND RACE

In *On the Study of Celtic Literature*, Arnold thus follows Thierry and Edwards in identifying England as a nation fundamentally constituted by a mixture of races: the racial and cultural typology of the English is made up of a commingled but still distinctive historical composite of Celtic, Germanic and Norman. In *Culture and Anarchy*, however, Arnold transforms this literal historical scheme into the dialogic cultural-racial model of the Hellenic and Hebraic. In Renan's philological ethnology, the Aryan Indo-Europeans are contrasted to the Semites; in *On the Study of Celtic Literature*, Arnold comments: 'so, after all we have heard, and truly heard, of the diversity between all things Semitic and all things European' (333). By *Culture and Anarchy*, he

utilizes this racial difference to characterize the bifurcating deviations of English culture. What is significant here is the fact that in doing so Arnold shifts away from a model of racial integration of sorts to one of dialogue (the preferred form of Renan), or, less benignly, racial conflict. Racial mixture is thus moved from the issue of interbreeding to one of interaction between incompatible cultures. In making this major shift from a historical, genetic account of the racial identity of the English to a cultural racial identity, Arnold is following in Renan's footsteps. For the latter, despite his emphasis on racial categories, increasingly regarded them as derived from differences of language (and subsequently of religion, law etc.) rather than physical characteristics. Renan himself defined what he meant by race as follows:

> From the point of view of the historical sciences, five things constitute the essential attributes of a race, and give us the right to speak about it as an individual entity within human kind. These five documents, which prove also that a race lives through its past, are a separate language, a literature stamped with a particular physiognomy, a religion, a history, and a civilization.

Todorov comments on this passage: 'One is almost surprised that Renan did not think of the word "culture"'.[72] That, at least, could be said to be Arnold's original contribution. Arnold's shift from *On the Study of Celtic Literature* to *Culture and Anarchy*, which follows Renan's thinking so closely, demonstrates how easy it was to move from scientific to cultural accounts of race, and that facility also suggests how nebulous the distinctions between them always were. However much Renan may have distinguished between the physical and cultural forms of race, by using the very word 'race' he was inevitably alluding to, and drawing upon, its other semantic echoes. In fact, he continued to use the word ambiguously, as Arnold did, so that its reference to language and people became inextricably mixed (it was, of course, the linguistic terms that soon became normative for racial ideologies). If there is one constant characteristic of the history of the use of the word 'race', it is that however many new meanings may be constructed for it, the old meanings refuse to die. They rather accumulate in clusters of ever-increasing power, resonance and persuasion. Even though Renan, and Arnold after him, tended to shift the emphasis of race from lines of blood to traditions of culture, race would never let go of its sanguinary past.

The dubious distinction, therefore, of *Culture and Anarchy* is that it introduced into British life not only the idea of culture as such but also the tenacious, modern identification of culture with race and nation. Given the racial foundation of his model, it is perhaps surprising to a twentieth-century reader that in *Culture and Anarchy* Arnold should

have taken such a relatively positive attitude towards the Jews. In fact, many at this time, such as Gobineau or Disraeli, characterized the Jews as Caucasian. It was primarily Renan's distinction of two language families within the Caucasians that confirmed at an academic level the tendency to regard the Jew as a denigrated racial other. Arnold himself, while clearly aware of Renan's fundamental distinction between the Aryan and the Semite, suggests that though, as he puts it, 'we English, a nation of Indo-European stock, seem to belong naturally to the movement of Hellenism' (141), nevertheless a 'likeness in the strength and prominence of the moral fibre, which, notwithstanding immense elements of difference, knits in some special sort the genius and history of us English ... to the genius and history of the Hebrew people'.[73] In fact, the idea of a resemblance between the English and the Jews, together with the Phoenicians who were commonly regarded as the Jews of the Ancient world, was not unusual in the mid-nineteenth century.[74] Indeed the tradition of the 'British Israelites' has continued well into the twentieth century, particularly in beleaguered settler colonies, and can still be found in Northern Ireland today. The Puritan fathers had seen affinities between themselves and the Old Testament patriarchs, and had even thought of the England that they were building as a new Jerusalem, as in Blake's poem. The financial skills and enterprise of the English again seemed to ally them to the Jews, and the resemblance was fostered in a way that, in historical retrospect after the intense anti-Semitism of the late nineteenth and early twentieth century, seems remarkable. Knox's or Thomas Arnold's anti-Jewish views were at the time relatively unusual. Disraeli's prime minister-ship, and George Eliot's *Daniel Deronda*, would be obvious examples of the tolerant and even positive attitude towards the Jews that could be found in nineteenth-century Britain.[75] In this context, it is noticeable that *Daniel Deronda*, like *Culture and Anarchy*, develops a conflictual narrative of the historical splitting of races, the Christian and the Jewish, the material and the spiritual.

In *On the Study of Celtic Literature*, Arnold, following Renan, suggests that mankind's 'primitive' Semitic age has given way to the Indo-European – so history has progressed from the Semitic to the Aryan epoch. In *Culture and Anarchy*, he suggests that history alternates from era to era between the two antagonistic polarities of the different races. Although Arnold found in Renan the idea that history took the form of a dialogue, or conflict, between the Aryans and the Semites, he characterizes this difference as that of the Hellenes and Hebrews. He is generally assumed to have taken these terms from Heine, although it seems at least as likely that he took them from Bunsen who had moved from the idea that civilization resulted from the historical interaction

between the Japhetic (i.e. Indo-European) and Semitic races, towards a belief in an 'Hellenic and Hebrew' progressive, moral order of the world.[76] At the same time, in promulgating this racialized view of history, Arnold found himself returning to the tradition of his father and other Saxon supremacists such as Robert Knox, who presented the history of the world as a violent, antagonistic, but creative war between the strong and the weak, between the light and the dark races, between the civilized and the savage.[77] Other contemporaries of Arnold, such as the French historians Augustin and Amédée Thierry and the later Michelet, had also turned linguistic division into violent historical conflict – a view reflected by Flaubert in his portrayal of the clash between the Romans and Carthaginians in *Salammbô* (1862), itself an allegory of the modern rivalry between the French and English. The most extreme exponent of history being determined by a form of racial antagonism was another Frenchman, the notorious Count Gobineau, whose *Essay on the Inequality of the Races* (1853–5) is often regarded as a precursor of fascist racial theory and who will be discussed in the following chapter. It is doubtless significant that Arnold himself was influenced by Gobineau, and based the last of the *Essays in Criticism* on his work, introducing him to English readers as follows,

> Count Gobineau ... published, a few years ago, an interesting book on the present state of religion and philosophy in Central Asia. He is favourably known also by his studies in ethnology. His accomplishments and intelligence deserve all respect.[78]

When touching on ethnology and philology, Arnold comments in the 'Introduction' to *On the Study of Celtic Literature,* 'the mere literary critic must owe his whole safety to his tact in choosing authorities to follow' (387): here Arnold's tact seems to have deserted him. In *Literature and Dogma,* however, he does question the work of Emile Burnouf, largely on the grounds of his anti-Semitism. Burnouf substantiated Gobineau's ideas of the three races of mankind (white, yellow and black) with new physiological evidence; Arnold takes issue with his demonstration of the ultimate Western fantasy – that Christ had not, in fact, been a Jew, and that Christianity was therefore essentially an Aryan religion.[79] Here anti-Semitism, the technical term for which did not emerge until the 1880s but which clearly betrays in its name its philological origins, is shown as part and parcel of the racial theory of nineteenth-century academic discourse.

The general academic reticence regarding these intellectual affiliations of Arnold's work is striking. Although the basis of Arnold's theory of history propelled by a fundamental division between the Aryan and Semitic races is relatively benign, it is certainly the case that

race is emphasized in this and other works to an extraordinary degree. Arnold is, characteristically, never very precise about what he means by race – sometimes leaning towards the 'scientific' linguistic, physiological or ethnological account of race, at other times using the phrase 'our race' to mean something much closer to the cultural and spiritual characteristics of peoples and nations. Cairns and Richards remark that the one time Arnold did not follow Renan was in response to the latter's later urgent appeal to separate the different usages of race in his essay 'What is a Nation?', written after the Franco-Prussian war of 1871. But Renan's retraction, like that of Max Müller, came too late. There was, of course, already a long tradition of identifying nation with race.[80] Arnold assimilated the older notion of race as 'lineage' with the newer, 'scientific' notions of race as 'type', as language, as mental difference, and above all as culture.

Arnold thus offers a remarkably up-front alliance of culture and race: admirer of Gobineau as an Orientalist and as an ethnologist, and disciple of Renan, Edwards and Michelet, he grounds and authenticates his argument about culture through contemporary racial science. In his *On the Study of Celtic Literature* (1867), we have seen how Arnold traces the apparently productive effects of the racial mixture of the 'feminine' Celt with the 'masculine' Anglo-Saxon in British history through the evidence of the imaginative characteristics of English Literature. More influentially, in *Culture and Anarchy* (1869), Arnold offers a theory of the production of English culture through a racial dialectic. In *Culture and Anarchy*, following Renan's identification of race with culture, the racial mixture is no longer described in terms of the actual bodily mixing that has occurred during the course of British history, but is transposed to a metaphorized cultural duality. The Celts have been unceremoniously abandoned for the Greeks, with whose culture Arnold doubtless felt more comfortable identifying himself. Wyndham Lewis comments astutely on

> Arnold's contrast of the Celt and the Saxon. Ethnologically, it is true, Arnold's book is worthless: he was not even a great student of celtic literature. He only went to the 'Celt' hurriedly, on a political mission, to get ammunition for his war with the 'creeping Saxon'.[81]

If the Celt has been switched to the Hellene, the identification of the philistine Saxon with the Jew was perhaps Arnold's final revenge on his father. What is striking, however, is that the new dialectic of *Culture and Anarchy* is still defined in racial terms. Trilling suggests in Arnold's favour that despite his immersion in racial theory, at least Arnold advocated racial mixture. No doubt after Holocaust, Trilling was

grateful for the way in which Arnold had at least included, rather than excluded, the Jews in his scheme. However, as the case of Renan shows, it was perfectly possible to understand history as a dialectic between Aryan and Semite while entertaining conventional racist attitudes to those not involved in this magical narrative; as we have seen with Renan and Edwards, it was possible to accept mixing in Europe within the white races while still regarding them as absolutely separate from the yellow and the black. Moreover, Arnold does not advocate an amalgamation that results in merging and fusion but rather an apartheid model of dialogic separation: in claiming the continued existence of types, which can still be distinguished by the perceptive ethnologist or literary critic, Arnold keeps to the idea of racial mingling with no loss of distinctness for each racial type, and thus shows his position to be much closer to those on the right such as Edwards, Knox, Nott and Gliddon. In his favour, Arnold did support the abolition of the slave-trade, and he did not, as Carlyle, Ruskin, Dickens, Tennyson or Kingsley did, publicly support Governor Eyre's brutal suppression of the 1865 Jamaica Insurrection (let no one assume that right-wing politics was a special characteristic of twentieth-century Modernist writers).[82] But it is noticeable that though Arnold refused to take sides in the bitter controversy about Governor Eyre's conduct, his comment in *Culture and Anarchy* about the correct way to deal with rioting ('flog the rank and file, and fling the ring-leaders from the Tarpeian rock!') more or less describes what happened to those in Jamaica after the Morant Bay uprising four years previously (85 people were killed without trial, 354 executed after trial and 600 flogged, 'some with disgusting cruelty').[83] Arnold did not join Mill, Huxley, Spencer, Darwin, Stephen and others who were involved in the Jamaica Committee that protested vigorously against Eyre's conduct. In the same way, he had refused to take sides over the question of slavery during the American Civil War.[84] This, therefore, was how the critical detachment of the cultural critic cashed out.

But this account of Arnold's racialism has not been given in the spirit of that popular academic activity, Arnold-bashing – the repetition of which only underlines how significant and active his ideas still are. His work on culture has become the dishonoured guest that is now considered embarrassing but refuses to go away, no doubt because it continues to be more of a part of our contemporary thinking than we care to admit. What Arnold's racialism suggests is the extent to which culture – and especially interdisciplinary academic knowledge – in the nineteenth century was permeated by such assumptions – indeed, much more seriously, that it was the source of them – which is one reason why racism remains so effectively embedded within our culture

today. If we worry today that we have been unable to establish any true knowledge of other cultures, we also need to make sure that we have a knowledge of the history of our own. The comparative silence in the academy on this question is indicative of its unwillingness to face the implications of its own past. The case of Paul de Man or of Heidegger shows how ill equipped we are to deal with these kind of questions.

At the same time, today's attempt to shift Arnold's supposedly high culture into a more acceptable anthropological form of culture itself overlooks the fact that Arnold's account of culture was already an anthropological one. The modern anthropological notion of culture does not refute Arnold: he originated its use in cultural theory. Moreover the high/low distinction is itself derived from late nineteenth-century anthropologico-sociological distinctions between high and low cultures. The ethnological basis of Arnold's cultural politics, and the way in which racism, ethnology and culture slide so easily into each other, might also give us pause about current ways in which we champion ethnicity, and promote a culturally defined ethnic, as opposed to a biologically defined racial, identity. In the nineteenth century, 'ethnic' was in fact used simply as the adjectival form of 'race'. Today's ethnicity, it could be argued, is merely an antithetical version of the same cultural discourse, albeit positively marked (but then so was race for Europeans in the nineteenth century). Arnold's ethnographic politics challenge our presumption that today's politics of ethnicity necessarily in themselves combat the racist ideologies of the past. At the same time, the complex and often bizarre forms through which hybridity and mongrelity were theorized in the nineteenth century can offer metaphorical models for today's cultural theory or even interdisciplinary practices.[85]

However objectionable the terms through which it is formulated, Arnold's account does at least suggest a dynamic theory of cultural change, which is what our contemporary precepts based on a more static spatial notion of identity and difference tend to find most difficult to formulate. More significant is the fact that Arnold's theory of culture does not suggest that a national culture is constituted by a pure origin or entity that necessarily needs to expel the Other in order to establish its own identity, as some contemporary accounts of the formation of the ideology of the nation in the nineteenth century suggest. In fact Arnold argues that the nation is dialectical, constituted by an antithetical mixture of cultural and racial difference. Arnold thus proposes an account of English culture in which it emerges as ambivalent, antagonistic, conflictual and divided. He therefore reproduces the dialectic that we have found operating within culture itself, a dynamic that we repeat, rather than revise, with our own notions of

high and low culture, of Culture with a capital C versus anthropo-
logical culture, of ethnicity, cultural difference and the politics of the
body. We are still operating, in other words, in complicity with the
history of our culture.

4

SEX AND INEQUALITY
The cultural construction of race

Two literary quotations: in many ways this chapter operates in the space between them. The first is from Yeats, and here we encounter the complicity of culture:

> Many times man lives and dies
> Between his two eternities,
> That of race and that of soul,
> And ancient Ireland knew it all.[1]

Here we find 'race' being used in its most traditional sense, as lineage: although by the 1930s even this could not claim to be innocent, to operate discretely from the prevalent teachings of racial science. The second quotation is from Tennyson, and here we come to the fantasy of colonial discourse:

> I will take some savage woman, she shall rear my dusky race.

In the manuscript, this is followed a few lines later by the question:

> Could I wed a savage woman steept perhaps in monstrous crime?[2]

In this characteristic ambivalent movement of attraction and repulsion, we encounter the sexual economy of desire in fantasies of race, and of race in fantasies of desire.

To suggest that culture and racism were complicit in the nineteenth century is not to say anything new. Yet the extent to which both the sciences and the arts were determined by assumptions about race is consistently underestimated. Even now Victorian ideas of race are sometimes discussed as if they were a separate entity, demarcated as 'racial theory' or 'racialism', an embarrassing interval in the history of science and Western knowledge. This scientism is dismissed in the same way as biologism in the case of gender: but given that the categories of science in these areas are themselves culturally determined, a rejection of this kind is less effective than is often assumed.

90

Although cultural historians have demonstrated the links between culture and racism beyond reasonable doubt, general awareness of this complicity has suffered a not-so-benign neglect, for reasons that are wholly imaginable, a curious process of the self-erasure of culture's own scene of production.[3] In the same way, it is noticeable how recently the media have regarded Edward Said's contention that there is a relation between culture and imperialism as a startling suggestion.[4]

Any notion of culture will involve a form of history; indeed, culture as well as capital is the form through which history manifests itself in the present, the labours of the dead that weigh upon and revisit the society of the living. The close relation between the development of the concepts of culture and race in the nineteenth century means that an implicit racism lies powerfully hidden but repeatedly propagated within Western notions of culture. The history of culture shows that Western racism is not simply an aberrant but discrete episode in Western history that can be easily excised, as the call to 'stamp out racism' assumes. As Lévi-Strauss argues, statements about race *are* statements about culture, and vice versa.[5] Or as Fanon puts it:

> Racism is never a super-added element discovered by chance in the course of investigation of the cultural data of a group. The social constellation, the cultural whole, are deeply modified by the existence of racism.[6]

We have already encountered the complexity of the range of meanings of the term 'culture'. In a significant sign of the times, in the second edition of *Keywords* (1983) Williams added the words 'race' and 'ethnicity', which he showed to be comparably complicated. If we take 'culture' with 'race' as a meaning-cluster we can say that it was largely the product of the nineteenth century. Of course, racial prejudice preceded racialism – that is, theories of race offered as a form of scientific knowledge about mankind; but the distinction is in many ways disingenuous, in that it implies that racism did not seep into and permeate a vast range of knowledges and cultural practices. Moreover, it implies that science is, and has been, otherwise entirely free of racial assumptions.[7] We can say that explicit theorizations of race began in the late eighteenth century, were increasingly scientificized in the nineteenth, and came to an official end as an ideology after 1945 with the UNESCO statements about race (which is not to say that they did not continue in theory or in practice). Racial theory cannot be separated from its own historical moment: it was developed at a particular era of British and European colonial expansion in the nineteenth century which ended in the Western occupation of nine-tenths of the surface territory of the globe. There

91

is an obvious connection between racial theories of white superiority and the justification for that expansion, which raises questions about the complicity of science as well as culture: racism knows no division between the sciences and the arts.

Paradoxically, in the light of today's values which tend to stress relativism, while the Enlightenment's universalism and espousal of sameness had brought with it a doctrine of human equality, the nineteenth century's apparently less eurocentric relativism, and recognition of human difference, engendered a theory and practice of human inequality. 'The same but different' was the trope of humanist universalism, of humankind as a universal egalitarian category made up of individuals, and in fact, despite today's customary gestures of derision, we still hang on to this humanist, universalizing equation: the whole ethic of sexual and racial equality rests upon it: difference which must be acknowledged, but also sameness which must be conceded. This now unfashionable assertion of universalism was set against the nineteenth century's darker aphorism: 'different – and also different, unequal'. The historian can detect a gradual shift from the dominance of the former to the latter view from the eighteenth to the nineteenth centuries. This was doubtless in part the product of economic self-interest: no one bothered too much about the differences between races until it was to the West's economic advantage to profit from slavery or to defend it against the Abolitionists. In the public realm in Britain, it can be plausibly argued that it was the conjunction of three historical events that dramatically altered the popular perceptions of race and racial difference and formed the basis of the widespread acceptance of the new, and remarkably up-front, claims of a permanent racial superiority: the shocked reaction in Britain to the Indian 'Mutiny' of 1857; the debates surrounding the question of slavery which developed at the time of American Civil War (1861–5); questions which were then given a 'local' British reference with the controversy surrounding Governor Eyre's merciless suppression of the Jamaica Insurrection at Morant Bay in 1865.[8] The new theories were presented in scientific terms, but racial theory was in fact always fundamentally populist in presentation and tone. The deliberately popular appeal of racial theory enabled it to develop strongly at a cultural level. In the imperial phase, from the 1880s onwards, the cultural ideology of race became so dominant that racial superiority, and its attendant virtue of civilization, took over even from economic gain or Christian missionary work as the presiding, justifying idea of the empire.[9] The two came together in the phrase with which the English began to describe themselves: the 'imperial race'. Racialism was a cultural as much as a scientific idea, which we could call, after Walter Benjamin, 'The Work of Culture in the Age of Colonial Reproduction'.

92

Race, therefore, like ethnicity, has always been a cultural, as well as a political, scientific and social construction.[10] The imbrication between them is such as to make them interdependent and inseparable. This can be seen particularly clearly in the nineteenth century in the way in which racialized thinking permeated and was diffused throughout the entire academic establishment. Most areas of culture were, implicitly or explicitly, defined academically in racial categories that themselves echoed and mimicked the methods according to which academics divided up and classified the world. In the nineteenth century racial theory, substantiated and 'proved' by various forms of science such as comparative and historical philology, anatomy, anthropometry (including osteometry, craniology, craniometry and pelvimetry), physiology, physiognomy and phrenology, became in turn endemic not just to other forms of science, such as biology and natural history, to say nothing of palaeontology, psychology, zoology and sexology, but was also used as a general category of understanding that extended to theories of anthropology, archaeology, classics, ethnology, geography, geology, folklore, history, language, law, literature and theology, and thus dispersed from almost every academic discipline to permeate definitions of culture and nation. Imperialistic doctrines of the diffusion of cultures describe equally well the way in which theories based on race spread from discipline to discipline and became one of the major organizing axioms of knowledge in general. Race became the fundamental determinant of human culture and history: indeed, it is arguable that race became *the* common principle of academic knowledge in the nineteenth century. As the Edinburgh anatomist Robert Knox put it in *The Races of Men* in 1850: 'Race is everything: literature, science, art – in a word, civilization, depends upon it'.[11] Disraeli, future prime minister, had already said it more succinctly three years before: 'All is race; there is no other truth'.[12]

Even after some of the scientific claims began to ebb away, racist assumptions remained fundamental to the knowledge of the West and to the Western sense of self. It is clear from the work of historians such as Lorimer or Chamberlain and Gilman that racial theory was a form of cultural self-definition.[13] Western culture has always been defined against the limits of others, and culture has always been thought through as a form of cultural difference. Culture and civilization have consistently been deployed as the defining characteristic of Western modernity – which by that very token inscribes its disavowed cultural other within itself. Scientific racialism for the most part was only used as a way of substantiating convictions that preceded scientific enquiry. As Barkan has shown, it only ebbed away when the political requirements that had brought it into being also disappeared.[14] The different Victorian scientific accounts of race each in their turn quickly became deeply

problematic; but what was much more consistent, more powerful and long-lived, was the cultural construction of race. Science has thus always been yoked to and subsumed in what Fanon, in a necessary tautology, calls 'cultural racism'. Scientific theories measuring the differences between the races and their capacities could come and go, but what they always did was to develop earlier ideas according to a new, merciless economy in which the multiple meanings of race were grafted incrementally on to each other. Barzun comments on how race-thinking shows itself as a

> tangle of quarrels, a confusion of assertions, a knot of facts and fictions that revolt the intellect and daunt the courage of the most persistent. In its mazes, race-thinking is its own best refutation. If sense and logic can lead to truth, not a single system of race-classification can be true.[15]

The problem, however, is that the very perversity of the logic of race theory also makes it hard to refute. If it simply erected essentialist, biological categories that could be deconstructed, then matters would be simple. But the complexity that Barzun points to highlights the way in which race theory possesses its own oneiric logic that allows it to survive despite its contradictions, to reverse itself at every refutation, to adapt and transform itself at every denial.

Disproving the claims of race theory is rather like trying to disprove psychoanalysis: it always survives. This is because the most consistent arguments regarding race have always been cultural and aesthetic ones. There are countless examples of the use of the cultural (or, to use the contemporary term, 'moral') argument as the means for demarcating the differences between the races and, inevitably, the superiority of the Europeans, from Hume to Heidegger. Race was defined through the criterion of civilization, with the cultivated white Western European male at the top, and everyone else on a hierarchical scale either in a chain of being, from mollusc to God, or, in the later model, on an evolutionary scale of development from a feminized state of childhood (savagery) up to full (European) manly adulthood. In other words, race was defined in terms of cultural, particularly gender, difference – carefully gradated and ranked. A racial hierarchy was established on the basis of a cultural pecking order, with those who had most civilization at the top, and those who were considered to have none – 'primitives' – at the bottom. Civilization and culture were thus the names for the standard of measurement in the hierarchy of values through which European culture defined itself by placing itself at the top of a scale against which all other societies, or groups within society, were judged. The principle of opposition, between civilization and barbarism or savagery, was nothing less than the ordering principle of

civilization as such.[16] In this sense, as we have seen, Stocking argues that even Arnold's culture works in exactly the same way as the anthropological and ethnological concepts of culture and civilization of his day which are predicated on a notion of 'cultural hierarchy'.[17] Fear of miscegenation can be related to the notion that without such hierarchy, civilization would, in a literal as well as a technical sense, collapse.

This also meant that increasingly definitions of what Western culture was required racial differentiation. The equation of the white race with civilization (and, as we have seen, of civilization as the cause of whiteness) makes it clear why it was so important during the nineteenth century for the Egyptians not to have been black: this gives a more immediate context and specific rationale for Bernal's argument in *Black Athena* that in the nineteenth century there was a concerted effort to turn the civilization of ancient Egypt from a black one to a white one, than his suggestion of a general conspiracy of European racism. Although Bernal does not discuss them, in fact, as we shall see, the most ardent proponents of the white Egypt thesis were Americans seeking to defend the institution of slavery in the American South. There are thus many debates about whether or not there have been black civilizations (*pro* and *contra*: for example, Thomas Smyth's *The Unity of the Human Races* (1851), Knox's *The Races of Men* (1850) or any of the works of Nott and Gliddon), because the arguments between those who believed in racial equality and inequality, and sought to prove that man consists of one or more species, more often than not boiled down to two questions: the possibility of hybridity, and the cultural and historical question of whether there had ever been any black civilizations.[18] Both parties to this argument, by the same token, were in fundamental agreement that civilization was the defining feature of racial capacity. The question then became what exactly constituted civilization proper.

As the defining feature of whiteness, civilization merged with its quasi-synonym 'cultivation', and thus the scale of difference which separated the white from the other races was quickly extended so that culture became the defining feature of the upper and middle classes. It thus marked out their differences from the working classes – and promoted the science of eugenics, first developed by Sir Francis Galton, Darwin's cousin.[19] As the history of social anthropology and criminology shows, the study of the physical differences between different races was developed in the second half of the nineteenth century into an obsessive delineation of British (and European) people into 'types' in the science of 'physiognomy'.[20] These racialized class differentiations offered some consolation and fantasized intrinsic qualities of class during a period when it was patently evident that you could

simply buy your way into the middle and upper classes if you had the cash. In this respect it is striking that the increased emphasis on racial difference, on the permanence of the intellectual capacities, or incapacities, of the different races, and the similar differentiations that could be made between the classes, emerged in the 1850s and 1860s, that is, not fortuitously, after 1848.

If, according to Marxism, race should properly be understood as class, it is clear that for the British upper classes class was increasingly thought of in terms of race. Another example from literature: in D. H. Lawrence's first version of *Lady Chatterley's Lover*, Connie considers whether she could ever move in with Parkin (Mellors in the final version), but then she thinks of him at home in his shirt-sleeves, eating bloaters for his tea, saying 'thaese' for 'these'. Lawrence writes: 'She gave it up, culturally he was another race'.[21]

As here in Lawrence, the cultural and class fix of the formulations of racial difference are particularly obvious in the aesthetic dimension that is so often emphasized in the distinctions between the races. It is telling that the physician Franz Joseph Gall, who invented the apparently irrefutable scientific tests of craniometry, nevertheless simply classified the races according to criteria of 'beauty' or 'ugliness'.[22] Aesthetic characteristics are generally most evident in depictions of physical differences, in which African faces, contrived to resemble apes as much as possible, are contrasted to European faces (or types) that are illustrated by Greek sculpture, such as the Apollo Belvedere.[23] Whereas the difference between civilization and savagery was something most readers could assume but not themselves experience (however much they might have thought they knew all about it), the visual distinction between the ideals of Western beauty and deliberately debased representations of other races could be judged from a quick glance at the page. The repulsion that writers commonly express when describing other races, particularly Africans, is, however, often accompanied at other points, with an equal emphasis, sometimes apparently inadvertent, on the beauty, attractiveness or desirability of the racial other. Thomas Hope, for example, in *An Essay on the Origin and Prospects of Man* (1831), after describing some of the black 'varieties of human races' with 'the least cultivation' as 'disgusting', 'repulsive', 'preposterous' and 'hideously ugly' in a chapter which pours out unmitigated abuse at the very existence of such peoples, suddenly ends with the following paragraph:

There are in Africa, to the north of the line, certain Nubian nations, as there are to the south of the line certain Caffre tribes, whose figures, nay even whose features, might in point of form serve as models for those of an Apollo. Their stature is lofty, their

frame elegant and powerful. Their chest open and wide; their extremities muscular and yet delicate. They have foreheads arched and expanded, eyes full, and conveying an expression of intelligence and feeling: high narrow noses, small mouths and pouting lips. Their complexion indeed still is dark, but it is the glossy black of marble or of jet, conveying to the touch sensations more voluptuous even than those of the most resplendent white.[24]

This sudden voluptuousness of gleaming blackness suggests that something else was going on at a fantasmatic level, namely a relation to sexuality. I want to suggest, in fact, that the link between culture and race theory in the nineteenth century involved sexuality as its third mediating term. Commentators have often suggested that there must be a deep connection between sexuality and racism: 'One thing is certain', remarks Hyam, 'Sex is at the very heart of racism'.[25] Commentators have also made the connection between culture and racism. What they have not pointed out is that it is racial theory itself that explicitly brings together all three.

Sander Gilman has demonstrated the ways in which the links between sex and race were developed in the nineteenth century through fantasies derived from cultural stereotypes in which blackness evokes an attractive, but dangerous, sexuality, an apparently abundant, limitless, but threatening, fertility.[26] And what does fantasy suggest if not desire? The fantasy and the desire is nicely illustrated in an example from De Quincey cited by John Barrell.[27] Barrell comments on how De Quincey's many dreams of desire, of searching in crowds, wading through an endless fluctuating reduplication of 'myriads of female faces', link up with the widespread cultural fantasy of the numberless, swarming, dehumanized populations of Asia. De Quincey writes:

The causes of my horror lie deep; and some of them must be common to others. Southern Asia, in general, is the seat of awful images and associations. As the cradle of the human race, it would alone have a dim and reverential feeling connected with it. But there are other reasons. No man can pretend that the wild, barbarous, and capricious superstitions of Africa or of savage tribes elsewhere, affect him in the way that he is affected by the ancient, monumental, cruel, and elaborate religions of Indostan, &c. The mere antiquity of Asiatic things ... is so impressive, that to me the vast age of the race and name overpowers the sense of youth in the individual. A young Chinese seems to me an antediluvian man renewed. Even Englishmen ... cannot but shudder at the mystic sublimity of *castes* that have flowed apart,

97

and refused to mix, through such immemorial tracts of time.[28]

De Quincey's dim and reverential feelings about Asia finally focus here on the 'mystic sublimity' of race: the fact that through time immemorial the different castes have refused to mix, to interbreed. Even Englishmen undergo a spasmodic thrill at the sublimity of this enduring racial purity of Asia. Yet this chaste abstention from racial sexual transgression, from hybridization and mongrelization, is symptomatically accompanied by overwhelming sexual production:

> It contributes much to these feelings, that Southern Asia is, and has been for thousands of years, the part of the earth most swarming with human life; the great *officina gentium*. Man is a weed in those regions.

'Officina gentium': the Orient is a 'workshop of peoples', better than the 'slave warehouse' it is a factory where people are made, a vast machine of endless self-reproduction, of 'luxuriant or virulent productivity', of unlimited, ungovernable fertility.[29] As in the biosociology of Herbert Spencer, the yardstick of racial difference consists of the 'excess of fertility' of the primitive over the civilized races.[30] The fear that this fecund image conjures up in the white Westerner has less to do, of course, with the prowess of the Easterner than with the prolific fantasies of the Westerner. De Quincey's need to veil the Oriental people-machine in polite and euphemistic Latin, *officina gentium*, betrays too that the idea of the Orient as a human factory here surfaces as a disavowed image of a strictly repressed feature of the proliferating machinery of colonization – sex.

Colonialism was a machine: a machine of war, of bureaucracy and administration, and above all, of power: 'all sorts of engines and machinery ... expressive of enormous power put forth, and resistance overcome'.[31] But as De Quincey's dreams suggest, it was also a machine of fantasy, and of desire – desire that was constituted socially, collectively, as the many analyses of Western cultural representations of colonialism have shown us. Colonialism, in short, was not only a machine of war and administration, it was also a desiring machine. This desiring machine, with its unlimited appetite for territorial expansion, for 'endless growth and self-reproduction', for making connections and disjunctions, continuously forced disparate territories, histories and people to be thrust together like foreign bodies in the night. In that sense it was itself the instrument that produced its own darkest fantasy – the unlimited and ungovernable fertility of 'unnatural' unions.

GOBINEAU: THE FANTASY OF RACE, SEX – AND INEQUALITY

Surprisingly enough, or perhaps predictably enough, the most up-front theorist of colonial desire is the notorious Count Gobineau, author of the *Essay on the Inequality of Races* (1853–5).[32] The founding status of Gobineau's text for European racial theory is often mentioned in relation to Hitler, but it was no doubt also acknowledged when a British Labour government in 1976 founded our own racial institution, the Commission for Racial Equality. Although he does not refer to him by name, it is generally accepted that Gobineau's ideas influenced those of Hitler in *Mein Kampf*, and it is this that has given rise to the misapprehension that Gobineau was vigorously anti-Semitic. He was not. (In fact, like his contemporary Disraeli, whose racism rivalled his own, and whom one writer even claims was the main source for Gobineau's ideas about race, Gobineau classified the Jews as Caucasians.)[33] What is striking, however, is that Hitler continued to use the basic distinction, common to Gobineau and many other writers, of 'civilization' and 'culture' as the defining criteria of Western modernity, and therefore of race and of the inequality between the races.[34]

In the *Essay on the Inequality of Races* Gobineau does not simply propose a theory of race as such. The *Essay* is first and foremost a theory of the decline and fall of civilizations and thus broaches a theory of history: to that extent, race is merely incidental. Race takes on a significance for Gobineau because, like Knox (whose work he seems not to have known) in *The Races of Men* of three years before, he identifies it as the determining motor of history. This allows him to provide an antithetical argument to the liberal sentiments of Rousseau's answer in the *Second Discourse* to the question of 'What is the origin of inequality among men, and is it authorized by natural law?' From the perspective of history, Gobineau's nature tells a different story to Rousseau's. History, he claims, in fact exists only through the activities of the white race: all civilizations of the world, including (via some ingenious arguments) those of Egypt, India and China, have been initiated by Aryans, but for the most part by contracting a 'fertile marriage' (*hymen fécond*) with other races.[35] Black people left on their own, by contrast, have remained 'immersed in a profound inertia' (II, 348). As with many of his opinions, Gobineau is here articulating sentiments that can be widely found in other writers. Hope, for example, had written in 1831 that 'Nowhere have they ["negroes"] through an innate force, and unassisted by the prior examples and precepts of white races, attained any degree of advancement in science, or of refinement in art'.[36]

Despite his supremacist thesis, Gobineau is not prejudiced in any

99

simplistic way in racial terms. It is true that he disputes any notion of equality among men or races, and is concerned to deny any substantive role for material, cultural or environmental factors in producing the differences between them. But, as one might expect from an Orientalist scholar, he often praises the achievement of other cultures above those of Europe, particularly that of India – though this surprising lack of ethnocentrism on Gobineau's part is less a legacy of Enlightenment tolerance than a Romantic dislike of the egalitarian, industrialized West. His love for Oriental culture is not contradictory in his own terms, given that for Gobineau all civilizations have been produced by Aryans anyway.[37] His whole thesis is advanced from a position of cultural relativism, from an awareness of the necessary temporality of civilizations and from a pessimism that projects the fall of that of Europe.[38] In that sense Gobineau's prophesy of catastrophe represents an early (and influential) form of the cultural pessimism that was to become such a distinctive feature of later nineteenth-century thought, which looks back to Volney and Gibbon, and continues today as the basic attitude of the cultural pessimists such as Allan Bloom, or Christopher Lasch, who comprise such a distinctive feature of the American popular press. There is always something obliquely comforting about the doom and gloom that the threat of deterioration holds, providing a solace of inevitability as it re-affirms the fall.

If white people have created all history, Gobineau's thesis is that the decline of civilizations is not to be explained by cultural factors such as excessive luxury, or the role of institutions, or Christianity. In his Dedication, he produces no evidence, only fervour, for the thesis that apparently came to him in a form of phallic annunciation:

> I was gradually penetrated by the conviction that the racial question overshadows all other problems of history, that it holds the key to them all, and that the inequality of races from whose fusion a people is formed is enough to explain the whole course of its destiny.

What has happened in this moment of brutal inspiration? What Gobineau has done here is to put two discrete discourses together: to the historical question of the decline and fall of civilizations, he has added the racial concept of degeneration.[39] Although Gobineau himself never mentions it, it is noticeable that the idea of degeneration had received added impetus and decisive authority only the year before in the formulation of the Second Law of Thermodynamics, which states that the amount of energy in the universe available for work is always decreasing, while randomness, disorder, correspondingly increases.[40] The sense of the gradual dissipation of the world into entropy was thus apparently irrefutable.

Buenzod suggests that Gobineau's major sources on racial matters for the *Essay* were Voltaire, Montaigne, Montesquieu and his contemporary Renan.[41] But Gobineau was more widely read in contemporary racial theory, and was familiar with writers who had linked race with history in the manner of Niebuhr or Thomas Arnold: in France, apart from Renan there was Thierry, Edwards and Michelet, while Gobineau knew the work in Germany of the anthropologist and historian Christoph Meiners of Göttingen and the philosopher Carl Gustav Carus (both of whom were to be praised by the Nazis). He was also familiar with, and declared himself to be for the most part in agreement with, the influential work of the American craniologist, S. G. Morton, who proposed a correlation between brain size and cultural development.[42]

For racial theorists of the early and mid nineteenth-century, as we have seen, the major dispute lay between monogenesis and polygenesis. The monogenetic argument was that the different human races were descended from a single source, as is suggested in the Biblical account, in which case racial difference was explained through the thesis of degeneration. This meant that the pure origin of man was the white male – that universal mean and measure of all things – and that all other forms were a deterioration from this ideal, as a result of gender or geography, or both. The polygenetic argument, on the other hand, that the different races were in fact different species, and had been different all along, allowed the argument that they would and should continue to be so. Not surprisingly, as we shall see, this was the idea cherished by those who wanted to uphold the most extreme forms of racial differentiation, and was popular with apologists for slavery in the American South, and their English supporters in the London Anthropological Society.

Debates about race therefore revolved around whether or not the different races were in fact polygenetic, that is species as different as men and monkeys. The effect of this was that in the nineteenth century the question of racial difference was focussed on a very particular feature of human sociability: sex, or rather its consequence, namely the degree of fertility of the union between different races. Perversely enough, therefore, it was from the results of the sexual conjunction between those races considered furthest apart, namely the black and the white, that race theory which sought to maintain the separation of the races had to start. It is for this reason that we find the question of hybridity at the centre of racial theory, with its key question of whether the product of sexual unions between different races were, or were not, fertile. The problem of hybridity almost always looms large in books about race of this period, and is discussed in extraordinary, indeed obsessive, detail. The problem for the polygenetic argument,

apart from the major cultural difficulty that it was at odds with the Bible, was that the technical definition of a species was that the product of any cross with another species, such as the offspring of a donkey and a horse, would be infertile, like the mule. The key issue in the dispute between the two camps, therefore, devolved on to the question of whether human hybrids, those of mixed race, were fertile or infertile. If hybrids were fertile through several generations, then this would undermine the polygenetic argument that the different races were fixed into permanent types for all time. The problem was that the time-scale involved of tracing fertility through several generations meant (conveniently) that the question could only be solved by analogy or anecdote, which was usually invoked to support the infertility thesis. The dispute over hybridity thus put the question of inter-racial sex at the heart of Victorian race theory. While many writers made strong claims affirming infertility in the second or subsequent generations, Gobineau, whom by temperament one might have expected to be a strong proponent of polygenesis, acknowledged, as he put it, 'the ease with which the different branches of the human family create hybrids, and the fertility of these hybrids' (I, 116). Indeed it is hard to imagine today how the human 'power of giving birth to fertile hybrids' was in fact so vociferously denied, given what was happening in the colonies themselves, where the fast growing numbers of mixed-race populations, the bodily legacy of white colonial patriarchy, proved very literally the hybrid's unbounded fertility.

For their part, as we have seen with Robert Knox in an earlier chapter, the polygenists, having to admit some degree of fertility, focussed on the question of how many generations the product of mixed-race unions could continue to propagate successfully, and came to distinguish between unions of related and distant groups. Gobineau, while admitting the fertility of miscegenated offspring, made what was to become the increasingly common claim, shared even by liberals such as Tylor, that the descendants of such inter-racial unions quickly betrayed evident signs of degeneration, a state often associated with the notion of 'degradation'. In this he was typically astute, given that long after the debates about hybridity and species had eventually ebbed away, the cultural myth of degeneration lived on. In the *Essay*, Gobineau quickly applied the idea to populations, and even nations, as a whole.

The organic imagery that Gobineau consistently uses throughout the *Essay* clusters around the central metaphor of the birth and death of civilizations. This emphasis on parturition inevitably brings with it as its corollary an equal emphasis on genesis, but the stress on procreation means that the focus is fixed on conception of a particular kind. Unlikely as it may seem from common assumptions about his racial

theories, the startling fact is that hybridity, or more specifically the miscegenation that results from racial sexual transgression, provides the foundation of Gobineau's theory of race. Although he accepts the monogenetic thesis that humans are a single species, Gobineau adroitly argues that despite their common origin, human beings were then separated permanently into types by a cosmic cataclysm that occurred soon after man's first appearance – an idea first proposed by Lord Kames in his *Sketches of the History of Man* (1774) and subsequently developed by anthropologists such as Vogt or Topinard as a way of making evolutionary change compatible with the doctrine of the permanency of racial types.[43] Gobineau implies that the fall itself brought about 'the eternal separation of races' rather as Babel produced the division of languages (I, 125–40). His argument, on this basis, thus projects a 'permanence of types', 'a permanence that can only be lost by a crossing of blood'. So races are fixed, unless they miscegenate, which of course they do. But in this way Gobineau manages to preserve the idea of a lost purity of racial division, while acknowledging the human 'power of giving birth to fertile hybrids'.

Gobineau divides the races of the world on physiological grounds into Cuvier's by-then-conventional division of the white, the yellow and the black. He postulates three historical phases of the human race: the first Adamic stage; the second stage after the fall in which the three permanent types of white, black and yellow were fixed; and the third stage of human history of the 'tertiary types' of racial intermixture. This means that he admits that the notion of a pure white, Aryan race is an ideal that has never existed historically, and though he continues to use the three categories of white, black and yellow, Gobineau concedes that even the white race is today a 'hybrid agglomeration'. There are no pure white races: they have all intermingled, in different combinations. Similarly, a nation will be unlikely to be able to claim racial purity – the consistency of its physical features and character will rather be the sign that 'the more or less numerous elements of which it is composed have ... been fused in a full and homogeneous unity' (I, 147). At best, this alloy means that an artificial 'quaternary' type has been established; if this process has not been achieved, there will be a state of 'confusion' and 'disorder' (I, 148) as the nation then begins to degenerate. Unlike Edwards, Arnold or Nott and Gliddon, who think in terms of a mixture whose elements remain distinct, Gobineau thus takes the constitution of a nation by a fusion of races into an organic totality as a given. As Henry Hotze summarizes in his *Analytical Introduction* to Gobineau's work, 'each ethnical element brings with it its own characteristics or instincts' (Table 1). The particular make-up of each individual racial fusion of a nation will explain its destiny, whether it is to be a strong or a weak race. He ascribes the formation

Table 1 Hotze's summary of the characteristics of the races according to Gobineau (1856).[44]

	Black races	Yellow races	White races
Intellect	Feeble	Mediocre	Vigorous
Animal propensities	Very strong	Moderate	Strong
Moral manifestations	Partially latent	Comparatively developed	Highly cultivated

of nations to a sanguinary tale of prowess and power: the conquest of territory by tribes who then assume rights of ownership over both the land and its indigenous inhabitants. The people of the two races gradually mingle and mix their blood, and the population becomes 'more and more fused into a single whole' – 'from this moment a real nation has been formed'. But by the very same token the seed of destruction has also been sown: 'From the very day when the conquest is accomplished and the fusion begins, there appears a noticeable change of quality in the blood of the masters' (I, 28–31).

The principle of life and death within a nation, the inner 'poison' or 'plague' that will eventually spell its death, comes from the continual 'adulteration' of its blood through the further mixing of races: adulteration manages to combine the idea of sexual transgression, adultery, with its root meaning of *ad + alter*, thus alterity, the mixture of self and other. It is through the adulteration of their blood that the people of a nation become progressively more degenerate. The degenerate man, says Gobineau, 'and his civilization with him, will certainly die on the day when the primordial race-unit is so broken up and swamped by the influx of foreign elements' (I, 25). The familiar imagery of racism here cannot be said to originate with Gobineau, though no doubt his work did much to promote it: threats of adulteration and contamination with respect to racial mixing can be found in France and England in the eighteenth century.[45] Knox cites Livy speaking of the Gauls as a 'degenerate, a mongrel race' and warning of the 'contagion' associated with 'the enticing delights of Asia'.[46] What is new, however, is the way in which this language is combined with Gobineau's second conviction which concerns the supreme role of the Aryan race, which is credited with every achievement in the history of mankind. Through analysing their qualities and researching their origins, Gobineau writes:

I convinced myself at last that everything great, noble, and fruitful in the works of man on this earth, in science, art, and civilization, derives from a single starting-point, is the develop-

ment of a single germ and the result of a single thought; it belongs to one family alone, the different branches of which have reigned in all civilized countries of the universe.

(I, xv)

The Aryan race thus becomes identified with civilization as such, an argument that is by no means confined to Gobineau. Knox, for example, had written that 'it is not merely savage races, properly so called, which seem incapable of civilization; the Oriental races have made no progress since the time of Alexander the Great. The ultimate cause of this, no doubt, is race'.[47] Just as everything good comes from the Aryans, so, as we have seen, for Gobineau degeneration has a correspondingly simple origin; it is described in terms of a disease whose cause can be isolated as if a nation works organically like a human body.

The founding analogy which Gobineau makes between the nation and the body is carried through in the extraordinary emphasis which he places on blood.[48] The notion of blood had already been used widely by the abolitionists who argued (following St Paul's 'And hath made of one blood all nations of men for to dwell on all the face of the earth', Acts 17: 26) that despite their outward differences, all human beings have the same blood flowing through their veins. Gobineau shifts the emphasis of blood to its other associations with the family and race. His whole book, in a sense, rests on a clever fusion of the implications of the older and newer uses of the word 'race': the traditional meaning involves bloodlines, the 'lineage' of an ancient family, with an aristocratic pedigree like a thoroughbred horse. The line of such a family is distinguished by its breeding, by the blood that flows through its veins through the act of procreation from father to son. Gobineau adapts this aristocratic notion of race as ancient stock to the modern notion, derived from linguistic families, of families of races, and assumes that however large they too are distinguished by their 'breeding', by a particular blood that flows through their veins, passed on through the act of reproduction from generation to generation. (Later in the century, this argument would be reversed so that, as in Bram Stoker's *Dracula* [1897], it became a matter of renewing thinning aristocratic blood with vigorous new red blood from the lower classes.[49]) Renan's somewhat half-hearted distinction between race as physical difference and race as cultural difference, has thus been neatly fused back together to make a metaphor of extraordinary potential that bonds the literal and the figural, the physical and the cultural, the sanguine and the sexual, indistinguishably together. Much of the power and influence of Gobineau's text stems from this beguiling assimilation of these two meanings and models of the term 'race'. It is, in fact, symptomatic that

105

his argument should itself focus on the mixing of races, for at a conceptual level, this reproduces Gobineau's own amalgamation of the two meanings of the word 'race'. His paradoxical theory thus repeats the 'mongrelity' that it describes.[50]

At this point something of the complexity of Gobineau's argument begins to become apparent. The mortality of civilizations derives from a 'seed of death' that can be found in all societies and is inherent in their life. Societies operate through life/death principles which, as in Freud, cannot be disentangled from each other, constitute the motor of life itself and seem to originate in sexuality. Gobineau's theory of civilization, then, is a theory of racial and cultural fusion: if that fusion produces septicaemia, it also generates the creativity of life. But the disease is not also the cure. Degeneration develops as the other, inevitable side of generation: for civilization, all life will carry within it the seeds of death.

The claimed supremacy of the Aryan race means that at the same time as Gobineau proposes adulteration of blood as the basic cause of the fall of nations, he also, as we have seen, suggests that any civilization that has ever existed must also be the result of Aryan elements within it: 'all civilizations derive from the white race ... none can exist without its help' (I, 210). Given that he admits that there have been no pure Aryan civilizations for some millennia, this means that it has only been through adultery that civilizations have since been born at all. 'Two points', writes Gobineau,

> become increasingly evident: first, that most human races are for ever incapable of civilization, so long as they remain unmixed; secondly, that such races are not only without the inner impulse necessary to start them on the path of improvement, but also that no external force, however energetic in other respects, is powerful enough to turn their congenital barrenness into fertility.
>
> (I, 63)

The continued existence of primitive peoples ('incapable of civilization') testifies to the pure-bloodedness of the 'yellow and black races', who have remained so, he claims, because they 'cannot overcome the natural repugnance, felt by men and animals alike, to a crossing of blood' (I, 27–8). He denies absolutely the possibility of their becoming civilized except through interbreeding. Education, missionary work, even colonial occupation are all equally useless in transforming the basic capacity of a race. Unless, that is, the strong race starts to interbreed with the weaker one.

Gobineau spends a considerable amount of time arguing that civilization is incommunicable, and that 'traces of civilization' among barbarous peoples are merely signs of past domination by a civilized

race. He denies absolutely that civilizations as such can fuse together. The basis of his argument, therefore, is that a race when still a tribe may conquer another and fuse with it through miscegenation, and develop its own particular civilization from this; but it is out of the question that a fully formed civilization can fuse with another productively. In this situation, hypergamy, or the acceptance of daughters from the inferior by the men of the superior race, would only bring about the degeneration of the higher. Arab civilization and modern colonialism, according to Gobineau, provide the best examples of this:

> Civilization is incommunicable, not only to savages, but also to more enlightened nations. This is shown by the efforts of French goodwill and conciliation in the ancient kingdom of Algiers at the present day, as well as by the experience of the English in India, and the Dutch in Java. There are no more striking and conclusive proofs of the unlikeness and inequality of races.
>
> (I, 171)

He instances the commonly used examples of St Domingo (Haiti) and the Sandwich Islands as proof that without the colonial power, civilization is lost.

Gobineau's thesis, therefore, is that the generation and degeneration of nations, their historical movement of homogenization and dissipation, of totalization and detotalization, are produced by a crossing of 'blood' which must result from sexual attraction. Against this, however, he also posits a natural repugnance between races. He cannot, however, claim this for every race, since his whole theory is predicated on the tendency towards the mixture of blood. So while he concludes that all races have 'a secret repulsion from the crossing of blood' (I, 29), a notion doubtless derived from the biological phenomenon of species tending to mate with their own kind, he has to face the paradox that those peoples 'who most completely shake off the yoke of this idea … are the only members of our species who can be civilized at all' (I, 30). Human races live in obedience to two laws, one of repulsion, the other of attraction: given Gobineau's preference for races to remain distinct, the irony is that it is only the power of sexual attraction between races that produces those races who raise themselves to the level of civilization. Civilization itself results from an excessive, and improper, sociability.[51] The core of Gobineau's argument emerges here: it is the white races who are inclined to be sexually attracted towards the other races which is why they mix with them; the yellow and brown races by contrast have a stronger tendency to repulsion – which is why they have tended to remain comparatively unmixed. It is thus the power of attraction felt by the whites for the yellow and brown races that

produces those peoples who raise themselves to the level of civilization.

Conjugal fusion of blood is therefore necessary for civilization, even if adulteration also destroys it; it is mixing between the races that turns 'barrenness into fertility'. Gobineau remarks 'The civilizing instincts of these chosen [Aryan] peoples were continuously forcing them to mix their blood with that of others. As for the black and yellow types, they are mere savages and have no history at all' (I, 149). The law that Gobineau proposes is thus that 'the civilizing races are especially prone to mix their blood'. Responsibility for the mixing of blood lies with the white race, because it is they who are sexually attracted towards other races, while otherwise the spirit of repulsion keeps the yellow and black races in their state of isolation beyond the pale of civilization. Civilization therefore contains its own tragic flaw, because the Aryan races are impelled by a civilizing instinct to mix their blood with the very races that will bring about their downfall.

The corollary of this is that the adulteration of the race derives from the attraction felt by the white for the black or yellow, and therefore, by inference, since the production of mixed-race children is the issue, by the white male for the yellow or black female. This union can be effected because the white male, belonging to a strong, conquering race, will be in a position of power: according to Gobineau's logic, it can only be this that allows the instinctive attraction felt by the white man to overcome the allegedly natural repulsion felt by the black or yellow woman. It is at this point that we encounter a glimpse of the disjunction, but also the link, between discursive desire and the violence of colonial desire in its execution. In the relation of hierarchical power, the white male's response to the allure of exotic black sexuality is identified with mastery and domination, no doubt fuelled by the resistance of the black female. This sadistic imperative, increased by the repugnance felt by the black for the white, is inevitably accompanied by the requirement of a masochistic submission by the subordinated, objectified woman. At the same time, the white male, according to Gobineau, still 'cannot get rid of the few last traces' of his feeling of repulsion towards another race (I, 30). The relation of attraction and repulsion between the races thus comprises a Hegelian structure of domination and servitude, but the sado-masochistic relation is (as always) reversible: the master generates his progeny of civilization through the rape of the slave, but the unwilling submission of the slave to the master also produces the offspring who initiates the degeneration that eventually brings about civilization's end. This sado-masochistic structure of inter-racial sexual relations in the colonial period is by no means confined to Gobineau; witness, for instance, the sexual sadism apparent in the James Grant's *First Love and*

Last Love: A Tale of the Indian Mutiny (1868), or in the stories of Hugh Clifford, variously Governor and Commander-in-Chief of North Borneo and the Gold Coast, such as his *Studies in Brown Humanity: Being Scrawls and Smudges in Sepia, White, and Yellow* (1898).[52] In Gobineau the complex mechanisms of the uncontrollable attraction of the white race for the yellow and black are naturalized by the idea that the different races themselves have opposite sexual characteristics. Gobineau thus rationalizes the apparently irrepressible sexual relations between the Aryans and the other races of the world by characterizing the active Aryans as the 'pre-eminently male groups' and the desirable yellow and black races as the 'female or feminized races'. Thus the sexual attraction felt by white males for black and yellow females lies at the basis of both the rise and the fall of civilizations. So the fabled erotic relation so fundamental to the history of European colonialism is given the status of a natural law, and becomes the motor of history and of civilization itself. At the same time, the gendering of racial difference means that the sex of the races to whom the Westerner is attracted becomes indifferent. Gobineau's thesis of racial mixing must imply that the fundamental white–black/yellow relation that he describes is one of male to female. But if all blacks and yellows are 'female or feminized', then the white male becomes instinctively attracted to both sexes; it is just that one kind of sexual engagement happens to produce mixed offspring. As so often in the colonial arena, civilization thus begins to merge with an inter-racial homo-eroticism.

CIVILIZATION

Like many other racial theorists, Gobineau admits that the basis of his pronouncements about racial differences and the relative values of the different races rests on the presence or absence of the attribute of 'civilization': the Aryan claim to supremacy, after all, is derived from this achievement alone. What, then, does Gobineau mean by this all-important term? He takes two chapters to define it. His discussion illustrates exactly how much the qualities of civilization and culture are defined and established as a way of establishing a racial typology. Unsurprisingly, this racial scheme is then extended into gender and class difference.[53]

Gobineau begins in good academic fashion with a discussion of precedents in Guizot and Humboldt, and contrasts the former's emphasis on civilization with the latter's on culture. Anticipating Arnold's arguments in *Culture and Anarchy*, Gobineau synthesizes the French and German values, formulating his own definition according to two instincts which he describes as basic to all human beings, the 'material' and the 'moral'. These clearly correspond to the distinction

that in a previous chapter we found between 'civilization' and 'culture'. According to Gobineau, it is the balance between the two that determines the level of civilization of any particular people. Initially, at the 'lowest' levels of humanity, among 'the most primitive peoples', 'they are never of equal intensity' and one or the other predominates (I, 84–5). Gobineau then moves 'upwards' through the stage of casual intermixture until he finds the tribe with strong racial elements that conquers and achieves territorial domination:

> For the first time we have reached what can be called a *civilization*. The same internal differences that I brought out in the first two stages appear in the third: they are in fact far more marked than before, and it is only in this third stage that their effects are of any real importance. From the moment when an assemblage of men, which began as a mere tribe, has so widened the horizon of its social relations as to merit the name of a *people*, we see one of the two currents of instinct, the material and the intellectual, flowing with greater force than before, according as the separate groups, now fused together, were originally borne along by one or the other. Thus, different results will follow, and different qualities of a nation will come to the surface, according as the power of thought or that of action is dominant.
>
> (I, 86)

Thus although the stage of civilization is marked by racial fusion, the absorption of the weak by the strong, it is not the case, as Todorov asserts, that for Gobineau civilization is simply equated with vitality and power, although these qualities are clearly required.[54] If civilization comes with a stable racial fusion, the different elements of thought and action within it continue to interact at a cultural level. Whereas Arnold also divides the English into thought and action, Celt and Anglo-Saxon, Hellene and Hebrew, but only implicitly sexualizes the division, Gobineau follows this account of the internal disjunction of civilization with one of the most extraordinary, but revealing, statements in the essay: 'We may use here the Hindu symbolism, and represent what I call the "intellectual current" by Prakriti, the female principle, and the "material current" by Purusha, the male principle' (I, 86) – a suggestion so provocative, in fact, that Henry Hotze, Gobineau's American translator, felt constrained to offer a very different version, translating the two principles as 'speculative' or 'utilitarian'.[55]

The sexuality that Gobineau finds at the heart of culture correlates with his cultural and biological arguments about race: it was no doubt the human facility for cross-breeding, which Gobineau admitted, that substantiated the fertile distinction between the 'female or feminized' and the masculine races, a division subsequently simplified into the

relations between the Aryan, Germanic and other 'pre-eminently male groups' (I, 93) and the rest of the world. This difference between races is then transformed into the dialectic that operates within the racial fusion of each individual nation so that 'one principle is fertilized by the other' in an act of 'reciprocal procreation'. Here Gobineau acknowledges that he is drawing on the *Naturphilosophie* of Klemm and Carus who developed the Enlightenment idea that the different races themselves have opposite sexual characteristics into a theory of the generation of culture through the 'marriage' and interaction between them.[56] According to the logic of this transposition of the qualities of gender to race, Gobineau's central argument that white males are driven by an attraction for black and yellow females turns out to be entirely consistent: sexual difference has been translated into the sexual division of race, so the white male's object of desire has been relocated across the racial divide. As in Arnold, this principle of sexual difference, and the interaction between sexualized races, provides the foundation of culture and civilization, according to the established hierarchy of gender relations. The 'natural' gender relations of European society are once again used to establish the authority of the natural laws that determine the relations between the races. Just as the white male rules at home, so he also lords it abroad. The orthodox hierarchy of gender is confirmed and reaffirmed at the level of race, which then in turn feminizes males and females alike in the black and yellow races. All hierarchies, together with their cultural values, can, it seems, be assimilated, so long as the white male remains at the top.

At the same time, the argument that the world operates according to the two sexual principles allows Gobineau to develop sexual difference of male and female into the libidinal drive of history:

> Further, we can see, at some periods of a people's existence, a strong oscillation between the two principles, one of which alternately prevails over the other. These changes depend on the mingling of blood that inevitably takes place at various times....
>
> I can thus divide peoples into two classes, as they come predominantly under the action of one or other of these currents.
>
> (I, 86–7)

Such characteristics are internalized: 'When we follow the nations down the ages, we find that the civilization of nearly all of them has been modified by their oscillation between the two principles'. As in Arnold again, the history of a nation will swing from the primacy of one to the primacy of the other, from male to female, from utilitarian to moral, from objective to subjective. Gobineau concludes:

111

every human activity, moral or intellectual, has its original source in one or other of these two currents, 'male' or 'female'; and only the races which have one of these elements in abundance (without, of course, being quite destitute of the other) can reach, in their social life, a satisfactory stage of culture, and so attain to civilization.

(I, 88)

The fusion of the two sexual principles thus becomes the basis for cultural production. While the difference between races is defined in cultural terms, through degrees of civilization, culture itself becomes the product of a sexual difference identified with the heterosexual mixture of races. Culture is thus produced by the same process of sexual relations between the male and female races that produce the degenerative force of endlessly miscegenated offspring – the same *mélange* of races, and therefore culture itself, also brings about the decay of civilization. This explains Gobineau's ambivalence. At the end of Volume 1 of the *Essay*, he cannot prevent himself from returning to the benefits of such intermixture, which include the creation of culture itself, 'the world of art and great literature', 'the improvement and ennoblement of inferior races', as well as 'the refinement of manners and beliefs, and especially the tempering of passion and desire' (I, 209).

But desire is not so easily tempered. In terms of the opposition that we have seen arise between civilization and culture, between material and technological progress and spiritual principles, Gobineau allies himself clearly with the Romantic affirmation of the latter. Indeed, the dialectic of his whole racial thesis about the generation and degeneration of civilizations in many ways emerges as a racialized version of Rousseau's equally paradoxical argument that humans are only constituted as fully human by the society that must also corrupt them, the origin of the Romantic idea that civilization brings about a material progress at the expense of unchanging 'natural' values of cultural and spiritual life. In identifying material progress with the masculine principle, cultural life with the feminine, Gobineau begins to invert his racial thesis towards his paradoxical preference for the feminized black races. According to Gobineau, 'the male nations look principally for material well-being, the female nations are more taken up with the needs of imagination' (I, 89). He claims stereotypically that 'the negro' possesses a terrible 'intensity of desire' and has the instincts of the senses developed to excess, and this balances the 'inferiority in the intensity' of the sensations of white peoples who have a corresponding 'immense superiority' in the field of the intellect (I, 205–7). The intellectual advantage of whites is merely a utilitarian one: in the realm of the sensory, the aesthetic and the imagination, it is the black races

who take the palm. Gobineau's unexpected enthusiasm here for the black race is not untypical, however contradictory it may seem; Buenzod comments that when he composed the *Essay*, Gobineau had never left Europe:

> But when five years later, in 1855, he found himself for the first time in contact with black tribes people, the Somalis of the East African coast ... he came out with cries of enthusiasm, declaring that he had never seen 'such beautiful or such perfect creatures'.[57]

Just as Arnold was a little later to argue that the feminine Celtic elements contribute at the level of imagination to philistine utilitarian English culture, so for Gobineau, imagination comes from the 'female' black races, and great art and literature, like physical beauty, come from a male–female white–black alliance: 'artistic genius', he states, 'arose only after the union of white and black'.[58] So, for example, when discussing Egyptian culture, Gobineau argues that despite its Caucasian origins it was specifically a black–white marriage (*hymen*) which 'formed a race thus infinitely endowed with imagination and with sensibility united with much intelligence' (II, 100).

Yet despite this enthusiastic emphasis on the products of racial intermixture – or perhaps because of it – the prospect of miscegenation itself paradoxically fills Gobineau with a horror that recalls that of Frankenstein contemplating the possibility of the results of a female companion for his monster deserting her own species for the 'superior beauty of man': 'No limits, except the horror excited by the possibility of infinite intermixture, can be assigned to the number of these hybrid and chequered races that make up the whole of mankind' (I, 208). These hybridized types characteristically indulge in ever further forms of mixture producing a dreadful state of 'confusion' and 'disorder':

> The more this product reproduces itself and crosses its blood, the more the confusion increases. It reaches infinity, when the people is too numerous for any equilibrium to have a chance of being established.... Such a people is merely an awful example of racial anarchy.... This is the state in which the great civilized nations are today; we may especially see proofs of it in their sea-ports, capitals, and colonies, where a fusion of blood is more easily brought about.... Commerce, peace, and war, the founding of colonies, the succession of invasions, have all helped in their turn to increase the disorder.

> (I, 149–50)

Both Paris and London are held up as examples of this phenomenon of the racial degeneration of population in cities. It is the very commercial, military and colonial success of these nations that has produced the

pollution of their 'racial anarchy', which, Gobineau claims, is particularly apparent in the 'lower classes'. This allows Gobineau both to claim civilization and culture for France and Britain while at the same time deploring their racial confusion. He has already argued that civilization has not really 'penetrated' the lower classes and is incommunicable to them just as, he claims, it is to lower races: race thus becomes identified once more with class, anarchic mixed race with the working class. Here Gobineau presents the basic paradigm of 'culture' versus 'anarchy', in which the civilizing spiritual forces of the racially purer upper classes are in conflict with the degenerate, miscegenated anarchic working class, with its materialistic democratic tendencies. The profoundly conservative basis of Gobineau's position emerges very clearly at this point: the 'inequality' of races, the different aspects of which he spends much time elaborating, means that the capacity does not exist for every human race to become equal with every other, and as far as this argument is concerned, race is indistinguishable from class.[59] In Gobineau's account of culture versus anarchy, therefore, there is no possibility of education of any kind effecting a civilizing force as there would be for Arnold, precisely because of the permanent differences of intellectual capacity.

The only possibility of achieving civilization lies in racial intermixture, but, once a civilization has been developed, increasing miscegenation through commerce and colonialism then gradually causes its decadence and decay: 'the children of a mulatto and a white woman', he observes, 'cannot really understand anything better than a hybrid culture' (I, 179). Yet characteristically Gobineau accompanies this pronouncement of decline consequent upon hybridity, which at the end of the book leads him to forecast the end of civilization-as-we-know-it, with an admission of the positive aspect of racial intermixture. Characterizing the 'negro race' at this point as ugly, and claiming the European as the most beautiful, he argues that those who come nearest to the Europeans in beauty are those from Aryan and Semitic stock 'least infected by the black race'. But he attaches the following revealing footnote to this statement:

It may be remarked that the happiest blend, from the point of view of beauty, is that made by the marriage of white and black. We need only put the striking charm of many mulatto, Creole, and quadroon women by the side of such mixtures of yellow and white as the Russians and Hungarians. The comparison is not to the advantage of the latter.

(I, 151)

The unexpected emphasis on the 'striking' sexual charm of many 'mulatto, Creole, and quadroon women' signals Gobineau's furtive

fascination with the sexual implications of the idea of miscegenation. It also has an interesting biographical correlation: as with Rochester in *Jane Eyre*, Gobineau's own wife was a creole whose unadulterated whiteness would always remain open to doubt.[60]

This admission of a positive feature of racial intermixture accords with the consistent tendency in Gobineau for the positive to intermingle with the negative, growth with degeneration, life with death. As we have seen, as far as he was concerned, it was the developments of capitalism and colonization themselves which brought about the modern conditions that facilitated an ever-increasing racial intermixing, forcing the prospect that the future evolution of the human species would involve the end, or at the very least the degeneration, of the very white, European races, who had brought 'humanity' and 'civilization' to the pitch of perfection that was now being extended throughout the world for the benefit of the so-called primitive races. In the same way, in the ambivalent double gesture of repulsion and attraction that seems to lie at the heart of racism, Gobineau articulates a horror of racial mixing while at the same time proposing the sexual desire of the white races for the brown and the yellow as the basis of civilization itself. Here we might recall Stallybrass and White's argument that the return of the socially repressed occurs symbolically, 'as a primary eroticized constituent of bourgeois fantasy life'. The civilized European subject defined himself specifically through the exclusion of what is marked out as dirty and low. But

> disgust always bears the imprint of desire. These low domains, apparently expelled as 'Other', return as the object of nostalgia, longing and fascination. The forest, the fair, the theatre, the slum, the circus, the seaside-resort, the 'savage': all these, placed at the outer limit of civil life, become symbolic contents of bourgeois desire.[61]

Gobineau's covert obsession with sexual transgression between races betrays just such a structure as Stallybrass and White describe.

So much can be read at the margins. The overt emphasis, however, gets placed on the way in which racial fusion threatens to bring about the decline of European civilizations and empires.

> If mixtures of blood are, to a certain extent, beneficial to the mass of mankind, if they raise and ennoble it, this is merely at the expense of mankind itself, which is stunted, abased, enervated, and humiliated in the persons of its noblest sons.
>
> (I, 210)

Civilization, therefore, in general is on a downward slope. Nothing can

compare with 'the glorious shades of noble races that have disappeared': an idealized greatness that 'the peoples, hybrid a hundred times over, of the present day', can never hope to attain. So, finally, Gobineau's ideal is assigned to the long-lost past, and his theory of the reason for the rise and fall of civilizations gives way to a more general sense of the decadence of the modern world:

> for when mediocre men are once created at the expense of the greater, they combine with other mediocrities, and from such unions, which grow ever and more degraded, is born a confusion which, like that of Babel, ends in utter impotence, and leads societies down to the abyss of nothingness whence no power on earth can rescue them.
>
> Such is the lesson of history.... There is no greater curse than such disorder, for however bad it may have made the present state of things, it promises still worse for the future.

<div align="right">(I, 210–11)</div>

Gobineau's apocalyptic, deterministic view of degradation represented a major assault on the Enlightenment theses of the perfectibility of mankind and (today's much-maligned) universal human nature, comparable only to that of Malthus in Britain.[62] Such cultural pessimism was by no means restricted to Gobineau himself. The gloomy history of the threatening idea of racial and cultural degeneration in nineteenth-century and twentieth-century European cultures has been well documented. In late nineteenth-century Britain, as Barry Smith puts it, 'this grand fear directly linked sexual pollution with the threat of social chaos and the fall of the Empire'.[63] The British response to the threat of physical and racial deterioration involved an attempt to curb colonial desire abroad: this took the form of the Colonial Office's Crewe Circular forbidding liaisons between colonists and native women. At home, it included the Purity Campaign and the Eugenics movement, and with them an assortment of calls for selective breeding for the improvement of British racial stock, sexual hygiene, male circumcision, prohibitions on masturbation, the Boy Scout movement, school games and subsidized school meals – doubtless with bromide in the tea.[64]

Judging by the appearance of books, essays and newspaper articles that discussed Gobineau's *Essay*, the popular impact of his work did not occur in France until the 1890s; the first German translation did not appear until 1898, while an accurate English translation of the full text of Volume 1 of the *Essay* was not published until 1915.[65] Gobineau, as we have seen, has been cited as a forerunner of fascism, largely because the Nazis are often thought to have accorded Gobineau the status of being politically correct; however, it should also be recalled that in 1944 they blew up a museum created in his honour.[66] The evidence for his

influence on Nazi thought rests largely on his theory of the rise and fall of civilizations based on notions of Aryan supremacy.[67] For Gobineau miscegenation, and the pessimistic thesis of increasing racial and cultural degeneration, played, as we have seen, a crucial role in the economy of this model. The Nazis, while accepting the general argument about miscegenation, did not subscribe to Gobineau's thesis of inevitable degeneration: by that time, after all, eugenics had been developed as a prophylactic against it. In this they were anticipated by some of Gobineau's earlier admirers.

The racial objectives of the eugenics movement were by no means confined to Nazi Germany. In 1890, for example, in the United States, the eminent palaeontologist and evolutionary biologist E. D. Cope, warned of 'Two Perils of the Indo-European', by which, he announced, he referred 'to the future relations of race and of sex'. The question of most urgent importance, Cope wrote,

> is that of the race mixture of whites and blacks which is inevitable, and which some persons believe will be the ultimate solution of the whole matter. Some persons seem to believe that this is a desirable prospect, and that there will be produced thereby a race superior to either of its progenitors. But the evidence is against such a view. With a few distinguished exceptions, the hybrid is not as good a race as the white, and in some respects it often falls below the black especially in the sturdy qualities that accompany vigorous physique. The highest race of man cannot afford to lose or even to compromise the advantages it has acquired by hundreds of centuries of toil and hardship, by mingling its blood with the lowest. It would be a shameful sacrifice, fraught with evil to the entire human species. It is an unpardonable sale of a noble birthright for a mess of potage.... The greatest danger which flows from the presence of the negro in this country, is the certainty of the contamination of the race.[68]

Cope's solution was to support the American Colonization Society's long-standing project of 'the return of the African to Africa', and he notes that two Senators had already introduced two bills into Congress 'looking to the transfer of our negroes to Africa'. In 1940 the Nazis were to moot the idea of a forced emigration of the Jews to Madagascar.[69] A hundred years before, after all, the English had forced out much of the population of Ireland, just as in the previous century they had depopulated the highlands of Scotland.

Today, racism continues to perform and act out its restless politico-cultural scissions.

5

EGYPT IN AMERICA, THE CONFEDERACY IN LONDON

The initial reception of Gobineau's *Essay on the Inequality of Races* was clearly complicated by the way in which his thesis of miscegenation and degeneration cut across the divisions between the two main camps in the debates about race. In England from the end of the eighteenth century until the late 1840s public attitudes towards racial difference were comparatively benign, and worked very much within the positive atmosphere of the anti-slavery movement. The Enlightenment emphasis on the unity of the human race was allied to an Evangelical Christian belief in the family of man. Racial theorists tended to subscribe to the Biblically sanctioned theory of monogenesis and ascribed the physical signifiers of racial difference to the effects of climate and the environment. The great ethnologists J. C. Prichard and R. G. Latham emphasized linguistic difference as the most effective model for distinguishing between the races. This was because language fulfills the criterion of being true both to the unity of humans and to their differences: all humans are distinguished from all other animals in that they speak, use languages and signs, and yet their difference from each other is marked by the diversity of their languages. It is noticeable that even in a work as revolutionary as *Vestiges of the Natural History of Creation* (1844), Chambers, in a chapter on the 'Early History of Mankind', followed Prichard and his linguistic paradigm and affirmed the single origin of the human race.[1] This model places its emphasis, therefore, on cultural rather than physical differences, and in the early part of the nineteenth century, it was ethnicity rather than race that formed the conceptual basis for cataloguing, and investigating the historical origins of, the differences between the peoples of the world (the term ethnicity is a modern invention). When the Ethnological Society was founded in 1843, with Prichard at its head, its members were in general agreement that humankind had developed from a single source and made up a unity. The Ethnological Society's liberal, if paternalistic, position can be detected from the fact that the new society was an offshoot of the earlier Society for the Protection of

Aborigines. Thus the attitude to non-Western races, predicated on the unity of all humankind, was characteristically benevolent even if hierarchical: though regarded as culturally backward in relation to the norms of European civilization, it was assumed that in time other peoples could be acculturated and educated up to European levels. Above all, the discourse and perspective of the anti-slavery lobby, who assumed as a necessary concomitant to their cause the possibility of conversion to Christianity, dominated attitudes towards race with the famous slogan 'Am I not a man and a brother? Am I not a woman and a sister?' However, even this liberal discourse of ethnologists and abolitionists was in certain respects ambivalent in its attitudes towards race: for, as Catherine Hall points out, it involved 'a belief in brotherhood and spiritual equality combined with an assumption of white superiority'.[2] The cultural racism displayed here made it much more vulnerable and in many ways allowed the subsequent breakdown of egalitarian arguments. 'Paradoxically,' Brantlinger suggests, 'abolitionism contained the seeds of empire'.[3]

By the 1850s, the British anti-slavery campaign had not yet slipped into distant memory; indeed, in 1852 it had been refreshed by the phenomenally successful *Uncle Tom's Cabin*. Nevertheless, the years that followed were marked by a discernible hardening of attitudes as the stress on universal brotherhood gave way to the notion of an imperial hierarchy.[4] In Britain, we have already suggested that more hostile attitudes to other races became more commonplace with the occurrence of three highly racialized events: the Indian 'Mutiny' of 1857, the American Civil War (1861–5) and the Jamaican Insurrection of 1865. But already 1848 marked a turning-point: in the scientific sphere the shift was signalled in the title of Van Amringe's *An Investigation of the Theories of the Natural History of Man, by Lawrence, Prichard, and others, founded upon Animal Analogies: and an Outline of a New Natural History of Man, founded upon History, Anatomy, Physiology, and Human Analogies* (1848); while in 1850, the Edinburgh anatomist Robert Knox published the first substantively racialist scientific work in Britain, *The Races of Men*, versions of which he had been delivering in lectures since 1846 in Newcastle, Manchester and other towns, gaining a substantial popular following. Knox, who brought together many of the racial ideas that had been developing during the course of the century, particularly with respect to antagonistic relations between the Saxons, Celts, Jews and 'the dark races of men', also exerted considerable influence upon subsequent scientific racial thinking.[5] In 1862, republishing the book as *The Races of Men: A Philosophical Enquiry into the Influence of Race over the Destinies of Nations*, Knox remarked that: 'Thus, for some years I had the whole question to myself, nor was it until the revolutionary epoch of 1848, that the press condescended to admit that

race had anything to do with human affairs'.[6] Since then, he claimed, the newspapers had widely reproduced his ideas, without acknowledgement. He was certainly right that nationalism and race as well as socialism were the conceptual categories through which the events of 1848 were understood at the time; 1848 was, indeed, commonly characterized as the year of the 'war of the races' as well as the struggle of 'class against class'.[7] However, as Knox must have known very well after his stays in Paris, analyses of a history determined by racial antagonism had already been undertaken in France for some time by the Thierrys and others; by 1850 Comte commented acerbically that 'our so-called thinkers all attribute a major role to this strange explanation'.[8] In France there were many who had moved over to racial difference as the major principle of historical explanation, which was, as Poliakov suggests, 'one way of substituting a scientific for a theological interpretation of human life, or, in other words, of replacing Providence by "physiology"'.[9] Race thus offered a fundamental principle of explanation from natural law as an alternative to Christian doctrine; its determinism meant that it was also able to counteract the threat of rampant individualism so keenly felt by those such as Arnold. The new racialism could be described, therefore, as the overdetermined product of the conjuncture of a loss of belief in Biblical explanation and its replacement by apparently authoritative scientific laws, a sense of European cultural and technological preeminence, accompanied by working-class unrest at home, revolution and colonial rebellion abroad and a Civil War in the United States focussed on the issue of slavery.

In Britain in the cultural sphere, Thomas Carlyle, even more of a 'Teutomaniac' than Thomas Arnold, published in 1849 his notorious 'Occasional Discourse on the Negro Question', republished in 1853 with the deliberately more offensive title of 'Occasional Discourse on the Nigger Question'.[10] Carlyle, like Trollope after him in *The West Indies and the Spanish Main* (1859), capitalized on the contemporary economic breakdown of the Jamaican economy, which seemed to bear out the arguments of the pro-slavery lobby that free labour was not viable for African workers. Dickens's story, 'The Perils of Certain English Prisoners', which displaced the Mutiny to 'West India', fictionalized his violent reaction to the events of 1857. He wrote:

> I wish I were commander in Chief in India. The first thing I would do to strike that Oriental race with amazement (not in the least regarding them as if they lived in the Strand, London, or at Camden Town), should be to proclaim to them in their language, that I considered my holding that appointment by the leave of God, to mean that I should do my utmost to exterminate the Race

upon whom the stain of the late cruelties rested; and that I was ...
now proceeding, with all convenient dispatch and merciful
swiftness of execution, to blot it out of mankind and raze it off the
face of the earth.[11]

Nothing equivocal there. These events, reactions and representations
enabled the development and – despite concerted efforts to contest
them, such as those of J. S. Mill or the degenerationist Thomas Smyth
– the acceptability of the full-blown assumptions and prejudices about
race, and the cultural implications about racial differences, that became
dominant in the general public domain by the 1860s.[12]

While the historical events in the colonies from 1857 onwards
undoubtedly mark the moment when public attitudes towards race
shifted from Evangelical tolerance to Imperial prejudice, this move had
been prepared for since the 1840s by a change in the emphasis of racial
theory. The significant development was the way in which theorists of
race developed a two-fold strategy: on the one hand the study of
humanity was increasingly emphasized as properly part of the science
of zoology, with human differences analysed through comparative
anatomy; on the other hand, this emphasis on science and facts was
paradoxically accompanied by ever more evaluative cultural judge-
ments that analysed and explained the differences that were estab-
lished. For the new racial theorists, as for Freud, anatomy was destiny.
Prior to this, the dominant mode of analysing race in Britain, as we
have suggested, had been one of ethnological classification and location
of origins, established on philological evidence. This existed alongside
classification on the basis of anatomical difference, but the latter
remained more or less within the province of zoology. From the 1840s
onwards these comparative forms of racial description were increas-
ingly augmented by evaluations based on a presupposition of cultural
hierarchy. The neutral linguistic account of race associated with
Prichard gave way to the culturalism of Renan and Gobineau, which
was combined in Knox and others with the new biological emphasis of
comparative anatomy. According to Foucault, medical discourse in this
period was characterized by the way in which the invisible was made
visible, the body turned inside out and opened to the scrutiny of the
medical gaze.[13] In racial theory, the domains of language and anatomy,
previously separate and discrete modes for analysing racial differences,
were brought together and articulated through a new emphasis on
cranial capacity which was both measured and demonstrated visibly
through reproductions of skulls and brains. Difference of capacity was
then connected to differences of cultural achievement and degrees of
civilization. The biological was thus fused inextricably with the
cultural in a persuasive and powerful way. As Philip Curtin puts it,

121

'where earlier writers had held that race was *an* important influence on human culture, the new generation saw race as *the* crucial determinant, not only of culture but of human character and of all history'.[14]

The development of a more vigorous racial theory via comparative anatomy may explain why in Britain the new racial theory largely emanated from Edinburgh. The Scottish capital prided itself on being very much in touch with contemporary scientific developments in Paris and Germany. For medicine in particular, Edinburgh embodied the modern scientific approach: in *Middlemarch*, George Eliot pointedly makes the properly scientific doctor Lydgate do his training at London, Edinburgh and Paris rather than at Oxford and Cambridge.[15] At this time, medical training in Oxbridge was largely classical rather than medical in the modern sense; Edinburgh was the most advanced medical school in Britain, while Paris, throughout the nineteenth century, was pre-eminent in postgraduate medical studies. Its reputation was particularly marked in anatomy (pioneered by Cuvier and Bichat), the opportunity for which was restricted in Britain because only the bodies of convicted murderers were legally available for dissection. It is noticeable that Knox was notorious in Edinburgh not for his *Races of Men*, but for having bought bodies from Burke and Hare, who murdered victims in order to supply Knox's demand for bodies for dissection.[16] Knox managed to escape prosecution – and the fitting fate of his own corpse being legally made available for dissection (though he was hanged in effigy by a mob outside his house). Until the time of the scandal, Knox had lectured on 'Comparative and General Anatomy and Ethnology' at the Medical School at Edinburgh University; he had studied in Paris under Cuvier and Geoffroy St-Hilaire. In Paris, as we have seen, he became a friend of Edwards, the white Jamaican, who, in turn, was a major influence on the ethnological thinking of Matthew Arnold and Josiah Nott. The ethnologist and craniologist S. G. Morton, commonly regarded as the founder of American anthropology, also took a medical degree in Edinburgh (having already taken one in Philadelphia), while he and his colleague Nott both undertook postgraduate training in Paris. The renowned racism of Cuvier, combined with the cultural assumptions of the 'transcendental anatomy' of Geoffroy St-Hilaire, seems to have set the tone for comparative anatomists, craniologists and phrenologists, who thereafter blended scientific observations of physical differences with cultural assumptions about white superiority, evident in the work of Carl Vogt or Charles Hamilton Smith. The latter translated Cuvier into English and published, in Edinburgh in 1848, his own *Natural History of the Human Species*, a work which for the first time in Britain analysed human beings, and human differences, on zoological principles on the assumption that the different human races were different species with

separate origins.[17] This new form of racial theory was never simply biological, zoological or anatomical, however. Comparative anatomy, and the more specialized craniometry, was almost always combined with some degree of comparative psychology, most evident in phrenology (of which Edinburgh was also a centre) which gave a cultural meaning to perceived anatomical differences. Such psychology, in turn, invoked history, aesthetics and questions of culture and civilization. If we recall Hume's, Kames's, Scott's, Carlyle's and De Quincey's attitudes towards race, and George Combe's work in phrenology, it becomes apparent that the Edinburgh comparative anatomists took part within what appears to have been a general culture of a consensus about racism that developed among the social evolutionary writers of the Scottish Enlightenment.[18] As in the rest of Europe, this racism cannot be separated from a more inward-looking interest: the military defeat of the Scots by the English encouraged the Scots to define their difference according to a nationalist and racialist model of ethnicity: just as in Germany after its defeat by Napoleon, racial theory originated with a Romantic passion for ethnicity developed by an oppressed, minority culture. The major exception to this thesis might be thought to be Prichard, who trained in Edinburgh but then devoted his life to demonstrating the unity of the human species. However, as Stocking suggests, it was precisely the polygenist milieu of Edinburgh that led him to commit his life to defending the Biblical view.[19] This also explains Prichard's somewhat unexpected comment in the Preface to the *Researches into the Physical History of Man*, that while those on the Continent tended towards a belief in the unity of the species, in Britain the few authors who had treated the question of the origin of man, 'have for the most part maintained the opinion that there exist in mankind several distinct species'.[20] From this perspective, Prichard's work can itself be seen as a prime cause of the scientific consensus about the single origin of mankind that lasted from 1813, the year of the first edition of his *Researches*, to 1848, the year of the third edition.

Evidence that the races were increasingly regarded as separate, however, can be found in Hamilton Smith's volume of 1848, Knox's of 1850, Beddoe's *Contribution to Scottish Ethnology* (1853), together with Nott and Gliddon's influential *Types of Mankind*, the standard American scientific explanation of racial differences published in 1854, which begins by citing Knox.[21] The success of these and other publications (*Types of Mankind* went into eight editions by 1860) marks the moment in which the doctrine of polygenesis began to gain ground.[22] It was the Americans who invented the terms, though not the ideas, of monogenesis and polygenesis; the context for their interest in the issue was clearly that of an increasing defensiveness about the practice of slavery. As we have seen, the debate focussed on two related

questions, one cultural, one biological: these two aspects always went hand in hand and were always assessed simultaneously. The cultural question was whether there had ever been a black civilization: if not, this would substantiate claims about the superiority of the white race and the inherent inferiority of the black; the biological question was whether the hybrid offspring of unions between the two races were fertile or not: if not, this would show that they were different species and prove that white and black really were different. For this reason the major emphasis in writing about race in this period gets placed on the history of black civilizations (particularly, though not exclusively, Egypt), and the question of hybridity in human reproduction. The success of Nott and Gliddon's volume was doubtless the result of a particular combination of skills that united both these areas: Nott was a physician (Professor of Anatomy at the University of Louisiana, with a medical practice in Mobile, Alabama, the centre of the Alabama slave trade and the port where the slave ships arrived from Africa; Nott himself owned nine slaves, six of them under 24 years old), while Gliddon, an Englishman by birth who had lived much of his life in Cairo, was an Egyptologist.[23] The significance of their work was the way they brought the scientific and the cultural together in order to promulgate an indistinguishably scientific and cultural theory of race. Biology and Egyptology thus constituted *together* the basis of the new 'scientific' racial theory.

The debates about slavery that preceded and accompanied the American Civil War were undoubtedly significant in changing the terms of debate about race even in Britain. An important factor here was the comparative ease with which black and white were divided and set against each other in the American accounts: this apparently absolute antithesis then became the dominant theoretical model for all the relations of the white to the non-white world, neatly coinciding with popular racism which is really only ever interested in distinguishing between black and white.[24] Thus instead of a general schema of degrees of difference between the races, the new model set up whites as absolute and distinct, and considered all non-white races only in terms of how much they deviated from the illustrious Caucasian standard.

With this new model, a more constitutive difference, of species, became the central focus of racial theory. The reason for this was quite simple. The constitution of the United States proclaimed that 'all men are created equal': the institution of slavery constituted a flagrant breach of that principle. However, if there were different species of men, created differently, with non-whites classified as lower species that did not share all the properly human characteristics, then it could be argued that constitutional equality did not apply to them. We thus

find a concerted effort gathering pace in the 1840s onwards to establish the doctrine of polygenesis in the place of monogenesis. This new model of an absolute difference between the races, with the whites providing the norm from which all others were regarded as deviations, meant that the fine discriminations made between shades of difference of the different varieties of humans characteristic of Prichard's accounts, gave way to models which only distinguished between a few (most often three) great races. In turn, however, the very claim for absolute difference meant that those of mixed race who crossed this boundary had to be policed with exceptional care.

It was in this context that Gobineau's work was to find its most enthusiastic reception – in the United States. Gobineau himself had predicted the United States' inevitable degeneration on the grounds of its 'ethnic chaos', something which, as we shall see, touched a nerve among Southern American whites; he was, above all, hostile towards the country because of its political doctrines of equality and democracy (doctrines that Gobineau always associated with dissolute mixed-race peoples). He therefore took evident pleasure in pointing out the hypocritical paradox of a nation founded on egalitarian doctrines that practised slavery. Despite this, and to Gobineau's surprise, his work was quickly taken up by the anti-abolitionist movement in the United States. Had Gobineau been aware of recent publications in the States such as Campbell's *Negro-Mania: Being an Examination of the Falsely Assumed Equality of the Various Races of Men* (1851) he would have more easily understood the relevance of his work in the United States. In 1856, the year after the publication of the final volume in France, an English version of Volume 1 of Gobineau's *Essay* appeared in the United States, translated and substantially edited by Henry Hotze, a Swiss-American, who had moved to Nott's home-town of Mobile, Alabama, in 1855.[25] The edition included a hundred-page 'Analytical Introduction' by Hotze, corrective notes (some of them extending to several pages) by Hotze and Josiah Nott, and three further appendices by Nott. The American title of Gobineau's book, *The Moral and Intellectual Diversity of Races,* shifted its emphasis away from inequality towards difference and separate development.[26] Hotze and Nott changed the text of the book considerably, subtly modifying its pessimistic tone throughout. This was nothing new for Nott: when one consults the originals cited in *Types of Mankind,* the quotations from his authorities often turn out to be half made-up, and deliberately interpolated with statements of his own views. So, characteristically, Hotze and Nott omitted Gobineau's comments on the United States, allying him rather to the white supremacist view, repeated by Hitler in *Mein Kampf,* that 'even now, the great body of the nation belongs to the Teuton race'.[27] The appendices, which contained 'a summary of the

latest scientific facts bearing upon the question of the unity or plurality of species', attacked head-on the basic problem with Gobineau's book for American polygenists: his acceptance of the fertility of hybrids, from which followed his whole thesis of the decline of civilizations as a result of miscegenation. Nott claimed that Gobineau's acceptance of the possibility of enduring racial mixing was an error caused by a 'want of accurate knowledge in that part of natural history which treats of the designation of *species*, and the laws of *hybridity*.'[28] He was well prepared to counter this argument, for the question of hybridity was his speciality. But in order to understand Nott's account of hybridity, it is necessary to take a short detour to Egypt.

EGYPT IN AMERICA

The whitening of Egypt that Martin Bernal points to in *Black Athena* here finds its rationale not just in the general connivance of European racism in nineteenth-century academia, but in the particular context of nineteenth-century American racial theory in its attempt to justify and rationalize slavery in the years leading up to the American Civil War. In keeping with his tendency to play down the contribution of earlier African-American writers who contested the de-Africanization of Egypt (Diop, Dubois, James), Bernal also omits any discussion of the central role of Egyptology in American racial theory, though the arguments, familiar to readers of *Black Athena*, will seldom be found stated in so bald and explicit a fashion as in American anthropology.[29] What is significant is that the academic account of Egypt was not simply influenced and changed because of increasing racism and racialism but actually provided the key to the arguments and constituted the proof of racial theory itself.

In 1843, Nott had published his first article entitled 'The Mulatto a Hybrid – Probable Extermination of the Two Races if the Whites and Blacks are Allowed to Intermarry'.[30] Here Nott addressed the contemporary debate that had arisen after the 1840 census as to the comparative conditions of the different races in the United States. Nott approached this by raising the question of the fertility of inter-racial unions, claiming that observation by himself and others in the Southern States showed that mulattos were less fertile than whites or blacks. Among Nott's conclusions were the claims

— That *mulattoes* are the shortest-lived of any class of the human race.
— That the *mulatto-women* are particularly delicate, and subject to a variety of chronic diseases. That they are bad breeders, bad nurses, liable to abortions, and that their children generally die young.

— That, when *mulattoes* intermarry, they are less prolific than when crossed on the parent stocks.[31]

Nott argued as a consequence that a mulatto must therefore be a hybrid of two separate species (remaining circumspect, however, over the question of how they had been created), and concluded that if a general mixing of races took place, the United States would degenerate not only culturally, but also physically. In maintaining the reduced fertility of mulattos, Nott thus put the emphasis less on any threatened degeneration of American culture as such than on the idea that widespread sexual interaction between white and black would cause the American people to decline and literally die out altogether. Only by uniting with a pure black or white could the mulattos increase their fertility, in which case, Nott claimed, the tendency was for the progeny to revert to one or other of their parent stocks. In Nott's argument sexuality and miscegenation thus occupy a core position in what amounts to a covert defence of the Southern American States' slave system.

It was not until the following year that Nott explicitly proposed the doctrine of separate creation. Here the evidence of Egypt was crucial: Nott argued that not only had the ancient Egyptians themselves been Caucasians, but that Egypt provided evidence that blacks and whites had been distinct races throughout the five thousand years of recorded historical time, thus refuting Prichard's thesis that racial difference was the gradual effect of environmental factors. In 1844, in one of a series of 'popular lectures', Nott began by emphasizing the crucial role that Egypt played in his racial theory:

> Before entering upon the Natural History of the human race, it is indispensably necessary, as a preliminary step, to examine some points in chronology, and to take a glance at the early history of Egypt. I must show that the Caucasian or white, and the Negro races were distinct at a very remote date, and *that the Egyptians were Caucasians.* Unless this point can be established the contest must be abandoned.[32]

Egypt, as the earliest civilization, developed in Africa, clearly represented the major potential stumbling-block to the claim for the permanent inferiority of the black race which, it was alleged, had never created or produced anything whatsoever of value. As Gliddon made clear in his best-selling *Ancient Egypt* (1843), those who advocated an African Egypt were in effect also advocating 'the African origin of civilization', with the (for him) unwelcome consequence that 'we, who trace back to Egypt the origin of every art and science known in antiquity, have to thank the sable Negro, or the dusky Berber, for the

127

first gleams of knowledge and invention'.[33] Mill's response to Carlyle shows the critical role that Egypt played in arguments about the inherent capability of Africans. Mill refuted Carlyle's arguments about the inherent inferiority and ineducability of those of African descent with the observation that

> the earliest known civilization was, we have the strongest reason to believe, a negro civilization. The original Egyptians are inferred, from the evidence of their sculptures, to have been a negro race: it was from negroes, therefore, that the Greeks learnt their first lessons in civilization.[34]

The racial identity of Egypt was thus crucial: for the polygenists, it had to have been a white civilization. It was therefore essential, as Nott candidly admits, to prove that the Egyptians were Caucasians. Nott and Gliddon substantiated their argument that 'Egypt was originally peopled by the Caucasian race' by recourse to the phrenological researches of their eminent fellow American S. G. Morton, also an anatomist and Egyptologist, whose *Crania Aegyptica* appeared in 1844, five years after his influential *Crania Americana*, in which he had first published his measurements of the different skull sizes of the different races, a method which was regarded as having enabled for the first time a precise scientific measurement of racial difference.[35] Morton's conclusion from his craniological investigation of Egyptian skulls was that 'the valley of the Nile, both in Egypt and in Nubia, was originally peopled by a branch of the Caucasian race'.[36] It had, in fact, been Gliddon himself who had provided the Egyptian skulls for Morton's research, urging him to use his anatomical and craniological skills to prove the Caucasian basis of Egyptian civilization. He wrote to Morton in 1841:

> I am hostile to the opinion of the *African* origin of the Egyptians. I mean of the *high caste* – kings, priests, and military.... We, as hieroglyphists, know Egypt better *now*, than all the Greek authors or the Romans. On this ground, unless you are convinced from Comparative Anatomy, with which science I am totally unacquainted, and be backed by such evidence as is incontrovertible, I urge your pausing, and considering why the Egyptians may not be of Asiatic, and perhaps of Arabic descent; an idea which, I fancy, from the tenor of your letters, is your present conclusion. At any rate, they are not, and never were, Africans, still less Negroes.[37]

Morton agreed, and in 1844 not only used skulls to prove that the Egyptians were originally Caucasians, but also invoked Egyptian wall illustrations to argue that 'Negroes were numerous in Egypt, but their social position in ancient times was the same that it now is, that of

servants and slaves'.[38] Here, then, was an ancient historical precedent for a white society with black slaves: Nott and Gliddon deployed Morton's account of Egypt to justify the place of 'negroes' as servants or slaves in American society through a theory of a permanent natural apartheid. They stressed the everlasting nature of racial social relations, and claimed that the Caucasian and Negro races were as different in ancient Egypt as in the United States of the 1840s. The 'proper' Egyptians, then, were Caucasians. Already in his lecture of 1844, Nott proclaims with apparent absolute confidence that

> the conclusion to my mind is irresistible, that the civilization of Egypt is attributable to these Caucasian heads; because civilization does not now and never has as far as we know from history, been carried to this perfection by any other race than the Caucasian – how can any reasoning mind come to any other conclusion?
>
> It is clear then that history, the Egyptian Monuments, her paintings and sculptures, the examination of skulls by Cuvier, Morton and others, analogy, and every thing else connected with this country, combine to prove beyond possible doubt, that the Ancient Egyptian race were Caucasians.

In Nott's account, the significance of the Caucasian identity of the ancient Egyptians is then developed into an important corollary that constitutes the always-present other side of racial theory: contamination. He goes on to speak of adulteration of Caucasian blood and the consequent decline of Egyptian civilization:

> Positive historical facts prove too, that Egypt has been conquered in early times by various inferior tribes, and the blood of her people adulterated. Beside the conquest of Hykshos, the Ethiopians, Persians and others, she has more recently been conquered by the Greeks, the Romans, and the Turks.
>
> But even the pure blood of Greece and Rome could not wash out the black stain, both moral and physical, which she had received.
>
> Naturalists have strangely overlooked the effects of mixing races, when the illustrations drawn from the crossing of animals speak so plainly – man physically is, but an animal at best, with the same physiological laws which govern others.
>
> This adulteration of blood is the reason why Egypt and the Barbary States never can rise again, until the present races are exterminated, and the Caucasian substituted.
>
> Wherever in the history of the world the inferior races have

conquered and mixed in with the Caucasian, the latter have sunk into barbarism.[39]

Having claimed that Egyptian civilization was the product of the arrival of Aryans from India, the question that Nott here addresses is how that theory can be squared with the racial identity of modern Egyptians. The fact that by the nineteenth century Egypt's population was clearly made up of a mixture of Arabs and Africans is not held to disprove the Caucasian thesis, but rather to explain Egypt's long decline.[40]

Nott comments in his Preface that 'the parts which treat of the effect of the crossing of races, are those to which I wish to draw more particular attention, as these facts have not heretofore been sufficiently considered'. In language that closely anticipates that of Gobineau, Nott here apparently rehearses the whole of his thesis. Gobineau, who accepted the fertility of hybrids, considered it to be the basis for all cultural decline in recorded history; he saw anarchic racial mixing as an inevitable effect of modern industrial society, whose result would be the rapid degeneration of Western civilization. Nott takes the same line, claiming that the Caucasians created Egyptian civilization, and that the subsequent mixing of races debased it and brought about its fall. He then concludes that all mixture of Caucasian races has caused them to sink into 'barbarism', thus extending his theory of Egyptian history into a general historical theory of the rise and fall of nations according to the determining principle of race. There is, however, a major divergence from Gobineau evident here, and this is the substance of what had to be 'corrected' in the American edition of Gobineau's *Essay*. For Nott claims that the Aryans created Egyptian civilization, and that the subsequent mixing of races debased it and brought about its fall. Gobineau, it will be recalled, ascribed the decay of Egyptian civilization to the mixing of the Aryan and black races as well – but also paradoxically credited the triumphs and achievements of Egyptian civilization to this very same mixture. For Gobineau the crossing of races is generative as well as degenerative. Nott, by contrast, here reveals himself as the ultimate white supremacist: according to him, the Caucasians did everything alone, and the mixing of races only brought about degeneration, infertility and barbarism. Egypt will never rise again until its present mixed population is 'exterminated'. This chilling prospect of racial 'extermination' was in fact a commonplace topic of discussion among Americans in this period in relation to the fast-disappearing population of native Americans; anthropologists also discussed the topic in the context of the apparently mysterious tendency for native populations to die out after contact with whites.[41]

In the 1856 'translation' of Gobineau, Nott, in a long Appendix,

corrected the Frenchman's acceptance of intra-racial fertility. By this point, however, his original thesis had been modified in his chapter on 'Hybridity of Animals, Viewed in Connection with the Natural History of Mankind' in *Types of Mankind* (1854).[42] Nott's views had been influenced by Morton's extensive publications on the subject of hybridity in his controversy with the Revd Dr Bachman. Bachman, speaking for Christians, humanitarian liberals and abolitionists, argued that all human beings were of one species, and therefore should be treated equally and could claim equal rights before God and the law; the differences between them were explained as a phenomenon of variety, that is, of sub-groups within the same species thought to have descended from the same parents. As proof, Bachman cited the test of specific fertility. Morton, by contrast, presenting the advanced scientific view, and supported by those on the right, including those such as Nott wishing to defend slavery, implied that the differences between the races were so fundamental as to suggest that they were in fact permanent different species; he therefore called the products of interbreeding between different races 'hybrids'. However, Morton then argued that there was some evidence in the natural sciences of fertile hybrids of different species. By demonstrating that in nature there were some examples of interfertility between species, he was able to attack fertility as a test of specificity, concluding that:

> Since various species of animals are capable of producing together a prolific hybrid offspring, hybridity ceases to be a test of specific affiliation.
> Consequently, the mere fact that several races of mankind produce with each other, a more or less fertile progeny, constitutes, in itself, no proof of the unity of the human species.[43]

Nott, following Morton, attempted to refute the miscegenation thesis of Gobineau's *Essay* by arguing for different degrees of fertility according to the closeness, or distance, of the racial mix.[44] Given *prima facie* evidence of miscegenation, Nott now admitted some fertility between different races, but argued that there was 'a regular gradation in the prolificness of species' (490) according to the degree of affinity between them: so, he argued, unions between black and white produce sterile offspring, whereas between European races there is some fertility, although the different European races can still be recognized. The argument thus comes close to that of Edwards; in the same way, we have already seen Knox use this line of reasoning as a way of accounting for the presence of mixed European races within a general argument suggesting the degeneration of all hybrid races.

Following the same line of argument that Darwin was to propose in 1859, Nott suggested that the problem lay with the unsatisfactory

definitions of and distinctions between genera, species and varieties; Darwin invoked the contradictory evidence to support his argument that 'there is no essential distinction between species and varieties'.[45] (This meant, as a corollary, that Darwin could not invoke hybridism, or the mixing between species, as a major cause of species modification.) Nott, by contrast, instead of using the contradictory evidence to attack the hard and fast difference between species and variety, proposed that the test of intrafertility should be abandoned as the absolute criterion of species.[46] Taking the very opposite tack from that which Darwin was to propose, Nott invoked the category of 'types', first introduced by Cuvier, and subsequently emphasized by Edwards and others, which bypassed altogether the distinctions between genera, species and varieties. In the chapter on 'Hybridism' in *Types of Mankind*, Nott argues from Edwards that some species (i.e. types, i.e. races) are so far apart that they are infertile. Others that are closer to each other may be partially fertile: however, they can only be subsequently perpetuated by union with one or other of the original race. Eventually, subsequent offspring will revert to one or other of the original types. Unions perpetuated through several generations between partners who are all of mixed race, on the other hand, will eventually become infertile and die out. In this way, the theory of types was able to incorporate the possibility of hybridization without relinquishing its central thesis of the permanence and distinctness of the separate types. In making this argument, Nott placed great emphasis on the evidence of Egyptian illustrations and skulls that were 5,000 years old, which, he claimed, proved 'the permanency of types'. Hotze comments, contra Prichard, in one of his many notes to Gobineau's text that in this way 'we have proved, and I think it is generally admitted, that the actual varieties of the human family, are *permanent*' (369). The advantage of this argument, as Banton suggests, is that it was possible to allow for some racial mixture, while still claiming the endurance of the type, 'which was immutable'.[47] The two American editors thus modified Gobineau's text so that it argued for the permanent difference between the races, their mutual antagonism and the necessity of their enduring separation. Natural law was now invoked not to explain the attraction between the races, but to keep them apart.

Despite the success of the notion of 'type' in the popular mind as a way of distinguishing between races (and classes), Nott and Gliddon's argument, though clearly useful for the Southern defence of slavery, remained vulnerable to the question of hybridity. Sex was less easy to contain than ancient Egypt. Notwithstanding their claim for the permanence of types, it is noticeable that in *Types of Mankind*, Nott and Gliddon also feel obliged to revert to the threat of the ghastly effects of miscegenation:

It seems ... certain, however, in human physical history, that the superior race must inevitably become deteriorated by an inter-mixture with the inferior ... through the operation of the laws of Hybridity alone, the human family might possibly become exterminated by a thorough amalgamation of all the various types of mankind now existing on earth.[48]

They thus make a double, and in fact contradictory, argument: the difference between the species is permanent, and this permanence is preserved through the laws of hybridity by the degeneration and eventual infertility of any cross between them. Conversely, however, the prospect of any breakdown of divisions between black and white in American society, which it was always assumed would lead inevitably to widespread inter-racial unions, would cause the eventual extermination of the whole nation or, in a different version of the argument, one or the other race. In fact, some, such as Lewis Henry Morgan, actively espoused the abolition of slavery on the grounds that, unprotected by the paternalistic benevolence of the slave-owners, freedom would actually cause the freed slaves to die out.[49] Nott put the point bluntly: 'The time must come when the blacks will be worse than useless to us. What then? Emancipation must follow, which, from the lights before us, is but another name for extermination'.[50]

THE CONFEDERACY IN BRITAIN

The more racial theory proposed permanent racial difference, the more obsessed its upholders became with the question of hybridity and the prospect of inter-racial sex. If it was in the United States that we find the greatest obsession and paranoia about hybridity, it was via the American fantasmatic ideology of race, a defence of slavery that posed as truth in the guise of 'the science of races', that Gobineau's work was most directly introduced to Britain. In 1861, in a startling historical connection, Gobineau's 'translator', Henry Hotze, was officially appointed a Commercial Agent in London by the new American Confederacy of Southern States; soon his task was extended to act as a secret Confederate agent, with a brief (in which he never succeeded) to persuade the British government to recognize the Confederacy. In December he left his home in Mobile, Alabama, running the Northern blockade from the port where, two years previously, the last African slave ship, the *Clothilde*, had docked in the United States. Hotze arrived in London on 29 January 1862, and immediately contacted the official Confederate emissary, James Murray Mason. Despite the Northern blockade which had cut off imports of cotton, Hotze initially found British public opinion 'cold and indifferent' to the Southern cause.[51]

Hotze, who was extraordinarily energetic, soon, however, began to meet with success in promoting sympathy for the Confederacy. Based in fashionable Savile Row, he was quickly introduced into London society by Mason, and before long began to write for the London papers: by 22 February he had written the principal leader for the *Morning Post*. The following day Hotze wrote to R. M. T. Hunter, the Confederate Secretary of State:

> I confess that the nearer I approached the scene of my labors the more the difficulties of my position loomed up before me, and on arriving here as the advocate of our case through the most fastidious press in the world, a stranger with barely a few friends or introductory letters, with no extensive political or literary reputation to precede me and smooth my way, I felt almost disheartened. Now the most formidable obstacles are overcome. The columns of the journals to which I most desired access are open to me, and with this I have acquired the secret of the 'open sesame' of the others I may need.[52]

Hotze's trick was to send his editorials not straight to the papers, but to professional editorial writers, who could then place them in the papers for which they wrote and pocket the fee of 2–10 guineas for themselves. Hotze was clearly a successful operator: before long, he was himself writing in support of the Confederate cause for *The Times*, the *Standard* and the *Herald*. By July, Hotze was dining with Gladstone, whom he reported, was 'friendly to the South'.[53]

It was during the time of Hotze's residency in London that the new racial science was deployed in support of the Confederacy. An early move in Hotze's strategy of making contact with those sympathetic to the Southern cause was to make contact with Dr James Hunt. Hunt, a disciple of Knox's, was one of the most active advocates of the new scientific racial theory in Britain. In 1863, impatient with the Ethnological Society's linguistic preoccupations, and provoked by a plan to admit women as members, Hunt, together with Richard F. Burton and others, seceded from the Society rather as the Confederates had seceded from the Union, and formed a rival Anthropological Society. The Anthropological Society presented itself as the institution of modern ideas, dedicated to the pursuit of science and facts without deference to assumptions derived from Biblical or theological beliefs. At the same time the Society also shared with the American anthropologists a particular concern with popularizing its views, a strategy that met with conspicuous and significant success.[54] But despite its pretence of confining itself to science and pure facts, and although it did allow the expression of opposing views, its own ideological commitment was clear. Writing to his Confederate masters with news of how he had

been elected a fellow of the Anthropological Society, and offered a seat on the Council, Hotze characterized the new society as an important indication of the waning of radical democratic and abolitionist opinion in Britain:

I feel sure that a reaction must speedily set in against certain fanatical beliefs of this century, and I know that my hopes do not deceive me when I see the signs of its having already set in. Among these is one to which perhaps you may be disposed to attach less importance than I do, but which appears to me most suggestive. A new scientific society composed of prominent names has been formed in London which has set itself the task of exposing the heresies that have gained currency in science and politics – of the equality of the races of men. The society is an offshoot or secession from the celebrated Ethnological Society. The President, in writing to me to offer me a seat in the council, said: 'You should and must take a strong interest in our objects, for in us is your only hope that the negro's place in nature will ever be scientifically ascertained and fearlessly explained.'[55]

With the nomadic Hotze, therefore, Gobineau, and the views of the American Anthropological School, became materially invested in British as well as American cultural life. The ground had already been well prepared by Knox's influential *Races of Men*.

In the autumn of 1863, shortly after this letter had been relayed to the Confederacy, the President, James Hunt, delivered his paper, 'On The Negro's Place in Nature', first to the British Association for the Advancement of Science and then to the Anthropological Society. The context for Hunt's essay was clearly Lincoln's proclamation of Negro Emancipation in October of the previous year, by which the American President had turned a war for the defence of the Union into one for the abolition of slavery, a move that effectively ended all possibility of British political recognition of the South. The paper consists of a long and detailed anthropological description of the anatomical, physiological and intellectual differences 'between the Negro and the European'. Citing almost the whole of Prunier Bey's *Mémoire sur les Nègres* (1861), Hunt draws on Carlyle, Trollope, Morton, Vogt and Nott and Gliddon, as well as J. H. Van Evrie's *Negroes and Negro 'Slavery'* (1861) and Campbell's *Negro-Mania* (1851). Inevitably, Hunt's deliberations of the intrinsic differences between black and white soon arrive at the question of 'human hybridity':

The assumption of the unity of the species of man has been based chiefly on the asserted fact that the offspring of all the mixtures of the so called races of man are prolific. Now this is assuming

what yet has to be established. At present it is only proved that the descendants of some of the different races of men are temporarily prolific; but there is the best evidence to believe that the offspring of the Negro and European are not indefinitely prolific. The question is one which must be dealt with separately and proved by facts. At present we find that all *prima facie* evidence is against the assumption that permanent mixed races can be produced, especially if the races are not very closely allied.... We, therefore, cannot agree with the asserted statement, especially when we find that the two scientific men who have in recent times paid the most attention to this subject – I allude to Messrs. Broca and Nott – have come to the conclusion that the offspring of the Negro and European are not indefinitely prolific.[56]

As a kind of corollary to this lack of prolificness, Hunt goes on to assert the 'intense immorality which exists amongst the Mulattoes and others of mixed blood'.[57] After further discussions of seemingly endless points of inferiority, Hunt concludes with 'the Negro's unfitness for civilisation as we understand it'.[58]

It is heartening to read that when he gave the paper to the British Association in Newcastle, Hunt was hissed by the audience and directly challenged by William Craft, the escaped slave and Abolitionist campaigner.[59] Hunt replied that Craft's evident intellectual ability in questioning his arguments did not in itself refute his paper because he was 'not a pure negro'. Later, in the Preface to the Essay addressed to Sir Richard Burton, he observed that 'it was not till then that I fully realised the profound ignorance which exists in the minds of even the semi-scientific public on the Negro race'.[60] When T. H. Huxley subsequently attacked Hunt's paper as unscientific, Hotze gave the Anthropological Society's President enthusiastic support.[61] Hunt, for his part, had clearly absorbed the message contained in Hotze's edition of the *Moral and Intellectual Diversity of Races*. In his Anniversary Address to the Anthropological Society of 1864 he argued for the usefulness of anthropology, declaring: 'the fate of nations depends on a true appreciation of the science of anthropology. Are the causes which have overthrown the greatest of nations not to be resolved by the laws regulating the intermixture of the races of man?'[62] Thus, with Hotze's encouragement, the new Anthropological Society supported the South during the American Civil War, and actively intervened in the debates about slavery. Hunt himself publicly stated his support for the institution. In the same way, in his President's Address of 1865, he announced his 'intense admiration' at the conduct of Governor Eyre, who was himself a member of the Society, in his brutal suppression of the Jamaica Insurrection in 1865.[63]

Hotze meanwhile provided material support for the Anthropological Society, and charged his donation to the Confederacy Secret Service Fund.[64] He does not, however, seem to have been very active within the Society in relation to anthropological matters: according to the records of the *Anthropological Review,* he never gave a paper, and is recorded as present only as a guest at a boisterous farewell dinner for Sir Richard F. Burton, the Vice-President. In fact Hotze was far too busy with more overtly political matters: in May 1862, he established a Confederacy paper in London which ran for the duration of the American Civil War.[65] Entitled *The Index, A Weekly Journal Of Politics, Literature, and News; Devoted to the Exposition of the Mutual Interest, Political and Commercial, of Great Britain and the Confederate States of America,* the paper characteristically emphasized not only the economic interests that allied Britain to the South (particularly the supply of cotton), but also the close ethnic ties between the two. Hotze wrote:

> The South, for generations back, has been proud of its closer affinity of blood to the British parent stock, than the North, with its mongrel compound of the surplus population of all the world, could boast of.[66]

To encourage such ideas, *The Index* quickly published a long 'review' of Hotze's own edition of Gobineau's *The Moral and Intellectual Diversity of Races,* entitled 'The Distinction of Race'. The writer, who was most likely Hotze himself, given his own admission that he wrote much of the paper, at first speaks of Gobineau and Hotze as co-authors, but ends by ascribing the book to Hotze alone. The review, carefully tailored like all of *The Index* to its English audience, begins by invoking innate differences of class before it moves on to analogous differences of nationality and race, ending up at those between Aryan and non-Aryan races ('it is much easier for the English', Hotze wrote in a letter, 'accustomed to a hierarchy of classes at home and to a haughty dominion abroad, to understand a hierarchy of races than it is for the French, the apostles of universal equality').[67] Cutting short the debate about origins, the reviewer contents himself with asserting the *de facto* differences of race, before broaching the question, always implicit in the book, of its implications for the relations between black and white in the American South. The reviewer suggests that the experiment of living together as equals has been tried in Jamaica but 'has utterly and disastrously failed':

> There remain, then, but three possible issues where, as in the Southern States, vast masses of two distinct and widely separate races are interfused – the extermination of the weaker, the amalgamation of both, or the subjection of the inferior.

Rejecting the possibility of the removal or the extermination of either race, the reviewer continues:

> Amalgamation must, we should think, revolt the feelings of every member of the superior race; it certainly is a consummation heartily to be deprecated by every man who knows what is the character of the mulatto blood.

This rejection of amalgamation between the races is betrayed by the literary echo that it lets slip – Hamlet's 'consummation/Devoutly to be wished'. Once again, disgust bears the imprint of desire. Oblivious to his self-revelations, the reviewer concludes: 'What remains, then, but that the Negro race should exist in a condition of permanent subjection, under the governance and tutelage ... of the white man?'[68]

With the brutal suppression of the Indian 'Mutiny' so recent and still active in British consciousness, Hotze was also keen to suggest similarities between the British rule over Indians in India and the Southerner's over the African slaves in America. *The Index* claimed that Lincoln's Act of Emancipation would lead to a slave uprising against the whites comparable to that of 1857 in India, an idea that was quickly repeated by British newspapers.[69] Hotze constantly fed British and European newspapers with propagandist stories, and his hand can doubtless be detected behind the following bizarre item published in the *Anthropological Review*'s 'Miscellanea Anthropologica':

> *Abolition of Slavery.* The following remarks are forwarded to us by a correspondent, who states that it is a *verbatim* report of a speech delivered at a meeting of a young man's debating society in October last [1862, i.e. the month of Lincoln's proclamation of Negro Emancipation] to advocate the abolition of slavery. We rely fully on the veracity of our correspondent, and give insertion to such a curious *morceau*, which, we fear, but too truthfully exhibits the ignorance which exists in this country respecting negro slavery.
>
> 'Mr. Chairman, the proof which I wish to prove this evening is, that it will be for the universal good that the Southern or Free States should conquer the Northern or Slaveholding States; for slavery, to all honest hearts and Christian men, must be an abomination; but over all other Slaveholding States, the Northern States of America have been held up to the execration of the world for their abominable conduct towards, and their atrocities committed on, the wretched Hindoos whom they have so villainously enslaved. But we hope now that retribution is at hand, and the brave Southern general McClellan, who is now at the doors of New York clamouring for admittance, and his coadjutor, Presi-

dent Jefferson Davis, will soon burst the bonds that have so long ground down the unfortunate Brahmins, and bound them in chains and fetters in New York dark dungeons and in the "dismal swamps" of Toronto, and restore these unfortunate members of society to that pre-eminence in the social scale of humanity that they have so long been deserving of. Their social life, and the high cultivation that those highly gifted members of the human race have attained to, is too well known to need any further argument upon it'.[70]

The analogy made here between 'Hindoos' and African-American slaves was primarily concerned to emphasize the common racial relations at the basis of the British rule in India and the Southern whites in the Confederacy. Although Hotze did not succeed in effecting any political alliance between Britain and the Confederacy, a move that was always unlikely as long as Palmerston remained in power, his energetic efforts (at one time he covered London with posters of the Union Jack crossed with the newly adopted Confederacy flag) clearly played a significant part in the shift in British public opinion towards sympathy with the South, which only seemed to increase as its situation became more desperate.[71] Mill commented with exasperation, 'Why is it that the nation which is at the head of Abolitionism, not only feels no sympathy with those who are fighting against the slaveholding conspiracy, but actually desires its success?'[72] One reason was the apparently sudden reaction against liberal, Enlightenment ideas of universal equality in the 1860s, embodied, as Hotze had perceived, in the new Anthropological Society of London.

What is striking as one reads through the pages of the *Anthropological Review* and its associated publications, is in fact how little there is of what would today be recognized as anthropology. Anthropological studies of the different peoples of the world are comparatively rare. The journal ranges instead over questions of physiology, zoology, comparative anatomy, psychology, history, geography, geology, palaeontology, archaeology (especially Egyptology), philology, phrenology and craniology. Anthropology promoted itself as the new discipline which synthesized all these other forms of knowledge bearing on the study of man.[73] The consistent perspective through which all this diverse material was unified was that of race, and it was the ubiquity of racial determinism that provided the major topic of interest for the Society. A sense of its preoccupations can be judged from the titles of papers and reviews in its early years. Apart from Hunt's own 'The Negro's Place in Nature', papers presented included 'On the Permanence of Type', 'The Influence of Race on Art', 'Race in History', 'Race in Medicine', 'Race in Music', 'Colonies and Climate – A

Prophecy', 'On the Commixture of the Races of Man as Affecting the Progress of Civilization', 'The Celtic Languages in Reference to the Question of Race', 'The Race Question in Ireland', 'On Human Hair as a Race-Character', 'Renan on the Shemitic Nations', 'An Inquiry into Consanguineous Marriages and Pure Races', 'Ethnology and Phrenology as an Aid to the Biographer', 'On the Phenomena of Hybridity', 'The Folds in the Hand as Indicating Race', 'On the Ideas of Species and Race Applied to Man and Human Society', 'Slavery', 'On Fixity of Type', 'The Larynx of the Negro', 'The Ethnic Relations of the Egyptian Race', 'On the Extinction of Races' (two papers), 'Weight of the Brain in Negroes', 'On the Theory of Natural Selection with Reference to the Origin of Races', 'On the Capabilities of the Negro Race for Civilization', 'On Race Antagonism' ... etc., etc. It was through material of this sort that the Anthropological Society promoted the new racial science that began to influence British thinking about empire and race.[74] But as many of the titles of these papers make clear, the scientific racial construction was used as the basis of racial constructions about cultural topics. The idea of race as the determining factor in cultural difference very quickly became part of a 'common knowledge' which did not have to be sustained by any form of empirical evidence. It was, after all, already well sustained by ambivalent forms of sexuality and desire.

At the same time, the scientific arguments themselves had a long run. Even among more liberal, progressive thinkers such as E. B. Tylor, it is noticeable how much of the doctrine reappears without qualification. In *Anthropology: An Introduction to the Study of Man and Civilization*, for example, published as late as 1881, and designed as a student textbook, Tylor begins, like Edwards, Knox and Nott and Gliddon before him, by invoking Egyptian monuments to demonstrate the permanence of racial types, remarking that 'it is surprising to notice how these old-world types of man are still to be recognised'. He continues:

> In [the following illustration] *a* is drawn from the head of a statue of Rameses, evidently a careful portrait, and dating from about 3,000 years ago, while *b* is an Egyptian of the present day, yet the ancient and modern are curiously alike. Indeed, the ancient Egyptian race, who built the Pyramids ... are with little change still represented by the fellahs of the villages.... Thus, too, the Ætheopians on the early Egyptian bas-reliefs have their counterparts picked out still among the White Nile tribes, while we recognise in the figures of Phoenician or Israelite captives the familiar Jewish profile of our own day. Thus there is proof that a race may keep its special characters for over thirty centuries, or a hundred generations.[75]

In the course of his opening chapters, Tylor discusses the question of

hybridity, compares the dolichocephalic, mesocephalic and brachyce-phalic indexes of Negro, European and Samoyed skulls, differentiates between African jaws as prognathous and European jaws as orthog-nathous, reproduces a much-magnified illustration of 'negro skin', compares Japanese, German, African Negro and Papuan sections of hair, and finally returns to the question of the permanency of racial types. The main cause of any change, he says, must be sought in 'intermarriage with foreigners', but having conceded this he goes on to argue for the reversion thesis:

> The result of intermarriage of crossing of races is familiar to all English people in one of its most conspicuous examples, the cross between white and negro called mulatto (Spanish *mulato*, from *mula*, a mule). The mulatto complexion and hair are intermediate between those of the parents, and new intermediate grades of complexion appear in the children of white and mulatto, called quadroon or quarter-blood ... and so on; on the other hand, the descendants of negro and mulatto, called sambo ... return towards the full negro type. This intermediate character is the general tendency of crossed races, but with more or less tendency to revert to one or other of the parent types.[76]

Although Tylor noticeably drops the infertility thesis, aside from the hint when giving the semantic origin of the word 'mulatto', the argument for reversion must still be implicitly predicated upon it. Moreover, he cannot forbear from illustrating his point, providing a portrait of a 'Malay mother and her half-caste daughters, the father being a Spaniard'. Here, Tylor suggests, 'while all the children show their mixed race, it is sometimes the European and sometimes the Malay cast of features that prevails'.[77] Tylor goes on to discuss tracing the intermixture in the hair, noticing 'the mulatto's crimped, curly locks', with further illustrations. In apartheid South Africa, a test of true whiteness was whether a pencil, when placed in a person's hair, would stay put or drop to the floor.

In such ways do the apparently ineffaceable, proliferating legacies of racialism continue to generate the cultures that produced them.

6

WHITE POWER, WHITE DESIRE

The political economy of miscegenation

> For the sun cannot mate with the darkness, nor the white with the black.
>
> Rider Haggard, *King Solomon's Mines* (1885)[1]

In the climate of obsession with the question of race in the 1860s, the increasing emphasis on the distinctness of races meant an ever greater fixation with the scientific question of hybridity and the imaginative phantasm of racial mixing which lay behind it. We have seen how Nott and Gliddon cannot put it out of their mind, despite their arguments proving its impossibility. Some, by contrast, were prepared to take a more radical stance, going so far as to advocate the advantages of racial amalgamation. In *The West Indies* (1859), Anthony Trollope argued for the advantages of racial 'amalgamation' on the grounds that colonization required different attributes of white and black:

> My theory ... is this: that Providence has sent white men and black men to these regions in order that from them may spring a race fitted by intellect for civilization; and fitted by physical organization for tropical labour.

The appointed work for the Anglo-Saxon race in the Caribbean, according to Trollope, was to create a new race (created magically, it seems, from white and black men alone) 'capable of living and working in the climate without inconvenience':

> when sufficient of our blood shall have been infused into the veins of those children of the sun; then, I think, we may be ready, without stain to our patriotism, to take off our hats and bid farewell to the West Indies.[2]

Trollope's low opinion of the African population, and the economic difficulties faced by Jamaica in the post-slavery period, doubtless suggested the pragmatic device of amalgamation as a means of achieving an honourable withdrawal from an uneconomic colony.

142

Trollope was not alone in proposing this solution to the difficulties encountered in the colonization of lands that proved climatically inhospitable.

In 1866, for example, Charles Brooke, younger nephew and his apparent to Sir James Brooke, the Rajah of Sarawak (and an Honorary Fellow of the Anthropological Society), argued in the Conclusion to his *Ten Years in Saráwak* that it was impossible for Europeans ever to acclimatize themselves permanently in India. In support he cites a chapter in W. J. Moore's *Health in the Tropics* (1862), 'On European Colonization in India', where Moore points to the fact that the climate makes it impossible to turn India into a settler colony: 'the melancholy truth is, that the European race dies out'. According to the doctor, there was no evidence that in India 'our race can be continued even through a few generations without Asiatic mixture'. But if that mixture allows the generations to survive, all that happens is that they degenerate into natives:

> An infusion of native blood is essential to the continuance of the species, and the barrier once broken down, the remoter descendants of an European ancestor become rapidly feeble, astute, passionate, and indolent, as any of the darker races around them.[3]

Brooke turns Moore's argument round: since the British cannot survive without the admixture of Asian blood, he proposes that the 'half-caste children of Europeans' should take over from them: 'It is my conviction, he writes, 'that a time will arrive when by modification of races, resulting from intermixture and amalgamation through marriage, a kind of inhabitants will be found who can make such a country their permanent home'. These descendants, with European brains but local resistance to climate, would gradually merge, he predicts,

> into a more enlightened race, better qualified in every way for the duties required of them.... These countries, it is to be hoped, will have steadfast populations and rulers ... when a sufficient modification has taken place among the number of races combining certain qualities which are modified and amalgamated in their progeny.

Brooke argues that had such a policy been adhered to in India, then 'we should in all probability have had to deal with no mutinies and other troubles resulting from holding ourselves too much aloof, being too exclusive, and too careless of native rights, sympathies, and interests'.[4] In some ways, Brooke's position is less liberal than it might sound. Although he disputes the thesis that those of mixed blood will necessarily degenerate, the argument for the breeding of a new strain of mixed-raced colonials is still a proposal for a more efficient form of colonialism. Although this view would influence conditions in Sarawak

right into the twentieth century, in the year after Morant Bay neither the Colonial Office nor the public at large in Britain were in any mood to revert to the looser practices of earlier times. In fact, the onus of British colonial policy came rather to be focussed on an effort to prevent mixing between the British and their subject peoples.[5]

In the United States the idea of amalgamation was also being actively debated at this time: it became the central issue in the crucial election held during the middle of the Civil War in 1864. The Anthropological Society was incensed by an anonymous pamphlet published in London and New York in that year, entitled *Miscegenation: The Theory of the Blending of the Races Applied to the American White Man and Negro*.[6] It was with this book that the word 'miscegenation' was first introduced, and the impact of the book can be measured from the fact that it caught on immediately. The authors begin with a short definition of the term, as well as a cluster of other mostly nonce-words: *miscegen, miscegenate, miscegenetic, melaleukation, melaleukon, melaleuketic* (the last three terms, from the Greek *melas* (black) and *leukos* (white) leading to a further term *melamigleukation*, 'the union of the races' (vii)). The strategy involved the production of a new word that would have the more specific meaning of actual racial mixture than the customary term 'amalgamation', which doubled as the term for the restoration of the Union. *Miscegenation* consists of an audacious, cheeky attack on the thesis of the pro-slavery anthropologists Morton, Nott and Gliddon that claimed inevitable decline to be the effect of the mixing of the races. The authors invoke instead another common argument, to be cited by Darwin in *The Descent of Man*, that a cross with 'civilized races' makes 'an aboriginal race' more fertile.[7] In *Miscegenation*, the authors advance the proposition that miscegenation, far from producing degeneration as Gobineau and his American sympathizers had claimed, would have altogether beneficial effects, in this case by arresting the people of the United States from their alleged current decline, and increasing their fertility and vigour so as to form them into a new super-race:

> Whatever of power and vitality there is in the American race is derived, not from its Anglo-Saxon progenitors, but from all the different nationalities which go to make up this people. All that is needed to make it the finest race on earth is to engraft upon our stock the negro element which Providence has placed by our side on this continent....
>
> We must become a yellow-skinned, black-haired people – in fine we must become Miscegens – if we would attain the fullest results of civilization.

(18, 28)

As proof of this argument, the authors cite nothing less than the phenomenon of the extraordinary military successes of the Confederates in the Civil War, which they trace to the

> notorious fact ... that, for three generations back, the wealthy, educated, governing class of the South have mingled their blood with the enslaved race. These illicit unions, though sanctioned neither by law nor conscience, and which, therefore, are degrading morally, have helped to strengthen the vitality and add to the mental force of the Southerner. The emotional power, fervid oratory and intensity which distinguishes all thoroughbred slaveholders, is due to their intimate association with the most charming and intelligent of their slave girls.
>
> (52)

The authors never ask whether, when liberated from slavery, the slave-girls would choose to continue these forced associations. But their target is the white Southerner. In a remarkably up-front chapter entitled 'Heart Histories of the White Daughters of the South', the authors rehearse the scare tactics of the Southerners who were prone to claim, as the Jamaican planters had done before them, that freeing the slaves would bring about sexual pandemonium between black men and white women. If the imputation that Southern men are mixed-race is not enough, the authors explain the basis of the female 'Southern Belle' in even more provocative, taunting terms:

> Nor are the Southern women indifferent to the strange magnetism of association with a tropical race. Far otherwise. The mothers and daughters of the aristocratic slaveholders are thrilled with a strange delight by daily contact with dusky male servitors....
>
> And this is the secret of the strange infatuation of the Southern woman with the hideous barbarism of slavery. Freedom, she knows, would separate her for ever from the coloured man, while slavery retains him by her side. It is idle for the Southern woman to deny it: she loves the black man, and the raiment she clothes herself with is to please him. What are the distinguishing characteristics of a Southern woman's attire? Why bright colours – a tendency to yellow and pale red, and those striking gold ornaments which make such a charming contrast to a dark skin, but are so out of place in the toilet of a blonde. Yes, the Southern beauty, as she parades her bright dresses and inappropriate colours in our Northern cities and watering places, proclaims by every massive ornament in her shining hair, and by every yellow shade in the wavy folds of her dress, 'I love the black man'.
>
> (54–5)

In a review of *Miscegenation* in the *Anthropological Review*, the writer comments that this chapter 'is too indecent for us to quote from; we believe that only a Mulatto or a Mulatress could have strung together such licentious absurdities'.[8]

In fact, the whole pamphlet was a hoax, written by two violently anti-Abolitionist New York journalists, David Croly and George Wakeman.[9] The Democrat strategy in the 1864 election was to claim that the subtext and secret agenda of Lincoln's two principles of amalgamating the North and South, and emancipating the slaves, was to bring about a racial amalgamation between black and white. The innuendo that followed was that Abolitionists themselves were motivated by a sexual desire for the slaves they sought to free.[10] A contemporary cartoon, entitled 'The Miscegenation Ball', portrays the leading Republicans at Lincoln's New York Headquarters dancing with fulsome black women.[11] *Miscegenation*, therefore, was written to inflame opposition by stating explicitly this alleged programme for racial amalgamation. To judge by the prominence the miscegenation issue gained in the election it certainly worked – though not enough for Lincoln to lose it. A whole series of counter-pamphlets followed, which could, of course, do no more than emphasize the horror of what *Miscegenation* had already stated explicitly. Thus a short pamphlet by the appropriately named L. Seaman, entitled *What Miscegenation is! What we are to Expect Now that Mr Lincoln is Re-elected*, carried its message with an illustration of a caricatured black 'sambo' figure kissing a white girl on its title-page.[12] The notorious racist, the New York publisher J. H. Van Evrie, published an anonymous reply, *Subgenation: The Theory of the Normal Relation of the Races: An Answer to Miscegenation*, which even the *Anthropological Review* dismissed as 'millennial ranting'.[13]

In the pamphlet and cartoon war that followed the publication of *Miscegenation*, in which Hunt's *The Negro's Place in Nature* is noticeably cited by both sides, there were in fact some campaigners who actively advocated racial amalgamation in the name of a new American race, no doubt in response to the claims of those such as Nott that Americans were fundamentally a Teutonic race. The abolitionist M. D. Conway, for example, argued that 'the mixture of the blacks and whites is good.... I believe that such a combination would evolve a more complete character than the unmitigated Anglo-Saxon'. America did not need a new nationality, he argued; rather, 'we have to rear a new Race'.[14] Conway also added wryly that:

it is well enough to remember that Miscegenation is already the irreversible fact of Southern Society in every thing but the recognition of it ... the mixture of blood has been very extensive.

These Southerners have proved that the repulsion to the alliance of the two bloods extends only to so much of it as the parson and magistrate have any thing to do with.

It was thus in the context of Southern separatism and Anglo-Saxon supremacist racism that the famous 'melting-pot' model of American identity as a form of racial fusion was advocated, an apparently liberal model that is today being questioned in favour of one that retains distinct ethnic identities which, paradoxically, comes closer to the position of the secessionists.

Even for many liberals, however, there were limits as to how far racial merging should be allowed to progress. In 1863 President Lincoln set up the American Freedmen's Inquiry Commission to report on the condition of the newly emancipated slaves. The following year, that of the 'Miscegenation Election', Robert Dale Owen, one of the members of the Commission, published *The Wrong of Slavery, the Right of Emancipation, and the Future of the African Race in the United States* (1864). Owen was an advocate of social integration, arguing that the newly emancipated slaves should avoid settling in separate areas:

> for such separation tends to keep up alienation of feeling and to nourish the prejudices of race. They will do well, therefore, to mingle their dwellings or farms with those of the whites; for the effect of this will be to take off the edge of national prejudice and weaken the feeling which regards them as a separate and alien race.[15]

The significant word here, however, as always, is 'mingle'. In the following chapter, on 'Amalgamation', Owen prescribes the limits of integration:

> Some may be of opinion that the effect of such commingling will be to introduce amalgamation between the races; others, that such amalgamation is the natural and proper solution of the problem. I believe neither the one nor the other.

Owen draws on the evidence of his Commission to claim that 'the mixed race is inferior, in physical power and in health, to the pure race, black or white'. A member of the Commission had investigated the condition of refugees of mixed race in Canada:

> He found them mostly of lymphatic temperament, with marks of scrofulous or strumous disposition, as shown in the pulpy appearance of portions of the face and neck, in the spongy gums and glistering teeth. There is a general prevalence of phthisical diseases.

147

Dr Mack, of St. Catherine's testified, 'The mixed race are the most unhealthy, and the pure blacks the least so. The disease they suffer most from is pulmonary. Where there is not real tubercular affection of the lungs, there are bronchitis and pulmonary affections. I have the idea that they die out when mixed, and that this climate will completely efface them. I think the pure blacks will live.'

Tables of births and deaths follow to show that the mixed-race population was diminishing (with no discussion of the physical and economic conditions under which such people lived), and the decreased fertility of the mulatto is also cited. Owen's position, therefore, despite his general liberal politics, is essentially the same as Nott's when it comes to the degenerative effects of sexual contact between black and white. He concludes that

amalgamation of these two races is in itself a physical evil injurious to both, – a practice which ought to be discouraged by public opinion, and avoided by all who consider it a duty, as parents, to transmit to their offspring the best conditions for sound health and physical well-being. Like other evils of the kind, however, this is beyond the legitimate reach of legislation.[16]

Which did not stop the legislators from trying, passing state laws outlawing sex between different races and miscegenation; at one time, as many as forty of the fifty states prohibited inter-racial marriage.[17] (Boas commented sharply that if such laws were designed to protect 'the white race against the infusion of negro blood', then they were misconceived, for 'with very few exceptions, the unions between whites and negroes are those of white men and negro women'.[18]) This remorseless logic did not prevent similar laws being proposed for Britain in the 1920s.[19] It was only in 1967 in the United States that such laws were declared unconstitutional.

The way in which Owen dwells on the physical details of the diseases of the Canadian refugees is symptomatic of the phobia and fascination that the idea of miscegenation summons forth in the white imagination. As we have seen, nineteenth-century scientists seemed particularly prone to such hostile obsessions and ambivalent fantasies. Take, for example, the reaction of the Swiss-American ethnologist, Louis Agassiz, Professor of Zoology at Harvard and contributor to *Types of Mankind*, when invited to comment to the American Freedmen's Inquiry Commission on the prospect for emancipated slaves in the United States, with particular reference to the question of whether they would amalgamate with the whites, and whether the mulattos would be prolific in reproducing themselves or die out as Nott had

claimed. Agassiz's own theory of the geographical distribution of the races led him to argue that blacks and whites would segregate naturally, with the whites going North and the blacks South. The mulattos, weak and infertile, he claimed, would die out. Rehearsing the argument of Nott, Agassiz similarly finds himself not entirely convinced by his own scientific racial theory. He cannot forbear from dwelling on the over-riding nightmare of the possibility of amalgamation:

> The production of halfbreeds is as much a sin against nature, as incest in a civilized community is a sin against purity of charac-ter.... Far from presenting to me a natural solution of our difficulties, the idea of amalgamation is most repugnant to my feelings, I hold it to be a perversion of every natural sentiment.... No efforts should be spared to check that which is abhorrent to our better nature, and to the progress of a higher civilization and a purer morality.

Yet as Stephen Gould remarks, if interbreeding among races is so repugnant, and inter-racial sex so abhorrent, this leaves Agassiz with the problem of explaining why the mixed-race population of the United States existed at all, let alone in such vast numbers. Rather than positing Gobineau's self-destructive civilizing instinct that attracts the white man to the yellow and black woman, Agassiz is more practically minded: he solves the problem by blaming the easy morality of 'halfbreed' servant-girls, combined with the naïvety of young white gentlemen. The men are, Agassiz claims, attracted by the white part of the 'colored' mixed-race housemaids, while the black part loosens the inhibitions of both maid and master. But if so, how were these 'colored' servant-girls themselves conceived, given that Agassiz claims a natural repugnance between white and black? Disgust always bears the imprint of desire: Agassiz goes on to suggest that the effect of such philandering with mixed-race servants is that the white Southern male increasingly acquires a taste for pure black women: 'This blunts his better instincts in that direction and leads him gradually to seek more spicy partners, as I have heard the full blacks called by fast young men'.[20] At this point Agassiz articulates the unspeakable, and opens up the basis of the necessity for why so much racial theory is based on the insistence on inalienable separation: not only the fear, and delicious fantasy, that the white woman really wants to proclaim 'I love the black man', but an avowal of the sexual desire of white men for black women. Once again, as in Gobineau, we find an ambivalent driving desire at the heart of racialism: a compulsive libidinal attraction disavowed by an equal insistence on repulsion. It was not only English colonials, who, in Jordan's words, 'were caught in the push and pull of an irreconcilable conflict between desire and aversion for interracial

sexual union' – an ambivalence nicely illustrated in Agassiz's own *Journey in Brazil*, where Agassiz's revulsion against 'half-breed' mixed-race populations – 'a mongrel crowd as repulsive as the mongrel dogs' – is matched by his wife's fascination for the 'fine-looking athletic negroes' from West Africa whom, she writes, she never tires of watching in the street and the market.[21]

WHITE POWER, WHITE DESIRE

> One of the most subtle physiological effects of a tropical climate is a surexcitation of the sexual organs, which in the presence of a native servile and morally underdeveloped population often leads to excesses even at a tender age.
>
> William Z. Ripley, *The Races of Europe*[22]

Edward Long's influential and long-considered-authoritative *History of Jamaica* (1774) offers a symptomatic example of this sexual contrariety. Modern commentators customarily cite Long for his expressions of overt racist sentiment about Africans ('the vilest of the human kind, to which they have little … pretension of resemblance'), just as many nineteenth-century commentators cite him approvingly for his claims that blacks and whites are separate species, and that mulattos are sterile. As Paul Fryer points out, it was propagandists for the West Indian planters such as Long who invoked the spectre of racial 'contamination' (an idea which can be traced all the way back to Tacitus and which as we have seen was reinvoked in the United States by Confederate propagandists in the 1860s) when reviewing the prospective effects of the freeing of slaves in Britain. Long writes:

> in the course of a few generations more, the English blood will become so contaminated with this mixture, and from the chances, the ups and downs of life, this alloy may spread so extensively, as even to reach the middle, and then the higher orders of people, till the whole nation resembles the *Portuguese* and the *Moriscos* in complexion of skin and baseness of mind. This is a venomous and dangerous ulcer, that threatens to disperse its malignancy far and wide, until every family catches infection from it.[23]

Here, indeed, are grounds that merit Long the title that Fryer gives him: 'the father of English racism'.[24] At the same time, Long's comments reveal the extent to which his racism constantly teeters into what has now become the familiar structure of sexual attraction and repulsion. In the *History of Jamaica* this occurs again when Long gratuitously extends his assertion that African women are 'libidinous and shameless as monkeys, or baboons' into the claim that they in fact admit 'these

animals frequently to their embrace'.[25] What is noticeable here, as at almost every point, is Long's predilection for expressing his racist views through comments about a repugnant sexuality. But the extent to which he dwells on such descriptions suggests an ambivalence that can also be heard in his comment that 'for my own part, I think there are *extremely potent* reasons for believing that the White and the Negro are two distinct species' (compare Arnold's remarks about 'the great and *pregnant* elements of difference which lie in race', and 'the *pregnant* and striking ideas of the ethnologists about the true natural grouping of the human race').[26] This other side of these threatening, apparently disgusting, but clearly fascinating, fantasies emerges elsewhere when Long turns to discuss the sexual relations, with which he was himself doubtless only too familiar, between white planters and black women in Jamaica. At this point he reveals that the white men of the colony are so enthralled by 'their infatuated attachments to black women', that they refuse to marry white women:

> In consequence of this practice we have not only more spinsters in comparison to the number of women among the natives ... in this small community, than in most other parts of his majesty's dominions, proportionately inhabited; but also, a vast addition of spurious offsprings of different complexions: in a place where, by custom, so little restraint is laid on the passions, the Europeans ... are too easily led aside to give a loose to every kind of sensual delight: on this account some black or yellow *quasheba* is sought for, by whom a tawney breed is produced.

Long then spells out his point: the white men refuse white women because they prefer black women: 'Many are the men, of every rank, quality and degree here, who would much rather riot in these goatish embraces, than share the pure and lawful bliss derived from matrimonial, mutual love'.[27] Citing this last revealing confession, Hyam comments bluntly:

> According to Edward Long, British men were all too prone to make unions with black women in the West Indies, not from any shortage of white women ... nor even from the supposed burdens and expenses of marriage, but from the sexual attractiveness of black flesh.[28]

'Many white men evince a wonderful inclination for black women' observed Peter Neilson when travelling in the United States in 1830.[29] For some, the attraction of 'nutmegging' clearly involved an erotic reversal of the customary power relation. Long comments how in the pursuit of the 'white gallants' for the 'sable beauty' 'even the authority of a master must bend to the more absolute empire of Cupid'.[30] For

others, no doubt the majority, the controlling power relation between slave-owner and slave was eroticized: in addition to the testimony of black women as victims of white male violence in the slave narratives, today there is also the evidence of Thomas Thistlewood's private diaries, ten thousand pages recording details of his often sadistic sex-life with his slaves.[31] Either way, public corroboration of this white desire for 'black flesh', carried out through either rape or coercive exploitation, came in the burgeoning mixed-race populations of the Caribbean and the Americas. At the same time, the white male's ambivalent axis of desire and repugnance was enacted through a remarkable ideological dissimulation by which, despite the way in which black women were constituted as sexual objects and experienced the evidence of their own desirability through their own victimization, they were also taught to see themselves as sexually unattractive.[32]

'The relationship between the imperialist subject and the subject of imperialism is at least ambiguous' remarks Gayatri Chakravorty Spivak in the context of the imperialist project of the outlawing of the practice *Sati,* or widow-burning. Spivak characterizes this pithily as 'White men are saving brown women from brown men'.[33] The outlawing of *Sati* is clearly the obverse of the more habitual narrative of legitimation of white men saving white women from brown men. Although Spivak denies that her sentence characterizes a Deleuzian collective fantasy, it still prompts the question who the brown women are being saved *for* in this act of delicious gallantry by the white men. Doubtless the answer was: for the white men themselves.

Another symptomatic example from Jamaica would be that of Bryan Edwards, a West India merchant and Member of Parliament. In his *History, Civil and Commercial, of the British Colonies in the West Indies* (1793), Edwards acknowledges that women

> of Colour ... are universally maintained by White men of all ranks and conditions, as kept mistresses. The fact is too notorious to be concealed or controverted.... Undoubtedly the conduct of many Whites in this respect, is a violation of all decency and decorum.[34]

Despite these moralistic remarks (perhaps in 1793 a sign of incipient pressure from the missionary and anti-slavery lobbies), Edwards nevertheless defends many aspects of the custom of concubinage, commenting, however, that of course marriage to the black *fille de joie* could never be contemplated.[35] (Tennyson perhaps deserves some credit for at least contemplating marriage to his dusky woman in 'Locksley Hall'.) He remains, however, more circumspect than Long as to why the norm in the West Indies is for white men to desire black women. In place of a direct comment, he ends his chapter by citing, with the illustration reproduced in Plate 4, Isaac Teale's poem, 'The

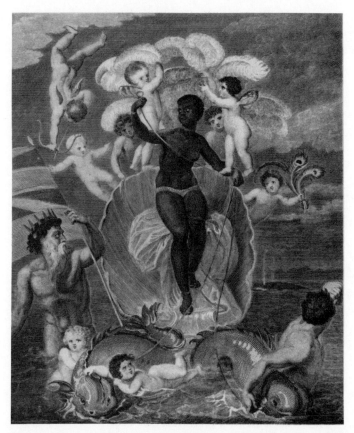

Plate 4 'The Voyage of the Sable Venus, from Angola to the West Indies'. Bryan Edwards, *The History, Civil and Commercial, of the British Colonies in the West Indies* (1793)

Sable Venus; An Ode' (1765), which, he suggests, will portray both 'the character of the sable and saffron beauties of the West Indies, and the folly of their paramours'.[36] This extraordinary poem marks an early articulation of the sexual economy of desire in the fantasies of race:

> *Alba ligustra cadunt, vaccinia nigra leguntur.* Virgil
> [*The white privet blossom is left to fall, black whortle berries are picked (Eclogues, 2: 18)*]

> I long had my gay lyre forsook,
> But strung it t'other day, and took
> T'wards Helicon my way;

153

The muses all, th'assembly graced,
The president himself was placed,
 By chance 'twas concert-day.

Erato smiled to see me come;
Asked why I stayed so much at home;
 I owned my conduct wrong;
But now the sable queen of love,
Resolved my gratitude to prove,
 Had sent me for a song.

The ladies looked extremely shy,
Apollo's smile was arch and sly,
 But not one word they said;
I gazed, – sure silence is content, –
I made my bow, away I went;
 Was not my duty paid?

Come to my bosom, genial fire,
Soft sounds, and lively thoughts inspire;
 Unusual is my theme:
Not such dissolving Ovid sung,
Nor melting Sappho's glowing tongue, –
 More dainty mine I deem.

Sweet is the beam of morning bright,
Yet sweet the sober shade of night;
 On rich Angola's shores,
While beauty clad in sable dye,
Enchanting fires the wondering eye,
 Farewell ye Paphian bowers.

O sable queen! thy mild domain
I seek, and court thy gentle reign,
 So soothing, soft and sweet;
Where mounting love, sincere delight,
Fond pleasure, ready joys invite,
 And unbought raptures meet.

The prating Frank, the Spaniard proud,
The double Scot, Hibernian loud,
 And sullen English own,
The pleasing fondness of thy sway,
And here, transferred allegiance pay,
 For gracious is thy throne.

From East to West, o'er either Ind'
They sceptre sways; thy power we find

154

By both the tropics felt;
The blazing sun that gilds the zone,
Waits but the triumph of they throne,
　　Quite round the burning belt.

When thou, this large domain to view,
Jamaica's isle, thy conquest new,
　　First left thy native shore,
Bright was the morn, and soft the breeze,
With wanton joy the curling seas
　　The beauteous burden bore.

Of ivory was the car, inlaid
With every shell of lively shade;
　　The throne was burnished gold;
The footstool gay with coral beamed,
The wheels with brightest amber gleamed,
　　And glistering round they rolled.

The peacock and the ostrich spread
Their beauteous plumes, a trembling shade,
　　From noon-day's sultry flame:
Sent by their fire, the careful East,
The wanton breezes fanned her breast,
　　And fluttered round the dame.

The winged fish, in purple trace
The chariot drew; with easy grace
　　Their azure rein she guides:
And now they fly, and now they swim;
Now o'er the wave they lightly skim,
　　Or dart beneath the tides.

Each bird that haunts the rock and bay,
Each scaly native of the sea,
　　Came crowding o'er the main:
The dolphin shows his thousand dyes,
The grampus his enormous size,
　　And gambol in her train.

Her skin excelled the raven plume,
Her breath the fragrant orange bloom,
　　Her eye the tropic beam:
Soft was her lip as silken down,
And mild her look as evening sun
　　That gilds the Cobre* stream.

*A river so called in Jamaica

The loveliest limbs her form compose,
Such as her sister Venus chose,
 In Florence, where she's seen;
But just alike, except the white,
No difference, no – none at night,
 The beauteous dames between.

With native ease serene she sat,
In elegance of charms complete,
 And every heart she won:
False dress deformity may shade,
True beauty courts no foreign aid:
 Can tapers light the sun? –

The power that rules old ocean wide,
'Twas he, they say, had calmed the tide,
 Beheld the chariot roll:
Assumed the figure of a tar,
The Captain of a man of war,
 And told her all his soul.

She smiled with kind consenting eyes; –
Beauty was ever valour's prize;
 He raised a murky cloud:
The tritons sound, the sirens sing,
The dolphins dance, the billows ring,
 And joy fills all the crowd.

Blest offspring of the warm embrace!
Fond ruler of the crisped race!
 Though strong thy bow, dear boy,
Thy mingled shafts of black and white,
Are winged with feathers of delight,
 Their points are tipped with joy.

But, when her step had touched the strand,
Wild rapture seized the ravished land,
 From every part they came:
Each mountain, valley, plain, and grove
Haste eagerly to show their love; –
 Right welcome was the dame.

Port-Royal shouts were heard aloud,
Gay St. Iago sent a crowd,
 Grave Kingston not a few:
No rabble rout, – I heard it said,
Some great ones joined the cavalcade –

156

The muse will not say who.

Gay Goddess of the sable smile!
Propitious still, this grateful isle
 With thy protection bless!
Here fix, secure, thy constant throne;
Where all, adoring thee, do ONE
 ONE Deity confess.

For me, if I no longer own
Allegiance to the Cyprian throne,
 I play no fickle part;
It were ingratitude to slight
Superior kindness; I delight
 To feel a grateful heart.

Then, playful goddess! cease to change,
Nor in new beauties vainly range;
 Though whatso'er thy view,
Try every form thou canst put on,
I'll follow thee through every one;
 So staunch am I, so true.

Do thou in gentle Phibba smile,
In artful Benneba beguile,
 In wanton Mimba pout;
In sprightly Cuba's eyes look gay,
Or grave in sober Quasheba,
 I still shall find thee out.

Thus have I sung; perhaps too gay
Such subject for such time of day,
 And fitter far for youth:
Should then the song too wanton seem,
You know who chose the unlucky theme,
 Dear Bryan, tell the truth.

In *Oroonoko*, Aphra Behn describes the 'Queen of Night', Imoinda, as

> a Beauty, that to describe her truly, one need say only, she was Female to the noble Male; the beautiful Black *Venus* to our young *Mars*; as charming in her Person as he, and of delicate Vertues. I have seen a hundred White men sighing after her, and making a thousand Vows at her feet, all in vain, and unsuccessful.[37]

In citing 'The Sable Venus', and in revealing at the end of the poem that he had himself chosen its 'wanton' theme, Edwards also confesses that

the insatiable desire of white men such as himself is less constant, desiring rather the taste of ever-changing black flesh: 'Try every form thou canst put on,/I'll follow thee through every one.... /Dear Bryan, tell the truth'. Apparently without any self-consciousness, Edwards follows this fantasy of a Black Botticellian Venus, triumphantly riding in her chariot from Angola to Jamaica to be enthroned by enraptured, desiring colonists, with an historical account of the slave trade, giving detailed figures for the numbers of Africans transported across the Atlantic each year. The cultural construction of race has always been fuelled by the corrupt conjunction of such hybridized sexual and economic discourses.

7

COLONIALISM AND THE DESIRING MACHINE

Colonial discourse analysis was initiated as an academic sub-discipline within literary and cultural theory by Edward Said's *Orientalism* in 1978.[1] This is not to suggest that colonialism had not been studied before then, but it was Said who shifted the study of colonialism among cultural critics towards its discursive operations, showing the intimate connection between the language and forms of knowledge developed for the study of cultures and the history of colonialism and imperialism. This meant that the kinds of concepts and representations used in literary texts, travel writings, memoirs and academic studies across a range of disciplines in the humanities and social sciences could be analysed as a means for understanding the diverse ideological practices of colonialism. Said's Foucauldian emphasis on the way in which Orientalism developed as a discursive construction, so that its language and conceptual structure determined both what could be said and what recognized as truth, had three main theoretical implications. First, Said showed how Foucault's notion of discourse offered an alternative way of thinking about the operations of ideology, both as a form of consciousness and as a lived material practice. If discourse comes close to Althusser's definition of ideology as the 'representation of the imaginary relationship of individuals to their real conditions of existence', Said extended the implication to be found in Althusser that a cultural construction could be historically determining.[2] *Orientalism* thus challenged the traditional self-devaluation in deference to the economic of orthodox Marxist cultural criticism. And though doubtless the Western expansion into the East was determined by economic factors, Said argued that the enabling cultural construction of Orientalism was not simply determined by them, and thus established a certain autonomy of the cultural sphere.

The second implication of the charting of the complicity of Western literary and academic knowledge with the history of European colonialism was that it emphasized the ways in which seemingly impartial, objective academic disciplines had in fact colluded with, and indeed

been instrumental in, the production of actual forms of colonial subjugation and administration. *Orientalism* provided powerful evidence of the complicity between politics and knowledge. In recent years it has been augmented by Martin Bernal's *Black Athena* (1987), which has provided the most detailed and comprehensive demonstration to date of the way in which the allegedly objective historical scholarship of an apparently non-political academic discipline, Classics, was in fact determined by its own cultural and political history – in this case, of racism and eurocentrism. Bernal's book suggests that the parameters that have already been set up defining the limits of colonial discourse need to be extended much more widely into the history of academic disciplines. *Black Athena* holds out the much more disturbing possibility that all Western knowledge is, directly or indirectly, a form of colonial discourse.

This can be related to the third, most controversial, contention of Said's book, namely that the discursive construction of Orientalism was self-generating, and bore little, if any, relation to the actuality of its putative object, 'the Orient'. The important point here is that Western knowledge of the Other can be seen to be constructed as a part of the whole system of Orientalist discourse: 'such texts can *create* not only knowledge but also the very reality that they appear to describe' (94). This knowledge has no necessary relation to the actual at all. It is for this reason that there is no *alternative* to the Western construction of the Orient, no 'real' Orient, because the Orient is itself an Orientalist concept. Orientalism, according to Said, is simply 'a kind of Western projection onto and will to govern over the Orient' (95). This has been the most disputed aspect of his thesis and the most difficult for his critics to accept.

At the same time, it has been one which, at worst, has allowed a certain lack of historical specificity. After all, if Orientalist discourse is a form of Western fantasy that can say nothing about actuality, while at the same time its determining cultural pressure means that those in the West cannot but use it, then any obligation to address the reality of the historical conditions of colonialism can be safely discarded. Such colonial-discourse analysis has meant that we have learnt a lot about the fantasmatics of colonial discourse, but at the same time it has by definition tended to discourage analysts from inquiring in detail about the actual conditions such discourse was framed to describe, analyse or control. Said's emphasis on the question of representation has at best been balanced by attention to the reality which that representation missed or excluded: not only the suppressed 'voice of the Other', but also the history of the subaltern, both in terms of the objective history of subaltern or dominated, marginalized groups, and in terms of the subjective experience of the effects of colonialism and domination, an

area most searchingly investigated by the founding father of modern colonial critique, Frantz Fanon.[3] The most productive revisions of Said's work have therefore focussed on the question of representation, mediated with analyses of counter-histories or the effects of colonialism on colonial subjects and the forms of their subjectivity.

The totalizing aspect of Said's argument in *Orientalism* was quickly challenged by Homi K. Bhabha, who maintained that Said assumed too readily that an unequivocal intention on the part of the West was always realized through its discursive productions.[4] Bhabha focussed on Said's claim that Orientalist knowledge was instrumental and always worked successfully when put into practice. In theoretical terms Bhabha's move was to add psychoanalysis to Said's Foucauldian analysis, and he did this neatly by finding it already in Said. Bhabha called attention to the moment in which Said briefly, but in an undeveloped way, set up the possibility of Orientalism working at two conflictual levels, and in a significant but uncharacteristic invocation of psychoanalysis, distinguished between a 'manifest' Orientalism, the conscious body of 'scientific' knowledge about the Orient, and a 'latent' Orientalism, an unconscious positivity of fantasmatic desire. Bhabha's outstanding contribution has been to develop the implications of this idea by emphasizing the extent to which the two levels fused and were, in operation, inseparable; he has shown how colonial discourse of whatever kind operated not only as an instrumental construction of knowledge but also according to the ambivalent protocols of fantasy and desire. Ambivalence is a key word for Bhabha, which he takes from psychoanalysis where it was first developed to describe a continual fluctuation between wanting one thing and its opposite (also 'simultaneous attraction toward and repulsion from an object, person or action'). In making ambivalence the constitutive heart of his analyses, Bhabha has in effect performed a political reversal at a conceptual level in which the periphery – the borderline, the marginal, the unclassifiable, the doubtful – has become the equivocal, indefinite, indeterminate ambivalence that characterizes the centre.

Bhabha has subsequently extended this idea of a constitutive ambivalence resting at the heart of colonial discursive production, an ambivalence that its appearance in a non-European context only accentuated. He has exhibited through a series of analyses the ways in which European colonial discourse – whether it be governmental decree, district officers' reports or missionary accounts – is effectively decentred from its position of power and authority. We have already seen how Bhabha shows that this occurs when authority becomes hybridized when placed in a colonial context and finds itself layered against other cultures, very often through the exploitation by the colonized themselves of its evident equivocations and contradictions

that are all too apparent in the more hostile and challenging criteria of alien surroundings. An example of the different kind of framing that Western culture receives when translated into different contexts would be Bhabha's illustration of a Christian missionary trying to teach Indian Hindus about the Christian communion service: the missionary is quite confounded when he finds that the vegetarian Hindus react with horror to the idea of eating Christ's body and drinking his blood. Suddenly it is the white English culture that betrays itself, and the English missionary who is turned into a cannibalistic vampire.[5] If Said shows that misrelation is the anagrammatic secret of Orientalism, then Bhabha demonstrates that oscillation is that of the colonialist.

By contrast, Gayatri Chakravorty Spivak has been concerned to emphasize, against Said, the possibility of counter-knowledges such as those constructed around the criteria of the journal *Subaltern Studies*.[6] The desire of today's anti-colonial historian is to retrieve a subaltern history that rewrites the received account both of the colonizing academics and of the native ruling elite, a history of the excluded, the voiceless, of those who were previously at best only the object of colonial knowledge and fantasy. Spivak seeks to analyse the effects of colonial violence and denial of subjectivity on subjectivity. She stresses the pitfalls and aporias that even radical historiography can fall into, drawing particular attention to examples of histories that continue to be ignored even today by revisionist historians, particularly those of native subaltern women. Such women were subject to what is today often called a 'double colonization' – that is, in the first instance in the domestic sphere, the patriarchy of men, and then, in the public sphere, the patriarchy of the colonial power.[7] This has led to increasing comparisons being made between patriarchy and colonialism. Spivak argues that taken always as an object of knowledge, by colonial and indigenous rulers who are as masculist as each other, the subaltern woman is written, argued about, even legislated for, but allowed no discursive position from which to speak herself.[8] She therefore tends to be absent from the documentary archives, and to write her history has to involve a particular effort of retrieval, or, in the case of fiction such as Toni Morrison's *Beloved*, a particular effort of historical imagination.

This focus on the kinds of exclusion produced not only by colonialism itself but even by current forms of understanding is typical of Spivak's more general concern with what she considers to be the continuing epistemic violence that is practised in the exercise of Western forms of thought upon the East. Equally importantly, Spivak has championed with a remarkable degree of success the cause of minority groups excluded or neglected by contemporary academic, particularly feminist, practices. It is typical of the relentlessly questioning nature of her work, however, that she has recently been concerned

with an interrogation of, as she sees it, the increasing commodification in academia of the category of 'marginality' itself.[9] Yet in her own work she has, through her own hybridizing, syncretic method which juxtaposes the political priorities of gender, class and race through a constant theoretical modulation brilliantly forced the disruption of the marginal through the mainstream of contemporary academic presuppositions, pushing them to their unrecognizable limits.

Aspects of these positions have been elaborated and developed by a number of other critics, but it would be true to say that Said, Bhabha and Spivak constitute the Holy Trinity of colonial-discourse analysis, and have to be acknowledged as central to the field. While there has been a remarkable, indeed quite staggering, growth of analysts researching in this area, an increasing tendency has been to produce new archival material rather than to develop further the theoretical parameters set up by Said *et al.* The main challenge has come from critics such as Chandra Talpade Mohanty, Benita Parry or Aijaz Ahmad, who have criticized a certain textualism and idealism in colonial-discourse analysis which, they allege, occurs at the expense of materialist historical enquiry.[10] There is considerable cogency to many of these objections, but it could be also argued that they also involve a form of category mistake: the investigation of the discursive construction of colonialism does not seek to replace or exclude other forms of analysis, whether they be historical, geographical, economic, military or political – and there are certainly plenty of studies of colonialism of those kinds. The contribution of colonial-discourse analysis is that it provides a significant framework for that other work by emphasizing that all perspectives on colonialism share and have to deal with a common discursive medium which was also that of colonialism itself: the language used to enact, enforce, describe or analyse colonialism is not transparent, innocent, ahistorical or simply instrumental. Colonial-discourse analysis can therefore look at the wide variety of texts of colonialism as something more than mere documentation or 'evidence', and also emphasize the ways in which colonialism involved not just a military or economic activity, but permeated forms of knowledge which, if unchallenged, may continue to be the very ones through which we try to understand colonialism itself. Here we have the ultimate explanation for the 'alienation effect' of much of the language of postcolonial criticism. It is for this reason also that a major task of postcolonialism must be the production of a 'critical ethnography of the West', analysing the story of a West haunted by the excess of its own history.[11]

The underlying message of the increasing fervour of attacks on Said has probably less to do with his own work than with his influence, and the sense that from a theoretical rather than archival perspective

colonial-discourse analysis as a general method and practice has reached a stage where it is itself in danger of becoming oddly stagnated, and as reified in its approach – and therefore in what it can possibly produce at the level of investigation – as the colonial discourse that it studies. We have reached something of an impasse with regard to the theoretical questions raised in the study of colonial discourse, and this has meant a certain complacency about or neglect of the problems of the methodologies that have been developed. In other words, we have stopped asking questions about the limits and boundaries of our own assumptions. It is true that we now generally acknowledge the operation of conflictual structures within colonial discourse: but this very textual ambivalence prevents us from standing back to reconsider colonial discourse itself as an entity. Problems there are, certainly, that remain, and they are not hard to locate. To what extent is 'colonial discourse' itself a legitimate general category? It is hard to avoid the accusation that there is a certain idealism involved in its use as a way of dealing with the totality of discourses of and about colonialism. If this has not been over-apparent it is because the dominance in recent years of India as object of attention among those working in the field – and therefore not surprisingly in the work done by them – has meant that there has been a noticeable geographical and historical homogenization of the history of colonialism. But does the fact that modern colonialism was effected by European or European-derived powers mean that the discourse of colonialism operated everywhere in a similar enough way for the theoretical paradigms of colonial-discourse analysis to work equally well for them all? Clearly the ideology and procedures of French colonialism, based on an egalitarian Enlightenment assumption of the fundamental sameness of all human beings and the unity of the human race, and therefore designed to assimilate colonial peoples to French civilization, differed very substantially from the indirect-rule policies of the British which were based on an assumption of difference and of inequality, or from those of the German or the Portuguese. (Even today, the weather report in *Le Monde* cites the temperature in Point-à-Pitre, capital of Guadeloupe, which, like Césaire's Martinique, is part of mainland France and thus of the European Union.) South America, where many states achieved independence in the early nineteenth century, would be only the most obvious example of a region where colonialism has a very different history from that of, say, India which the British left only in 1947. Contemporary forms of colonialism, such as exist in Northern Ireland or Palestine, provide further complications. This heterogeneity points to the question of historical difference. Can we assume that colonial discourse operates identically not only across all space but also throughout time? In short, can there be a general theoretical matrix that

is able to provide an all-encompassing framework for the analysis of each singular colonial instance?

In recent years there has also been a growing unease about the tendency of anti-eurocentric writing to homogenize not just the 'Third World' but also the category of 'the West' as such – by writers who are, of course, very often themselves the product of that same 'West'. But in the face of such objections we need to remind ourselves that these increasingly troublesome general categories, such as 'the West', or 'colonialism' or 'neocolonialism' – and even 'colonial discourse' – are themselves in their current usage often the creation of Third World theorists, such as Fanon, Nkrumah or Said, who needed to invent such categories precisely as general categories in order to constitute an object both for analysis and for resistance.[12] At a certain level, most forms of colonialism are after all, in the final analysis, colonialism, the rule by force of a people by an external power. In practical political terms, it was necessary to construct a general object of attack in order to counter the divide-and-rule policies of colonial administrations. During the independence struggles, it was also imperative to form alliances with all those who were suffering from colonial oppression from whatever source – particularly when the European, North American and Asian colonial powers were themselves engaged in fierce struggles with each other which were partly played out in colonial scenarios. Fanon points out how colonialism itself was 'separatist and regionalist', a technique designed to reinforce separation and quietism.[13] Those who today emphasize its geographical and historical differences may in effect be only repeating uncritically colonialism's own partitioning strategies. Yet at this point in the postcolonial era, as we seek to understand the operation and effects of colonial history, the homogenization of colonialism does also need to be set against its historical and geographical particularities. The question for any theory of colonial discourse is whether it can maintain, and do justice to, both levels.

It is also time to consider the extent to which certain Western assumptions, evaluations and even institutional divisions operate within the emphases and priorities that we place through the selection of material for study. In Britain, work on Latin America, for example, tends to function rather distinctly and in isolation from much of the rest of colonial-discourse analysis, largely because it is not an area where the English have played any great historical role, and therefore tends to remain the preserve of Latin Americanists within Departments of Hispanic Studies. In comparison to the extensive work done on India, meanwhile, Africa remains comparatively neglected.[14] In Britain the reasons for this doubtless begin with the greater number of British Asians in higher education, as well as the difference in comparable numbers of academics and graduate students from Africa

165

and Asia. Nevertheless, the greater attention accorded to India still seems to perpetuate the differing evaluations that the British accorded to the various parts of their empire. It was always India that received the greatest economic, cultural and historical attention from the British. In the same way, today India quite clearly retains that position of pride of place, the jewel in the crown of colonial-discourse analysis.

ANTI-OEDIPUS: THE GEOPOLITICS OF CAPITALISM

From a theoretical point of view, this situation has occurred because the analytic paradigms developed for other literatures or continents have not apparently been strong enough to challenge the discursive model of *Orientalism*; indeed it is not uncommon today to find cultural critics using the term 'Orientalism' as a synonym for 'colonialism' itself. The problem with Said's book was that its historical and theoretical argument was so persuasive that it seemed to allow no alternatives. As the *New York Times* put it, 'his case is not merely persuasive, but conclusive'. After his brilliant demonstration that Orientalism as a discourse constructed an all-encompassing representation of, and form of knowledge about, the Orient, we have ever since been looking for chinks in its apparently hegemonic surface. The crucial point here is that it is not enough to produce individual instances that appear to contradict Said's thesis – for his thesis already includes that possibility. So I want to explore now a different tack, by taking instead Said's argument a bit further.

David Trotter has recently emphasized the way that the concept of colonial discourse implies an understanding of colonialism as 'a text without an author': there will always be authors of individual texts, but colonial discourse as such makes up a signifying system without an author. Colonialism therefore becomes a kind of machine. At the same time, like Adam Smith's economic and historical machines, colonialism is also a determining, law-governed process; its workings, therefore, get attached to those of the historical and economic machines.[15] It was indeed as a machine that the colonialists themselves often envisaged the operations of colonial power. Said cites Lord Cromer's essay on 'The Government of Subject Races' (1908), in which he

> envisions a seat of power in the West, and radiating out from it towards the East a great embracing machine, sustaining the central authority yet commanded by it. What the machine's branches feed into it in the East – human material, material wealth, knowledge, what have you – is processed by the machine, then converted into more power.[16]

Or, in a somewhat perverse but characteristic later reversal of the image, colonists argued that even resistance to the machine was a sign of its effectiveness. Lord Lugard, for example, cites approvingly a particularly interesting mixed metaphor from Lucas's 'United Empire' (1919): 'Nothing should appeal so strongly as the Empire to democracy, for it is the greatest engine of democracy the world has ever known.... It has infected the whole world with liberty and democracy'.[17]

It is in the context of the widespread idea of the Empire as machine that I want to consider the work of Deleuze and Guattari; they offer, I suggest, not something that could be described as an alternative to Said's paradigm, but a related though different way of thinking about some of the operation of colonialism, particularly not just as a form of fantasy but also as a form of ambivalent desire. In the first place, the *Anti-Oedipus* has the advantage of decentring colonial analysis away from the East towards a more global surface.[18] It also redirects our attention towards two obvious but important points that tend to get lost in today's emphasis on discursive constructions – the role of capitalism as the determining motor of colonialism, and the material violence involved in the process of colonization. The attraction of Deleuze and Guattari's argument from a theoretical point of view is similarly the way in which philosophy, psychoanalysis, anthropology, geography, economics *et al.* are all brought together in one interactive economy and shown to be implicated in capitalism's colonizing operations.

The first thing to remark about Deleuze and Guattari's *Anti-Oedipus* is its virtual absence from discussions of postcolonial theory. Only their essay 'What is Minor Literature?' has achieved any substantive impact in this area, though in recent years the formulations about minorities in *A Thousand Plateaus* have been increasingly cited in the context of discussions of new concepts of radical democracy.[19] Despite the very real difficulty of the *Anti-Oedipus* which has doubtless been a major factor in preventing its widespread reception in this country (though why the difficulty of *this* book?), its basic paradigm is relatively simple and is derived from Reich. The argument is that the flow of desire, or as Deleuze and Guattari call it in their desubjectified version, the desiring machine, has been repressed in our society through the mechanism of the Oedipus complex. The Oedipal triad institutes a structure of authority and blockage that operates not only in the family, but through the family at the level of society in general. Freud's 'discovery' of the Oedipus complex was therefore his most radical insight, but one which he immediately suppressed by regarding it as the normal form of development through which all individuals should go, rather than recognizing it as the primary means of ideological repression in capitalist society. Psychoanalysis as a

therapeutic institution therefore operates, in this account, as a policing agent for capitalism. While only those profiting from the analytic institution would probably want to dispute this part of the argument, it is true that Deleuze and Guattari's description of repression retains a Reichian or even a Lawrentian simplicity in its nature/culture, natural/artificial opposition; the general panacea of 'schizoculture' as the preferred form for the production of desire and the curing of the ills imposed by psychoanalysis and capitalism is no doubt a discouragement for many readers. But despite this problem, I want to argue that there are good reasons for reconsidering the *Anti-Oedipus* in the context of postcolonial critique.

What is important is the way in which Deleuze and Guattari produce a social theory of desire which cuts through the problematic psychic–social opposition of orthodox psychoanalysis. Central to Freud's repression of his own Oedipal insight would be the way in which he failed to see the intimate connection between the production of desire and social production in its widest sense – a schism that has remained a defining feature of most psychoanalysis ever since. Deleuze and Guattari retrieve this relation through their famous Spinozistic 'body without organs' which constitutes the (social) body to which desire attaches itself in a movement of coupling and disjunction, as well as the unseen body of 'capital as a proliferating body, money that produces more money', and even the totality of the earth itself, a vast 'surface for the recording of the entire process of production of desire'.[20] Desire flows laterally according to points of disjunction and zones of intensity on the grids of this egg-like surface. The 'subject', instead of being at the centre, is 'produced as a mere residuum' of the processes of the desiring machines, the nomadic offshoot of striated mental spaces and of the body defined as longitude and latitude: 'Individual or group, we are traversed by lines, meridians, geodesics, tropics, and zones marching to different beats and differing in nature'.[21]

Deleuze and Guattari are thus concerned to break down the conventional epistemological distinction between materiality and consciousness. The general thrust of their work is to deny any differentiation between 'the social production of reality on the one hand, and a desiring production that is mere fantasy on the other': rather, they maintain that 'the social field is immediately invested by desire, that it is the historically determined product of desire' (28–9). Desire is a social rather than an individual product; it permeates the infrastructure of society – a position that Deleuze and Guattari can hold because they have already separated desire from the subject by defining sexuality as 'the libidinal unconscious of political economy', a move that opens up new possibilities for the analysis of the dynamics of desire in the social field.[22] Racism is perhaps the best example through which we can

immediately grasp the form of desire, and its antithesis, repulsion, as a social production: 'thus fantasy is never individual: it is *group fantasy*'.[23]

Colonial discourse would provide another example of such a group fantasy, and we can see other ways in which the *Anti-Oedipus* impinges upon questions relating to colonialism. This is most pronounced in the theorization of capitalism according to a geospatial model of the inscription of the flows of desire upon the surface or body of the earth: the operations of global capitalism are here characterized as a form of 'cartography'.[24] Social production works, in Deleuze and Guattari's terms, as an inscription or writing machine:

. The prime function incumbent on the socius has always been to codify the flows of desire, to inscribe them, to record them, to see to it that no flow exists that is not properly dammed up, channeled, regulated.... But the *capitalist machine* ... finds itself in a totally new situation: it is faced with the task of decoding and deterritorializing the flows.

(33)

Where capitalism differs from earlier historical forms such as despotism is that it does not simply encode and therefore control desire: it has to operate through a double movement because it must first of all do away with the institutions and cultures that have already been developed. The basic need of capitalism is to engineer an encounter between the deterritorialized wealth of capital and the labour capacity of the deterritorialized worker.[25] The reduction of everything, including production and labour, to the abstract value of money enables it to decode flows and 'deterritorialize' the socius. Having achieved a universal form of exchange, it then reterritorializes – 'institutes or restores all sorts of residual and artificial, imaginary, or symbolic territorialities' such as states, nations or families:

There is the twofold movement of decoding or deterritorializing flows on the one hand, and their violent and artificial reterritorialization on the other. The more the capitalist machine deterritorializes, decoding and axiomatizing flows in order to extract surplus values from them, the more its ancillary apparatuses, such as government bureaucracies and the forces of law and order, do their utmost to reterritorialize, absorbing in the process a larger and larger share of surplus value.

(34–5)

This description of the operations of capitalism as a territorial writing machine seems not only especially suited to the historical development of industrialization, but also describes rather exactly the violent

169

physical and ideological procedures of colonization, deculturation and acculturation, by which the territory and cultural space of an indigenous society must be disrupted, dissolved and then reinscribed according to the needs of the apparatus of the occupying power. These structures of decoding and recoding, of deterritorialization and reterritorialization, operate rather like the simultaneous antithetical categories of Roget's *Thesaurus*: their repetitive wave-like movements upon the territories and cultures of the earth provide a dynamic model for the processes of colonization, and also have the advantage of being able to describe both the historical material procedures of colonialism and its ideological operations, whether it be the severing of the body from the land, the destruction and reconstruction of cultures or the fabrication of knowledge according to the propriety of new disciplines. In this way it can be argued that Deleuze and Guattari have produced a theory of capitalism to which the operation of colonialism as a form of writing geography is central. It is not surprising, therefore, that the idea has been taken up most effectively, if briefly, by a geographer: in the *Condition of Postmodernity* (1989), David Harvey argues that

> the accumulation of capital is perpetually deconstructing ... social power by reshaping its geographical basis. Put the other way round, any struggle to reconstitute power relations is a struggle to reorganize their spatial basis. It is in this light that we can better understand 'why capitalism is continuously reterritorializing with one hand what it was deterritorializing with the other'.[26]

It is this link between capitalism, colonialism and spatiality that is so effectively articulated by Deleuze and Guattari. At the same time, Fanon provides a necessary complementary perspective of the historical and the actual, of the practices by means of which land and bodies are brought under colonial control, of the forms of violent inscription through which power relations are established. His account of 'the enterprise of deculturation' no doubt inspired the theoretical paradigm of the *Anti-Oedipus* and its articulation of the mechanisms that the native population undergoes under colonial enslavement:

> For this its systems of reference have to be broken. Expropriation, spoliation, raids, objective murder, are matched by the sacking of cultural patterns, or at least condition such sacking. The social panorama is destructured; values are flaunted, crushed, emptied.[27]

At the same time, Fanon also emphasizes the dialectical effect of the violence of colonial imposition so that there is a complicity between the interventions of capitalism and colonialism and the reactive 'violent forces that blaze up in colonial territory':

The violence which has ruled over the ordering of the colonial world, which has ceaselessly drummed the rhythm for the destruction of native social forms and broken up without reserve the systems of reference of the economy, the customs of dress and external life, that same violence will be claimed and taken over by the native at the moment when, deciding to embody history in his own person, he surges into the forbidden quarters.[28]

The destruction of the colonizer's zone is fuelled by the way in which colonial violence has been enacted on the subjectivity of the native. In this articulation of the social with the subjective we find a further analogy between Fanon and Deleuze and Guattari. The latter link the geographical back to the psychical through what they call 'the analytic imperialism of the Oedipus complex' (23). Once again they reverse the normal procedure whereby colonialism is seen as the aberrant offshoot of European civilization: according to them the link between the family and the state is achieved through a form of interior, ideological territorialization of the psyche that turns questions and dilemmas from the social realm into the problem of the individual. Freud participates in this transaction by using the Oedipus myth to interpret the neuroses of family life – 'not as effects of the society which the family represents, but as the psychic production of the children who suffer them'.[29] The foreign is thus made domestic in a movement of psychic recodification: 'Oedipus is always colonization pursued by other means, it is the interior colony ... it is our intimate colonial education'. Oedipus is not simply the normal structure through which all humans travel on the path to mental, sexual and social maturity: it is the means through which the flow of desire is encoded, trapped, inscribed within the artificial reterritorializations of a repressive social structure – the family, the party, the nation, the law, the educational system, the hospital, psychoanalysis itself. The disruptive effect of the colonial space upon the claims of psychoanalysis, by demonstrating that the Oedipus complex is not universal outside the operations of capitalism, is a matter as much for the politics of psychoanalysis as of colonialism, but is significant for the theory in providing the basis of the proof that Oedipus consists of a limit-case and therefore a form of ideological reterritorialization.[30] The structure of the Oedipus complex may emerge in the colonial situation but only because the colonial subject is constructed through imposed cultural and political forms which are internalized as a condition of psychic reality, and then reproduced as the basis for normative social experience. In Deleuze and Guattari's argument, this procedure also operates equally for the subjects of the West: the metropolitan–colonial relation has thus once again been turned round so that global colonialism becomes the historical

structure of capitalism, whether at home or abroad.[31]

Deleuze and Guattari's concept of territorialization is also partic-ularly important in the context of colonialism and involves three further implications. The first serves as a reminder that colonialism above all involves the physical appropriation of land, its capture for the cultivation of another culture. It thus foregrounds the fact that cultural colonization was not simply a discursive operation but a seizure of cultural (in all senses of the word) space. Early examples of attempts at mapping the world show how colonialism was impelled by a global desire which fuelled its ever-increasing spatial expansion. This moved, inevitably, through different stages: in the first, space forms the basis of a trade which changed a self-sufficient feudal society into a city-culture based on trade between cultures absent to each other; the colonialism of 'commerce and cultivation' sought land for the cultiva-tion of hot-climate crops, while the colonialism derived from popula-tion surpluses required more temperate land for emigration; finally, there was imperial space – required because of a belief in the necessarily expansive nature of culture *per se*, a doctrine that fuelled the famous 'scramble' for Africa from the 1880s onwards.[32] Each of these moments can be articulated with Deleuze and Guattari's definition of territorialization, deterritorialization and reterritorialization as the dynamics of the colonial or imperial propagation of economic, cultural and social spatialization.

The second implication of territorialization can be viewed in terms of the relation between the land and the state. The institution of the state is frequently regarded as the distinctive sign of the arrival of 'civilization' over 'primitivism'. As Engels pointed out, the state is first and foremost a territorial concept.[33] In colonialism, therefore, we often have a conflict between societies that do and do not conceive of land as a form of private property: at one level indeed, colonialism involves the introduction of a new notion of land as property, and with it inevitably the appropriation and enclosure of land. This develops into a larger system of the imposition of economic roles and identities. Deleuze and Guattari's later concept of 'nomadism', which appears in volume two of the *Anti-Oedipus, A Thousand Plateaus,* is important here. Nomadism works as a form of indirect opposition to the state; so Deleuze and Guattari challenge their readers to find 'points of non-culture and underdevelopment, the zones of ... third-worlds' in their own societies and knowledge systems.[34] Nomadism thus describes both the form of society that preceded feudalism and capitalism as well as a certain strategic manoeuvring that can be employed in the terrain of the present. As the idea of movement across territories in its name suggests, nomadism involves forms of lateral resistance to any asser-tion of hegemonic control through strategies of multiplicity, forms of

deterritorialization that cannot be reterritorialized because they frustrate interpretation and recoding. Terrorism would be an extreme example of a political activity whose deeds are designed to resist interpretation as much as to assert power. But nomadism involves any activity that transgresses contemporary social codes through the dissolution of cultural and territorial boundaries.[35] At the same time, Deleuze and Guattari reach too quickly for such counter-strategies: if we recall the enforced dislocations of the peoples of the South, it means that we cannot concur with the idea that 'nomadism' is a radically anti-capitalist strategy; nomadism is, rather, one brutal characteristic mode of capitalism itself.[36]

Territorialization in its third mode highlights that characteristic of colonialism so effectively emphasized, as we have already noted, by Fanon, *contra* Gandhi: violence. Colonization begins and perpetuates itself through acts of violence, and calls forth an answering violence from the colonized.[37] Here capitalism is the destroyer of signification, the reducer of everything to a Jakobsonian system of equivalences, to commodification through the power of money. This allows a certain degree of historical specificity: for colonialism operated through a forced symbiosis between territorialization as, quite literally, plantation, and the demands for labour which involved the commodification of bodies and their exchange through international trade. Commerce, by reducing everything in a society to a system of universal equivalency, to a value measured in terms of something else, thus performs an operation of cultural decoding that works according to the linguistic form of metaphor. At the same time, at a literal level, the goods provided in exchange for bodies were often articles like iron, copper or cloth that were already available locally. Such trade had the effect of destroying indigenous industries and thus deterritorializing and reterritorializing production through the creation of forms of dependency.

All this suggests the ways in which the *Anti-Oedipus* offers a means of thinking through not only the discourse, but also the repressive geopolitics of colonialism. The desiring machine provides a means of articulating the violent way in which colonial practices were inscribed both physically and psychically on the territories and peoples subject to colonial control. The problem with the *Anti-Oedipus* as it stands for any form of historical analysis, apart from its sheer difficulty, is that the processes of decoding, recoding and overcoding imply a form of cultural appropriation that does not do justice to the complexities of the way in which cultures interact, degenerate and develop over time in relation to each other. Decoding and recoding implies too simplistic a grafting of one culture on to another. We need to modify the model to a form of palimpsestual inscription and reinscription, an historical

paradigm that will acknowledge the extent to which cultures were not simply destroyed but rather layered on top of each other, giving rise to struggles that themselves only increased the imbrication of each with the other and their translation into increasingly uncertain patchwork identities. In addition, contrary to the implication of deterritorialization and reterritorialization, it was often the case that colonial powers such as Britain did not erase or destroy a culture, but rather attempted to graft on to it a colonial superstructure that would allow the convenience of indirect rule, freezing the original indigenous culture by turning it into an object of academic analysis, while imposing the mould of a new imperial culture. This was not a simple process of the production of a new mimesis, however. Analysis of colonial discourse has shown that no form of cultural dissemination is ever a one-way process, whatever the power relation involved. A culture never repeats itself perfectly away from home. Any exported culture will in some way run amok, go phut or threaten to turn into mumbo-jumbo as it dissolves in the heterogeneity of the elsewhere.

Above all, however, what the *Anti-Oedipus* offers is a way of theorizing the material geopolitics of colonial history as, at the same time, an agonistic narrative of desire. While providing an overall theoretical paradigm, the desiring machine also allows for the specificity of incommensurable, competing histories forced together in unnatural unions by colonialism. Nothing catches this disavowed but obsessional tale of disjunctive connections between territories and bodies better than the pulsations of the desiring machines caught up in a continual process of breaks and flows, couplings and uncouplings, 'crossing, mixing, overturning structures and orders ... always pushing forward a process of deterritorialization'.[38] The repressive legacy of the desiring machine of colonial history is marked in the aftermath of today's racial categories that speak of hybrid peoples, yoked together: Black British, British Asian, Kenyan Asian, Anglo-Indian, Indo-Anglian, Indo-Caribbean, African-Caribbean, African-American, Chinese-American.... The names of these diasporic doubles bear witness to a disavowal of any crossing between white and black. In today's political terms any product of white and black must always be classified as black. In the racial categories of the past, although the same general rule applied, it was not so simple. The traces of miscegenation were tracked with a furtive but obsessive interest and attention and marked with a taxonomic fervour through which we can glimpse an extraordinary ethnography of colonial desire.

COLONIAL DESIRE: RACIAL THEORY AND THE ABSENT OTHER

In the nineteenth century, for the most part the cultural relation between Britain and her colonies was thought through on the basis of what Foucault calls the sovereign model of power (the basic assumption of diffusionism). But we can also see in the endless discussions of questions of racial miscegenation the soft underbelly of that power relation, fuelled by the multifarious forms of colonial desire. So, for example, Frederick Marryat's Peter Simple differentiates between the participants at a fancy dress ball in Barbados before announcing his own sexual preference:

> The progeny of a white and a negro is a mulatto, or half and half – of a white and mulatto, a *quadroon*, or one-quarter black, and of this class the company were chiefly composed. I believe a quadroon and white make the *mustee* or one-eighth black, and the mustee and white the mustafina, or one-sixteenth black. After that, they are *whitewashed*, and considered as Europeans.... The quadroons are certainly the handsomest race of the whole; some of the women are really beautiful.... I must acknowledge, at the risk of losing the good opinion of my fair country-women, that I never saw before so many pretty figures and faces.[39]

But as we have seen, such desire, constituted by a dialectic of attraction and repulsion, soon brings with it the threat of the fecund fertility of the colonial desiring machine, whereby a culture in its colonial operation becomes hybridized, alienated and potentially threatening to its European original through the production of polymorphously perverse people who are, in Bhabha's phrase, white, but not quite:[40] in the nineteenth century, this threatening phenomenon of being degraded from a civilized condition was discussed as the process of 'decivilization'. The obsessive detail with which the allegedly decivilizing activity of miscegenation was analysed can be seen at a glance in Table 2, originally published in the German Johann von Tschudi's *Travels in Peru*, and subsequently widely reproduced in anthropological accounts of race, for example in Nott and Gliddon's *Types of Mankind*, or, as here, Robert Brown's four-volume survey, *The Races of Mankind*.[41]

South America was always cited as the prime example of the degenerative results of racial hybridization ('Let any man turn his eyes to the Spanish American dominions, and behold what a vicious, brutal, and degenerate breed of mongrels has been there produced, between Spaniards, Blacks, Indians, and their mixed progeny' remarks Edward Long; 'they are a disgrace to human nature', adds Knox, blaming the

Table 2 Tschudi's table of Peruvian 'mongrelity', as reproduced in Brown's *The Races of Mankind* (1873–9)

Nothing could perhaps better illustrate the mongrel character of the Spanish-American population than by saying that twenty-three crosses can be determined, and have received names. They are as follows:

PARENTS			CHILDREN
White father and	negro	mother	mulatto
" "	Indian	"	mestiza
Indian "	negro	"	chino
White "	mulatto	"	cuarteron
" "	mestiza	"	creole (pale-brownish complexion)
" "	chino	"	chino-blanco
" "	cuarterona	"	quintero
" "	quintera	"	white
Negro "	Indian	"	zambo
" "	mulatto	"	zambo-negro
" "	mestiza	"	mulatto-oscura
" "	chino	"	zambo-chino
" "	zamba	"	zambo-negro (perfectly black)

PARENTS			CHILDREN
Negro father and	quintera	mother	mulatto (rather dark)
Indian "	mulatto	"	chino-oscura
" "	mestiza	"	mestizo-claro (frequently very beautiful)
" "	chino	"	chino-cola
" "	zamba	"	zambo-claro
" "	chino-cola	"	Indian (with frizzly hair)
Mulatto "	quintera	"	mestizo (rather brown)
" "	zamba	"	zambo (a miserable race)
" "	mestiza	"	chino (rather clear complexion)
" "	chino	"	chino (rather dark)

In America the terms mulatto, quadroon and octoroon are commonly used to express the possession of a half, a fourth or an eighth of black blood, and the nomenclature goes no further, but experienced observers can detect much more minute quantities. A person with one half of Indian blood is usually styled a half-caste, or more commonly a half-breed. The term is used, however, very vaguely to denote the presence of a greater or less amount of white blood.

perpetual revolutions of South America on their degenerate racial mixture; observations that are dutifully repeated by Spencer and Hitler).[42] According to Alvar's *Lexico del mistiza en hispanoamérica*, published in 1987, there are 128 words in Spanish for different combinations of mixed races.[43] Such charting was important in all countries where there was slavery: in Latin America where, since the *Real Pragmática* of 1776, the Imperial state had legislated rules governing marriage for Spanish subjects;[44] in the West Indies, where by law persons of mixed race could not vote or inherit property beyond £2,000; and of course in the United States, which shared the convention, recognized in law, that variously from one-eighth to one-thirty-second part African blood (i.e. three to five generations back) defined the boundary between being black and white.[45] But even for later generations who had become indistinguishably white, further tests were devised to track any furtive vestiges of secreted blackness. According to Sir William Lawrence:

> Europeans and Tercerons produce Quarterons or Quadroons (ochavones, octavones, or alvinos), which are not to be distinguished from whites; but they are not entitled, in Jamaica at least, to the same legal privileges as the Europeans or the white Creoles, because there is still a contamination of dark blood, although no longer visible. It is said to betray itself sometimes in a relic of the peculiar strong smell of the great-grandmother.[46]

If the olfactory nerves were not sensitive enough for such mephitic clues, E. B. Tylor tells of a simpler visual test employed in the Southern United States where, as he puts it, 'the traces of negro descent were noted with the utmost nicety':

> Not only were the mixed breeds regularly classed as mulattos, quadroons, and down to octoroons, but even where the mixture was so slight that the untrained eye noticed nothing but a brunette complexion, the intruder who had ventured to sit down at a public dinner-table was called upon to show his hands, and the African taint detected by the dark tinge at the root of the finger nails.[47]

Should that fail, the Anthropological Society President, James Hunt, cites a lady correspondent from the Confederate States of America, who informed him that:

> It is an attested fact, that if there is a drop of African blood in the system of a white person, it will show itself upon the scalp. The greater the proximity, the darker the hue, the larger the space: there may not be the slightest taint perceptible in any other part

177

of the body, but this spot can never be wiped out, no intervening time will ever efface it; and it stands in the courts of law in the Southern Confederacy as a never-failing test, unimpeachable as a law of Nature.[48]

Such obsessive investigation was by no means confined to the Americas. In India, the government Census of 1901 was devised by Herbert H. Risley on the social Darwinist principle that 'caste was the result of interactions between two racial types, a white and a black', and ended up by classifying the people of India into 2,378 main castes and tribes, competitively arranged according to social precedence.[49]

In the anthropological discussions of miscegenation, it is noticeable that reproductions of Tschudi's table unfailingly include his evaluative comments: the curious descriptions of the children of different proportions of mixed race that increasingly supplement the second column show the influence of the contemporary emphasis on the different mental and physical qualities of different races and the intermixtures between them. (It is no doubt symptomatic that despite its exhaustive categorizations, Tschudi never raises in the table the possibility of the coupling of any 'Indian' or 'negro' father with a white mother: the whole process is theoretically not reversible.) We can read this table of miscegenation or 'mongrelity', as Brown describes it, as an obsessive tabulation of desire, as well as an analytic account of the intricate gradations of cultural fusion, regarded as a process of degeneration that mocked the nineteenth century's 'diffusion' model of the spread of cultures with the confusion of fusion, subverted alike both evolutionist and polygenist schools of ethnography, and beyond these held out the threat of undoing the whole progressive paradigm of Western civilization. Here theories of racial difference as degeneration themselves fused with the increasing cultural pessimism of the late nineteenth century and the claim that not only the population of cities but the world itself, that is the West, was degenerating. Each new racial ramification of miscegenation traced an historical trajectory that betrayed a narrative of conquest, absorption and inevitable decline. For the Victorians, race and sex became history, and history spoke of race and sex.

It has often been suggested that the problem with Western historiography is that, generally speaking, only the West has been allowed a history. But in fact while this is in certain respects true, a different, covert history *was* assigned to the non-West in the nineteenth century, and that was the history produced by historical philology, which told of the development and diffusion of languages through a panoramic narrative of tribal migration and conquest, bringing in its wake the absorption of weak races by the strong. Aryan identity was also

constituted through diaspora, through a history that equated migration with colonization. While this Darwinian, diasporic narrative of the Indo-European family was used as a way of giving European imperial expansion the status of natural law, its story of absorption, and therefore of linguistic and racial inmixing, at the same time also implicitly foretold the corruption, decadence and degeneration of European imperial civilization.

So much so, in fact, that it eventually gave rise to arguments for the necessity of decolonization. C. L. Temple, for example, in his *Native Races and Their Rulers* (published in 1918, just fifteen years after the British annexation of what was to become Nigeria), argued that history has showed that 'one of three destinies awaits the conquered ... race. It either fuses with, *i.e.* becomes absorbed in and absorbs the conquering race, and this is the usual result; or it re-captures its liberty; or, less often, it dies out'. Temple reasons that Africans are unlikely to die out (far too fertile; it was, of course, precisely this third option that became part of Nazi ideology); but he also considers that 'fusion between the European and the dark-skinned races of Africa is entirely out of the question'. Temple therefore asks of the Africans: 'What then is to be their future?' He answers: 'Historical analogies lead us to one conclusion only, *i.e.*, that they will some day recapture their liberty'.[50] Fear of racial fusion, therefore, brings him to the extreme position of envisaging the necessity of the dismantling of the Empire itself. Forty years later, it was gone.

In recent years a whole range of disciplines has been concerned with the question of the exclusion and representation of 'the Other', of inside/outside notions of otherness or of the difficulties, negotiated so painfully though not powerlessly by anthropologists, of self–other relations.[51] Our talk of Manichean allegories of colonizer and colonized, of self and Other, mirrors the ways in which today's racial politics work through a relative polarization between black and white. This remorseless Hegelian dialectalization is characteristic of twentieth-century accounts of race, racial difference and racial identity. I want to argue, however, that for an understanding of the historical specificity of the discourse of colonialism, we need to acknowledge that other forms of racial distinction have worked simultaneously alongside this model. Without any understanding of this, we run the risk of imposing our own categories and politics upon the past without noticing its difference, turning the otherness of the past into the sameness of the today. The loss that follows is not merely one for the knowledge of history: as with the case of hybridity, we can also remain unaware of how much that otherness both formed and still secretly informs our present.

Brown's finely gradated table suggests that Victorian racism, and

therefore the colonialism with which it is associated, worked not only according to a paradigm of the Hegelian dialectic of the same and the Other but also according to the norm/deviance model of diversity and inequality.[52] Deleuze and Guattari get it right in their analysis of race and 'faciality', where they argue that it is Christ's face that has come to be identified with the White Man himself:

> If the face is in fact Christ, in other words, your average ordinary White Man, then the first deviances, the first divergence-types are racial: yellow man, black man.... European racism as the white man's claim has never operated by exclusion, or by the designation of someone as Other.... Racism operates by the determination of degrees of deviance in relation to the White-Man face, which endeavours to integrate non-conforming traits into increasingly eccentric and backward waves.... From the viewpoint of racism, there is no exterior, there are no people on the outside. There are only people who should be like us and whose crime is not to be.[53]

Racial difference in the nineteenth century was constructed not only according to a fundamental binary division between black and white but also through evolutionary social anthropology's historicized version of the Chain of Being.[54] Thus racialism operated both according to the same–Other model and through the 'computation of normalities' and 'degrees of deviance' from the white norm, by means of which racial difference became identified with other forms of sexual and social perversity as degeneracy, deformation or arrested embryological development.[55] But none was so demonized as those of mixed race. A race, Deleuze and Guattari observe, 'is defined not by its purity but rather by the impurity conferred upon it by a system of domination. Bastard and mixed-blood are the true names of race'.[56] The uncontrollable expenditure of a 'spermatic economy' was the real work of colonial dissemination. Paradoxically it was the very desire of the white for the non-white, and the proliferating products of their unions, that 'dislimned boundaries', in Gillian Beer's phrase, and undid the claim for permanent difference between the races while at the same time causing the boundary territories of the racial frontier to be policed ever more possessively.[57]

If it was through the category of race that colonialism itself was theoretically focussed, represented and justified in the nineteenth century, it was also through racial relations that much cultural interaction was practised. The ideology of race, a semiotic system in the guise of ethnology, 'the science of races', from the 1840s onwards necessarily worked according to a doubled logic, according to which it both enforced and policed the differences between the whites and the

non-whites, but at the same time focussed fetishistically upon the product of the contacts between them. Colonialism was always locked into the machine of desire: 'the machine remains desire, an investment of desire whose history unfolds'.[58] Folded within the scientific accounts of race, a central assumption and paranoid fantasy was endlessly repeated: the uncontrollable sexual drive of the non-white races and their limitless fertility. What was clearly so fascinating was not just the power of other sexuality as such, the 'promiscuous', 'illicit intercourse' and 'excessive debauchery' of a licentious primitive sexuality, so salaciously imagined in the later editions of Malthus's *Principle of Population*, in the marriage-by-capture fantasies of McLennan's *Primitive Marriage* (1850), or in Spencer's chapters on 'Primitive Relations of the Sexes' and 'Promiscuity' in his *Principles of Sociology*.[59] As racial theories show in their unrelenting attempt to assert inalienable differences between races, this extraordinary vision of an unbounded 'delicious fecundity', in Virginia Woolf's phrase, only took on significance through its voyeuristic tableau of frenzied, interminable copulation, of couplings, fusing, coalescence, *between races*. At its core, such racial theory projected a phantasmagoria of the desiring machine as a people factory: a Malthusian fantasy of uncontrollable, frenetic fornication producing the countless motley varieties of interbreeding, with the miscegenated offspring themselves then generating an ever-increasing *mélange*, 'mongrelity', of self-propagating endlessly diversifying hybrid progeny: half-blood, half-caste, half-breed, cross-breed, amalgamate, intermix, miscegenate; alvino, cabre, cafuso, castizo, cholo, chino, cob, creole, dustee, fustee, griffe, mamaluco, marabout, mestee, mestindo, mestizo, mestize, metifo, misterado, mongrel, morisco, mule, mulat, mulatto, mulatta, mulattress, mustafina, mustee, mustezoes, ochavon, octavon, octoroon, puchuelo, quadroon, quarteron, quatralvi, quinteron, saltatro, terceron, zambaigo, zambo, zambo prieto.... Nineteenth-century theories of race did not just consist of essentializing differentiations between self and other: they were also about a fascination with people having sex – interminable, adulterating, aleatory, illicit, inter-racial sex.

But this steamy model of mixture was not a straightforward sexual or even cultural matter: in many ways it preserved the older commercial discourse that it superseded. For it is clear that the forms of sexual exchange brought about by colonialism were themselves both mirrors and consequences of the modes of economic exchange that constituted the basis of colonial relations; the extended exchange of property which began with small trading-posts and the visiting slave ships originated, indeed, as much as an exchange of bodies as of goods, or rather of bodies as goods: as in that paradigm of respectability, marriage, economic and sexual exchange were intimately bound up, coupled

with each other, from the very first. The history of the meanings of the word 'commerce' includes the exchange both of merchandise and of bodies in sexual intercourse. It was therefore wholly appropriate that sexual exchange, and its miscegenated product, which captures the violent, antagonistic power relations of sexual and cultural diffusion, should become the dominant paradigm through which the passionate economic and political trafficking of colonialism was conceived. Perhaps this begins to explain why our own forms of racism remain so intimately bound up with sexuality and desire. The fantasy of post-colonial cultural theory, however, is that those in the Western academy at least have managed to free themselves from this hybrid commerce of colonialism, as from every other aspect of the colonial legacy.

NOTES

1 HYBRIDITY AND DIASPORA

1 On Englishness see Colley, *Britons: Forging the Nation*; Colls and Dodd, *Englishness*; and C. Hall, *White, Male and Middle-Class*. Though the political point is important, the overdetermined history of Englishness makes it difficult to claim, as Hall does, that 'Englishness is an ethnicity, just like any other' (205).

2 Heathcliff, perhaps the most famous Liverpudlian in English literature, engages in the following dialogue about his racial origins with Nelly Dean:

> 'In other words, I must wish for Edgar Linton's great blue eyes, and even forehead,' he replied. 'I do – and that won't help me to them.'
> 'A good heart will help you to a bonny face, my lad,' I continued, '*if you were a regular black*; and a bad one will turn the bonniest into something worse than ugly. And now that we've done washing, and combing, and sulking – tell me whether you don't think yourself rather handsome? I'll tell you, I do. You're fit for a prince in disguise. Who knows but your father was Emperor of China, and your mother an Indian queen.... And you were kidnapped by wicked sailors, and brought to England.'
>
> (emphasis mine; *Wuthering Heights*, 54)

On miscegenation in fiction, see Busia, 'Miscegenation as Metonymy', and Henriques, *Children of Caliban, passim*.

3 See Showalter's brilliant reading of *The Strange Case of Dr Jekyll and Mr Hyde* in *Sexual Anarchy*, 105–26.

4 Kureishi, *My Beautiful Laundrette*, 60. Kipling, *Kim*, 341.

5 See Bhattacharyya, 'Cultural Education in Britain', 19n; and, for an up-front statement of its ideological strategy, Dilke, *Greater Britain*. It is for this reason that I have not used the term 'British' to describe 'English' Literature.

6 Wills, *Improprieties*, 78–9. According to the OED, the term 'Great Britain' came 'into practical politics in connection with the efforts to unite England and Scotland'; in 1604 James I was declared 'King of Great Britain, France and Ireland', and this phrasing was adopted for the United Kingdom at the Union in 1707.

7 Spencer, *Essays*, I, 3. The essay, 'Progress: Its Law and Cause', was first published in 1857. Cf. Haller, *Outcasts from Evolution*, 95–152.

8 Sartre, *Critique of Dialectical Reason*; Fanon, *The Wretched of the Earth*; Memmi, *The Coloniser and The Colonised*; JanMohamed, 'The Economy of Manichean Allegory'.
9 Anthias and Yuval-Davis, *Racialized Boundaries*, 175.
10 Bhabha, *Nation and Narration*; Bitterli, *Cultures in Conflict*; Fabian, *Time and the Work of Anthropology*; Hulme, *Colonial Encounters*; Reuter, *Race and Culture Contacts*; Spivak, *In Other Worlds* and *The Post-Colonial Critic*.
11 Commodities: see Appadurai, *The Social Life of Things*, and Wolf, *Europe and the People Without History*. Health and disease: Crosby, *Ecological Imperialism*; Janzen, *The Quest for Therapy in Lower Zaire*; Macleod and Lewis, *Disease, Medicine and Empire*; Vaughan, *Curing Their Ills*. Religion: Comaroff, *Of Revelation and Revolution*.
12 Among recent discussions, see in particular, Fabian, *Language and Colonial Power*.
13 Hyam, *Empire and Sexuality*, 211.
14 Carlyle, 'The Nigger Question', 354.
15 Nott, 'The Mulatto a Hybrid'. OED gives one (highly significant) earlier example, from Ben Jonson: 'She's wild Irish born, sir, and a hybride' (Jonson, *The New Inn, or the Light Heart*, 1630).
16 Prichard, *Researches*, 9 ff, and *The Natural History of Man*, 11 ff.
17 Stuart Glennie, 'The Aryan Cradle-Land', 554, cited in OED.
18 Long, *History of Jamaica*, II, 336. On monogenism and polygenism, see Haller, *Outcasts from Evolution*, 69–94; Stepan, *The Idea of Race in Science*, 29–46; on hybridity, see Stepan, 'Biological Degeneration: Races and Proper Places', in Chamberlain and Gilman, *Degeneration*, 104–12.
19 Waitz, *Introduction to Anthropology*, 13.
20 Holland, 'Natural History of Man', 5. For a succinct account of the fundamental issues in nineteenth-century anthropology, see Beer, 'Speaking for the Others'.
21 Knox, *The Races of Men*, 2nd edn, 487.
22 Long, *History of Jamaica*, II, 335.
23 Hitler, *Mein Kampf*, 258.
24 Lawrence, *Lectures*, 209–24.
25 Rich, *Race and Empire*, 132–3; Reuter, *Race Mixture*, 183–201; Baker, *Race*, 11–12, 89–98, 223–31.
26 See, for example, Hernton, *Sex and Racism*.
27 Anon., 'The New System of Colonization', 258. The writer continues: 'This is the natural course of events when a superior race establishes itself in a country peopled by an inferior one'.
28 Huxley, *Lectures to Working Men*, II, 423–4.
29 It was only those arguing for the unity of species who insisted on the difference between mongrelity and hybridity, for example, Quatrefages (*The Human Species*, 70–80), who makes the same point about the difference between atavism and reversion (77–8).
30 Prichard, *The Natural History of Man*, 18, 19. The best account of Prichard's work is Stocking's introduction to the 1973 reprint of *Researches into the Physical History of Man*, 'From Chronology to Ethnology. James Cowles Prichard and British Anthropology', ix–cx; see also his *Victorian Anthropology*, 46–77. As Stepan points out (*The Idea of Race in Science*, 33), Prichard admitted some difficulties with the criterion of intrafertility, and therefore bolstered his argument by emphasizing the similarities of human to animal variation.

31 The discursive consistency of the ubiquitous topic of hybridity can be found by consulting the works cited in the bibliography by Agassiz, Bachman, Baker, Broca, Brown, Crawfurd, Darwin, W. F. Edwards, Huxley, Knox, Morton, Nott, Nott and Gliddon, Pickering, Pouchet, Prichard, Quatrefages, Ripley, Hamilton Smith, Smyth, Spencer, Topinard, Tylor, Vogt, Waitz.

32 Waitz, *Introduction to Anthropology*, 25.

33 Darwin, *The Descent of Man*, 272.

34 Darwin, *Origin of Species*, 288. Further references will be cited in the text. The complex cultural context of Darwin's work has been addressed in two outstanding modern studies, Beer, *Darwin's Plots*, and Young, *Darwin's Metaphor*.

35 Despite this conclusion, it is noticeable, however, that Darwin continues to distinguish carefully between 'hybrids', the crossing of two species, and 'mongrels', the crossing of two varieties.

36 Stepan, 'Biological Degeneration: Races and Proper Places', in Chamberlain and Gilman, *Degeneration*, 119, n. 44.

37 Darwin, *Descent of Man*, 280.

38 For the endurance of polygenism throughout the nineteenth century, see Stocking, 'The Persistence of Polygenist Thought in Post-Darwinian Anthropology', in *Race, Culture, and Evolution*, 42–68.

39 Darwin, *Descent of Man*, 282–3. For the influences of Darwin's ideas in contemporary discussions of the extinction of races, see, for example, Bendyshe, 'On the Extinction of Races'; Lee, 'The Extinction of Races'; Wallace, 'The Origin of Human Races'.

40 For discussions of the effect of Darwin's work in the sphere of racial and cultural theory see Jones, *Social Darwinism and English Thought*; Stepan, *The Idea of Race in Science*, 47–139; Stocking, *Victorian Anthropology*, 128–273.

41 Cf. Jones, *Social Darwinism and English Thought*, 159.

42 See Stocking, *Victorian Anthropology*, 148–85.

43 Cf. Banton, *Racial Theories*, 28–64.

44 Hotze, 'The Distinction of Race', 414.

45 Knox, *The Races of Men*, 2nd edn, 577–8, citing Edwards, *Des caractères physiologiques*, 18–20.

46 Knox, *The Races of Men*, 481–507. Broca had published his *On the Phenomena of Hybridity in the Genus Homo* in book form in 1860, having been writing on the topic since the 1830s. The Anthropological Society of London arranged for its translation into English in 1864.

47 Pouchet, *Plurality of the Human Race*, 97. Pouchet was, as his title suggests, a polygenist.

48 Knox, *The Races of Men*, 2nd edn, 495.

49 Nott and Gliddon, *Types of Mankind*, 373; Knox, *The Races of Men*, 2nd edn, 486–98.

50 Prichard, *Natural History of Man*, 4th edn, I, xviii–xix; Norris's 'correction' is noted by Curtin, *The Image of Africa*, 368–9. Cf. Stepan, 'Biological Degeneration', in Chamberlain and Gilman, *Degeneration*, 97–120. Stepan points out that by this point Quatrefages remained virtually the last adherent of monogenism among leading European biologists.

51 Among many examples, Henriques cites a nineteenth-century commentator on the West Indies remarking that the *fille de couleur* was classed with 'the most beautiful women of the human race' (*Children of Caliban*, 110).

52 Broca, *On the Phenomena of Hybridity*, x. Cf. Latham, *The Natural History of*

the Varieties of Man, who contrasts 'Hybridism (Extreme Intermixture)' with the 'Simple Intermixture' of the English (555–7).

53 Beddoe, *The Races of Britain.* Beddoe's work is discussed further in Chapter 3.
54 Defoe, 'The True-Born Englishman' (1701), 335, 340, cited by Anderson, *Imagined Communities,* 10; Vogt, *Lectures on Man,* 433.
55 Crawfurd, 'On the Classification of the Races of Man', 357.
56 *The London Review,* 16 Feb. 1861, 187 (OED). OED also cites Southey's *Madoc in Wales* (1805). Madoc exclaims:

> Barbarians as we are,
> Lord Prelate, we received the law of Christ
> Many a long ago before your pirate sires
> Had left their forest dens; nor are we now
> To learn that law from Norman or from Dane,
> Saxon, Jute, Angle, or whatever name
> Suit best your mongrel race!
>
> (XV, 103–9, *Poems,* 512).

Cf. Rodney Hilton, 'Were the English English?', in *Patriotism,* ed. Samuel, I, 39–43.

57 Spencer, *Principles of Sociology,* I, 593.
58 Sir Arthur Keith, *Nationality and Race* (Robert Boyle Lectures, 1919), cited in Poliakov, *The Aryan Myth,* 52.
59 See Stepan, *The Idea of Race in Science,* 105–6.
60 Vogt, *Lectures on Man,* 441.
61 Spencer, *Principles of Sociology,* I, 594.
62 Spivak, *In Other Worlds,* 79.
63 Spivak, 'Can the Subaltern Speak?', 295.
64 William von Humboldt, 'The Nature and Conformation of Language', in Mueller-Vollmer, *The Hermeneutics Reader,* 104; Voloshinov, *Marxism and the Philosophy of Language,* 23.
65 Bakhtin, *The Dialogic Imagination,* 358. Further references will be cited in the text.
66 Brathwaite, *The Development of Creole Society,* 296 ff.
67 Bhabha, 'Signs Taken for Wonders', 154. Further references will be cited in the text.
68 Bhabha, 'The Postcolonial Critic', 57–8. Cf. also 61.
69 Bhabha, 'The Commitment to Theory', 13.
70 Said, *Culture and Imperialism,* 406; Bhabha, 'DissemiNation', in Bhabha, *Nation and Narration,* 312.
71 Rushdie, *Imaginary Homelands,* 394; Ashcroft *et al., The Empire Writes Back,* 33–7; Bongie, *Exotic Memories,* 26–9.
72 Gates, *The Signifying Monkey,* 50–1; Voloshinov, *Marxism and the Philosophy of Language,* 19.
73 Hall, 'New Ethnicities', 27.
74 Ibid., 29–30. Cf. Hall, 'Cultural Identity and Diaspora'.
75 Mercer, 'Diaspora Culture and the Dialogic Imagination', 57.
76 On race and homosexuality see Dollimore, *Sexual Dissidence,* 329–56.
77 Cf. Suleri, *The Rhetoric of English India,* 17; Bristow, *Empire Boys.*
78 See Talbot, 'The Intermixture of Races', in *Degeneracy,* 92–103. Cf. Nordau, *Degeneration;* Gilman, *Difference and Pathology;* Chamberlain and Gilman,

Degeneration; Pick, *The Faces of Degeneration;* Burleigh and Wippermann, *The Racial State.*

79 Foucault, 'The Subject and Power', 210.

2 CULTURE AND THE HISTORY OF DIFFERENCE

1 Cromer, *Political and Literary Essays,* Third Series, 2.
2 Lugard, *The Dual Mandate,* 618–19.
3 Dollimore, *Sexual Dissidence,* 344.
4 Adorno to Benjamin, 18 March 1936, in Bloch *et al., Aesthetics and Politics,* 123.
5 Williams, *Keywords,* 87–93; the analysis of the word 'culture' that follows is indebted to Williams's entry in *Keywords* and to the discussions in *Culture and Society* and *Culture.* Cf. also Marcuse, 'The Affirmative Character of Culture', *Negations,* 88–133. For historical analyses of the sociogenesis of the concepts 'civilization' and 'culture', see especially Elias, *The Civilizing Process,* and Stocking, *Victorian Anthropology.*
6 *Mill on Bentham and Coleridge,* 106–7, cited in Williams, *Culture and Society,* 68.
7 Williams, *The Country and the City;* Mumford, *The City in History;* White, *Tropics of Discourse,* 150–82.
8 Boswell, *Boswell's Life of Johnson,* II, 155.
9 Benjamin, 'Theses on the Philosophy of History', VII, *Illuminations,* 258.
10 Williams, *Keywords,* 58.
11 Pye, *The Progress of Refinement,* II, 751–6. Pye somewhat contradictorily also, however, includes a patriotic empire: surveying the colonization of the world, Albion excitedly exclaims how her descendants will 'Extend o'er half the globe Britannia's laws' (770).
12 Ibid., 735–40. Although the reference to the absence of culture clearly includes agriculture, it also involves learning, social institutions and a holistic notion of society; at I, 53–5, Pye uses culture in its older, agricultural sense.
13 See Sekora, *Luxury.*
14 In this connection it is useful to recall Coleridge's remarks (in *On the Constitution of Church and State*) on '*the permanent distinction and the occasional contrast between cultivation and civilization* ... a nation can never be a too cultivated, but may easily become an over-civilized, race', cited by Williams, *Culture and Society,* 76.
15 See Meek, *Social Science and the Ignoble Savage.*
16 Knight, *The Progress of Civil Society,* V, 315n. Knight's sympathies become clearer when he traces the causes of the calamities of the French Revolution 'to manufacturing and commercial mobs', observing sourly, 'And rapes and murders grow the rights of man' (VI, 428).
17 Mill, 'Civilization', in *Dissertations and Discussions,* I, 160–205. 'Barbarian', meaning an 'uncultured person', was first used 1762 by Hume, of Cromwell. Amongst many further examples of this identification of civilization with race, one could cite Lewis Henry Morgan's *Ancient Society: Researches in the Lines of Human Progress from Savagery through Barbarism to Civilization* (1877) which was used by Marx, and formed the basis for Engels's arguments in *The Origin of the Family, Private Property, and the State* (1884).

18 Prichard, *Researches*, 233–9. Cf. Stepan, *The Idea of Race in Science*, 38.
19 Mill, 'Civilization', in *Dissertations and Discussions*, I, 160.
20 Stocking, *Race, Culture, and Evolution*, 71. The major ethnological exhibits were not introduced until the Crystal Palace was moved to Sydenham in 1852. See Stocking, *Victorian Anthropology*, 47, 53.
21 Lenin, *Imperialism*, 93–4 (Lenin's interpolation).
22 Cf. Anderson, *Imagined Communities*, 67–8.
23 Williams, *Keywords*, 89.
24 Herder, *Outlines*, 241. Further references will be cited in the text.
25 Todorov, *Nous et les autres*, 28.
26 Herder, *Outlines*, 264; cf. 166.
27 See Agassiz's 'Sketch of the Natural Provinces of the Animal World and Their Relation to the Different Types of Man', in Nott and Gliddon's *Types of Mankind*, lviii–lxxvi, and Stepan, 'Biological Degeneration: Races and Proper Places', in Chamberlain and Gilman, *Degeneration*, 98–104.
28 See Gobineau, *Inequality of Races*, I, 171; Knox, *The Races of Men*, 42–3.
29 Cf. Herder, 'Yet Another Philosophy of History', in *J. G. Herder on Social and Political Culture*, ed. Barnard, 199 ff.
30 Herder, *Outlines*, 562. This line of argument would be reiterated by Thomas Arnold in his *Introductory Lectures on Modern History*.
31 Herder, *Outlines*, 146. This allows him a little later, to go even further: 'That African forms may coalesce with ideal Beauty, is proved by every head of Medusa' (343).
32 Olender, *The Languages of Paradise*, 49.
33 Though see Todorov, *Nous et les autres*, 51–70, for discussion of eighteenth-century relativists such as Montaigne, Rousseau and Helvétius.
34 On the invention of folk-culture, see Shiach, *Discourse on Popular Culture*.
35 See Derrida, 'The Violence of the Letter: From Lévi-Strauss to Rousseau', in *Of Grammatology*, 101–40; on Lévi-Strauss, see also Derrida's 'Structure, Sign, and Play in the Discourse of the Human Sciences', in *Writing and Difference*, 278–93.
36 *Mill on Bentham and Coleridge*, 132, cited by Williams, *Culture and Society*, 74–5.
37 *Culture and Anarchy* is discussed in detail in the following chapter.
38 Williams, *Culture and Society*, 124. According to OED, however, the word had been used in this sense since 1805.
39 Williams, *Keywords*, 91. Closest to the anthropological sense in OED was 'a particular form or type of intellectual development' (5b); in the second edition, this definition is confirmed for the anthropological: 'Also, the civilization, customs, artistic achievements, etc., of a people, especially at a certain stage of its history'. The first recorded instance of this use of the word 'culture' is not given from Tylor, but rather from Freeman's *The Norman Conquest* (1867): 'a language and culture which was wholly alien to them'. A citation from 1891 reads: 'speaking all languages, knowing all cultures, living amongst all races'.
40 Lévi-Strauss, *The View from Afar*, 26.
41 Stocking, *Victorian Anthropology*, 138–9.
42 Kroeber and Kluckhohn, *Culture*; Stocking, 'Matthew Arnold, E. B. Tylor, and the Uses of Invention', in *Race, Culture, and Evolution*, 69–90. Further references will be given in the text.
43 Tylor, *Primitive Culture*, I, 1.
44 Stocking suggests that degenerationists subscribed to the doctrine of

polygenesis, but this was by no means always the case.

45 By the time of the First World War, the argument about species and cultural difference was turned into a way of differentiating the difference between the Germans and the English. So, for example, Clifford, in *German Colonies: A Plea for the Native Races*, asserts that the Hottentots in German South West Africa were considered by the Germans to be 'mere useless cumberers of the earth, and their systematic extirpation was determined upon in the holy name of *Kultur*' (96). A little later, he makes the bizarre claim that 'We may thank God that throughout the Dark Continent "white men" and "Germans" are regarded and spoken of by the natives as two utterly distinct species of mankind' (113).

46 The key text in this area was Lyell's *Geological Evidences of the Antiquity of Man*.

47 Cf. Stocking, *Victorian Anthropology*, 169–85.

48 Hotze, *Analytical Introduction*, 35–7.

49 Trollope, *North America*, 22. Not in *OED*.

50 Honan, *Arnold*, 9. In his essay on 'On the Origins of Civilization' (1854), in *Miscellaneous Lectures and Reviews*, 26–57, Whately distinguished between material evolution of societies and their spiritual development as Arnold himself was to do. Stocking points out that unlike the hard-line polygenists, Arnold himself believed in the possibility of education and therefore not in absolute distinct differences between races; but the idea that the savage could be educated into civilization was not unacceptable to some polygenists, such as Whately, so long as they were not shown to have originated it themselves but to have been assisted; see Stocking, *Race, Culture, and Evolution*, 76–8.

51 Tylor, *Primitive Culture*, 23; Stocking, *Race, Culture, and Evolution*, 79.

52 Vogt, *Lectures on Man*, 262, 294.

53 Stocking, *Victorian Anthropology*, 73–4, 172–3, 181.

54 See Stocking, 'The Persistence of Polygenist Thought in Post-Darwinian Anthropology', in *Race, Culture, and Evolution*, 42–68.

55 Clark, *Civilisation*, 346.

56 Boas, *The Mind of Primitive Man, Anthropology and Modern Life*, and *Race, Language and Culture*.

57 On Modernism and Primitivism, see Torgovnick, *Gone Primitive*; Hiller, *The Myth of Primitivism*; and Kuper, *The Invention of Primitive Society*.

58 Arnold, *Literature and Dogma*, in *Dissent and Dogma*, 162.

59 See Viswanathan, *Masks of Conquest*.

60 For analysis of this institutional dissension, see my 'Idea of a Chrestomathic University'.

61 See Carey, *The Intellectuals and the Masses*; Huyssen, *After the Great Divide*; and, for a longer-term view, Brantlinger, *Bread and Circuses*.

62 Williams, *Keywords*, 92.

63 Eliot, *Notes towards the Definition of Culture*, 16.

64 See Jones, *Social Darwinism and English Thought*, 144–59.

65 Marcuse, *Eros and Civilization*, 198: 'If the guilt accumulated in the civilized domination of man by man can ever be redeemed by freedom, then the "original sin" must be committed again: "We must again eat from the tree of knowledge in order to fall back into the state of innocence" (Kleist, "Ueber das Marionettentheater").'

66 Williams, *Keywords*, 91.

67 Bauman, *Modernity and Ambivalence*, and *Intimations of Postmodernity*.

3 THE COMPLICITY OF CULTURE

1 *Keywords,* and see *Culture and Society,* 134–5. Arnold, *Culture and Anarchy* (ed. Dover Wilson): further references in the text will be to this, the most widely used edition.
2 Herder is in fact cited approvingly by Arnold, *Culture and Anarchy,* 70–1.
3 See Stepan, *The Idea of Race in Science,* 37.
4 Mill, *Dissertations and Discussions,* I, 174.
5 Williams, *Culture and Society,* 132. Cf. my 'Idea of a Chrestomathic University'.
6 Cf. Said, *The World, the Text, the Critic,* 174; and Bennett's advocacy of the study of the institutionalization of literary culture in *Outside Literature.*
7 Arnold, *Culture and Anarchy,* 198.
8 Avebury, *The Origin of Civilization,* 345.
9 Arnold, *Culture and Anarchy,* 109, 99, 106; cf. Sinfield, *Postwar Britain,* 273–4, and Said, *The World, the Text, the Critic,* 15.
10 Said, 'Criticism Between Culture and System', in *The World, the Text, the Critic,* 178–225.
11 Arnold, Preface to *Literature and Dogma,* in *Dissent and Dogma,* 162.
12 Arnold, *Culture and Anarchy,* 228–9n. Arnold first defines 'philistinism' at length in the essay on Heinrich Heine, *Essays in Criticism,* First Series, 162–7.
13 Arnold, *Culture and Anarchy,* 168–9.
14 Stocking, *Victorian Anthropology,* 213–15.
15 In *Minotaur,* Tom Paulin, citing Burckhardt, remarks astutely that 'at some deep, culturally inherited level, it would appear that the European imagination perceives a secret kinship between art and the state' (4). In this, as in so many other ways, Arnold seems to have been a true European.
16 Arnold, *Culture and Anarchy,* 131, 129, 130; cf. *Literature and Dogma,* in *Dissent and Dogma,* 164–5.
17 Cf. Stepan, 'Race and Gender', in Goldberg, ed., *Anatomy of Racism,* 38–57.
18 Cf. Mahaffy, *Social Life in Greece,* 305–11, and Ellmann, *Oscar Wilde,* 27, 281, 304, 363–4. For Wilde's exchange of letters with Arnold, see 137–8.
19 See, for example, Holland, Latham, Prichard, Wood on 'The Natural History of Man'.
20 *Culture and Anarchy,* 182. Arnold's identification with the Greeks begins from the moment he names the aristocracy as the Barbarians: for the Greeks, anyone who was not a Greek was a barbarian.
21 Lewis, *The Lion and The Fox,* 298.
22 'In order to appreciate the impact of "blood" on culture, the determining role of race in history had to be learned': Court, *Institutionalising English Literature,* 108–9; Cheyette, *Constructions of 'the Jew',* 14; Russell, *Letters of Matthew Arnold,* II, 11.
23 Said, *Orientalism,* 14.
24 Lewis, *The Lion and the Fox,* 299–326.
25 Trilling, *Matthew Arnold,* 232–43.
26 James Joyce, *Ulysses,* 622. For a recent historical treatment, see Lambropoulos, *The Rise of Eurocentrism.* Lambropoulos argues that Derrida's hebraism constitutes an attempt to reverse Arnold's hellenic culture. His discussion of the racial basis of the distinction is, however, limited to citations from Bernal's *Black Athena* (83–4). I am grateful to Edward Said

for drawing this book to my attention.

27 Williams, *Culture and Society*, 135.
28 Bernal, *Black Athena*, 220.
29 Said, *Orientalism*, 227.
30 Gilman, *Difference and Pathology*; Nordau, *Degeneration*; Chamberlain and Gilman, *Degeneration*; Pick, *The Faces of Degeneration*; Burleigh and Wippermann, *The Racial State*.
31 Blumenbach, *Anthropological Treatises*.
32 Cf. Stocking, *Victorian Anthropology*, 48–53; Banton, *Racial Theories*, 22–4.
33 Nott and Gliddon, *Types of Mankind*, 49; cf. Hotze, *Analytical Introduction*, 58.
34 Thomas Arnold, *Introductory Lectures*, 33–5.
35 See Poliakov, *The Aryan Myth*, 231.
36 Knox, *The Races of Men*, 378, 341.
37 Cf. Stocking, *Victorian Anthropology*, 56–62.
38 Césaire, *Discourse on Colonialism*, 16, citing Renan's *La Réforme intellectuelle et morale de la France* (1871) (*Œuvres complètes*, I, 390); Arnold, 'Renan's *La Réforme intellectuelle et morale de la France*' (1872), in *God and the Bible*, 40–50.
39 Todorov, *Nous et les autres*, 129–36, 141–6, 165–78.
40 Ibid., 137.
41 See Poliakov, *The Aryan Myth*, 222.
42 'Lettre à Gobineau' (26 June 1856), *Œuvres complètes*, 10, 203–5; *The Future of Science*, xv.
43 *Œuvres complètes*, 2, 322; cited by Olender, *The Languages of Paradise*, 53.
44 Cited by Lewis, *The Lion and the Fox*, 24.
45 For the influence of Renan, Bunsen and Müller on Hopkins's language theories, see Sprinker, *Counterpoint of Dissonance*, 56–62. In 1886 Hopkins even described 'inscape' in the language of racialized essences as '*species* or individually-distinctive beauty of style' (my emphasis), *Further Letters*, 373. Cf. Paulin, 'Hopkins on the Rampage', in *Minotaur*, 90–8.
46 Arnold, *Celtic Literature* in *Lectures*, 335.
47 Cf. Cairns and Richards, *Writing Ireland*, 43–9, and Lloyd, *Nationalism and Minor Literature*, 6–13.
48 Renan, *The Poetry of the Celtic Races*, 1. Further references will be cited in the text.
49 Arnold, *Celtic Literature*, 293. Further references will be cited in the text.
50 Ibid., 500, n. 297.
51 Ibid., 299 and n.
52 Kingsley, *Charles Kingsley*, III, 111; Beddoe, *The Races of Britain*, 11. Cf. Gibbons, 'Race against Time', and Bracken, 'Essence, Accident and Race', 90–1, for a summary of racial attitudes towards the Irish in this period.
53 Knox, *The Races of Men*, 379.
54 Edwards, *Des caractères physiologiques des races humaines*; Arnold's list 'Read 1865', *Notebooks*, 578. A detailed synopsis of Edwards's book had appeared in the *Phrenological Journal* in 1835 (Anon., 'The Physiological Characters of Races of Mankind').
55 Nott and Gliddon, *Types of Mankind*, 93.
56 Morton, *Crania Americana*, Davis and Thurnam, *Crania Britannica*, I, 238. Arnold also seems not to have known Price's *Essay on the Physiognomy and Physiology of the Present Inhabitants of Britain, with reference to their Origin as Goths and Celts*, which was published the same year as Edwards's book

(1829); in general, his knowledge of the considerable literature that existed on Celts and Saxons by 1867 was clearly limited.

57 Knox, *The Races of Men*, 2nd edn, 506.
58 Blanckaert, 'On the Origins of French Ethnology'; Curtin, *Image of Africa*, 363.
59 Cited in Banton, *Racial Theories*, xiii.
60 Thierry, Augustin, *Histoire de la conquête de l'Angleterre par les Normands*.
61 Lonsdale, *A Sketch of the Life and Writings of Robert Knox*, 293.
62 Beddoe, *Races of Britain*; Beddoe was Welsh by birth; his first work was *A Contribution to Scottish Ethnology* (1853); like Knox and Edwards, his interest in race probably stemmed from a concern with his own ethnicity. Havelock Ellis, *A Study of British Genius*.
63 Hodgkin's involvement in trying to counteract the contemporary trend towards the extinction of races led him to found the Aborigines' Protection Society in 1837 (it became the Ethnological Society in 1843). Hodgkin was instrumental in drawing up the British Association for the Advancement of Science's list of 'Queries respecting the Human Race, to be addressed to Travellers and others'. Despite his more liberal attitude compared to Knox, Hodgkin's Queries, originally 89 in number, but later extended to 103, are clearly based on the same racial theories of type. A question on racial intermixture asks 'whether there is a marked difference arising from the father or the mother belonging to one of the types in preference to another; also whether the mixed form resulting from such intermarriage is known to possess a permanent character, or after a certain number of generations to incline to one or other of its component types' (Hodgkin, 'Varieties of Human Race', 334).
64 Edwards, *Des caractères physiologiques*, 19.
65 Knox, *The Races of Men*, 181. The story is repeated in *The Races of Men*, 2nd edn, 504.
66 Belzoni, *Description of the Egyptian Tomb*, 12; the figures are illustrated in Belzoni, *Narrative*, Plates VI–VIII. For a modern account of the tomb, see Mayes, *The Great Belzoni*, 257–63.
67 Edwards, *Des caractères physiologiques*, 26.
68 Ibid., 29.
69 Davis and Thurnam, *Crania Britannica*, I, 8. It could only have been this theory that enabled Knox, whose father was German (descended, he claimed, from John Knox) and mother Scottish, to ally himself with the Saxons, not the Celts.
70 Arnold, *Celtic Literature*, 339–40, translating Edwards, *Des caractères physiologiques*, 70–1.
71 See the Preface to Beddoe, *The Races of Britain*; Beddoe mentions that other candidates for the prize included Owen L. Pike, author of *The English and Their Origin: A Prologue to Authentic History* (1866). Cf. Strangford, 'Mr Arnold on Celtic Literature', in *Original Letters*, 223–30, and Faverty, *Matthew Arnold*, 34.
72 Todorov, *Nous et les autres*, 168.
73 142. Cf. Arnold, *Celtic Literature*, 300. For a detailed account of Arnold's interest in Jews and Judaism, see Cheyette, *Constructions of 'the Jew'*, 14–23.
74 Cf. Faverty, *Matthew Arnold*, 173–4.
75 See Cheyette, *Constructions of 'The Jew'*.
76 Bunsen, 'On the Result of Recent Egyptian Researches', 268; *Philosophy of Universal History*, I, 5–6, II, 183–96, and *God in History*, 75–7. The source of the Hellene/Hebrew dualism is normally ascribed to Heine (e.g. *Culture*

and Anarchy, ed. Super, 435n), and sometimes compared to Moses Hess's theory of the eternal differences of Rome and Jerusalem. Arnold would have found the identification of the English with the 'Hellenic' races in Taine; in making the distinction between epochs of Hebraic concentration and Hellenic expansion he follows Renan's distinction between Aryan multiplicity and Semitic unity in his *Histoire générale et système comparé des langages sémitiques* (1855) (*Œuvres complètes,* VIII, 127–589). Cf. Todorov, *Nous et les autres,* 180, 171, 146.

77 Knox provides a convenient summary of his model of history as a succession of racial conflicts in *The Races of Men,* 2nd edn, 588–600.

78 'A Persian Passion Play', *Essays in Criticism,* 3rd edn (1875), in *God and the Bible,* 14.

79 Arnold, *Literature and Dogma,* in *Dissent and Dogma,* 239–41, and 479–80n; Burnouf, *The Science of Religions.* Despite his scepticism, Arnold cites Burnouf's *Science of Religions* in his *Note-Books* (178), as well as the following extract from 'Origines de la poésie hellénique': 'Les Hellènes sont un des plus brillans rameaux du tronc Aryen, mais non le seul; il y en a eu deux autres dans l'antiquité, la Perse ... et l'Inde' (495).

80 Renan, 'What is a Nation?' (1882). There is no evidence that Arnold in fact knew Renan's essay.

81 Lewis, *The Lion and the Fox,* 306.

82 Both Fryer (*Staying Power,* 178) and Said (*Culture and Imperialism,* 157) state that Arnold publicly supported Eyre, but produce no evidence in support of this. Fryer, 524, cites *The Times* no. 25,584 (23 Aug. 1866), 7, which reports Kingsley's speech at a banquet at Southampton for Eyre on his return to Britain; but there is no mention of Arnold. Semmel, *The Governor Eyre Controversy* mentions Arnold briefly, but only cites his disapproval of all rioting in general expressed in a letter of 14 Dec. 1867 to his mother (132–4).

83 Green, *British Slave Emancipation.*

84 Arnold, 'A French Eton, or Middle-Class Education and the State' (1864), in *Democratic Education,* 319.

85 Cf. Beer, *Forging the Missing Link,* 3.

4 SEX AND INEQUALITY

1 Yeats, 'Under Ben Bulben', *Collected Poems,* 398.

2 Tennyson, *Locksley Hall,* 168, 177n, *Poems of Tennyson,* 698.

3 Cf. Derrida, 'White Mythology', in *Margins,* 213.

4 Said, *Culture and Imperialism.*

5 Lévi-Strauss, *Structural Anthropology,* II, 325.

6 Fanon, 'Racism and Culture', in *Toward the African Revolution,* 46.

7 For an analysis of the continued operation of racism in science, see Gould, *The Mismeasure of Man.*

8 On the 'Mutiny', see Brantlinger, *Rule of Darkness;* on the American Civil War, Stanton, *The Leopard's Spots;* on Morant Bay, Lorimer, *Colour, Class, and the Victorians,* Hall, *White, Male and Middle-Class.*

9 For this dating of imperialism, see Thornton, *The Imperial Idea and Its Enemies.*

10 Cf. de Lepervanche and Bottomley, *The Cultural Construction of Race.* Goldberg's *Racist Culture* unfortunately appeared too late for consideration here.

11 Knox, *The Races of Men*, Preface, v.
12 Disraeli, *Tancred*, 153.
13 Lorimer, *Colour, Class, and the Victorians*; Chamberlain and Gilman, *Degeneration*.
14 Barkan, *The Retreat of Scientific Racism*; cf. Stephan and Gilman, 'Appropriating the Idioms of Science: The Rejection of Scientific Racism', in LaCapra, *The Bounds of Race*, 72–103.
15 Barzun, *Race*, 11.
16 Cf. Castle, *Masquerade and Civilization*, 78.
17 Stocking, *Race, Culture, and Evolution*, 82–4.
18 Knox, 'Africa: Its Past, Present, and probable Future', in *The Races of Men*, 532–62; Nott, *Two Lectures*; Gliddon, *Ancient Egypt*.
19 Galton, *Hereditary Genius*.
20 See Cowling, *The Artist as Anthropologist*.
21 *The First Lady Chatterley*, 82. I am grateful to Emily Beevers for pointing out this reference to me.
22 Gall, *Vorlesungen über die Verrichtung des Gehirns*.
23 The aesthetic basis of racial distinction is evident throughout the century: see, for example, the accounts of Hope, *On the Origin and Prospects of Man*, Nott and Gliddon, *Types of Mankind*, Knox, *The Races of Men*, or Cope, *The Origin of the Fittest* (Chapter IX, 'The Developmental Significance of Human Physiognomy', 281–93).
24 Hope, *On the Origin and Prospects of Man*, II, 400–1.
25 Hyam, *Empire and Sexuality*, 203. Cf. also Hernton, *Sex and Racism*, and Stember, *Sexual Racism*.
26 Gilman, *Difference and Pathology*, 76–128.
27 Barrell, *The Infection of Thomas De Quincey*.
28 De Quincey, *Confessions*, 73.
29 Cf. Majeed, *Ungoverned Imaginings*, 163–4.
30 Spencer in fact claims that civilized races are more fertile than uncivilized ones; but this goes against his general proposition that 'excess of fertility, through the changes it is ever working in Man's environment, is itself the cause of Man's further evolution; and the obvious corollary here to be drawn, is, that Man's evolution so brought about, itself necessitates a decline in his fertility' (*Principles of Biology*, II, 501). Spencer first advanced his thesis of an 'excess of fertility' in 'A Theory of Population'.
31 De Quincey, *Confessions*, 70.
32 Gobineau, *Essay on the Inequality of Races* (vol. I). Further references will be cited in the text. References to Volumes II–IV will be cited from the untranslated volumes of the *Essai sur l'inegalité des races humaines*.
33 See Poliakov, *The Aryan Myth*, 233.
34 Thus Hitler makes much of the idea of a natural repulsion between races, which he takes from the biological phenomenon of species mating with their own kind, and it is from this fact that he develops his opposition between Aryans and Jews. Hitler's stress on the Aryan (rather than the German, or Indo-German), his major argument (that all civilizations are the exclusive product of Aryans and that the Jews never had a civilization of their own), his contention that civilizations die out through miscegenation between the culture-creating (i.e. Aryan) and culture-bearing or destroying races, described in terms of imagery of 'blood-poisoning' and adulteration, point conclusively to the influence of Gobineau. However, Hitler does not follow Gobineau's argument that racial mixture constitutes

the originating basis for civilization; instead of the instinctive drive of the Aryan to mix their blood that is found in Gobineau, Hitler argues for a natural 'urge towards racial purity'; the fate of a nation revolves around whether it preserves the purity of its blood. See *Mein Kampf*, 258–99.

35 II, 247. Gobineau's ingenuity does not stretch too far: although acknowledging their existence, he declines to explain how South American civilizations have come about.

36 Hope, *Origin and Prospects of Man*, II, 399.

37 See, for example, vol. II, chapter 3.

38 For examples of Gobineau's relativism, see I, 45, 90, 104, 161, 167.

39 It is generally assumed that Gobineau took the concept of degeneration from Blumenbach; if he did, he reversed Blumenbach's optimistic thesis of a slow and progressive development of humanity. See Imhoff, 'L'idée de "dégénération" chez Blumenbach et Gobineau'. For the influence of Egyptology, see the discussion of Nott, below.

40 See Kern, *The Culture of Time and Space*, 104–5.

41 Buenzod, *La Formation de la pensée de Gobineau*, 339.

42 For a complete list of the works cited by Gobineau in the *Essay*, see Buenzod, *La Formation de la pensée de Gobineau*, 601–9.

43 See Stepan, *The Idea of Race in Science*, 88.

44 Hotze, *Analytical Introduction*, 94. Hotze claims that he takes this table from Latham's *Natural History of Man* (14), but the resemblance consists only in the tripartite division of the races.

45 See, for example, Fryer, *Staying Power*, 153–7.

46 Knox, *The Races of Men*, 482–3.

47 Ibid., 599. For Gobineau's antecedents with respect to the role of the Aryans, see Poliakov, *The Aryan Myth*.

48 Cf. Coetzee's discussion of Gobineau's fantasies of blood in 'Blood, Taint, Flaw, Degeneration', in *White Writing*, 145–9, and Foucault's analysis of the symbolic overlappings that culminate in racism during the passage from a society of sanguinity to one of sexuality (*The History of Sexuality*, I, 146–50).

49 Stoker, *Dracula*. As one might expect, we also find in *Dracula* the same sexual dialectic of attraction and repulsion: 'The fair girl went on her knees and bent over me, fairly gloating. There was a deliberate voluptuousness which was both thrilling and repulsive, and as she arched her neck she actually licked her lips like an animal' (52).

50 The term 'mongrel' (and mongrelity) was used since the sixteenth century to denote the offspring of parents of different classes, nationalities – or race.

51 While Gobineau is concerned to stress the intellectual differences between races, and the 'innate repulsion' between them which must imply 'unlikeness and inequality' (I, 179), he admits that there are also 'two great forces' that are always acting on individual humans and 'are continually setting up movements that tend to fuse the races together': the first is bodily attraction and physical compatibility, the second 'the common power of expressing ideas and sensations by the modulation of the voice' (181), in other words, language. But if language allows another form of physical and mental communication, Gobineau concludes that: 'I can now say with certainty that, with regard to the special character of races, philology confirms all the facts of physiology and history … a people's language corresponds to its mentality' (I, 203). Language, Gobineau argues, follows

exactly the same cultural model as 'blood': initially, there is a perfect correspondence between the intellectual powers of races and their language. Any modification derives from intermixture: 'their qualities and merits, like a people's blood, disappear or become absorbed, when they are swamped by too many heterogeneous elements' (I, 204). At the same time, Gobineau admits that 'with the exception of the negroes, and a few yellow groups, we meet only quaternary races in recorded history. All the languages we know are thus derivative' (I, 203). This kind of paradox is characteristic.

52 Grant, *First Love and Last Love* (cf. Brantlinger, *Rule of Darkness*, 209–10); Clifford, *Studies in Brown Humanity*. In Clifford, from the point of view of the attraction/repulsion dialectic that characterizes the white response to black sexuality, the most suggestive story is 'The Strange Elopement of Châlang the Dyak', a tale of a Dyak kidnapped on his wedding day by an amorous orang-utan, whom he eventually stabs. On sado-masochism and white–black relations, see Paulhan's essay, 'A Slave's Revolt: An Essay on *The Story of O*', which compares *The Story of O* to a revolt by slaves against their emancipation (discussed in Huston, 'Erotic Literature in Postwar France'). See also Chapter 6.

53 I, 93–4.

54 Todorov, *Nous et les autres*, 158–9.

55 Gobineau, *Moral and Intellectual Diversity*, 268.

56 According to Carus, the races were also related to bodily organs: the whites to the brain, the blacks to the genitals. See Burleigh and Wippermann, *The Racial State*, 24.

57 Cited in Buenzod, *La Formation de la pensée de Gobineau*, 377.

58 I, 208; see also II, 97–100. Gobineau's paradoxical enthusiasm for the black race was to be developed by Frobenius, and subsequently seized upon by Léopold Senghor for his theory of Négritude. Cf. Miller, *Theories of Africans*, 17–18.

59 Cf. I, 180.

60 Biddiss, *Father of Racist Ideology*, 45.

61 Stallybrass and White, *The Politics and Poetics of Transgression*, 5, 191.

62 Malthus, *Principle of Population*.

63 F. B. Smith, 'Sexuality in Britain, 1800–1900', *University of Newcastle Historical Journal* (New South Wales) 2 (1974), 29, cited in Hyam, *Empire and Sexuality*, 65. On late nineteenth-century cultural degeneration, see Hirsch, *Genius and Degeneration*; Nordau, *Degeneration*; Talbot, *Degeneracy*; and, for modern accounts, Chamberlain and Gilman, *Degeneration*, and Pick, *Faces of Degeneration*.

64 See Hyam, *Empire and Sexuality*, 65–79; Davin, 'Imperialism and Motherhood'; Jones, 'The Eugenics Movement', in *Social Darwinism and English Thought*, 99–120; Weeks, *Sex, Politics and Society*, 128–40.

65 Gobineau's early influence in Germany has been analysed in detail by Michel Lémonon in a series of articles in *Etudes Gobiniennes*, starting in 1967.

66 See Banton, *Racial Theories*, 51.

67 See Burleigh and Wippermann, *The Racial State*, 27–8.

68 Cope, 'Two Perils of the Indo-European', 2052, 2054. Cope's work is discussed by Haller, *Outcasts from Evolution*, 187–202.

69 Burleigh and Wippermann, *The Racial State*, 99.

5 EGYPT IN AMERICA, THE CONFEDERACY IN LONDON

1 Chambers, *Vestiges of the Natural History of Creation*, 277–323.
2 Hall, *White, Male and Middle-Class*, 214, and for ambivalence towards equality in terms of class as well, 239.
3 Brantlinger, *Rule of Darkness*, 174.
4 See Curtin, *The Image of Africa*, 385, on the decline of the power of the anti-slavery rhetoric; and Hyam, *Britain's Imperial Century*, 78–85, for the hardening of racial attitudes.
5 See Stocking, 'What's in a Name?'; *Victorian Anthropology*, 64–5; Stepan, *The Idea of Race in Science*, 41–3.
6 Knox, *The Races of Men*, 565. Curtin notes that the change in attitudes towards race was especially noticeable in the literary reviews, where the work of Knox, and Nott and Gliddon, was warmly received (*Image of Africa*, 381–2).
7 See, for example, the *Quarterly Review* 84 (1848–9), 547; the *Edinburgh Review* 90 (1849), 238–9; Milnes, *The Events of 1848*, 66; and Hotze, *Analytical Introduction*, 101–3. Cf. Stocking, *Victorian Anthropology*, 63.
8 Cited in Poliakov, *The Aryan Myth*, 224.
9 Poliakov, *The Aryan Myth*, 224.
10 Carlyle, 'The Nigger Question'; see Hall, *White, Male and Middle-Class*, 286. Carlyle's later pamphlet, 'Shooting Niagara: And After' (1867) further reinforced his position. On slavery and its aftermath in the West Indies see Curtin, *Two Jamaicas*; Temperley, *British Anti-Slavery*; and Walvin, *Slavery and British Society*.
11 Dickens, 'The Perils of Certain English Prisoners'; *Letters*, 4 Oct. 1857, II, 889, partly cited in Brantlinger, *Rule of Darkness*, 207.
12 For works contesting the new racialism, see Mill, 'The Negro Question'; Bachman, *The Doctrine of the Unity of the Human Race*; Smyth, *The Unity of the Human Races*; and Waitz, *Introduction to Anthropology*. Pickering's *Races of Man* was erroneously thought by some of his contemporaries to be defending the unity of man; in fact, it had been censored by a Committee of the Library of Congress (see Stanton, *The Leopard's Spots*, 92–6).
13 Foucault, *The Birth of the Clinic*, 135–6.
14 Curtin, *Image of Africa*, 364.
15 Eliot, *Middlemarch*, 174.
16 For information on Knox see Lonsdale, *Robert Knox*, Stephan, *Robert Knox*, and Rae, *Knox the Anatomist*, all of whom seem unperturbed by his racism. Knox was clearly a contradictory character. While serving in South Africa in the Fifth Kaffir War against the Bantu, 1817–19, he supported the Bantu's right to independence.
17 Smith, *The Natural History of the Human Species*. On phrenology, see R. M. Young, *Mind, Brain, and Adaptation in the Nineteenth Century*, 9–53, and Stepan, *The Idea of Race in Science*, 21–8.
18 On Hume's racism, see Fryer, *Staying Power*, 152; Beer's 'Carlylean Transports' provides the best understanding of the overall mode of Carlyle's writing (*Arguing with the Past*, 74–98). For a general account of the racism of Carlyle, Trollope, and the anti-racism of Mill, see Jones, 'Trollope, Carlyle, and Mill on the Negro'.
19 Stocking, 'From Chronology to Ethnology', in Prichard, *Researches*, ed. Stocking, xliv, and *Victorian Anthropology*, 49.

20 Prichard, *Researches*, i.
21 Nott and Gliddon, *Types of Mankind*. The best account of American anthropology in this period is Stanton, *The Leopard's Spots*.
22 In 1848 Morton finally stated publicly his belief in a separate origin of races ('Account of a Craniological Collection'); in 1850, Agassiz did the same ('The Diversity of Origin of Human Races').
23 Horsman, *Josiah Nott*, 57–8, Stanton, *The Leopard's Spots*, 45–8. Gliddon's brother was married to the daughter, and his sister to a son (Thornton), of Leigh Hunt. G. H. Lewis and his wife lived in the same establishment in London with them, until Mrs Lewis left him for Thornton Hunt – after which Lewis lived with Mary Ann Evans (George Eliot).
24 Cf. Williamson's discussion of the development of the 'two-colour' system of racial difference in the USA in *New People*, 61–109.
25 See Wakelyn, *Biographical Dictionary of the Confederacy*, 239–40. The best sources on Hotze can be found in Owsley, *King Cotton Diplomacy*, Hotze, *Three Months in the Confederate Army*, Oates, 'Henry Hotze: Confederate Agent Abroad', and Jenkins, *Britain and the War for the Union*.
26 Gobineau, *The Moral and Intellectual Diversity of Races*. Further references will be cited in the text. Hotze's name is also Americanized in this edition and spelt 'Hotz' throughout, but elsewhere he appears as Hotze.
27 Gobineau, *The Moral and Intellectual Diversity of Races*, 241; Hitler, *Mein Kampf*, 260. On American Anglo-Saxonism see Horsman, *Race and Manifest Destiny*.
28 Nott, Appendix to Gobineau, *The Moral and Intellectual Diversity of Races*, 464.
29 Bernal, *Black Athena*. For further discussion of the significance of his omission of American anthropology, see my 'Egypt in America'.
30 Nott, 'The Mulatto a Hybrid'.
31 Ibid., 253, as summarized in *Types of Mankind*, 373.
32 Nott, *Two Lectures*, 8; italics in original.
33 Gliddon, *Ancient Egypt*, 58–9. In five years, Gliddon's book sold 24,000 copies in the USA.
34 Mill, 'The Negro Question', 29–30; cf. Smyth, 'On the Former Civilization of Black Races of Men', *The Unity of the Human Races*, 353–75.
35 Morton, *Crania Americana*, 260. *Crania Americana* also contains an essay on phrenology by the pre-eminent phrenologist of the day, George Combe.
36 Morton, 'Observations on Egyptian Ethnography', 157. Stanton incorrectly states that Morton suggests that 'the Egyptians had been neither Caucasians nor Negroes' (*The Leopard's Spots*, 51). In fact, he states that it was the Copts who were of mixed race (158).
37 Nott and Gliddon, *Types of Mankind*, xxxvi–xxxvii.
38 Morton, 'Observations on Egyptian Ethnography', 158; cf. Nott, *Two Lectures*, 16. Snowden's *Before Color Prejudice* gives a modern view.
39 Nott, *Two Lectures*, 16.
40 For the colonial impact on contemporary Egypt, see Mitchell, *Colonising Egypt*.
41 See, for example, Lee, 'The Extinction of Races', and Bendyshe, 'On the Extinction of Races'. In this context, it might be remarked, that in *Heart of Darkness* Kurtz's scrawled message at the end of his report on 'The Suppression of Savage Customs', 'Exterminate all the brutes!', was not unusual in its choice of terminology (on the assumption, that is, that Kurtz was referring to the Africans).

42 Nott and Gliddon, *Types of Mankind*, 372–410. Further references will be given in the text.
43 Morton, 'Hybridity in Animals', 212.
44 Cf. Broca, *On the Phenomena of Hybridity*. Broca's book is cited extensively by Darwin in *The Descent of Man*. Their accounts of hybridity are discussed in Chapter 1.
45 Darwin, *Origin of Species*, 288.
46 Darwin also attacked the problematic notion of species as fixed categories, but his reaction was not to reject it altogether but to show the conceptual problems arose precisely because species are not in fact absolutely distinct from each other. He used Broca's argument about gradations of fertility to back this up. In emphasizing sexual choice, and the malleability of species, plus the idea of selection and extinction, however, Darwin's ideas moved in the direction of eugenics, and encouraged the increasing prohibitions on cross-sexual relations from the late nineteenth century onwards.
47 Banton, *Racial Theories*, 41.
48 Nott and Gliddon, *Types of Mankind*, 407.
49 See Harris, *The Rise of Anthropological Theory*, 139. In 1850 Morgan was arguing that 'it is time to fix some limits to the reproduction of this black race among us'.
50 Cited by Smyth, *The Unity of the Human Races*, 45. Cf. Frederickson, *The Image of the Black in the White Mind*, 4–36, and Stepan, 'Biological Degeneration: Races and Proper Places', in Chamberlain and Gilman, *Degeneration*, 101–2.
51 28 Feb. 1862, in US War Dept, *Official Records*, III, 352.
52 23 Feb. 1862, ibid., III, 346–7.
53 4 Aug. 1862, ibid., III, 506.
54 See Stocking, *Victorian Anthropology*, 248. For an account of the Anthropological Society, see Burrow, *Evolution and Society*, 118–27; Stocking, 'What's in a Name?'
55 27 Aug. 1863, *Official Records*, III, 878. Hotze's colleague, Josiah Nott, was made an Honorary Fellow of the Anthropological Society.
56 Hunt, *The Negro's Place in Nature*, 24–6.
57 Ibid., 34.
58 Ibid., 60.
59 *Anthropological Review* I (1863), 388–9. The *Anthropological Review* refused to reproduce Craft's own paper to the British Association about his visit to Dahomey, on the grounds that it was incoherent. It did, however, record that in response to a later paper, Craft observed tartly that 'there was just as much difference between individual Africans as between individual Englishmen. He found that all Englishmen were not Shakespeares' (410). For Craft's own slave narrative, see his *Running a Thousand Miles for Freedom*.
60 Hunt then, however, adds a plaintive P.S.: 'N.B. I ought to tell you that I had a goodly number of supporters among the audience at Newcastle.... In time the truth will come out, and then the public will have their eyes opened, and will see in its true dimensions that gigantic imposture known by the name of "Negro Emancipation"' (Hunt, *The Negro's Place in Nature*, v–viii).
61 *The Index*, 4 (24 Mar. 1864), 189; cf. Adams, *Great Britain and the American Civil War*, II, 222; and Huxley, 'Emancipation Black and White'.
62 Hunt, 'President's Address', (1864), xciii.

63 Hunt, 'President's Address', (1866), lxxviii.
64 Jameson, 'The London Expenditures of the Confederate Secret Service', 818. In addition to his own accounts, Hotze's contribution is also recorded in the *Journal of the Anthropological Society*, II (1864), lxxix.
65 By the end of 1863, Hotze was the Confederacy's only representative remaining in Britain, but he continued to be very active, organizing the Peace Petition of 1864, and continuing to publish *The Index* until August 1865.
66 *The Index*, 1 (15 May 1862), 40, cited in Jenkins, *Britain and the War for the Union*, II, 44–5.
67 26 Sept. 1863, *Official Records*, III, 916.
68 Hotze, 'The Distinction of Race', 414.
69 'The Last Card of the North', *The Index*, 1 (7 Aug. 1862), 233–4; Jenkins, *Britain and the War for the Union*, II, 158, cites the *Morning Herald*, the newspaper for which Hotze often wrote, suggesting the same idea on 7 and 13 Aug.; and *The Times*, on 19 Sept. 1862. Trollope had earlier thought Ireland was a better comparison (*North America*, 23).
70 *Anthropological Review*, I (1863), 182. No doubt it was also Hotze who facilitated the publication of Nott's 'The Negro Race' in the Anthropological Society's *Popular Magazine of Anthropology*.
71 6 June 1863, *Official Records*, III, 785.
72 Mill, 'The Slave Power', 503.
73 See Wallace's address to the British Association ('Anthropology'), given the year that anthropology was finally allowed to detach itself from Section V (Geography and Ethnology), and join Section IV (Anatomy and Physiology).
74 Cf. Rich, *Race and Empire in British Politics*.
75 Tylor, *Anthropology*, 4, 80.
76 Ibid., 81–2.
77 Ibid.

6 WHITE POWER, WHITE DESIRE

1 Haggard, *King Solomon's Mines*, 281. Street comments that Haggard's 'treatment of cross-breeds throughout his work suggests that the "scientific" arguments about hybrids also lie behind his objections [to inter-racial marriage]' (*The Savage in Literature*, 101).
2 Trollope, *The West Indies*, 75, 96, 84.
3 Moore, *Health in the Tropics*, 277, 280, 277. On climate and colonization, cf. Hunt, 'On Ethno-Climatology'; on white degeneracy in the tropics, see Stepan, 'Biological Degeneration: Races and Proper Places', in Chamberlain and Gilman, *Degeneration*, 99–104.
4 Brooke, *Ten Years in Saráwak*, II, 331–8. See Reece, 'A "Suitable Population": Charles Brooke and Race-Mixing in Sarawak'. The advantages of 'ethnic intermarriage or crossing' for colonization is discussed by Ripley, *The Races of Europe*, 569–70.
5 See Hyam, 'Chastity and the Colonial Service', *Empire and Sexuality*, 157–81.
6 Croly and Wakeman, *Miscegenation*. Further references will be given in the text.
7 In *The Descent of Man* (1871), Darwin gives the following oft-cited example: 'Thus the crossed offspring from the Tahitians and English, when settled

in Pitcairn Island, increased so rapidly that the Island was soon over-stocked; and in June 1856 they were removed to Norfolk Island. They then consisted of 60 married persons and 134 children, making a total of 194. Here they likewise increased so rapidly, that although sixteen of them returned to Pitcairn Island in 1859, they numbered in January 1868, 300 souls' (295). The idea of a special 'hybrid vigour' is quite common in the period (e.g. Quatrefages, *The Human Species*, 87).

8 *Anthropological Review*, II (1864), 120–1.
9 The National Union Catalogue also gives E. C. Howell as an author of the anonymous *Miscegenation*, but this is an error. For a full account of the controversy caused by the pamphlet, see Kaplan, 'The Miscegenation Issue in the Election of 1864'.
10 Cf. Pratt, 'Eros and Abolition', in *Imperial Eyes*, 86–107.
11 Reproduced in Wood, *Black Scare* (Plate 3, facing page 193).
12 Seaman, *What Miscegenation is!* The title page is illustrated in Henriques, *Children of Caliban* (Plate 1, facing page 84).
13 *Anthropological Review*, II (1864), 288.
14 Conway, *Testimonies Concerning Slavery*, 75–7.
15 Owen, *The Wrong of Slavery*, 212.
16 Ibid., 213, 218–19. See Haller, *Outcasts from Evolution*, 40–68, 203–10, for contemporary debate on the effects of the emancipation of the slave population, including the thesis of a 'natural extinction'.
17 Day, *Sexual Life between Blacks and Whites*, 12.
18 Boas, *The Mind of Primitive Man*, 276–7.
19 See Rich, *Race and Empire*, 127–8.
20 Letter of 9 Aug. 1863, to Samuel Howe, one of the three members of Lincoln's Commission, cited from manuscript by Gould, *The Mismeasure of Man*, 48–9. Agassiz's four letters to Howe are expurgated in the standard collection of Agassiz's letters published by his wife in 1895. See also Stanton, *The Leopard's Spots*, 189–91.
21 Jordan, *White over Black*, 137; Agassiz, *A Journey in Brazil*, 298, 82.
22 Ripley, *The Races of Europe*, 562.
23 Edward Long, *Candid Reflections Upon the Judgement lately awarded by the Court of King's Bench ... On What is Commonly Called the Negro Cause, by a Planter* (London, 1772), 48–9, cited by Fryer, *Staying Power*, 157–8. For comparable anxieties in the twentieth century, see Rich, 'The "Half-Caste" Pathology', in *Race and Empire*, 120–44, and Dover, *Half-Caste*.
24 Fryer, *Staying Power*, 70. Curtin, on the other hand, awards this title to Knox (*The Image of Africa*, 377).
25 Long, *History of Jamaica*, II, 383.
26 Ibid., II, 336; Arnold, *Culture and Anarchy*, 141, *On the Study of Celtic Literature*, 300 (my emphasis).
27 Long, *History of Jamaica*, II, 327–8. In this context, the development and popularity during the course of the century of what one might term 'ethno-porn', popular anthropology liberally illustrated by photographs that largely seem to consist of naked, full-breasted women from around the world, is no doubt symptomatic (see Alloula, *The Colonial Harem*, and Hammerton, *Peoples of All Nations*, Hutchinson, Gregory and Lydekker, *The Living Races of Mankind*, Joyce and Thomas, *Women of All Nations*, Redpath, *With the World's Peoples*). Sir Arthur Keith's introductory essay to Hammerton's *People of All Nations*, while describing the different races as different species, and claiming racial prejudice to be a natural aversive

instinct, also takes care to warn the concupiscent reader that 'the sex instinct will break down the strongest racial barriers' (xx).

28 Hyam, *Empire and Sexuality*, 92; see also 203–6. Cf. Alloula, *The Colonial Harem*; Beckles, 'Prostitutes and Mistresses', in *Natural Rebels*, 141–51; Genovese, 'Miscegenation', in *Roll Jordan Roll*, 413–31; Gilman, 'Black Sexuality and Modern Consciousness', in *Difference and Pathology*, 109–27; Henriques, *Children of Caliban*, 98–110, 120–1; Schipper, 'L'homme blanc et la femme noire', in *Le Blanc et l'Occident*, 30–2. Fanon's 'The Woman of Colour and the White Man', in *Black Skin, White Masks* (41–62), though focussing exclusively on the basis of the desire of the black woman for the white man, interestingly assumes the desire of the white man for the black woman as an unproblematical given.

29 Neilson, *Recollections of a Six Years Residence*, 297, cited in Henriques, *Children of Caliban*, 72.

30 Long, *History of Jamaica*, II, 415. Cf. Henriques's discussion of the sexual politics of New Orleans in *Children of Caliban*, 66–8.

31 Hall, *In Miserable Slavery*. On black women as victims of white male violence, see hooks, 'Sexism and the Black Female Experience', in *Ain't I a Woman*, 15–49; and also Henriques, *Children of Caliban*, 62–3, 96–8; Hernton, *Sex and Racism in America*, 123–68; and Walvin, 'Sex in the Slave Quarters', in *Black Ivory*, 214–29.

32 See hooks, 'Continued Devaluation of Black Womanhood', in *Ain't I a Woman*, 51–86, and Morrison, *The Bluest Eye*.

33 Spivak, 'Can the Subaltern Speak', 297, 296.

34 Edwards, *History of the West Indies*, II, 21–2.

35 In the early nineteenth century the sexual habits of the planters came under increasing moral disapprobation from the missionaries and anti-slavery lobby, who emphasized the 'debauchery' of the white population in their campaigns. See C. Hall, 'Missionary Stories: Gender and Ethnicity in England in the 1830s and 1840s', in *White, Male and Middle-Class*, 207–54. Hall notes that after abolition in 1833 the same criticisms began to be made of the missionaries.

36 Edwards, *History of the West Indies*, II, 26. The attribution to Teale is made by Brathwaite, *Creole Society*, 179.

37 Behn, *Oroonoko*, 9. Cf. Hulme, 'Inkle and Yarico', in *Colonial Encounters*, 224–63.

7 COLONIALISM AND THE DESIRING MACHINE

1 Said, *Orientalism*. Further references will be cited in the text. For an extended discussion of the work of Said, Bhabha and Spivak, see my *White Mythologies*, chapters 7–9.

2 Althusser, *Lenin and Philosophy*, 153.

3 Fanon, *The Wretched of the Earth*, and *Black Skin, White Masks*; Memmi, *The Coloniser and Colonised*; Nandy, *The Intimate Enemy*.

4 Bhabha, 'Difference, Discrimination, and the Discourse of Colonialism', 200.

5 Bhabha, 'Signs Taken for Wonders', 145–6.

6 Spivak, *In Other Worlds*; *The Post-Colonial Critic*; *Outside in the Teaching Machine*; 'Can the Subaltern Speak?'; Guha, 'On Some Aspects of the Historiography of Colonial India'.

7 Holst-Peterson and Rutherford, *A Double Colonization*.
8 Cf. Said's comment in *Orientalism*: 'Flaubert's encounter with an Egyptian courtesan produced a widely influential model of the Oriental woman; she never spoke of herself, she never represented her emotions, presence, or history. *He* spoke for and represented her' (6).
9 Spivak, 'Theory in the Margin'.
10 Mohanty, 'Under Western Eyes'; Parry, 'Problems in Current Theories of Colonial Discourse'; Ahmad, *In Theory*.
11 See Bhabha, 'The Postcolonial Critic', 54.
12 Fanon, *The Wretched of the Earth*; Nkrumah, *Neo-Colonialism*.
13 Fanon, *The Wretched of the Earth*, 74.
14 In recent years, however, there has been some excellent work on Africa, which includes Appiah, *In My Father's House*, Boahen, *African Perspectives on Colonialism*, Curtin, *The Image of Africa*, Hobsbawm and Ranger, *The Invention of Tradition*, Mudimbe, *The Invention of Africa*, Ngugi, *Decolonizing the Mind*, Schipper, *Beyond the Boundaries*, Soyinka, *Myth, Literature and the African World*, Vaughan, *Curing Their Ills*.
15 Trotter, 'Colonial Subjects'; Meek, *Social Science and the Ignoble Savage*, 220–1.
16 Said, *Orientalism*, 44, citing Cromer, *Political and Literary Essays, 1908–1913*, 35; cf. Inden, 'Science's Imperial Metaphor – Society as a Mechanical Body', in *Imagining India*, 7–22.
17 Lugard, *The Dual Mandate*, 608.
18 Deleuze and Guattari, *Anti-Oedipus*. Further references will be cited in the text. For recent accounts of Deleuze and Guattari's work see Bogue, *Deleuze and Guattari*, and Massumi, *A User's Guide*.
19 Deleuze and Guattari, 'What is Minor Literature?'; *A Thousand Plateaus*; JanMohamed and Lloyd, *Minority Discourse*. See also Spivak's judicious discussion of Deleuze's work in 'Can the Subaltern Speak?', 272–6.
20 Deleuze and Guattari, 'Balance Sheet – Program for Desiring Machines', 132; *Anti-Oedipus*, 11.
21 Deleuze and Guattari, *A Thousand Plateaus*, 260, 202.
22 Deleuze and Guattari, 'Balance Sheet – Program for Desiring Machines', 133.
23 *Anti-Oedipus*, 30; cf. the attack on the traditional logic of desire as lack, and thus as an hallucinatory double of reality, 25.
24 For Deleuze and Guattari's account of maps and tracings, see especially *A Thousand Plateaus*, 12–15.
25 Deleuze and Guattari, 'Balance Sheet – Program for Desiring Machines', 133.
26 Harvey, *The Condition of Postmodernity*, 238. This emphasizes the problem of the totalizing perspective of *Anti-Oedipus*: despite its emphasis on minorities, decentring etc., its very global pretensions as a theory continue to make a claim to a general status that will always be hard to sustain in the face of historical particularities. Harvey shows how the apparent absolutism of Deleuze and Guattari's account of the processes of capitalism can be modified to register the continual play of the power struggles of forms of regional resistance, but he ends with the observation that 'the power of capital over the co-ordination of universal fragmented space and the march of capitalism's global historical time' will always achieve final victory (239).
27 Fanon, 'Racism and Culture', in *Toward the African Revolution*, 41, 43.

28 Fanon, *The Wretched of the Earth*, 51, 31.
29 Deleuze and Guattari, 'What is Minor Literature?', 28 n. 3.
30 Deleuze and Guattari, *Anti-Oedipus*, 94, 169.
31 Cf. William Pietz, 'The Phonograph in Africa', in Attridge, Bennington and Young, *Post-Structuralism and the Question of History*, 267–8.
32 See Kern, *The Culture of Time and Space*, 234–40, and cf. Noyes, *Colonial Space*.
33 Engels, *Origin of the Family, Private Property, and the State*, 208.
34 Deleuze and Guattari, *A Thousand Plateaus*, 27.
35 See Deleuze and Guattari, 'What is Minor Literature?', 13–14.
36 Cf. Spivak's comments on the limitations of Deleuze's position in 'Can the Subaltern Speak?', 272–4.
37 The role of violence in Fanon's *Wretched of the Earth* is consistently underestimated by commentators. Violence was, as Todorov points out, often quite openly proclaimed by the colonists themselves, by, for example, de Tocqueville (*Nous et les autres*, 231).
38 Deleuze and Guattari, 'Balance Sheet – Program for Desiring Machines', 123.
39 Frederick Marryat, *Peter Simple* (1834), II, 195–7, partly cited by Brantlinger, *Rule of Darkness*, 59–60. The substance of Marryat's accompanying observations on how attentive everyone is to shades of lightness and darkness in skin colour can be found repeated by commentators again and again, and demonstrates graphically the way in which, as Dollimore observes, 'discrimination is internalized psychically and perpetuated socially *between* subordinated groups, classes, and races' (*Sexual Dissidence*, 344).
40 Bhabha, 'Of Mimicry and Man', 132.
41 Tschudi, *Travels in Peru*, 114; Nott and Gliddon, *Types of Mankind*, 455; Brown, *The Races of Mankind*, II, 6. Tschudi's table is a revision and correction of W. B. Stevenson's 1825 list, where there are no evaluative comments, which is reproduced in Pratt, *Imperial Eyes*, 152. Cf. W. Lawrence's discussion of human hybridity, also including a table, *Lectures*, 252–63.
42 Long, *History of Jamaica*, II, 327; Knox, *The Races of Men*, 505; Spencer, *Principles of Sociology*, I, 592; Hitler, *Mein Kampf*, 260.
43 Alvar, *Lexico del mistiza en hispanoamérica*. For further analysis see Mörner, *Le Métissage dans l'histoire de l'Amerique Latine*.
44 See Susan M. Socolow, 'Acceptable Partners', in Lavrin, *Sexuality and Marriage in Colonial Latin America*, 210–13. Cf. François Bourricaud, 'Indian, Mestizo and Cholo as Symbols in the Peruvian System of Stratification', in Glazer and Moynihan, *Ethnicity*, 350–87; and Stepan, 'The Hour of Eugenics'.
45 In *The Classification of Mankind* (1852) P. A. Browne produced detailed tables and nomenclature for degrees of human hybridity based on a scientific analysis of hair (see Stanton, *The Leopard's Spots*, 152).
46 Lawrence, *Lectures*, 254.
47 Tylor, *Anthropology*, 3.
48 Hunt, *The Negro's Place in Nature*, viii.
49 See Inden, *Imagining India*, 58–66; cf. Ballhatchet, *Race, Sex and Class under the Raj*. I am grateful to Gauri Viswanathan for drawing my attention to the Census of India in this context.
50 Temple, *Native Races and Their Rulers*, 23.
51 For critical analyses of this paradigm, see Beer, 'Speaking for the Others',

and *Forging the Missing Link*, 8; Bhabha, 'The Commitment to Theory', 16; Fabian, *Time and the Other*; Said, 'Representing the Colonized'; Spivak, 'Can the Subaltern Speak?', 280.

52 See Canguilhem's analysis of the ramifications of this model in *The Normal and the Pathological*.

53 Deleuze and Guattari, *A Thousand Plateaus*, 178.

54 Cf. Stepan, *The Idea of Race in Science*, 12 ff.

55 Cf. Stepan, 'Biological Degeneration: Races and Proper Places', in Chamberlain and Gilman, *Degeneration*, 97–120.

56 Deleuze and Guattari, *A Thousand Plateaus*, 379. Stepan, *The Idea of Race in Science*, observes 'that racial crosses were usually bad was an idea that was to endure very long in science.... It was not, in fact, until the 1930s that opinion changed and mulatto populations came to be considered as biologically fit as other populations' (105–6). Dover's *Half-Caste* (1937) constituted the most substantial attack on this powerful racial mythology. Franz Boas should also be given credit for his part in transforming attitudes: in 1911 he wrote: 'It appears from this consideration that the most important practical questions relating to the negro problem have reference to the mulattoes and other mixed bloods – to their physical types, their mental and moral qualities, and their vitality. When the bulky literature of this subject is carefully sifted, little remains that will endure serious criticism' (*The Mind of Primitive Man*, 277).

57 For the 'spermatic economy', see Barker-Benfield, 'The Spermatic Economy: A Nineteenth-Century View of Sexuality', cited in Hyam, *Empire and Sexuality*, 57; Beer, *Arguing with the Past*, 74.

58 Deleuze and Guattari, *Anti-Oedipus*, 38.

59 Malthus, *Principle of Population*, 156, 195, 146; McLennan, *Primitive Marriage*; Spencer, *The Principles of Sociology*, I, 621–97.

BIBLIOGRAPHY

Adams, E. D., *Great Britain and the American Civil War*, 2 vols (London: Longman, 1925).

Adams, H. G., *God's Image in Ebony: Being a Series of Biographical Sketches, Facts, Anecdotes, &c., Demonstrative of the Mental Powers and Intellectual Capacities of the Negro Race* (London: Partridge and Oakey, 1854).

Adorno, Theodor W., *Prisms*, trans. Samuel and Shierry Weber (Cambridge, Mass.: MIT Press, 1981).

Agassiz, Louis, 'The Diversity of Origin of Human Races', *Christian Examiner*, 49 (1850), 110–45.

—— and Agassiz, Mrs Louis, *A Journey in Brazil* (London: Trübner, 1868).

Ahmad, Aijaz, *In Theory: Classes, Nations, Literatures* (London: Verso, 1992).

Alloula, Malek, *The Colonial Harem* (Manchester: Manchester University Press, 1987).

Althusser, Louis, *Lenin and Philosophy, and Other Essays* (London: New Left Books, 1971).

Alvar, Manuel, *Lexico del mistiza en hispanoamérica* (Madrid: Ediciones cultura hispánica, 1987).

Anderson, Benedict, *Imaginary Communities: Reflections on the Origin and Spread of Nationalism* (London: Verso, 1983).

Anon., 'The Physiological Characters of Races of Mankind Considered in their Relations to History: Being a Letter to M. Amédée Thierry, Author of the History of the Gauls', *Phrenological Journal and Magazine of Modern Science*, 10 (1835), 97–108.

—— 'The New System of Colonization – Australia and New Zealand', *The Phrenological Journal and Magazine of Modern Science*, 11, n.s. 1 (1838), 247–60.

Anthias, Floya and Yuval-Davis, Nira, *Racialized Boundaries: Race, Nation, Gender, Colour and Class and the Anti-Racist Struggle* (London: Routledge, 1992).

Appadurai, Arjun, ed., *The Social Life of Things: Commodities in Cultural Perspective* (Cambridge: Cambridge University Press, 1986).

Appiah, Kwame, *In My Father's House: Africa in the Philosophy of Culture* (London: Methuen, 1992).

Arato, Andrew, ed., *The Essential Frankfurt School Reader* (Oxford: Blackwell, 1978).

Armistead, Wilson, *A Tribute for the Negro: Being a Vindication of the Moral, Intellectual, and Religious Capabilities of the Coloured Portion of Mankind* (Manchester: Irwin, 1848).

Arnold, Matthew, *Culture and Anarchy* [1869], ed. J. Dover Wilson (Cambridge: Cambridge University Press, 1932).
—— *The Note-Books of Matthew Arnold*, eds H. F. Lowry, K. Young and W. H. Dunn (London: Oxford University Press, 1952).
—— *Democratic Education*, ed. R. H. Super (Ann Arbor: University of Michigan Press, 1962).
—— *Lectures and Essays in Criticism*, ed. R. H. Super (Ann Arbor: University of Michigan Press, 1962).
—— *Culture and Anarchy, with Friendship's Garland and Some Literary Essays*, ed. R. H. Super (Ann Arbor: University of Michigan Press, 1965).
—— *Dissent and Dogma*, ed. R. H. Super (Ann Arbor: University of Michigan Press, 1968).
—— *God and the Bible*, ed. R. H. Super (Ann Arbor: University of Michigan Press, 1970).
—— *Culture and Anarchy and Other Writings*, ed. Stefan Collini (Cambridge: Cambridge University Press, 1993).
Arnold, Thomas, *Introductory Lectures on Modern History, with the Inaugural Lecture delivered in Dec., 1841* (Oxford: Parker, 1842).
Ashcroft, Bill, Griffiths, Gareth and Tiffin, Helen, *The Empire Writes Back: Theory and Practice in Post-Colonial Literatures* (London: Routledge, 1989).
Attridge, Derek, Bennington, Geoff and Young, Robert, eds, *Post-Structuralism and the Question of History* (Cambridge: Cambridge University Press, 1987).
Avebury, John Lubbock, *The Origin of Civilization and the Primitive Condition of Man: Mental and Social Condition of Savages* [1870], 6th edn (London: Longmans, Green, 1902).
Bachman, John, *The Doctrine of the Unity of the Human Race Examined on the Principles of Science* (Charleston: Canning, 1850).
—— 'An Investigation of the Cases of Hybridity in Animals on Record, considered in reference to the Unity of the Human Species', *Charleston Medical Journal*, 5 (1850), 168–97.
—— 'A Reply to the Letter of Samuel George Morton, M.D., on the Question of Hybridity in Animals considered in reference to the Unity of the Human Species', *Charleston Medical Journal*, 5 (1850), 466–508.
—— 'Second Letter to Samuel G. Morton, M.D., on the Question of Hybridity in Animals, considered in reference to the Unity of the Human Species', *Charleston Medical Journal*, 5 (1850), 621–60.
Baker, John R., *Race* (London: Oxford University Press, 1974).
Bakhtin, M. M., *The Dialogic Imagination: Four Essays*, trans. Caryl Emerson and Michael Holquist (Austin: University of Texas Press, 1981).
Ballhatchet, K., *Race, Sex and Class under the Raj: Imperial Attitudes and Policies and Their Critics, 1793–1905* (London: Weidenfeld & Nicolson, 1980).
Banton, Michael, *Racial Theories* (Cambridge: Cambridge University Press, 1987).
Barkan, Elazar, *The Retreat of Scientific Racism: Changing Concepts of Race in Britain and the United States between the World Wars* (Cambridge: Cambridge University Press, 1992).
Barker, Francis, Hulme, Peter, Iversen, Margaret and Loxley, Diana, eds, *Europe and Its Others*, 2 vols (Colchester: University of Essex, 1985).
Barker-Benfield, G. J., 'The Spermatic Economy: A Nineteenth-Century View of Sexuality', in M. Gordon, ed., *The American Family in Social-Historical Perspective*, 2nd edn (New York: St Martin's Press, 1978), 374–402.
Barrell, John, *The Infection of Thomas de Quincey: A Psychopathology of Imperialism* (New Haven: Yale University Press, 1991).

Barzun, Jacques, *Race: A Study in Modern Superstition* (London: Methuen, 1938).
Bauman, Zygmunt, *Modernity and Ambivalence* (Cambridge: Polity Press, 1991).
—— *Intimations of Postmodernity* (London: Routledge, 1992).
Beckles, Hilary McD., *Natural Rebels: A Social History of Enslaved Black Women in Barbados* (London: Zed Books, 1989).
Beddoe, John, *A Contribution to Scottish Ethnology* (London: Lewis, 1853).
—— *The Races of Britain: A Contribution to the Anthropology of Western Europe* (Bristol: Arrowsmith, 1885).
Beer, Gillian, *Darwin's Plots: Evolutionary Narrative in Darwin, George Eliot, and Nineteenth-Century Fiction* (London: Routledge & Kegan Paul, 1983).
—— *Arguing with the Past: Essays in Narrative from Woolf to Sydney* (London: Routledge, 1989).
—— 'Speaking for the Others: Relativism and Authority in Victorian Anthropological Literature', in Robert Fraser, ed., *Sir James Frazer and the Literary Imagination: Essays in Affinity and Influence* (Basingstoke: Macmillan, 1990), 38–60.
—— *Forging the Missing Link: Interdisciplinary Stories* (Cambridge: Cambridge University Press, 1992).
Behn, Aphra, *Oroonoko: or, the Royal Slave. A True History* [1688] (New York: Norton Library, 1973).
Belzoni, G., *Narrative of the Operations and Recent Discoveries within the Pyramids, Temples, Tombs, and Excavations, in Egypt and Nubia; and of a Journey to the Coast of the Red Sea, in Search of the Ancient Berenice; and another to the Oasis of Jupiter Ammon* (London: Murray, 1820).
—— *Description of the Egyptian Tomb, Discovered by G. Belzoni* (London: Murray, 1821).
Bendyshe, T., 'On the Extinction of Races', *Journal of the Anthropological Society of London*, 2 (1864), xcix–cviii.
Benjamin, Walter, *Illuminations*, trans. H. Zohn (London: Fontana, 1973).
Bennett, Tony, *Outside Literature* (London: Routledge, 1990).
Bernal, Martin, *Black Athena: The Afroasiatic Roots of Classical Civilization. Volume I. The Fabrication of Ancient Greece 1785–1985* (London: Free Association Books, 1987).
Bhabha, Homi K., 'Difference, Discrimination, and the Discourse of Colonialism', in Francis Barker, Peter Hulme, Margaret Iversen and Diana Loxley, eds., *The Politics of Theory* (Colchester: University of Essex, 1983), 194–211.
—— 'Of Mimicry and Man: The Ambivalence of Colonial Discourse', *October*, 28 (1984), 125–33.
—— 'Signs Taken for Wonders: Questions of Ambivalence and Authority under a Tree Outside Delhi, May 1817', *Critical Inquiry*, 12:1 (1985), 144–65.
—— 'The Commitment to Theory', *New Formations*, 5 (1988), 5–23.
—— 'The Postcolonial Critic', *Arena*, 96 (1991), 47–63.
—— ed., *Nation and Narration* (London: Routledge, 1990).
Bhattacharyya, Gargi, 'Cultural Education in Britain; From the Newbolt Report to the National Curriculum', in Robert Young, ed., *Neocolonialism* (*Oxford Literary Review*, 13) (1991), 4–19.
Biddiss, Michael, *Father of Racist Ideology: The Social and Political Thought of Count Gobineau* (London: Weidenfeld & Nicolson, 1970).
Bitterli, Urs, *Cultures in Conflict: Encounters Between European and non-European Cultures, 1492–1800* (Cambridge: Polity Press, 1989).
Blankaert, Claude, 'On the Origins of French Ethnology. William Edwards and the Doctrine of Race', in George W. Stocking Jr, ed. *Bones, Bodies, Behavior.*

Essays on Biological Anthropology (Madison: University of Wisconsin Press, 1988), 18–55.

Bloch, Ernst, *et al., Aesthetics and Politics: Debates Between Bloch, Lukács, Brecht, Benjamin and Adorno* (London: Verso, 1977).

Blumenbach, J. F., *The Anthropological Treatises of Johann Friedrich Blumenbach* [1775–95], ed. and trans. T. Bendyshe (London: Anthropological Society, 1865).

Boahen, A. Adu, *African Perspectives on Colonialism* (Baltimore: Johns Hopkins University Press, 1987).

Boas, Franz, *The Mind of Primitive Man* (New York: Macmillan, 1911).

—— *Anthropology and Modern Life* (London: Allen & Unwin, 1929).

—— *Race, Language and Culture* (New York: Free Press, 1940).

Bogue, Ronald, *Deleuze and Guattari* (London: Routledge, 1989).

Bolt, Christine, *Victorian Attitudes to Race* (London: Routledge & Kegan Paul, 1971).

Bongie, Chris, *Exotic Memories: Literature, Colonialism, and the Fin de Siècle* (Stanford: Stanford University Press, 1991).

Boswell, James, *Boswell's Life of Johnson. Together with Boswell's Journal of a Tour to the Hebrides and Johnson's Diary of a Journey into North Wales* [1791], ed. George Birkbeck Hill, rev. L. F. Powell, 6 vols (Oxford: Clarendon Press, 1934).

Bracken, H. M., 'Essence, Accident and Race', *Hermathena*, 116 (1973), 81–96.

Brantlinger, Patrick, *Bread and Circuses: Theories of Mass Culture as Social Decay* (Ithaca: Cornell University Press, 1983).

—— *Rule of Darkness: British Literature and Imperialism, 1830–1914* (Ithaca: Cornell University Press, 1988).

Brathwaite, Edward, *The Development of Creole Society in Jamaica 1770–1820* (Oxford: Clarendon Press, 1971).

Bristow, Joseph, *Empire Boys: Adventures in a Man's World* (London: Harper-Collins, 1991).

Broca, Pierre Paul, *On the Phenomena of Hybridity in the Genus Homo* [1860], trans. C. Carter Blake (London: Anthropological Society, 1864).

Brontë, Emily, *Wuthering Heights* [1847], ed. William M. Sale (New York: Norton, 1972).

Brooke, Charles, *Ten Years in Saráwak*, 2 vols (London: Tinsley, 1866).

Brown, Robert, *The Races of Mankind: Being a Popular Description of the Characteristics, Manners and Customs of the Principal Varieties of the Human Family*, 4 vols (London: Cassell, Petter & Gilpin, [1873–9]).

Browne, Peter A., *The Classification of Mankind, by the Hair and Wool of their Heads, with the Nomenclature of Human Hybrids* (Philadelphia: Jones, 1852).

Buchan, John, *The African Colony: Studies in Reconstruction* (Edinburgh: Blackwood, 1903).

Buenzod, Janine, *La Formation de la pensée de Gobineau et l'Essai sur l'inegalité des races humaines* (Paris: Nizet, 1967).

Bunsen, Christian Charles Josias, 'On the Results of the Recent Egyptian Researches in Reference to Asiatic and African Ethnology, and the Classification of Languages', *Reports of the British Association*, 17 (1848), 254–99.

—— *Outlines of the Philosophy of Universal History, applied to Language and Religion*, 2 vols (London: Longman, Brown, Green, and Longmans, 1854).

—— *God in History, or the Progress of Man's Faith in the Moral Order of the World* [1857–8], trans. S. Winkworth, 3 vols (London: Longmans, Green, 1868–70).

Burleigh, Michael and Wippermann, Wolfgang, *The Racial State: Germany 1933–1945* (Cambridge: Cambridge University Press, 1991).

Burnouf, Emile, *The Science of Religions* [1872], trans. J. Liebe (London: Sonnenschein, Lowrey, 1888).

Burrow, J. W., *Evolution and Society. A Study in Victorian Social Theory* (Cambridge: Cambridge University Press, 1966).

Busia, Abena P. A., 'Miscegenation as Metonymy: Sexuality and Power in the Colonial Novel', *Ethnic and Racial Studies*, 9:3 (1986), 360–72.

Cairns, David and Richards, Shaun, *Writing Ireland: Colonialism, Nationalism and Culture* (Manchester: Manchester University Press, 1988).

Callaway, Helen, *Gender, Culture, and Empire* (London: Macmillan, 1987).

Campbell, John, *Negro-Mania: Being an Examination of the Falsely Assumed Equality of the Various Races of Men; Demonstrated by the Investigations of Champollion, Wilkinson and Others, together with a Concluding Chapter, Presenting a Comparative Statement of the Condition of the Negroes in the West Indies Before and Since Emancipation* (Philadelphia: Campbell & Power, 1851).

Canguilhem, Georges, *The Normal and the Pathological*, trans. C. Fawcett (New York: Zone Books, 1989).

Carey, John, *The Intellectuals and the Masses: Print and Prejudice among the Literary Intelligentsia, 1880–1939* (London: Faber & Faber, 1992).

Carlyle, Thomas, 'The Nigger Question' [1849], in *Critical and Miscellaneous Essays*, 5 vols (London: Chapman and Hall, 1899), IV, 348–83.

—— 'Shooting Niagara – And After' [1867], in *Critical and Miscellaneous Essays*, 5 vols (London: Chapman and Hall, 1899), V, 1–48.

Castle, Terry, *Masquerade and Civilization: The Carnivalesque in Eighteenth-Century Culture and Fiction* (Stanford: Stanford University Press, 1986).

Césaire, Aimé, *Discourse on Colonialism* [1955], trans. Joan Pinkham (New York: Monthly Review Press, 1972).

Chamberlain, J. Edward and Gilman, S., *Degeneration: The Dark Side of Progress* (New York: Columbia University Press, 1985).

Chambers, Robert, *Vestiges of the Natural History of Creation* (London: Churchill, 1844).

Cheyette, Brian, *Constructions of 'the Jew' in English Literature and Society: Racial Representations, 1875–1945* (Cambridge: Cambridge University Press, 1993).

Clark, Kenneth, *Civilisation: A Personal View* (London: British Broadcasting Corporation and John Murray, 1969).

Clifford, Hugh, *Studies in Brown Humanity: Being Scrawls and Smudges in Sepia, White, and Yellow* (London: Richards, 1898).

—— *German Colonies: A Plea for the Native Races* (London: Murray, 1918).

Clifford, James, *The Predicament of Culture: Twentieth-Century Ethnography, Literature, and Art* (Cambridge, Mass.: Harvard University Press, 1988).

Coetzee, J. M., *White Writing: On the Culture of Letters in South Africa* (New Haven: Yale University Press, 1988).

Colley, Linda, *Britons: Forging the Nation, 1707–1837* (New Haven: Yale University Press, 1992).

Colls, Robert and Dodd, Phillip, eds, *Englishness: Politics and Culture 1880–1920* (London: Croom Helm, 1987).

Comaroff, Jean and John, *Of Revelation and Revolution: Christianity, Colonialism, and Consciousness in South Africa* (Chicago: University of Chicago Press, 1991).

Conway, M. D., *Testimonies Concerning Slavery*, 2nd edn (London: Chapman and Hall, 1865).

Coon, Carleton S., *The Origin of Races* (London: Cape, 1963).
Cope, E. D., *The Origin of the Fittest. Essays on Evolutions* (London: Macmillan, 1887).
—— 'Two Perils of the Indo-European', *The Open Court*, 3 (1890), 2052–4, 2070–1.
Court, Franklin E., *Institutionalizing English Literature: The Culture and Politics of Literary Study, 1750–1900* (Stanford: Stanford University Press, 1992).
Cowling, Mary, *The Artist as Anthropologist: The Representation of Type and Character in Victorian Art* (Cambridge: Cambridge University Press, 1989).
Craft, William, *Running a Thousand Miles for Freedom, or, the Escape of William and Ellen Craft from Slavery* (London: Tweedie, 1860).
Crawfurd, J., 'On the Classification of the Races of Man', *Transactions of the Ethnological Society of London*, n.s., 1 (1861), 354–78.
—— 'On the Supposed Infecundity of Human Hybrids or Crosses', *Transactions of the Ethnological Society of London*, n.s., 3 (1865), 356–62.
Croly, D. G. and Wakeman, G., *Miscegenation: The Theory of the Blending of the Races Applied to the American White Man and Negro* (London: Trübner, 1864).
Cromer, Evelyn Baring, *Political and Literary Essays, 1908–1913* (London: Macmillan, 1913).
—— *Political and Literary Essays, Third Series* (London: Macmillan, 1916).
Crosby, Alfred W., *Ecological Imperialism: The Biological Expansion of Europe, 900–1900* (Cambridge: Cambridge University Press, 1986).
Curtin, Philip, *Two Jamaicas: The Role of Ideas in a Tropical Colony 1830–65* (Cambridge, Mass.: Harvard University Press, 1955).
—— *The Image of Africa. British Ideas and Action 1780–1850* (Madison: University of Wisconsin Press, 1964).
Darwin, Charles, *The Origin of Species by Means of Natural Selection, or the Preservation of the Favoured Races in the Struggle for Life* [1859], ed. J. W. Burrow (Harmondsworth: Penguin, 1968).
—— *The Descent of Man and Selection in Relation to Sex* [1871] (London: Murray, 1901).
Davin, Anna, 'Imperialism and Motherhood', *History Workshop*, 5, 1978, 9–65.
Davis, J. B. and Thurnam, J., *Crania Britannica. Delineations and Descriptions of the Skulls of the Aboriginal and Early Inhabitants of the British Isles: With Notices of their Other Remains*, 2 vols (London: printed for the subscribers, 1865).
Day, Beth, *Sexual Life Between Blacks and Whites: The Roots of Racism* (London: Collins, 1974).
DeLaura, David J., *Hebrew and Hellene in Victorian England: Newman, Arnold, and Pater* (Austin: University of Texas Press, 1969).
Deleuze, Gilles and Guattari, Félix, *Anti-Oedipus: Capitalism and Schizophrenia*, vol. I [1972], trans. Robert Hurley, Mark Seem and Helen Lane (New York: Viking, 1977).
—— 'Balance Sheet – Program for Desiring Machines' [1973], *Semiotext(e)*, 2:3 [6] (1977), 117–35.
—— 'What is Minor Literature?', in *Kafka: For a Minor Literature* [1975], trans. Dana Polan (Minneapolis: University of Minnesota Press, 1985), 16–27.
—— *A Thousand Plateaus: Capitalism and Schizophrenia*, vol. II [1980], trans. Brian Massumi (London: Athlone, 1988).
de Lepervanche, Marie and Bottomley, Gillian, eds, *The Cultural Construction of Race*, Sydney Studies in Society and Culture, no. 4 (Sydney: Sydney Association for Studies in Society and Culture, 1988).
De Quincey, Thomas, *Confessions of an English Opium-Eater, and Other Writings*,

ed. G. Lindop (Oxford: Oxford University Press, 1985).

Derrida, Jacques, *Of Grammatology* [1967], trans. Gayatri Chakravorty Spivak (Baltimore: Johns Hopkins University Press, 1976).

—— *Writing and Difference* [1967], trans. Alan Bass (London: Routledge & Kegan Paul, 1978).

—— *Margins – Of Philosophy* [1972], trans. Alan Bass (Chicago: University of Chicago Press, 1982).

Dickens, Charles, 'The Perils of Certain English Prisoners' [1857], in *Works*, The Charles Dickens Library, 18 vols (London: The Educational Book Co., [1910]), 16, 133–218.

—— *Letters*, ed. Walter Dexter, 3 vols (London: Nonesuch Press, 1937–8).

Dilke, Charles, *Greater Britain: A Record of Travel in English-Speaking Countries during 1866 and 1867*, 2 vols (London: Macmillan, 1868).

Diop, Cheikh Anta, *Nations nègres et culture* (Paris: Editions africaines, 1955).

—— *The African Origin of Civilization: Myth or Reality?* [1955, 1967], trans. M. Cook (Westport: Hill, 1974).

Disraeli, Benjamin, *Tancred, or the New Crusade* [1847], Bradenham edn, vol. 10 (London: Peter Davis, 1927).

Dollimore, Jonathan, *Sexual Dissidence: Augustine to Wilde, Freud to Foucault* (Oxford: Clarendon Press, 1991).

Donald, James and Rattansi, Ali, *'Race', Culture and Difference* (London: Sage/Open University, 1992).

Dover, Cedric, *Half-Caste* (London: Secker & Warburg, 1937).

Dubois, W. E. B., *The World and Africa* (New York: Kraus-Thompson, 1976).

Edwards, Bryan, *The History, Civil and Commercial, of the British Colonies in the West Indies*, 2 vols (London: Stockdale, 1793).

Edwards, W. F., *Des caractères physiologiques des races humaines, considérés dans leur rapports avec l'histoire, lettre à M. Amédée Thierry, auteur de l'histoire des Gaulois* (Paris: Jeune, 1829).

—— *Recherches sur les langues Celtiques* (Paris: Imprimerie royale, 1844).

—— 'De l'influence réciproque des races sur le caractère national', *Mémoires de la Société d'ethnographie*, 2 (1845), 1–12.

Elias, Norbert, *The Civilizing Process: The History of Manners* [1939], vol. I, trans. Edmund Jephcott (Oxford: Blackwell, 1978).

Eliot, George, *Middlemarch* [1871–2], ed. W. J. Harvey (Harmondsworth: Penguin, 1965).

Eliot, T. S., *Notes towards the Definition of Culture* [1948] 2nd edn (London: Faber & Faber, 1962).

Ellis, Henry Havelock, *A Study of British Genius* (London: Hurst & Blackett, 1904).

Ellmann, Richard, *Oscar Wilde* (London: Hamish Hamilton, 1987).

Engels, Friedrich, *The Origin of the Family, Private Property, and the State* [1884] (Harmondsworth: Penguin, 1985).

Fabian, Johannes, *Time and the Other: How Anthropology Makes Its Object* (New York: Columbia University Press, 1983).

—— *Language and Colonial Power: The Appropriation of Swahili in the Former Belgian Congo 1880–1938* (Cambridge: Cambridge University Press, 1986).

—— *Time and The Work of Anthropology. Critical Essays 1971–1991* (Chur: Harwood, 1991).

Ferguson, *Subject to Others: British Women Writers and Colonial Slavery, 1670–1834* (New York: Routledge, 1992).

Fanon, Frantz, *Black Skin, White Masks* [1952], trans. Charles Lam Markmann

(London: Pluto, 1986).
——— *The Wretched of the Earth* [1961], trans. Constance Farrington (Harmondsworth: Penguin, 1967).
——— *Toward the African Revolution. Political Essays* [1964], trans. Haakon Chevalier (Harmondsworth: Penguin, 1970).
Faverty, Frederic E., *Matthew Arnold, the Ethnologist* (Evanston: Northwestern University Press, 1951).
Foster, R. F., *Modern Ireland 1600–1972* (London: Allen Lane, 1988).
Foucault, Michel, *The Birth of the Clinic: An Archaeology of Medical Perception* [1963], trans. A. M. Sheridan (London: Tavistock, 1973).
——— *The History of Sexuality. Volume One: An Introduction* [1976], trans. Robert Hurley (London: Allen Lane, 1979).
——— 'The Subject and Power', Afterword to Herbert L. Dreyfus and Paul Rabinow, *Michel Foucault: Beyond Structuralism and Hermeneutics* (Brighton: Harvester Press, 1982), 208–26.
Frederickson, George M., *The Image of the Black in the White Mind* (New York: Harper & Row, 1971).
Freeman, Edward Augustus, *The History of the Norman Conquest of England: its Causes and its Results*, 6 vols (Oxford: Clarendon Press, 1867).
Fryer, Paul, *Staying Power: The History of Black People in Britain* (London: Pluto Press, 1984).
Gall, Franz Joseph, *Vorlesungen über die Verrichtung des Gehirns* (Berlin: Selpert, 1805).
Galton, Francis, *Hereditary Genius: An Inquiry into its Laws and Consequences* (London: Macmillan, 1869).
Gates, Henry Louis, Jr, *The Signifying Monkey: A Theory of African-American Literary Criticism* (New York: Oxford University Press, 1988).
Genovese, Eugene D., *Roll Jordan Roll: The World the Slaves Made* (New York: Pantheon Books, 1974).
Gibbons, Luke, 'Race Against Time: Racial Discourse and Irish History', in Robert Young, ed., *Neocolonialism* (*Oxford Literary Review*, 13) (1991), 95–117.
Gilman, Sander L., *Difference and Pathology: Stereotypes of Sexuality, Race and Madness* (Ithaca: Cornell University Press, 1985).
Gilroy, Paul, 'There Ain't No Black in the Union Jack': The Cultural Politics of Race and Nation* (London: Hutchinson, 1987).
Glazer, Nathan and Moynihan, Daniel P., eds, *Ethnicity: Theory and Experience* (Cambridge, Mass.: Harvard University Press, 1975).
Glennie, J. Stuart, 'The Aryan Cradle-Land', *Nature*, 42 (1890), 544–5.
Gliddon, George R., *Ancient Egypt. A Series of Chapters on Early Egyptian History, Archaeology, and other Subjects, Connected with Hieroglyphical Literature* [1843], 12th edn (Philadelphia: Peterson, 1848).
Gobineau, Joseph Arthur comte de, *Essai sur l'inegalité des races humaines*, 4 vols (Paris: Firmin Didot, 1853–5).
——— *The Moral and Intellectual Diversity of Races, with Particular Reference to their Respective Influence in the Civil and Political History of Mankind. With an analytical introduction and copious historical notes, by H. Hotz. To which is added an Appendix containing a summary of the latest scientific facts bearing upon the question of the unity or plurality of species. By J. C. Nott, M.D., of Mobile* (Philadelphia: Lippincott, 1856).
——— *The Inequality of Human Races* [vol. I], trans. Adrian Collins (London: Heinemann, 1915).
Goldberg, David Theo, *Racist Culture: Philosophy and the Politics of Meaning*

(Oxford: Blackwell, 1993).

────── ed., *Anatomy of Racism* (Minneapolis: University of Minnesota Press, 1990).

Gossett, Thomas F., *Race: The History of an Idea in America* (Dallas: Southern Methodist University Press, 1963).

Gould, Stephen Jay, *The Mismeasure of Man* (Harmondsworth: Penguin, 1984).

Grant, James, *First Love and Last Love: A Tale of the Indian Mutiny*, 3 vols (London: Routledge, 1868).

Green, William A., *British Slave Emancipation: The Sugar Colonies and the Great Experiment 1830–1865* (Oxford: Clarendon Press, 1976).

Guha, Ranajit, 'On Some Aspects of the Historiography of Colonial India', *Subaltern Studies: Writings on South Asian History and Society*, vol. I, ed. Ranajit Guha (Delhi: Oxford University Press, 1982), 1–8.

Haggard, Rider, *King Solomon's Mines* [1885], ed. Dennis Butts (Oxford: Oxford University Press, 1989).

────── *She* [1887], ed. Daniel Karlin (Oxford: Oxford University Press, 1991).

Hall, Catherine, *White, Male and Middle-Class: Explorations in Feminism and History* (Cambridge: Polity Press, 1992).

Hall, Douglas, ed., *In Miserable Slavery, Thomas Thistlewood in Jamaica, 1750–1786* (London: Macmillan, 1989).

Hall, Stuart, 'Cultural Identity and Diaspora', in Jonathan Rutherford, ed., *Identity: Community, Culture, Difference* (London: Lawrence & Wishart, 1990), 222–37.

────── 'New Ethnicities', *Black Film British Cinema*, ICA Documents, 7 (1988), 27–31.

Haller, John S., *Outcasts from Evolution: Scientific Attitudes of Racial Inferiority, 1859–1900* (Urbana: University of Illinois Press, 1971).

Hammerton, J. A., *Peoples of All Nations. Their Life Today and the Story of Their Past. By Our Foremost Writers of Travel, Anthropology, and History*, 7 vols (London: Educational Book Co., [1922]).

Harris, Marvin, *The Rise of Anthropological Theory* (London: Routledge & Kegan Paul, 1968).

────── *Cultural Materialism: The Struggle for a Science of Culture* (New York: Random House, 1979).

Harvey, David, *The Condition of Postmodernity* (Oxford: Blackwell, 1989).

Henriques, Louis Fernando M., *Children of Caliban. Miscegenation* (London: Secker & Warburg, 1974).

Herder, Johann Gottfried, *Outlines of a Philosophy of the History of Man* [1784–91], trans. T. Churchill (London: Johnson, 1800).

────── *J.G. Herder on Social and Political Culture*, ed. F. M. Barnard (Cambridge: Cambridge University Press, 1969).

Hernton, Calvin C., *Sex and Racism* (London: André Deutsch, 1969).

Herbert, Christopher, *Culture and Anomie: Ethnographic Imagination in the Nineteenth Century* (Chicago: University of Chicago Press, 1991).

Hiller, Susan, ed., *The Myth of Primitivism: Perspectives on Art* (London: Routledge, 1991).

Hirsch, William, *Genius and Degeneration: A Psychological Study* (New York: Appleton, 1896).

Hitler, Adolf, *Mein Kampf* [1925–6], trans. Ralph Manheim (London: Hutchinson, 1969).

Hobsbawm, E. J. and Ranger, Terence, eds, *The Invention of Tradition* (Cambridge: Cambridge University Press, 1983).

Hodgkin, Thomas, 'On Inquiries into the Races of Men', *Reports of the British Association*, 11 (1842), 52–5.

—— 'Varieties of Human Race. Queries respecting the Human Race, to be addressed to Travellers and others. Drawn up by a Committee of the British Association for the Advancement of Science, appointed in 1839', *Reports of the British Association*, 11 (1842), 332–9.

—— and Cull, Richard, 'A Manual of Ethnological Inquiry; being a series of questions concerning the Human Race, prepared by a Sub-Committee of the British Association for the Advancement of Science, appointed in 1851 (consisting of Dr Hodgkin and Richard Cull), and adapted for the use of travellers and others in studying the Varieties of Man', *Reports of the British Association*, 22 (1853), 243–52.

Holland, Henry, 'Natural History of Man', *Quarterly Review*, 86 (1850), 1–40.

Holst-Peterson, K. and Rutherford, A., eds, *A Double Colonization: Colonial and Post-Colonial Women's Writing* (Oxford: Dangaroo Press, 1985).

Honan, Park, *Matthew Arnold: A Life* (London: Weidenfeld & Nicolson, 1981).

hooks, bell, *Ain't I a Woman. Black Women and Feminism* (Boston: South End Press, 1981).

—— *Black Looks: Race and Representation* (London: Turnaround, 1992).

Hope, Thomas, *An Essay on the Origin and Prospects of Man*, 3 vols (London: Murray, 1831).

Hopkins, Gerard Manley, *Further Letters of Gerard Manley Hopkins, Including His Correspondence with Coventry Patmore*, ed. Claude Colleer Abbott, 2nd edn (London: Oxford University Press, 1956).

Horsman, Reginald, *Race and Manifest Destiny: The Origins of American Racial Anglo-Saxonism* (Cambridge, Mass.: Harvard University Press, 1981).

—— *Josiah Nott of Mobile, Southerner, Physician, and Racial Theorist* (Baton Rouge: Louisiana State University Press, 1987).

Hotze, Henry, *Analytical Introduction to Count Gobineau's Moral and Intellectual Diversity of Races* (Mobile: n.p., [1856]).

—— 'The Distinction of Race', *The Index*, 1 (23 October 1862), 413–14.

—— *Three Months in the Confederate Army*, ed. Richard P. Harwell (University, Alabama: University of Alabama Press, 1952).

Hulme, Peter, *Colonial Encounters: Europe and the Native Caribbean, 1492–1797* (London: Methuen, 1986).

Hunt, James, 'On Ethno-Climatology; or, the Acclimatization of Man', *Reports of the British Association*, 31 (1862), 129–50.

—— *On The Negro's Place in Nature* (London: Anthropological Society, 1863).

—— 'President's Address', *Journal of the Anthropological Society of London*, 2 (1864), lxxx–xciii.

—— 'President's Address', *Journal of the Anthropological Society of London*, 4 (1866), lix–lxxxi.

Huston, Nancy, 'Erotic Literature in Postwar France', *Raritan*, 12:1 (1992), 29–45.

Hutchinson, H. N., Gregory, J. W. and Lydekker, R., *The Living Races of Mankind. A Popular Illustrated Account of the Customs, Habits, Pursuits, Feasts and Ceremonies of the Races of Mankind Throughout the World*, 2 vols (London: Hutchinson, [1900–1]).

Huxley, T. H., *Six Lectures to Working Men 'On Our Knowledge of the Causes of the Phenomena of Organic Nature'* [1863], in *Collected Essays* (London: Macmillan, 1893–5), II, 303–475.

—— 'Emancipation Black and White' [1865], *Collected Essays* (London: Macmillan, 1893–5), III, 66–75.

—— 'On the Natural Inequality of Men' [1890], *Collected Essays* (London: Macmillan, 1893–5), I, 290–335.

Huyssen, Andreas, *After the Great Divide: Modernism, Mass Culture, Postmodernism* (Bloomington: Indiana University Press, 1986).

Hyam, Ronald, *Britain's Imperial Century 1815–1914: A Study of Empire and Expansion* (London: Batsford, 1976).

—— *Empire and Sexuality: The British Experience* (Manchester: Manchester University Press, 1990).

Imhoff, Gérard, 'L'Idée de "dégénération" chez Blumenbach et Gobineau', *Etudes Gobiniennes*, 5 (1971), 193–202.

Inden, Ronald, *Imagining India* (Oxford: Blackwell, 1990).

The Index, A Weekly Journal Of Politics, Literature, and News; Devoted to the Exposition of the Mutual Interest, Political and Commercial, of Great Britain and the Confederate States of America, 5 vols (1 May 1862–12 August 1865).

James, G. G. M., *Stolen Legacy: The Greeks were not the Authors of Greek Philosophy, but the People of North Africa: Commonly Called the Egyptians* (New York: Philosophical Library, 1954).

Jameson, J. F., 'The London Expenditures of the Confederate Secret Service', *The American Historical Review*, 35 (1930), 811–24.

JanMohamed, Abdul R., 'The Economy of Manichean Allegory: The Function of Racial Difference in Colonialist Literature', *Critical Inquiry*, 12:1 (1985), 59–87.

—— and Lloyd, David, eds, *The Nature and Context of Minority Discourse* (New York: Oxford University Press, 1990).

Janzen, John M., *The Quest for Therapy in Lower Zaire* (Berkeley: University of California Press, 1978).

Jenkins, Brian, *Britain and the War for the Union*, 2 vols (Montreal: McGill-Queen's University Press, 1980).

Jones, Greta, *Social Darwinism and English Thought: The Interaction between Biological and Social Theory* (Brighton: Harvester Press, 1980).

Jones, Iva G., 'Trollope, Carlyle, and Mill on the Negro: An Episode in the History of Ideas', *Journal of Negro History*, 52 (1967), 185–99.

Jordan, W.D., *White Over Black: American Attitudes Toward the Negro, 1550–1812* (Chapel Hill: University of North Carolina Press, 1968).

Joyce, T. Athol and Thomas, N. W., eds, *Women of All Nations. A Record of Their Characteristics, Habits, Manners, Customs and Influence*, 2 vols (London: Cassell, 1908).

Joyce, James, *Ulysses* [1922] (London: Bodley Head, 1960).

Kaplan, Sydney, 'The Miscegenation Issue in the Election of 1864', *Journal of Negro History*, 34:3 (1949), 274–343.

Kern, Stephen, *The Culture of Time and Space, 1880–1918* (London: Weidenfeld & Nicolson, 1983).

Kiernan, V. G., *The Lords of Human Kind: European Attitudes to the Outside World in the Imperial Age* (London: Weidenfeld & Nicolson, 1969).

Kingsley, Frances E., ed., *Charles Kingsley, His Letters and Memories of His Life*, 3 vols (London: Macmillan, 1901).

Kipling, Rudyard, *Kim* (London: Macmillan, 1901).

Kirk-Greene, Anthony, 'Colonial Administration and Race Relations: Some Research Reflections and Directions', *Ethnic and Racial Studies*, 9:3 (1986), 275–87.

Knight, Richard Payne, *The Progress of Civil Society: A Didactic Poem* (London: Nicol, 1796).

Knox, Robert, *The Races of Men: A Fragment* (London: Renshaw, 1850).
—— *The Races of Men: A Philosophical Enquiry into the Influence of Race over the Destinies of Nations*, 2nd edn (London: Renshaw, 1862).
Kroeber A. L. and Kluckhohn, Clyde, *Culture: A Critical Review of Concepts and Definitions*, Papers of the Peabody Museum of American Archaeology and Ethnology, Harvard University, 47:1 (Cambridge, Mass.: Harvard University Press, 1952).
Kuper, Adam, *The Invention of Primitive Society: Transformations of an Illusion* (London: Routledge, 1988).
Kureishi, Hanif, *My Beautiful Laundrette and The Rainbow Sign* (London: Faber & Faber, 1986).
LaCapra, Dominick, ed., *The Bounds of Race: Perspectives on Hegemony and Resistance* (Ithaca: Cornell University Press, 1991).
Lambropoulos, Vassilis, *The Rise of Eurocentrism. Anatomy of Interpretation* (Princeton: Princeton University Press, 1993).
Latham, R. G., *The Natural History of the Varieties of Man* (London: Van Voorst, 1850).
—— *The Ethnology of the British Colonies and Dependencies* (London: Van Voorst, 1851).
—— *Descriptive Ethnology*, 2 vols (London: Van Voorst, 1859).
Lavrin, Asuncion, ed., *Sexuality and Marriage in Colonial Latin America* (Lincoln: University of Nebraska Press, 1989).
Lawrence, D. H., *The First Lady Chatterley* (Harmondsworth: Penguin, 1973).
Lawrence, William, *Lectures on Physiology, Zoology, and the Natural History of Man, Delivered to the Royal College of Surgeons* [1819], 3rd edn (London: Smith, 1823).
Lee, Richard, 'The Extinction of Races', *Journal of the Anthropological Society of London*, 2 (1864), xcv–xcix.
Leiris, Michel, *Race and Culture* (Paris: Unesco, 1951).
Lémonon, Michel, 'A propos de la diffusion du Gobinisme en Allemagne', *Etudes Gobiniennes*, 2 (1967), 261–7.
—— 'Les Débuts du Gobinisme en Allemagne', *Etudes Gobiniennes*, 3 (1968–9), 183–93.
—— 'La Première recension de l'*Essai* en Allemagne: Gobineau et Ewald', *Etudes Gobiniennes*, 4 (1970), 189–96.
—— 'Les Débuts du Gobinisme en Allemagne', *Etudes Gobiniennes*, 5 (1971), 149–54.
Lenin, V. I., *Imperialism, the Highest Stage of Capitalism* [1917] (Peking: Foreign Languages Press, 1965).
Lévi-Strauss, Claude, *The View from Afar*, trans. Joachim Neugroschel and Phoebe Hoss (Harmondsworth: Penguin, 1987).
—— *Structural Anthropology*, vol. II, trans. Monique Layton (London: Allen Lane, 1977).
Lewis, Percy Wyndham, *The Lion and the Fox: The Role of the Hero in the Plays of Shakespeare* [1927] (London: Methuen, 1951).
Lloyd, David, *Nationalism and Minor Literature: James Clarence Mangan and the Emergence of Irish Cultural Nationalism* (Berkeley: University of California Press, 1987).
Long, Edward, *Candid Reflections upon the Judgement Lately Awarded by the Court of King's Bench, in Westminster-Hall, on what is commonly called the Negro Cause, by a Planter* (London: Lowndes, 1772).
—— *The History of Jamaica. Or, General Survey of the Antient and Modern State*

of that Island; with Reflections on its Situation, Settlements, Inhabitants, Climate, Products, Commerce, Laws, And Government, 3 vols (London: Lowndes, 1774).

Lonsdale, Henry, *A Sketch of the Life and Writings of Robert Knox, the Anatomist* (London: Macmillan, 1870).

Lorimer, Douglas A., *Colour, Class, and the Victorians: English Attitudes to the Negro in the Mid-Nineteenth Century* (Leicester: Leicester University Press, 1978).

Lucas, John, *England and Englishness: Ideas of Nationhood in English Poetry 1688–1900* (London: Hogarth Press, 1991).

Lugard, Frederick John D., *The Dual Mandate in British Tropical Africa* (Edinburgh: Blackwood, 1922).

Lyell, Charles, *Principles of Geology. Being an Attempt to Explain the Former Changes of the Earth's Surface, by Reference to Causes Now in Operation,* 2 vols (London: Murray, 1830).

—— *The Geological Evidences of the Antiquity of Man, with remarks on Theories of the Origin of Species by Variation* (London: Murray, 1863).

McLennan, J. F., *Primitive Marriage: An Inquiry into the Origin of the Form of Capture in Marriage Ceremonies* (Edinburgh: Black, 1865).

Macleod Ray and Lewis, Milton, *Disease, Medicine and Empire: Perspectives on Western Medicine and the Experience of European Expansion* (London: Routledge, 1988).

Mahaffy, J. P., *Social Life in Greece from Homer to Menander* (London: Macmillan, 1874).

Majeed, Javed, *Ungoverned Imaginings. James Mill's 'The History of British India' and Orientalism* (Oxford: Clarendon Press, 1992).

Malthus, T. R., *An Essay on the Principle of Population; or, A View of its Past and Present Effects on Human Happiness; with an Inquiry into our Prospects respecting the Future Removal or Mitigation of the Evils which it Occasions* [1798], 6th edn, 2 vols (London: Murray, 1826).

Marcuse, Herbert, *Eros and Civilization: A Philosophical Inquiry into Freud* [1955], 2nd edn (Boston: Beacon Press, 1966).

—— *Negations: Essays in Critical Theory,* trans. Jeremy J. Shapiro (London: Free Association Books, 1988).

Marryat, Frederick, *Peter Simple,* 3 vols (London: Saunders and Otley, 1834).

Marx, Karl and Engels, Friedrich, *On Colonialism,* 4th edn (Moscow: Progress Publishers, 1968).

Massumi, Brian, *A User's Guide to 'Capitalism and Schizophrenia': Deviations from Deleuze and Guattari* (Cambridge, Mass.: MIT Press, 1992).

Mayes, Stanley, *The Great Belzoni* (London: Putnam, 1959).

Meek, Ronald L., *Social Science and the Ignoble Savage* (Cambridge: Cambridge University Press, 1976).

Memmi, Albert, *The Coloniser and the Colonised* (London: Souvenir Press, 1974).

Mercer, Kobena, 'Diaspora Culture and the Dialogic Imagination: The Aesthetics of Black Independent Film in Britain', in Mbye B. Cham and Claire Andrade-Watkins, eds, *Blackframes: Critical Perspectives on Black Independent Cinema* (Cambridge, Mass.: MIT Press, 1988), 50–61.

Mill, J. S., 'The Negro Question', *Fraser's Magazine,* 41 (1850), 25–31.

—— *Dissertations and Discussions, Political, Philosophical, and Historical, reprinted chiefly from the Edinburgh and Westminster Reviews,* 4 vols (London: 1859–75).

—— 'The Slave Power', *Westminster Review,* 22 (1862), 489–510.

—— *Mill on Bentham and Coleridge,* ed. F. R. Leavis (Cambridge: Cambridge

University Press, 1950).

Miller, Christopher L., *Theories of Africans: Francophone Literature and Anthropology in Africa* (Chicago: University of Chicago Press, 1990).

Milnes, Richard Monckton, *The Events of 1848, Especially in Their Relation to Great Britain. A Letter to the Marquis of Lansdowne* (London: Ollivier, 1849).

Mitchell, Timothy, *Colonising Egypt* (Cambridge: Cambridge University Press, 1988).

Mohanty, Chandra Talpade, 'Under Western Eyes: Feminist Scholarship and Colonial Discourse', *Boundary*, 2 Spring/Fall 1984, 71–92.

Moore, W. J., *Health in the Tropics; or, Sanitary Art Applied to Europeans in India* (London: Churchill, 1862).

Morgan, Lewis Henry, *Ancient Society: Researches in the Lines of Human Progress from Savagery through Barbarism to Civilization* [1877] (New York: Meridian Books, 1963).

Mörner, Magnus, *Le Métissage dans l'histoire de l'Amerique Latine* (Paris: Fayard, 1971).

Morrison, Toni, *The Bluest Eye* [1970] (London: Chatto & Windus, 1979).

────── *Beloved* (London: Chatto & Windus, 1988).

Morton, Samuel George, *Crania Americana; or, A Comparative View of the Skulls of Various Aboriginal Nations of North and South America: To which is prefixed an Essay on the Varieties of the Human Species* (London: Simpkin, Marshall, 1839).

────── 'Observations on Egyptian Ethnography, Derived from Anatomy, History, and the Monuments', *Transactions of the American Philosophical Society, held at Philadelphia, for Promoting Useful Knowledge*, n.s., 9 (1846), 93–159, also published as *Crania Aegyptica, or Observations on Egyptian Ethnography, derived from Anatomy, History, and the Monuments* (London: Madden, 1844).

────── 'Hybridity in Animals and Plants, Considered in Reference to the Question of the Unity of the Human Species', *American Journal of Sciences and Arts*, n.s., 3 (1847), 39–50, 203–12.

────── 'Account of a Craniological Collection with Remarks on the Classification of Some Families of the Human Race', *Transactions of the American Ethnological Society*, 2 (1848), 215–22.

────── 'Letter to the Rev. John Bachman, D.D., on the Question of Hybridity in Animals Considered in reference to the Unity of the Human Species', *Charleston Medical Journal*, 5 (1850), 328–44.

────── 'Additional Observations on Hybridity in Animals, and on Some Collateral Subjects; being a Reply to the Objections of the Rev. John Bachman', *Charleston Medical Journal*, 5 (1850), 755–805.

────── 'Notes on Hybridity, designed as a supplement to the memoir on that subject in the last number of this Journal', *Charleston Medical Journal*, 6 (1851), 145–52.

Mosse, George L., *Nationalism and Sexuality: Respectability and Abnormal Sexuality in Modern Europe* (New York: Fertig, 1985).

Mudimbe, V. J., *The Invention of Africa* (Chicago: Chicago University Press, 1988).

Mueller-Vollmer, Kurt, ed., *The Hermeneutics Reader* (Oxford: Blackwell, 1985).

Mumford, Lewis, *The City in History: Its Origins, Its Transformations, and Its Prospects* (London: Secker & Warburg, 1961).

Nandy, Ashis *The Intimate Enemy, Loss and Recovery of Self Under Colonialism* (Delhi: Oxford University Press, 1983).

Neilson, Peter, *Recollections of a Six Years' Residence in the United States of America, Interspersed with Original Anecdotes, Illustrating the Manners of the Inhabitants of the Great Western Republic* (Glasgow: Robertson, 1830).

Newman, Gerald, *The Rise of English Nationalism: A Cultural History 1740–1830* (London: Weidenfeld, 1987).

Ngugi, Wa Thiong'o, *Decolonizing the Mind* (London: Currey, 1981).

Nkrumah, Kwame, *Neo-Colonialism. The Last Stage of Imperialism* (London: Heinemann, 1965).

Nordau, Max, *Degeneration* (London: Heinemann, 1895).

Nott, Josiah C., 'The Mulatto a Hybrid – Probable Extermination of the Two Races if the Whites and Blacks are Allowed to Intermarry', *American Journal of the Medical Sciences*, n.s., 6 (1843), 252–6.

—— *Two Lectures on the Natural History of the Caucasian and Negro Races* (Mobile: n.p., 1844).

—— 'The Negro Race', *Popular Magazine of Anthroplogy*, 3 (1866), 102–18.

—— and Gliddon, George R., *Types of Mankind: or, Ethnological Researches, Based upon the Ancient Monuments, Paintings, Sculptures, and Crania of Races, and upon their Natural, Geographical, Philological, and Biblical History: illustrated by Selections from the unedited papers of Samuel George Morton, M.D., and by additional contributions from Prof. L. Agassiz, LL.D., W. Usher, M.D.; and Prof. H.S. Patterson, M.D.* (London: Trübner, 1854).

—— *The Indigenous Races of the Earth, or, New Chapters of Ethnological Enquiry* (Philadelphia: Lippincott, 1857).

Noyes, John, *Colonial Space: Spatiality in the Discourse of German South West Africa 1884–1915* (Chur: Harwood, 1992).

Oates, Stephen B., 'Henry Hotze: Confederate Agent Abroad', *The Historian*, 27 (1965), 131–45.

Olender, Maurice, *The Languages of Paradise: Race, Religion, and Philology in the Nineteenth Century* (Cambridge, Mass.: Harvard University Press, 1992).

Owen, Robert Dale, *The Wrong of Slavery, the Right of Emancipation, and the Future of the African Race in the United States* (Philadelphia: Lippincott, 1864).

Owsley, Frank Lawrence, *King Cotton Diplomacy. Foreign Relations of the Confederate States of America*, 2nd edn, rev. H. C. Owsley (Chicago: Chicago University Press, 1959).

Parker, Andrew, Russo, Mary, Sommer, Doris and Yaeger, Patricia, eds, *Nationalisms and Sexualities* (London: Routledge, 1992).

Parry, Benita, 'Problems in Current Theories of Colonial Discourse', *Oxford Literary Review*, 9 (1987), 27–58.

Paulhan, Jean, 'A Slave's Revolt: An Essay on *The Story of O*', in Pauline Réage, *The Story of O* [1954] (London: Corgi Books, 1972), 161–73.

Paulin, Tom, *Minotaur: Poetry and the Nation State* (London: Faber & Faber, 1992).

Pick, Daniel, *The Faces of Degeneration: A European Disorder 1848–1918* (Cambridge: Cambridge University Press, 1989).

Pickering, Charles, *The Races of Man and Their Geographical Distribution* (London: Bohn, 1849).

Poliakov, Léon, *The Aryan Myth. A History of Racist and Nationalist Ideas in Europe*, trans. Edmund Howard (London: Chatto, Heinemann for Sussex University Press, 1974).

Pouchet, Georges, *The Plurality of the Human Race*, trans. H. J. C. Beavan (London: Anthropological Society, 1864).

Pratt, Mary Louis, *Imperial Eyes: Travel Writing and Transculturation* (London: Routledge, 1992).

Price, Thomas, *An Essay on the Physiognomy and Physiology of the Present Inhabitants of Britain, with reference to their Origin, as Goths and Celts. Together with Remarks on the Physiognomical Characteristics of Ireland, and Some of the Neighbouring Continental Nations* (London: n.p., 1829).

Prichard, James Cowles, *Researches into the Physical History of Man* (London: Arch, 1813).

—— *Researches into the Physical History of Man*, reprint of 1813 edn, ed. George W. Stocking (Chicago: Chicago University Press, 1973).

—— *The Natural History of Man; Comprising Inquiries into the Modifying Influence of Physical and Moral Agencies on the Different Tribes of the Human Families* (London: Baillière, 1843).

—— *The Natural History of Man; Comprising Inquiries into the Modifying Influence of Physical and Moral Agencies on the Different Tribes of the Human Families*, 4th edn, ed. and enlarged by Edwin Norris, 2 vols (London: Baillière, 1855).

—— 'On the Relations of Ethnology to Other Branches of Knowledge', *Journal of the Ethnological Society of London*, 1 (1848), 310–29.

Pye, Henry James, *The Progress of Refinement. A Poem. In Three Parts* (Oxford: Clarendon Press, 1783).

Quatrefages de Bréau, Jean Lois Armand de, *Unité de l'espèce humaine* (Paris: Hachette, 1861).

—— *Rapport sur les progrès de l'anthropologie* (Paris: Imprimerie impériale, 1867).

—— 'The Formation of the Mixed Human Races', *Anthropological Review*, 7 (1869), 22–40.

—— *The Human Species* (London: Kegan Paul, 1879).

Rae, Isobel, *Knox, the Anatomist* (Edinburgh: Oliver & Boyd, 1964).

Ratzel, Friedrich, *The History of Mankind*, trans. A. J. Butler, introduction by E. B. Tylor, 3 vols (London: Macmillan, 1896–8).

Redpath, John Clark, *With the World's People. An Account of the Ethnic Origin, Primitive Estate, Early Migrations, Social Evolution, and Present Conditions and Promise of the Principal Families of Men, together with a Preliminary Enquiry on the Time, Place and Manner of their Beginning*, 8 vols (Cincinnati: Jones, 1911).

Reece, R. H. W., 'A "Suitable Population": Charles Brooke and Race-Mixing in Sarawak', *Itinerario*, 9:1 (1985), 67–112.

Renan, Joseph Ernest, *The Poetry of the Celtic Races, and Other Studies* [1854], trans. W. G. Hutchison (London: Scott, 1896).

—— *Studies of Religious History* [1857] (London: Heinemann, 1893).

—— *The Life of Jesus* [1863] (London: Trübner, 1864).

—— 'What is a Nation?' [1882], trans. Martin Thom, in Homi K. Bhabha, ed., *Nation and Narration*, (London: Routledge, 1990), 8–22.

—— *The Future of Science, Ideas of 1848* [1890] (London: Chapman and Hall, 1891).

—— *Oeuvres complètes*, ed. H. Psichari, 10 vols (Paris: Calmann-Levy, 1947–64).

Reuter, E. B., *The Mulatto in the United States; Including a Study of the Role of Mixed-Blood Races Throughout the World* (Boston: Badger, 1918).

—— *Race Mixture* (New York: Whittlesey House, 1931).

—— *Race and Culture Contacts* (New York: McGraw Hill, 1934).

Rich, Paul B., *Race and Empire in British Politics* (Cambridge: Cambridge University Press, 1986).

Ripley, William Z., *The Races of Europe: A Sociological Study* (London: Kegan Paul, Trench, 1900).

Ross, Robert, ed., *Racism and Colonialism* (The Hague: Martinus Nijhoff, for Leiden University Press, 1982).

Rushdie, Salman, *Imaginary Homelands: Essays and Criticism 1981–1991* (London: Granta, 1991).

Russell, G. W. E., ed., *Letters of Matthew Arnold 1848–1888*, 2 vols (London: Macmillan, 1895).

Sack, Robert David, *Conceptions of Space in Social Thought: A Geographic Perspective* (London: Macmillan, 1980).

Said, Edward W., *Orientalism: Western Representations of the Orient* (London: Routledge & Kegan Paul, 1978).

—— *The World, the Text and the Critic* (Cambridge, Mass.: Harvard University Press, 1983).

—— 'Representing the Colonized: Anthropology's Interlocutors', *Critical Inquiry*, 15:2 (1989), 205–25.

—— *Culture and Imperialism* (London: Chatto & Windus, 1993).

Samuel, Raphael, ed., *Patriotism: The Making and Unmaking of British National Identity*, 3 vols (London: Routledge, 1989).

Sartre, Jean-Paul, *Anti-Semite and Jew* [1946], trans. George J. Becker (New York: Schocken Books, 1948).

—— *Critique of Dialectical Reason: 1. Theory of Practical Ensembles* [1960], trans. Alan Sheridan-Smith (London: Verso, 1976).

Schipper, Mineke, *Le Blanc et l'Occident* (Assen: Van Gorcum, 1973).

—— *Beyond the Boundaries: African Literature and Literary Theory* (London: Allison & Busby, 1989).

Seaman, L., *What Miscegenation is! What we are to Expect Now that Mr Lincoln is Re-elected* (New York: Waller & Willets, 1885).

Sekora, J., *Luxury: the Concept in Western Thought, Eden to Smollett* (Baltimore: Johns Hopkins University Press, 1977).

Semmel, Bernard, *The Governor Eyre Controversy* (London: MacGibbon & Kee, 1962).

—— *The Liberal Ideal and the Demons of Empire: Theories of Imperialism from Adam Smith to Lenin* (Baltimore: Johns Hopkins University Press, 1993).

Shiach, Morag, *Discourse on Popular Culture: Class, Gender and History in Cultural Analysis, 1730 to the Present* (Cambridge: Polity Press, 1989).

Showalter, Elaine, *Sexual Anarchy: Gender and Culture at the Fin-de-siècle* (London: Bloomsbury, 1991).

Sinfield, Alan, *Literature, Politics and Culture in Postwar Britain* (Oxford: Blackwell, 1989).

Smith, Charles Hamilton, *The Natural History of the Human Species, its Typical Forms, Primaeval Distribution, Filiations, and Migrations* (Edinburgh: Lizars, 1848).

Smyth, Thomas, *The Unity of the Human Races Proved to be the Doctrine of Scripture, Reason, and Science: with a Review of the Present Position and Theory of Professor Agassiz* (Edinburgh: Johnstone and Hunter, 1851).

Snowden, Frank M., Jr, *Before Color Prejudice: The Ancient View of Blacks* (Cambridge, Mass.: Harvard University Press, 1983).

Southey, Robert, *Poems of Robert Southey*, ed. Maurice H. Fitzgerald (London: Oxford University Press, 1909).

Soyinka, Wole, *Myth, Literature and the African World* (Cambridge: Cambridge University Press, 1976).

Spencer, Herbert, 'A Theory of Population, Deduced from the General Law of Animal Fertility', *Westminster Review*, 57, n.s., 1 (1852), 468–501.

—— *The Principles of Biology,* 2 vols (London: Williams & Norgate, 1864–7).
—— *Essays, Scientific, Political and Speculative,* 2 vols (London: Williams & Norgate, 1868).
—— *The Principles of Sociology,* vol. I (London: Williams & Norgate, 1876).
Spivak, Gayatri Chakravorty, *In Other Worlds: Essays in Cultural Politics* (New York: Methuen, 1987).
—— 'Can the Subaltern Speak? Speculations on Widow Sacrifice', in Cary Nelson and Lawrence Grossberg, eds, *Marxism and the Interpretation of Culture* (London: Macmillan, 1988), 271–313.
—— *The Post-Colonial Critic: Essays, Strategies, Dialogues,* ed. Sarah Harasym (New York: Routledge, 1990).
—— 'Theory in the Margin: Coetzee's *Foe* reading Defoe's *Crusoe and Roxana',* in Jonathan Arac and Barbara Johnson, eds, *Consequences of Theory: Selected Papers from the English Institute* (Baltimore: Johns Hopkins University Press, 1991), 154–80.
—— *Outside in the Teaching Machine* (New York: Routledge, 1993).
Sprinker, Michael, *'A Counterpoint of Dissonance': The Aesthetics and Poetry of Gerard Manley Hopkins* (Baltimore: Johns Hopkins University Press, 1980).
Stallybrass, Peter and White, Allon, *The Politics and Poetics of Transgression* (London: Methuen, 1986).
Stanton, William, *The Leopard's Spots: Scientific Attitudes Toward Race in America 1815–59* (Chicago: Chicago University Press, 1960).
Stember, C. H., *Sexual Racism: the Emotional Barrier to an Integrated Society* (New York: Elsevier, 1976).
Stepan, Nancy, *The Idea of Race in Science: Great Britain 1800–1960* (London: Macmillan, 1982).
—— *'The Hour of Eugenics': Race, Gender and Nation in Latin America* (Ithaca: Cornell University Press, 1991).
Stephan, Kathy, *Robert Knox M.D., F.R.S.E.* (Edinburgh: History of Medicine and Science Unit, 1981).
Stocking, George W. Jr, 'What's in a Name? The Origins of the Royal Anthropological Institute: 1837–1871', *Man,* 6 (1971), 369–90.
—— *Race, Culture, and Evolution: Essays in the History of Anthropology,* rev. edn (Chicago: University of Chicago Press, 1982).
—— *Victorian Anthropology* (New York: Free Press, 1987).
Stoker, Bram, *Dracula* [1897] (Harmondsworth: Penguin, 1979).
Strangford, Viscount, *Original Letters and Papers of the late Viscount Strangford, upon Philological Subjects,* ed. Viscountess Strangford (London: Trübner, 1878).
Street, Brian, *The Savage in Literature: Representations of 'Primitive' Society in English Fiction, 1858–1920* (London: Routledge & Kegan Paul, 1975).
Suleri, Sara, *The Rhetoric of English India* (Chicago: Chicago University Press, 1992).
Talbot, Eugene S., *Degeneracy: Its Causes, Signs, and Results* (London: Scott, 1898).
Temperley, Howard, *British Anti-Slavery 1833–70* (London: Longman, 1972).
Temple, C. L., *Native Races and Their Rulers: Sketches and Studies of Official Life and Administrative Problems in Nigeria* (Cape Town: Argus, 1918).
Tennyson, Alfred Lord, *The Poems of Tennyson,* ed. C. Ricks (London: Longman, 1969).
Thierry, Amédée, *Histoire des Gaulois, depuis les temps les plus reculés jusqu'à l'entière soumission de la Gaule à la domination romaine* (Paris: Sautelet, 1828).
Thierry, Augustin, *Histoire de la conquête de l'Angleterre par les Normands: de ses*

causes, et de ses suites jusqu'à nos jours, en Angleterre, en Ecosse, en Irlande et sur le continent, 3 vols (Paris: Didot, 1825).

Thornton, A. P., *The Imperial Idea and Its Enemies: A Study in British Power*, 2nd edn (Basingstoke: Macmillan, 1985).

Todorov, Tzvetan, *Nous et les autres: La réflexion française sur la diversité humaine* (Paris: Seuil, 1989).

Topinard, Paul, *Anthropology* [1876] (London: Chapman and Hall, 1878).

Torgovnick, Marianna, *Gone Primitive: Savage Intellects, Modern Lives* (Chicago: Chicago University Press, 1990).

Trilling, Lionel, *Matthew Arnold* (London: Allen & Unwin, 1939).

Trollope, Anthony, *The West Indies and the Spanish Main* (London: Chapman and Hall, 1859).

—— *North America* [1862] (Harmondsworth: Penguin, 1992).

Trotter, David, 'Colonial Subjects', *Critical Quarterly*, 32:3 (1990), 3–20.

Tschudi, J. J. von, *Travels in Peru, During the Years 1838–1842 on the Coast, and in the Sierra, across the Cordilleras and the Andes, into the Primeval Forests*, trans. Thomasina Ross (London: Bogue, 1847).

Tylor, Edward B., *Primitive Culture: Researches into the Development of Mythology, Philosophy, Religion, Art, and Custom*, 2 vols (London: Murray, 1871).

—— *Anthropology: An Introduction to the Study of Man and Civilization* (London: Macmillan, 1881).

US War Dept., *Official Records of the Union and Confederate Navies in the War of Rebellion*, 2nd series, 3 vols (Washington, 1920–2).

Van Amringe, W. F., *An Investigation of the Theories of the Natural History of Man, by Lawrence, Prichard, and others, founded upon Animal Analogies: and an Outline of a New Natural History of Man, founded upon History, Anatomy, Physiology, and Human Analogies* (New York: Baker & Scribner, 1848).

Van Evrie, J. H., *Subgenation: The Theory of the Normal Relation of the Races: An Answer to 'Miscegenation'* (New York: Bradburn, 1864).

Vaughan, Megan, *Curing Their Ills: Colonial Power and African Illness* (Oxford: Blackwell, 1991).

Viswanathan, Gauri, *Masks of Conquest: Literary Study and British Rule in India* (London: Faber, 1990).

Vogt, Carl, *Lectures on Man: His Place in Creation, and in the History of the Earth* [1863], trans. James Hunt (London: Anthropological Society, 1864).

Voloshinov, V. N., *Marxism and the Philosophy of Language* [1929] (New York: Seminar Press, 1973).

Wagner, Roy, *The Invention of Culture*, rev. edn (Chicago: Chicago University Press, 1980).

Waitz, Theodor, *Introduction to Anthropology* [1859], trans. J. Frederick Collingwood (London: Anthropological Society, 1863).

Wakelyn, Jon L., *Biographical Dictionary of the Confederacy* (Westport: Greenwood Press, 1977).

Wallace, A. R., 'The Origin of Human Races and the Antiquity of Man Deduced from the Theory of "Natural Selection"', *Journal of the Anthropological Society of London*, 2 (1864), clvii–clxxxvii.

—— 'Anthropology', *Reports of the British Association*, 36 (1867), 93–4.

Walvin, James, *Black Ivory: A History of British Slavery* (London: Harper Collins, 1992).

—— ed., *Slavery and British Society 1776–1846* (London: Macmillan, 1982).

Ward, J. R., *British West Indian Slavery, 1750–1834: The Process of Amelioration* (Oxford: Clarendon Press, 1988).

Weeks, Jeffrey, *Sex, Politics and Society. The Regulation of Sexuality since 1800* (London: Longman, 1981).

Whately, Richard, *Miscellaneous Lectures and Reviews* (London: Parker, Son, & Brown, 1861).

White, Hayden V., *Tropics of Discourse: Essays in Cultural Criticism* (Baltimore: Johns Hopkins University Press, 1978).

Williams, Raymond, *Culture and Society, 1780–1850* (London: Chatto & Windus, 1958).

—— *The Country and the City* (London: Chatto & Windus, 1973).

—— *Keywords: A Vocabulary of Culture and Society* [1976], rev. edn (London: Fontana Press, 1983).

—— *Culture* (London: Fontana, 1981).

Williamson, Joel, *New People: Miscegenation and Mulattoes in the United States* (New York: Free Press, 1980).

Wills, Clair, *Improprieties: Politics and Sexuality in Northern Irish Poetry* (Oxford: Clarendon Press, 1993).

Wolf, Eric R., *Europe and the People Without History* (Berkeley: University of California Press, 1982).

Wood, Forrest G., *Black Scare: The Racist Response to Emancipation and Reconstruction* (Berkeley: University of California Press, 1968).

Wood, J. G., *The Natural History of Man, Being an Account of the Manners and Customs of the Uncivilized Races of Men*, 2 vols (London: Routledge, 1868).

Wurgaft, Lewis D., *The Imperial Imagination* (Middletown: Wesleyan University Press, 1983).

Yeats, W. B. *Collected Poems* (London: Macmillan, 1950).

Young, Robert J. C., *White Mythologies: Writing History and the West* (London: Routledge, 1990).

—— 'The Idea of a Chrestomathic University', in Richard A. Rand, ed., *Logomachia: The Conflict of the Faculties* (Lincoln: Nebraska University Press, 1992), 97–126.

—— 'Black Athena: The Politics of Scholarship', *Science as Culture*, 19 (1994), 274–81.

—— 'Egypt in America: Black Athena and Colonial Discourse', in Ali Rattansi and Sallie Westwood, eds, *Racism, Modernity and Identity* (Cambridge: Polity Press, 1994), 150–69.

Young, Robert M., *Mind, Brain and Adaptation in the Nineteenth Century: Cerebral Localization and its Biological Context from Gall to Ferrier* (Oxford: Clarendon Press, 1970).

—— *Darwin's Metaphor: Nature's Place in Victorian Culture* (Cambridge: Cambridge University Press, 1985).

INDEX

hair, in racial theory 78, 140–1, 144–5, 156, 177
Haiti 107
Hall, Catherine 119
Hall, Stuart 24
Hardy, Thomas 2
Harvey, David 170
Hebraism 58, 60–3, 82
Hegel, G.W.F. 108, 179–80
hegemony 24–5, 166, 172
Heidegger, Martin 63, 88, 94
Heine, H. 84
Hellenism 60–3, 82–5
Helvétius, 38
Herder, J.G. 36–43, 46, 55, 65
heterogeneity 1–4, 25, 41, 70, 164, 173; heterogeneous races 17–18
hierarchy, cultural and racial 6, 32, 35, 41, 46–52, 60, 68–9, 94–5, 111, 119, 121, 137
Himalayas 65
history: colonial 160–82; counter-histories 24, 98, 161–2, 174; and race xi, 14–15, 35, 60–2, 67, 76, 82–5, 120, 127, 130, 178–9; universal 32–7, 40, 46, 103
Hitler, Adolf 8, 18, 99, 125, 177
Hodgkin, Thomas 78
Holland, Henry 7
Holocaust 86
homogeneity: of culture 24–5, 39–42; of nation and race 2, 17, 71–3, 103, 107
Hope, Thomas 96, 99
Hopkins, Gerard Manley 70
Hotze, Henry 14, 48, 103, 110, 125, 132–9
Humboldt, W. von 20, 109
Hume, David 94, 123
Hunt, James 39, 49, 66, 134–6, 139, 146, 177
Hunter, John 7
Hunter, R.M.T. 134
Husserl, Edmund 20
Huxley, T.H. 9–10, 63, 87, 136
Hyam, Ronald 5, 97, 151
hybridity: cultural 5, 22–8, 39–41, 160–1, 175; linguistic 20–2; and mongrelity 6–12; in racial theory 5–20, 26–8, 75, 79–80, 101–3, 113–17, 124, 126–33, 135, 174–81; reversion 15, 79, 141; taxonomies of 114–15, 141, 174–81

identity 1–5, 17, 27, 83, 88, 128–30, 147, 179
ideology 31, 36–7, 159, 167; colonial 159, 164, 170–1; racial 7, 13, 19, 27–8, 42, 50–2, 64, 67–9, 83, 88, 91–2, 133–4, 152, 180
imperialism 23, 29, 36, 42, 50, 62, 91–2, 140, 152, 159, 171
India 2, 36, 67, 69, 97, 99–100, 107, 120, 130, 138–9, 143, 152, 164–6, 178
Indian Mutiny 92, 119, 138
industrialization 35–6, 42, 55, 100, 130, 169
instincts 61, 70, 103, 108, 110, 112, 149
institutions 32, 45, 51–2, 56–7, 61, 67, 100, 134, 165, 168–9, 172
invasions 2, 36, 79, 113
Ireland 3, 68, 72, 73, 84, 90, 117, 140, 164

Jamaica 137, 142, 151–8, 177
Jamaica Insurrection (1865) 61, 87, 92, 119, 136
James, G.G.M. 126
James, Henry 3, 63
Java 107
Johnson, Samuel 31
Jordan, Winthrop D. 149
Joyce, James 3, 63
Jung, C.G. 63

Kames, Lord 103, 123
Keats, John 44
Keith, Sir Arthur 17
Kingsley, Charles 72, 87
Kipling, Rudyard 3
Klemm, Gustav 111
Kluckhohn, Clyde 45
Knight, Richard Payne 34
knowledge, academic and scientific 62–3, 71–2, 82, 84–5, 87–8, 90–3, 139–40, 159–63, 179–82; counter-knowledges 23, 162
Knox, Robert 7, 12, 14–17, 39–40, 72, 75–6, 78–81, 84–5, 87, 95, 102, 104–5, 119–23, 131, 134–5, 140, 175; *The Races of Men* 14, 16, 67, 78, 93, 95, 99, 119, 122, 135
Kroeber, A.L. 45
Kureishi, Hanif 3

La Bruyère 38

Tibet 2
Todorov, T. 38, 69, 83, 110
Topinard, P. 103
Toronto 139
trade 29, 57, 172–3
transgression 26, 98, 103–4, 115, 173
tribes 11, 13, 31, 33, 46, 96–7, 104, 107,
 110, 113, 129, 140, 178
Trilling, Lionel 63, 86
Trollope, Anthony 49, 120, 135, 142,
 143
Trotter, David 166
Tschudi, J.J. von 175–8
Turgot, Baron 32
Tylor, Edward B. 51, 63, 80, 102, 140–1,
 177; *Primitive Culture* 44–50
types, theory of 13–15, 17–18, 38, 42–3,
 47, 50, 61, 66, 71–2, 75–82, 86–7,
 95–6, 102–3, 108, 129–33, 136, 140–1,
 178, 180; English 77; hybrid 2, 17,
 113, 133; quaternary 18, 103;
 stereotypes 97

United States 11, 55, 117, 120, 124–6,
 133, 144, 148–51, 177; Southern
 States 126–7, 133, 137
universalism 8, 32, 34, 38, 45, 47, 54,
 65, 92, 101, 105, 116, 119, 137, 169–73
universities 51, 56, 58, 61, 64, 71, 122,
 124

Van Amringe, W.F. 119
Van Evrie, J.H. 135, 146
varieties, in racial theory 9–13, 19, 64,
 78–9, 96, 125, 131–2, 181; see also
 species
violence: colonial 23, 87, 136, 138, 162,
 167, 169–74, 182; of colonial desire
 19, 108–9, 152; racial 4, 30, 37
Virgil 153
Vogt, Carl 17–19, 49, 103, 122, 135

Volney, C.F. 100
Voloshinov, V.N. 20, 24
Voltaire 15, 101

Waitz, T. 7, 11, 63
Wakeman, G. 146
Wales 71–2
West Indies 8, 15, 142, 151, 153, 177
Whately, Richard 49
White, Charles 7–8
white race (Aryans) 7–9, 65, 69, 79–80,
 84–5, 87, 95, 97–109, 111–15, 117, 119,
 124–33, 135–42, 146–52, 175–81;
 white desire 142, 150–8; white male
 65, 94, 101, 111; white supremacy 13,
 106, 109, 117, 119, 122, 124; white
 supremacists 85, 99, 125, 130, 147;
 whiteness 16, 35, 95, 115, 141
Williams, Raymond 37, 40, 42, 44–5,
 52–3, 55–6, 64; *Culture and Society*
 55; *Keywords* 30, 53, 91
Wilson, John Dover 59
women 61, 114–16, 134, 148–52, 162;
 African 2, 150; black 108–11, 145–6,
 149, 150–8; creole 114–15; mulatto
 114, 126, 146, 181; native 90, 116, 151,
 162; of colour 149, 152, 175; servants
 149; slaves 145; subaltern 19; white
 114, 145–6, 151–2, 177
Woolf, Virginia 181
working class 23, 58–60, 114, 169;
 compared to savages 56, 59; see
 also *culture*

Yeats, W.B. 90
yellow race 69, 103, 111
Yuval-Davis, N. 5

zoology 9, 75, 93, 121–3, 139, 148